NAUTILUS

OCTOPUS

PUFFERFISH

QUETZALCOATLUS

RIGHT WHALE

SEA BUTTERFLY

THORNY DEVIL

'UNICORN', the
Goblin Shark

VENUS'S GIRDLE

WATERBEAR

XENOGLAUX
XENOPHYOPHORE

YETI CRAB

ZEBRA FISH

THE BOOK

of

BARELY

IMAGINED

BEINGS

As centuries pass by, the mass of works grows
endlessly, and one can foresee a time when it will be almost as
difficult to educate oneself in a library, as in the universe,
and almost as fast to seek a truth subsisting in nature,
as lost among an immense number of books.

Denis Diderot, *Encyclopédie*, 1755

In our gradually shrinking world, everyone is
in need of all the others. We must look for man wherever we can
find him. When on his way to Thebes Oedipus encountered the
Sphinx, his answer to its riddle was: 'Man'. That simple word
destroyed the monster. We have many monsters to destroy.
Let us think of the answer of Oedipus.

George Seferis, Nobel Prize speech, 1963

THE BOOK

of

BARELY

IMAGINED

BEINGS

A 21st Century Bestiary

CASPAR
HENDERSON

THE UNIVERSITY OF CHICAGO PRESS
CHICAGO AND LONDON

CASPAR HENDERSON is a writer and journalist whose work has appeared in the *Financial Times*, the *Independent*, and *New Scientist*. He lives in Oxford, UK.

The University of Chicago Press, Chicago 60637
The University of Chicago Press, Ltd., London
© 2013 by Caspar Henderson
All rights reserved. Published 2013.
Printed in the United States.

22 21 20 19 18 17 16 15 14 13 1 2 3 4 5

ISBN-13: 978-0-226-04470-5 (cloth)
ISBN-10: 978-0-226-04484-2 (e-book)

Originally published in English by Granta Publications under the title
The Book of Barely Imagined Beings © 2012 by Caspar Henderson.
First published in Great Britain by Granta Books 2012.

Library of Congress Cataloging-in-Publication Data

Henderson, Caspar, author.
 The book of barely imagined beings : a 21st century bestiary / Caspar Henderson.
 pages cm
 Includes bibliographical references and index.
ISBN 978-0-226-04470-5 (cloth : alkaline paper) — ISBN 978-0-226-04484-2 (e-book)
 1. Bestiaries. 2. Rare animals. I. Title.
 QL50.H463B66 2013
 591.68—dc23

 2012040239

♾ This paper meets the requirements of ANSI / NISO Z39.48-1992 (Permanence of Paper).

A serious and good philosophical work could
be written consisting entirely of jokes.
Ludwig Wittgenstein

The world is full of magical things patiently
waiting for our wits to grow sharper.
Bertrand Russell

The true measure of a mountain's greatness
is not its height but whether it is charming
enough to attract dragons.
from a Chinese poem

The most barbarous of our maladies is
to despise our being.
Michel de Montaigne

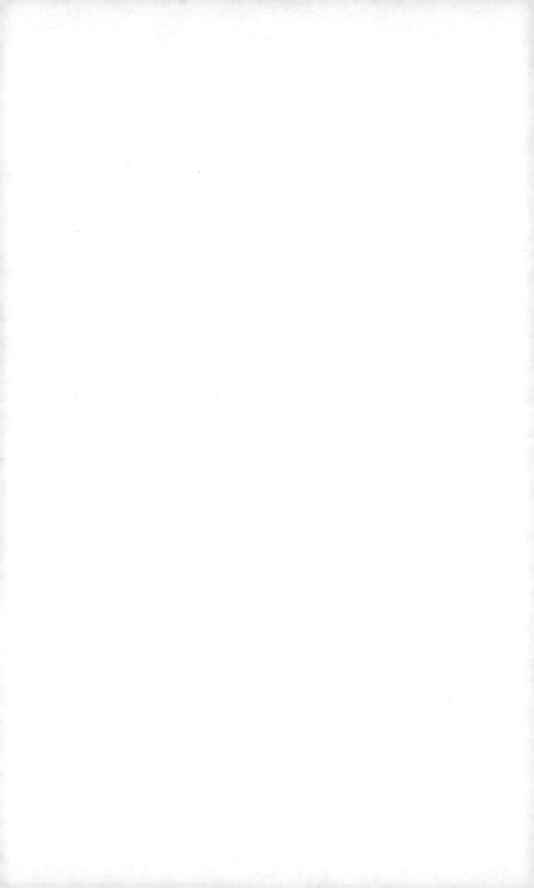

CONTENTS

INTRODUCTION

On a bright afternoon in early summer a few years ago, my wife and I took our tiny new daughter out on a picnic. The air was so clear that everything seemed like a hyper-real version of itself. We sat down next to a bubbling stream on grass that glowed in the sunlight. After a feed our daughter fell asleep. I turned to a bag of books, magazines and papers which I tended to carry about in those pre-tablet days and which always contained far more than I had time to read on topics like ecological degradation, nuclear proliferation and the latest concessions made to torturers and criminals: the funnies.

Also in the bag that day was a copy of *The Book of Imaginary Beings* – a bestiary, or book of beasts, by the Argentine writer Jorge Luis Borges, first published in 1967. I had last looked at it almost twenty years before and had thrown it in as an afterthought. But as soon as I started to read I was riveted. There's Humbaba, the guardian of the cedar forest in *Gilgamesh*, the world's oldest known poem, who is described as having the paws of a lion, a body covered with horny scales, the claws of a vulture, the horns of a wild bull and a tail and penis both ending in snake's heads. There's an animal imagined by Franz Kafka which has a body like that of a kangaroo but a flat, almost human face; only its teeth have the power of expression and Kafka has the feeling it is trying to tame him.

There is the Strong Toad of Chilean folklore, which has a shell like a turtle, glows in the dark like a firefly and is so tough that the only way to kill it is to reduce it to ashes; the great power of its stare attracts or repels whatever is in its range. Each of these – and many others from myths and fables from all over the world as well as several from the author's own imagination – is described in vignettes that are charming, weird, disturbing or comic, and sometimes all four. The book is a bravura display of human imagination responding to and remaking reality. As I say, I was riveted – until I dozed off in the sunshine.

I woke with the thought that many real animals are stranger than imaginary ones, and it is our knowledge and understanding that are too cramped and fragmentary to accommodate them: we have *barely imagined* them. And in a time that we are now learning to call the Anthropocene, a time of extinctions and transformations as momentous as any in the history of life, this needs attention. I should, said this niggling thought, look more deeply into unfamiliar ways of being in the world of which I had only an inkling. And I should map those explorations in a Book of Barely Imagined Beings.

Normally I would shrug off such a half-formed idea pretty quickly. But this one refused to go away, and over the months that followed it became an obsession to the point where I could no longer avoid doing some actual work. The result is what you are holding in your hands: explorations and sketches towards a twenty-first-century bestiary.

We typically think of bestiaries, if we think of them at all, as creations of the medieval mind: delightful for their bizarre and beautiful images illuminated in gold and precious pigments from far-off lands. The Ashmole Bestiary, a thirteenth-century manuscript in the Bodleian Library in Oxford, is a good example. In one picture, a man dressed in red is watching a pot on a fire he has made on a small island in the sea, unaware that the island is actually the back of a huge whale. Meanwhile, a high-castled ship sails by, silhouetted against a sky entirely of gold. In another picture, barnacle geese, depicted in black, hang by their beaks from what look

'All the creatures in this world have dimensions that cannot be calculated.' (Zhuangzi c.300 BC)

The present geological epoch used to be called the Holocene (derived from ὅλος – *holos* – whole or entire, and καινός – *kainos* – new) and referred to the 10,000 years or so since the end of the last Ice Age. In 2008 geologists agreed a new term, the Anthropocene, to acknowledge that humans are now the largest single influence on the Earth system. Typically, the new epoch is said to have begun with the large-scale combustion of fossil fuels

like green, red and blue Art Deco trumpets but are supposed to be flowers on a tree. The text is often as entrancing as the pictures. The asp is an animal that blocks its ear with its tail so as not to hear the snake charmer. The panther is a gentle, multicoloured beast whose only enemy is the dragon. And the swordfish uses its pointed beak to sink ships.

But there is more to bestiaries than this. Along with zany pictures, bizarre zoology and religious parables, they contain gems of acute observation: attempts to understand and convey how things actually are. Undaunted by (and unaware of) the limits of the knowledge of their time, they celebrate the beauty of being and of beings.

A full account of the inspirations and origins of the great illuminated bestiaries of the High Middle Ages would refer to the great scientific works of the ancients, especially Aristotle's *History of Animals* written in the fourth century BC and Pliny's *Natural History* of 77 AD. And it would record how, via a text called *The Physiologus* and through the turbulent years after the sack of Rome (which included a plague that may have killed as much as half the population of Europe), extracts from these and other sources were combined with Bible stories and Christian teaching and shoehorned into compendia of natural history and spiritual teaching. (It might, along the way, allude to masterpieces of the Dark Ages such as the Lindisfarne Gospels, decorated on the Northumbrian coast around 700 AD with braided animal figures from the pagan north as well as mandala-like designs from the sunlit eastern Mediterranean.) But I want to trace something else: an older and more enduring phenomenon – one that predates even images such as the scenes of abundant bird life and dancing dolphins painted in, respectively, Egypt and Crete more than a thousand years before Aristotle was born.

At around 30,000 years old, the paintings in Chauvet Cave in France are among the oldest known. These images of bison, stags, lions, rhinos, ibex, horses, mammoths and other animals were made by artists as skilful as any working today. We will never know exactly what they meant for their creators, but

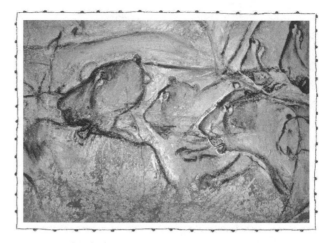

Lions in the Chauvet cave.

we can see that these artists had studied their subjects with great care. They knew, for instance, how the animals changed over the seasons of the year. As the paleoanthropologist Ian Tattersall writes, 'depictions sometimes show bison in summer molting pelage, stags baying in the autumn rut, woolly rhinoceroses displaying the skin fold that was visible only in summer, or salmon with the curious spur on the lower jaw that males develop in the spawning season. Indeed, we know things about the anatomy of now-extinct animals that we could only know through [their] art.' And we know from handprints stamped or silhouetted on the cave walls that people of both sexes and all ages, including babies, took some part in at least some of whatever took place here. We can see that the animals *mattered* to these people. The same species recur, but there are no images of landscape; no clouds, earth, sun, moon, rivers or plant life, and only rarely is there a horizon or a human or partly human figure.

All this points to something obvious but which is, I think, so important that it is hard to overstate. And that is that for much of human history attempts to understand and define ourselves have been closely linked to how we see and represent other animals. Methods of representation may change but a fascination with other

Perhaps, contrary to Plato's allegory of the cave, we sometimes only see the real once we have seen its shadow in art.

THE BOOK OF BARELY IMAGINED BEINGS

modes of being remains. The cabinets of curiosities of the sixteenth and seventeenth centuries, for example, are in obvious respects quite different from the bestiaries of the medieval period. Bringing together actual specimens and fragments of exotic animals, plants and rocks, they helped pave the way for more systematic study of the natural world in the eighteenth century when the taxonomic system that we still use today came into being. But, like the bestiaries, these cabinets still had the power to enchant, as their German name, *Wunderkammern* ('cabinets of wonders'), attests. Today our fondness for curiosities and wonders is no less. From the *Wunderkammer* to the Internet is a small step, and the latter – containing virtually everything – is both the servant of science and an everyday electronic bestiary. From giant squid to two-faced cats, what we know about animals and what we don't, the amazing things they can do and the things they can't, the ways they never stop being strange or surprising, feature constantly among the most shared articles and video clips on the web.

The following seems to be true: our attention is often momentary or disorganized, but fascination with other ways of being, including that of animals, is seldom far from our minds, and gushes up like spring water from within dark rock in every human culture. We may be shameless voyeurs, passionate conservationists or simply curious, but we are seldom indifferent. Like our ancestors, we are continually asking ourselves, consciously or unconsciously, 'what has this got to do with me, my physical existence, the things I hope for and the things I fear?'

The selection of animals in these pages is not intended to be representative of what there is in the world. Still less is this book an attempt at a comprehensive work of natural history. And while I have made every attempt to get the facts right, I have not tried to produce a systematic overview of each animal but have, rather, focused on aspects that are (to my mind, at least) beautiful and intriguing about them, and the qualities, phenomena and issues that they embody, reflect or raise. In some respects, the arrangement resembles the one in a Chinese encyclopedia called the

Ole Worm's cabinet of curiosities, circa 1655.

Celestial Emporium of Benevolent Knowledge imagined by Borges:

> In its distant pages it is written that animals are divided into (a) those that belong to the emperor; (b) embalmed ones; (c) those that are trained; (d) suckling pigs; (e) mermaids; (f) fabulous ones; (g) stray dogs; (h) those that are included in this classification; (i) those that tremble as if they were mad; (j) innumerable ones; (k) those drawn with a very fine camel's-hair brush; (l) etcetera; (m) those that have just broken the flower vase; (n) those that at a distance resemble flies.

This book is envisaged as an 'aletheiagoria' – a new coinage so far as I know, which alludes to phantasmagoria (a light-projected ghost show from the era before cinema) but uses the word 'aletheia', the Greek

for 'truth' or 'revealing'. It suggests (to me, at least) flickering 'real' images of a greater reality. I have tried to look at a few ways of being from different angles and, through 'a wealth of unexpected juxtapositions', explore both how they are like and unlike humans (or how we imagine ourselves to be) and also how their differences from and similarities to us cast light on human capabilities and human concerns. The results are a little strange in places and, indeed, a little strained. Some of the analogies and digressions I have followed have little to do with the animals themselves. They are deliberate attempts to use the animals to think with, but not to think only about the animals. And, for all the digression, there are themes or strands that weave the book together.

One theme of the book is how evolutionary biology (and the scientific method of which it is part) give us a richer and more rewarding sense of the nature of existence than a view informed by myth and tradition alone. Not only is it the case that, in Theodosius Dobzhansky's phrase, 'nothing makes sense except in the light of evolution'; it's also true that astonishment and celebration flourish when rooted in an appreciation of what can be explained. As Robert Pogue Harrison puts it, 'imagination discovers its real freedom in the measured finitude of what is the case'; it was Henry David Thoreau, a radical political activist as well as environmental visionary, who actually measured the depth of Walden Pond with a plumb line, not the 'practical' folk around him who said the pond was bottomless. In the words of Richard Feynman, 'Our imagination is stretched to the utmost not, as in fiction, to imagine things which are not really there, but just to comprehend those things which *are* there.' Thanks to evolutionary theory, the world becomes a transparent surface through which one can see the whole history of life.

Another theme is the sea. About two-thirds of the creatures headlining the chapters are marine. There are several reasons why this is so. For one, the world ocean is our distant origin and by far the largest environment on Earth, covering more than seven-tenths of its surface and comprising more than 95 per cent of its habitable

Italo Calvino uses the phrase 'wealth of unexpected juxtapositions' to describe Pliny's *Natural History*, which divides (for example) fish into: 'Fish that have a pebble in their heads; Fish that hide in winter; Fish that feel the influence of stars; Extraordinary prices paid for certain fish.' And so it is in the essays (in Samuel Johnson's definition: loose sallies of the mind, irregular indigested pieces) in this book.

zone. (Recall Ambrose Bierce's definition: 'Ocean, n. A body of water occupying about two-thirds of a world made for Man – who has no gills.') And yet this great realm is far less known to us than is the land. It is our 'job' to know it better. As Bill Bryson has observed, nothing speaks more clearly of our psychological remoteness from the seas, at least until comparatively recently, than that the main expressed goal of oceanographers during the International Geophysical Year of 1957–8 was to study 'the use of the ocean depths as the dumping ground of radioactive wastes.' Only quite recently have we gone from seeing the world ocean as peripheral to beginning to understand that it plays a central role in the Earth system, including its climate and biodiversity, and so in our fate. And only recently have we begun to learn that the seas are rich with real rather than mythical beings that are strange and sometimes delightful in ways we would never have imagined – that there are, for example, creatures as tall as men which have no internal organs and thrive in waters that would scald us to death in moments, that there is a vast world of cold darkness in which almost all creatures glow with light, or that there are intelligent, aware animals that can squeeze their bodies through a space the width of one of their eyeballs.

Yet another strand running through the book concerns consequences of human behaviour. A few years ago I found myself in a snowstorm on a beach in the Arctic staring at a pile of fat, farting walruses. I was an afterthought, almost a stowaway, on an expedition of artists, musicians and scientists come by sailboat to the Svalbard archipelago (commonly known in English as Spitsbergen) to see for ourselves some signs of the momentous changes under way in the region, and to contemplate what's at stake. (The Arctic is warming more rapidly than anywhere else on Earth. The evidence overwhelmingly points to human activity as the cause.)

Walruses – bulky and comical on land but exquisitely agile and sensitive in the water – are among my favourite animals. Indeed, my daughter may owe them her existence because it was with a drawing of a walrus on a napkin that I first beguiled her mother. I am not alone in my inordinate fondness for these

The scale of human impacts on the ocean, the gravity of the consequences and an agenda for hope and practical action can be found in *Ocean of Life* by Callum Roberts.

beasts if the many films on the Internet of walruses performing aerobic manoeuvres in synchrony with trainers, playing the tuba and making very rude sounds are anything to go by. Nor is delight at walrus appreciation especially new. In 1611 a young one was displayed at the English court,

> where the kinge and many honourable personages beheld it with admiration for the strangenesse of the same, the like whereof had never been seene alive in England. As the beast in shape is very strange, so it is of a strange docilitie, and apt to be taught.

But all this amusement hides an uglier reality. For most of the last four hundred years Europeans laughed at walruses and then killed them – for fun, but mainly for profit driving many populations (though not the species as a whole) to extinction. In their first encounter, in 1604, English sailors quickly learnt that walruses were not only harmless but rich in oil and furnished with splendid tusks, and both fetched good money. In 1605 ships of the London Muscovy Company returned to Spitsbergen to spend the entire summer killing walruses, boiling down the blubber for soap and extracting tusks. By the 1606 season they were so experienced that they killed between 600 and 700 full-grown animals within six hours of landing.

We twenty-first-century visitors, prancing about with caring-sharing environmental sensitivity, meant no harm, we most truly did not. But we had to get photos, so photos we got. And in our excitement, each wanting to get closer, we panicked the animals and sent them tumbling for the sea. The ship's captain was furious: walruses need their rest, and we were ruining it. Individually well-meaning (or so we believed), we were, collectively, small-time vandals. Writing in 1575, Michel de Montaigne asked:

> Who hath perswaded [man] that this admirable moving of heavens vaults, that the eternal light of these lampes so fiercely rowling over his head, that the horror-moving and continuall motion of this infinite vaste ocean were established, and continue

There's a larger point here, encapsulated by the novelist Ian McEwan in his account (reported in a newspaper article and then included in his novel *Solar*) of a scene of chaos on an expedition like ours that he joined the following year. The ship's boot room, a store for gear against the harsh conditions outside, quickly descended into chaos as people grabbed what they wanted without regard to who it belonged to. If, McEwan asks, people widely regarded as sensitive, intelligent and talented can't even manage a boot room, what hope do they have of saving the planet? As the philosopher Raymond Geuss puts it, 'don't look just at what [people] say, think, believe, but at what they actually do, and what actually happens as a result.'

so many ages for his commoditie and service? Is it possible to imagine anything so ridiculous as this miserable and wretched creature, which is not so much as master of himselfe, exposed and subject to offences of all things, and yet dareth call himselfe Master and Emperour of this Universe?

This passage, which clearly influenced *Hamlet*, often comes to mind when I think of our experience with the walruses and other expeditions and experiments I have seen and participated in. It is a reminder of how thoughtless we can be of the consequences of our actions, but it also relates to another strand in the book.

Humans have much more powerful senses than we often realize. A young, healthy person can see a candle flame in the dark thirty miles away, and the human ear can hear down to the threshold of Brownian motion, which is caused by the movement of individual molecules. Still, other creatures have powers of perception – vision, hearing, smell and so on – that vastly exceed our own. In some ways their awareness of the world is superior to ours. And yet in at least one respect – consciousness – all (or virtually all) other animals seem to be greatly our inferiors. Not surprisingly we make a big deal out of human consciousness and identity. But a greater appreciation of the evolutionary inheritance and capacities we share with other animals – and of how, in some ways they surpass us – can contribute to better ways of thinking about the nature of being human and being otherwise.

All these strands mentioned here, and others, including the question of how we perceive time and value over time, connect to a central question: what are our responsibilities as citizens of the Anthropocene to present and future generations? Medieval bestiaries described both real and what we now know to be imaginary animals. They were full of allegory and symbol because for the medieval mind every creature was a manifestation of a religious or moral lesson. Since at least Hume and Darwin many of us no longer believe this. But as we increasingly reshape Creation through science and technology, not to mention our sheer numbers, the creatures that do thrive and evolve are, increasingly, corollaries of

Douglas Hofstadter suggests the 'I' is actually 'a hallucination hallucinated by a hallucination'. Spinoza thought that 'The ocean stands for God or nature, the sole substance, and individual beings are like waves – which are modes of the sea.' At the level of quantum mechanics, at least, Spinoza's intuition may be strictly true: 'The connections to all the things around you literally define who you are,' says the physicist Aaron O'Connell.

our values and concerns. The Enlightenment and the scientific method will, therefore, have made possible the creation of a world that really will be allegorical because we will have remade it in the shadow of our values and priorities. Perhaps the philosopher John Gray is right when he says that the only genuine historical law is a law of irony. This book – a stab at a bestiary for the Anthropocene, in which all the animals are real, evolving and in many cases threatened with imminent extinction – asks what we should value, why we fail to value and how we might change.

In *The Book of Imaginary Beings*, Borges describes the A Bao A Qu, a creature something like a squid or cuttlefish, which only stirs each time a human enters the dark tower in which it lives with the intention of making the arduous climb to the top:

> . . . only when it starts up the spiral stairs is the A Bao A Qu brought to consciousness, and then it sticks close to the visitor's heels, keeping to the outside of the turning steps where they are most worn by generations of pilgrims. At each level the creature's colour become more intense, its shape approaches perfection, and the bluish light it gives off is more brilliant. But it achieves its ultimate form only at the topmost step, when the climber is a person who has attained Nirvana and whose acts cast no shadows. Otherwise, the A Bao A Qu hangs back before reaching the top, as if paralysed, its body incomplete, its blue growing pale, its glow hesitant. The creature suffers when it cannot come to completion, and its moan is a barely audible sound, something like the rustling of silk. Its span of life is brief, since as soon as the traveler climbs down, the A Bao A Qu wheels and tumbles to the first steps, where, worn out and almost shapeless, it waits for the next visitor.

One can interpret Borges's strange story in many ways or not at all. Here I'll call it an allegory, and stick my own crude meaning on it: unless we enlarge our imaginations to better take account of the realities of other forms of being as well as our own, we miss our main task.

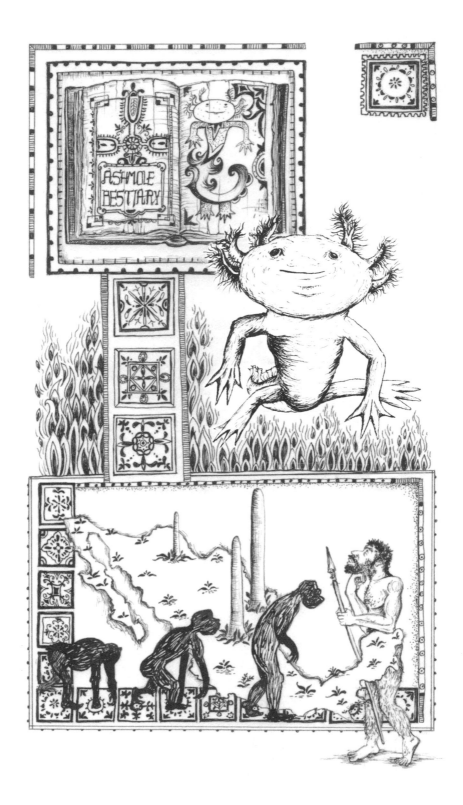

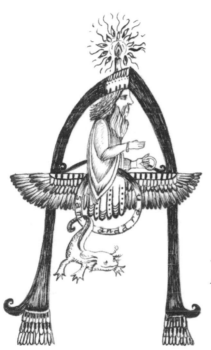

AXOLOTL

Ambystoma mexicanum

Phylum: Chordata
Class: Amphibia
Order: Caudata
Conservation status:
Critically Endangered

... the Salamander, which feedeth upon ashes as bread, and whose joy is at the mouth of the furnace.

Christopher Smart

The history of the errors of mankind ... is more valuable and interesting than that of their discoveries. Truth is uniform and narrow ... but error is endlessly diversified [and] in this field, the soul has room enough to expand herself to display all her boundless faculties and all of her beautiful and interesting extravagancies and absurdities.

Benjamin Franklin

A distant relation of the axolotl known as the Olm, or Proteus, also has pale pink, (European) human-like skin and external gills. It lives in streams in the lime-stone caves of Slovenia and is known as the 'Human fish'.

The first time you see an axolotl it is hard to look away. The lidless, beady eyes, the gills branching like soft coral from its neck, and the lizard-like body kitted out with dainty arms and legs, fingers and toes, together with a tad-pole-like tail make this creature seem quite alien. At the same time the large head, fixed smile and flesh-pink skin give it a disconcertingly human appearance. Combined, such contradictory traits are fascinating. It's easy to see why one of the first European names for this creature translates as 'ludicrous fish'. The Argentine writer Julio Cortázar imagines a character gazing at an axolotl for so long and so intently that he *becomes* one.

The comparatively sober findings of scientific research provide another reason to marvel. Along with its newt cousins, the axolotl is able to regenerate entire severed limbs. Some specialists in regenerative medicine believe that it may be possible one day to restore human limbs and even organs in ways derived at least in part from what we have learned from these creatures. If this does prove to be the case – and even if the potential for axolotl-like regeneration in humans is not as great as hoped – much will have been learned along the way about the workings of cells, which are perhaps the most complex objects in the universe apart from the human brain. And the knowledge

THE BOOK OF BARELY IMAGINED BEINGS

gained will be another step in the emergence of unequivocally better ways of understanding life and the relation of the human to the non-human.

But before trying to address such matters, this chapter will digress into what humans have believed about the order of animals to which the axolotl belongs, the actual role that the ancestors of that order played in evolution, and some of the errors people have made in interpreting the past and the present.

The axolotl is a kind of salamander, one of about five hundred species alive today. For thousands of years people believed that salamanders had a special relationship with fire. The *Ashmole Bestiary*, an illuminated book of beasts made in England in the High Middle Ages, mirrors this: 'The salamander lives in the midst of flames without pain and without being consumed; not only does it not burn, but it puts out flames.'

Few medieval authors or readers would have thought to test this claim. They wouldn't have seen the need. They already knew that every beast in Creation was a lesson in God's plan – or several lessons at once. In the case of the salamander, St

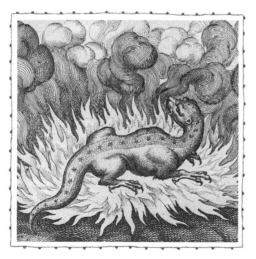

A mythical fire-salamander.

Augustine had, early in the Christian era, cited its fire-hardiness to bolster the case for the physical reality of damnation. 'The salamander', he wrote, 'is a sufficiently convincing example that everything which burns is not consumed, as the souls in hell are not.' Later commentators, by contrast, saw the animal's supposed non-combustibility as a symbol of righteousness: like the salamander, the chosen would withstand fire just as Shadrach, Meshach and Abednego had withstood the fiery furnace.

The union of salamander and fire actually predates Christianity and perhaps Judaism. 'Sam andaran' means 'fire within' in Persian, the language of Zoroastrians – early monotheists for whom fire was an important symbol of the divine. But there was more to the salamander in ancient and medieval minds than fire. According to the *Ashmole Bestiary*, it is also an animal of mass destruction:

Zoroastrians do not worship fire itself. Rather, fire (along with water) is seen as an agent of purity: an individual who has passed the fiery test has attained physical and spiritual strength, wisdom, truth and love with serenity.

> It is the most poisonous of all poisonous creatures. Others kill one at a time; this creature kills several at once. For if it crawls into a tree all the apples are infected with its poison, and those that eat them die. In the same way, if it falls in a well, the water will poison those who drink it.

'This Salemandre berithe wulle, of which is made cloth and gyrdles that may not brenne in the fyre.' (William Caxton, 1481)

These various attributes – fire creature, symbol of virtue, or poison – sit alongside each other in medieval European bestiaries. By the Renaissance, however, the connection with fire had come to dominate. An unburnable cloth from India is 'salamander wool' (this is probably an early mention of asbestos). For Paracelsus and other European alchemists, the salamander was the 'fire elemental', the essence of one of the four fundamental substances of the universe, which could be summoned to the practitioner's aid. A salamander amid flames also became a piece of branding for a king: a Nike swoosh for Francois I of France competing with Henry VIII of England at the Field of the Cloth of Gold. In the following centuries, storytellers from Cyrano de Bergerac to J. K. Rowling have rejoiced in the fantastic qualities of the fire-living salamander. For some it is entirely make-believe. For

others it is definitely real but extremely rare, like – say – the snow leopard today. The Renaissance artist, sexual predator and murderer Benvenuto Cellini provides a good example of this second view:

> When I was about five years of age, my father happening to be in a little room in which they had been washing, and where there was a good fire of oak burning, looked into the flames and saw a little animal resembling a lizard, which could live in the hottest part of that element. Instantly perceiving what it was he called for my sister and me, and after he had shown us the creature, he gave me a box on the ear. I fell a crying, while he, soothing me with caresses, spoke these words: 'My dear child, I do not give you that blow for any fault you have committed, but that you may recollect that the little creature you see in the fire is a salamander; such a one as never was beheld before to my knowledge.' So saying he embraced me, and gave me some money.

It's easy to see that if your only knowledge of the salamander came from bestiaries and the stories they inspired then a real sighting such as the one Cellini recalls would seem to confirm it. The actual explanation – that they like to sleep in cool, damp places such as piles of logs, get carried along when the wood is taken in for burning and, far from sporting in the flames, are writhing in their death throes – would seem dull and unconvincing.

The ancient Greeks and Romans had been more empirical, if not always right, in their claims. When Aristotle refers to a salamander in his *History of Animals*, written in about 340 BC, he makes it clear that he is relying only on hearsay in claiming that they walk through fire and in doing so put the fire out. And in the *Natural History*, written more than four hundred years later, Pliny distinguishes the salamander (an amphibian) from lizards (which are reptiles), describing 'an animal like a lizard in shape and with a body starred all over; it never comes out except during heavy showers and disappears the moment the weather becomes clear.' This is a good description of the golden Alpine salamander

and of some subspecies of the fire salamander. But Pliny also writes – in a passage that inspired later bestiaries – that a salamander is 'so cold that it puts out fire on contact' and that it can be toxic.

Pliny's *History* is full of things that seem fantastical and bizarre to our eyes. In Ethiopia, he writes, there are winged horses with horns, manticores, which have the face of a man, the body of a lion and the tail of a scorpion, and something called a catoblepas, which kills you if you look into its eyes. Even creatures we know to be real become fantastical. The porcupine, for example, can shoot its quills like spears. If a shrew runs across a wheel-rut it dies. Frogs melt away into slime in the autumn and coalesce into frogs again in the spring. The anthiae, a kind of fish, rescue their hooked companions by cutting fishing lines with their fins.

But while Pliny accepts, or reports, many claims that are plainly false to us, he is not entirely gullible. He is for example scathing about astrology and the afterlife, which are items of faith for vast numbers of people today. And when he realizes he doesn't know something, he says so plainly. In the case of the salamander he does at least start from observed reality. Salamanders are indeed 'cold-blooded' – more precisely, ectotherms, which means they take their temperature from their surroundings – so if found in a cool damp place they are indeed cool to human touch. You'd be ill-advised to lick a salamander, but it would be an exaggeration to call it more than mildly toxic. Fire salamanders, which are common on forested hillsides in southern and central Europe, extrude secretions onto their skin containing a neurotoxic alkaloid, Samandarin, when they think they are under attack. This can cause muscle convulsions, high-blood pressure and hyperventilation in small vertebrates. Perhaps this is their real 'fire within'.

The *Natural History* is a remarkable attempt, perhaps the first in the West, to compile all knowledge. Still, Thomas Browne, the seventeenth-century English physician, is pretty unforgiving of what Pliny actually achieved: 'there is scarce a popular error passant in our days', he writes, 'which is not either directly expressed, or deductively contained in [it].' He tried

For all the knowledge he compiled, Pliny concluded that 'among all things, this alone is certain: that nothing is certain, and that there is nothing more proud or more wretched than man'.

to put the record straight with the *Pseudodoxia Epidemica*, or *Vulgar Errors* (the *Bad Science* of its day, it ran to six editions between 1646 and 1672). Browne identifies the causes of popular delusions as, variously, 'erroneous disposition, credulity, supinity, obstinate adherence to antiquity' and 'the endeavours of Satan', but most of his energy goes on demolishing the delusions themselves. The myth of the salamander is one of 'fallacious enlargement', and is easily demolished by a bit of solid English empiricism: 'We have found by [our own] experience, that it is so far from quenching hot coals, that it dieth immediately therein.'

Browne was a practical man but he was also fascinated by symbols and mysteries. His *Garden of Cyrus* is an exuberant vision of the interconnection of art, nature and the universe. For Browne, God is a universal geometer, who places the quincunx (the X shape formed by five points arranged like the five spots on dice) everywhere in living and non-living forms. As W.G. Sebald notes, Browne identifies the quincunx everywhere: in crystalline forms, in starfish and sea urchins, in the vertebrae of mammals and the backbones of birds and fish and in the skins of various species of snake; in the sunflower and the Caledonian pine, within young oak shoots or the stem of the horsetail; and in the creations of mankind, in the pyramids of Egypt and in the garden of King Solomon, which was planted with mathematical precision with pomegranate trees and white lilies. Examples might be multiplied without end.

The salamander reappears in a riddle unearthed more than fifty years after Browne's death when the Swiss physician and naturalist Johann Scheuchzer found a fossil of a creature whose large skull resembled that of a human child, he declared it to be *Homo diluvii testis*, or man, witness to the Great Flood: 'a rare relic of the accursed race of the primitive world'. And this judgement stood for another hundred years until the French comparative anatomist Georges Cuvier examined it. The fossil, he declared in 1812, was definitely not human. A positive identification, however, wasn't made until 1831: *Diluvii testis* was a giant salamander of a type now extinct but related to

Given sufficient enthusiasm one can find the quincunx almost anywhere, including the salamander. As the 'fire elemental', it can be connected to the tetrahedron, the perfect form which Plato believed was the element that constituted fire. The tetrahedron is a 3-simplex whose 4-simplex analog is the pentachoron, a four-dimensional body which can be orphographically projected onto a quincunx (as well as a pentagram and other shapes). You could almost do the same for the code of life itself if you look no further than Rosalind Franklin's 'Photograph 51', which shows DNA in cross section as something like a quincunx.

the enormous creatures that are still found in a few Chinese and Japanese rivers.

Cuvier and others showed that many species that had once roamed the Earth were now extinct, and it was increasingly apparent that there had been vast periods of time before humans appeared. What, then, was our true place and role in Creation? For James McCosh, a philosopher in the once influential but now little remembered Scottish School of Common Sense, the answer was clear: man was the culmination of a process that had produced the ideal form in nature. 'Long ages had yet to roll on before the consummation of the vertebrate type,' McCosh wrote in 1857; 'the preparations for Man's appearance were not yet completed. Nevertheless, in this fossil of Scheuchzer's there was a prefiguration of the more perfect type which Man's bony framework presents.'

Words and phrases like 'consummation' and 'perfect type' are out of fashion today. 'Prefiguration' less so. Amphibian fossils *do* prefigure much of what we see in modern vertebrates, ourselves included. The bodies of salamanders alive today (not to mention those of geckos, grebes and gibbons) share a lot with ours. Salamander limbs may be smaller and slimier than those of most people, but they have essential similarities: they are encased in skin and contain a bony skeleton, muscles, ligaments, tendons, nerves and blood vessels. There are big differences of course – their hearts, for example, have three chambers rather than the four found in reptiles and mammals – but what's a ventricle between friends?

The palaeontologist Richard Owen, a contemporary of both James McCosh and Charles Darwin, thought such similarities, or homologies as he called them, were evidence of 'transcendental anatomy', of a divine plan, with God as a carpenter running off creatures on his workbench as variations of archetypal themes. (He called this the 'axiom of the continuous operation of the ordained becoming of living things'.) But, Owen insisted, each species was separate: one did not evolve into another, and man stood outside as a unique creation. Darwin, by contrast, argued that the similarities seen in so many living creatures,

including man, were better explained by descent with modification from a common ancestor.

Most of us now accept that humans are continuous in an evolutionary sense but we continue to insist that there are essential differences in our way of being. As the anthropologist Loren Eiseley wrote in the 1950s, man is a 'creature of dream [who] has created an invisible world of ideas, beliefs, habits and customs which buttress him about and replace for him the precise instincts of lower creatures'. Eiseley thought that 'a profound shock at the leap from animal to human status is echoing still in the depths of our subconscious minds'.

What could account for our apparently unique ability to be the carriers of such dreams in a way that creatures with superficially similar anatomy – like the salamander – are not? The answer pieced together by paleobiologists and geneticists over that last hundred years is, of course, that after diverging from a common ancestor with our nearest ape cousins, our hominid ancestors acquired much larger brains in a series of evolutionary spurts, notably in the last two million years, until they reached a form very close to ours less than 200,000 years ago. But there is a problem with such an account – at least I have stated it here.

The problem is not that this account is in any way misleading – it is not – but that it is too matter-of-fact; it fails to convey how singular it is that, after so many hundreds of millions of years of vertebrate life – much of it, as we shall see, filled with strange creatures resembling the axolotl – something as marvellous as the human brain evolved in such a comparatively short period of time.

People have looked for all kinds of ways to get around this counterintuitive truth. Among those that claim to be scientific here are two of the most delightfully absurd. In 1919 a distinguished English physical anthropologist named F. Wood Jones argued that large-brained proto-humans were actually tens of millions of years old and 'utterly unlike the slouching, hairy ape-men of which some have dreamed'. They were, rather, 'small active animals' resembling tarsiers,

'If you know how to look, our body becomes a time capsule that, when opened, tells of critical moments in the history of our planet and of a distant past in oceans, streams and forests. Changes in the ancient atmosphere are reflected in the molecules that allow our cells to cooperate to make bodies. The environment of ancient streams shaped the basic anatomy of our limbs. Our colour vision and sense of smell has been molded by life in ancient forests and plains.' (Neil Shubin, 2008)

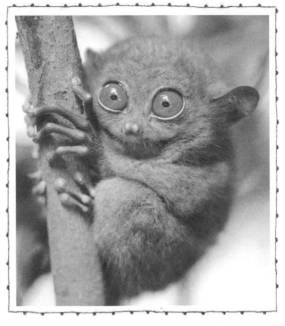

A Tarsier.

already endowed with legs longer than arms, small jaws and a greatly enlarged cranium.

Even at the time he advanced it, Wood Jones's hypothesis was at the outer edge of plausibility which is a pity, given how cute tarsiers are. Wilder still is the theory of initial bipedalism advanced by François de Sarre, which posits that human-like forms preceded not only all other apes but all tetrapods (that is, land animals with backbones: amphibians, reptiles, mammals and birds) and even fish. This homunculus, says this theory, actually evolved directly from an aquatic 'pre-vertebrate' that looked a bit like a lancelet, or amphioxus (a creature alive today that looks like a small and simple fish with a nerve chord but no brain or spine). Humans, therefore, have retained the most primitive body shape of all terrestrial vertebrates, and all the others – stegosaurus, snake and salamander, cow, capybara and coati – have evolved from it: we are the archetype from which all other vertebrates have arisen.

The theory of initial bipedalism claims that our lancelet-like ancestors evolved a bubble-like, gas-filled floating organ that helped control buoyancy.

The coati, also known as the hog-nosed coon, the snookum bear or the Brazilian aardvark, is a kind of raccoon.

At first, this acted as a float, allowing the little crea-
tures to float like champagne corks with their bodies
suspended vertically in the water. Two pairs of limbs
and a little tail evolved to help the animals steer
themselves in the water and they began to look like
vertically-poised floating embryos, with axolotl-like
branched gills sticking out of the neck. The globular
head, meanwhile, allowed space for a big brain to
develop. This aquatic homunculus then evolved
endothermy (warm-bloodedness), body hair, ears,
prehensile hands and live birth, and became the first
animal to colonize the land.

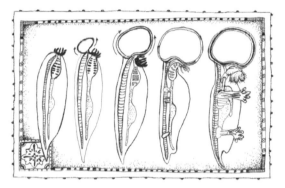

Early stages in the development of the aquatic homunculus.

If this theory is absurd it is at least splendidly and
originally so. And the *actual* shapes of our proto-
amphibian ancestors are no less strange and fascinating.

Many scientists used to think that the first vertebrates
to venture onto land were something like coelacanths –
ancient fish with stubby fins – and that they wriggled
out of the water *before* they evolved legs as we think of
them, or lungs. The model in mind was probably the
'walking fish' such as the mudskippers we see today.
This is now known to be wrong (although mere
wrongness doesn't stop it from being the basis for an
inventive and funny beer advertisement, *noitulovE*).
Lungs and limbs came first, but the creatures that
evolved them were still wholly aquatic.

Our, and the salamanders', ancestors, the first tetrapods (four-limbed vertebrates), evolved in the Devonian geological period, roughly 365 million years ago. They lived in slow-moving, shallow waters of estuaries or coastal swamps, rich in food and places to hide. In these conditions, 'fishapods', able to do push-ups on proto-limbs to gulp fresh air from just above its river habitat, would have had an edge over those relying only on gills to extract meagre oxygen from the murky water. Flexible necks and multiple digits – sometimes seven or eight on each 'hand' or 'foot' – evolved to help a body twist, finger and pick through the weeds and rotting logs.

What would their world have been like? Imagine yourself thrown back in time and washed up on the edge of a Devonian river mouth. It's warm, and you feel a little light-headed because the oxygen concentration in the air, at around 15 per cent, is lower than you're used to. But the water flows and the waves lap just as they always do, and this is reassuring. Looking at the sand beneath your feet, you half recognize something scuttling along the shallow lip of the water: it's a small version of the horseshoe crabs we know today. (Out to sea are placoderms – heavily armoured fish, some of them more than six metres (twenty feet) long and equipped with massive, powerful jaws. But they're out of sight so they don't trouble your glance.)

Moving inland, the vegetation on the riverbanks is bewildering. Nearby is something like a tree trunk: a tall round cylinder about eight metres (twenty-five feet) high with smooth sides and a rounded top. It vaguely resembles a saguaro cactus but without the spikes. This is the fruiting body of *Prototaxites*, the 'humungous fungus'. A little further away is a thicket of … well … nearly-trees, sporting ferns fronds rather then needles or leaves, arranged in odd, symmetrical umbrella-shapes. There are also stumpy things that look like green traffic bollards in various stages of emerging from the ground. And there are shrub-sized clubmosses, their stems close-packed with green scales, looking like bendy policeman's truncheons. You see some strange insects on the ground

and the plant stems, but there are none buzzing in the air – flying insects will not evolve for another sixty millions years. And there's no birdsong, of course: there won't be any for another three hundred million years.

The meandering river mouth is a patchwork of weeds and deep pools. And there, through murky water, you glimpse something about the size of a ten-year-old child, poised delicately on short limbs that end in seven webbed digits. It has a tail rather like a newt's and a face somewhere between fish and frog. You are looking at *Ichthyostega,* and this species, or something very like it, may be our, and the salamander's, direct ancestor. This particular individual saw you coming, however, and quickly swims away: a ripple, then silence.

Three or four thousand years ago in Mesopotamia people imagined that a being called Oannes, half-man and half-fish, rose from the sea to teach wisdom to mankind. *Icthyostega* is emphatically not a supernatural being; it is just a tetrapod from the almost unimaginably remote past. And unlike Oannes, it does not 'teach' us anything in any direct sense. But if we allow it to exist on the water's edge of our conscious minds we may allow ourselves to learn more, feel more deeply about our own rootedness in antiquity and in the strange transformations that have unfolded deep in our past.

After *Icthyostega* there is a break in the fossil record of about twenty million years before there is evidence of amphibians that were completely at home on land.

Insect flight evolved less than 300 million years ago, in the Permian. Songbirds evolved in the early Eocene, less than 56 million years ago.

A primordial being that looks like a fish may seem a little silly but consider that until two or three thousand years ago giant carp and sturgeon, many of them larger than a man and weighing a tonne or more, were not uncommon in many Asian and European rivers. They must have been impressive presences, and would surely have set people to wondering. A few species of giant fish have hung onto existence in the Mekong and some remote rivers until very recently. Not all river-dwelling mythical beings are benign: the Nhang of Armenian lore, for example, is a river-dwelling serpent-monster with shape-shifting abilities that can lure a man by transforming itself into a woman, or changing into a seal and dragging him down to drown to drink his blood. Following the 2003 invasion of Iraq, river carp were said to be growing to the size of men on all the dead bodies thrown into the Tigris and Euphrates.

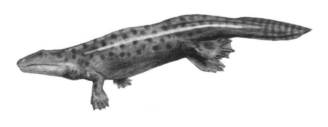

Ichthyostega

Fossilization is rare in nature. Bill Bryson estimates that the entire fossil legacy of the approximately 300 million Americans alive, with 206 bones each, would amount to about fifty bones, or less than a quarter of one complete skeleton.

The last common ancestor of frogs, toads, salamanders and newts is the Elderly Frog of Dr Nicholas Hotton III, or *Gerobatrachus hottoni*. This amphibian Abraham, aka the frogamander, lived during the early Permian but was only discovered in 2007, a fossil in Don's Dump Fish Quarry in Baylor County, Texas. The frog/salamander lineage split during the next 100 million years, before the break-up of the supercontinent Pangea. Ancient frogs and toads became better jumpers, while salamanders specialized in slithering.

This gap may be filled one day. Whatever the precise details turn out to be, this transition was momentous: coming onto land from an environment where animals are essentially weightless was at least as great a challenge as the one an astronaut endures returning to gravity after a long time in space.

For over a hundred million years through the Carboniferous and Permian periods – five hundred times as long as anatomically modern humans have existed – amphibians were top predators on land. *Cacops* looked like a foreshortened crocodile crossed with a really big frog. *Eryops* resembled a monstrous salamander. *Prionosuchus* was, superficially, a dead ringer for a crocodile, only it was nine metres (thirty-three feet) long – much bigger than the largest saltwater crocodiles today. Other species kept the external gills of their larval stage into adulthood, like axolotls but well over twice the size. And at least one, *Diplocaulus*, had a head shaped like a large boomerang.

Amniotes – creatures whose eggs have protective membranes that prevent them from drying out on land – first evolved quite early in the Carboniferous. And, over time, descendants of the first amniotes evolved into reptiles (including the dinosaurs and later their descendants, the birds) and the beasts that eventually became mammals. Ultimately these new kinds of land-adapted vertebrates displaced amphibians in many niches on land, which is probably why this book was not written by a large frog. But it took a long time and there were bumps along the way. A little over 254 million years ago, for example, the greatest catastrophe in the history of life so far killed-off more than two thirds of all terrestrial vertebrates and 97 per cent of all marine life. Amphibians suffered even more than the amniotes. Even so, some survived. And, having ceded much of the ground to reptiles and protomammals, the ancestors of modern amphibians made a virtue of life in the niches remaining available to them. They exploded again (over geological time) into a diversity of beings stranger than anything you'll find in a medieval bestiary.

THE BOOK OF BARELY IMAGINED BEINGS

Consider *Beelzebufo*, a warty 'toad from hell' of Miltonic resonance as big as a super-size pizza. Behold *Nasikabatrachus sahyadrensis,* a rare purple frog as squishy as a bag full of jelly but tough enough to survive almost unchanged for 150 million years. Lo, the crab-eating frog, which lives in mangrove swamps and marshes, and is the only known modern amphibian which can tolerate salt water. Hail the Southern Gastric Brooding Frog, which – until it recently became extinct – swallowed its fertilised eggs and allowed the young frogs to develop into tadpoles and then froglets in the safety of its stomach before disgorging them on an eager world. *Ave*, the caecilians, an entire order which are neither frog, toad, nor salamander but, like the pelican of story, feed their young with their own flesh. And let Earth rejoice in the salamanders, wondrous in their more than five hundred kinds.

It would take another Christopher Smart – the English poet best known for the *Jubilate Agno*, a paean to all creation (but most especially his cat Jeoffrey) – to celebrate all these beings: to write a *Jubiliate Amphibio*. And it would take another William Dunbar – the Scots author of the *Lament for the Makars*, a roll call of poets and friends taken by death – to lament the passing of so many in what, on current trends, looks likely to be the greatest amphibian extinction since the Permian.

The axolotl is a member of the Mole salamanders, a genus found only in North America, and one of a handful of species found only in the highland lakes of Mexico. There are two explanations for its name. One connects it to Xolotl, the Aztec god of fire, guide of the dead, and sometime bringer of bad luck. In a story associated with the legend of the Five Suns, Xolotl (who has backwards feet and the head of a dog) transforms into an axolotl. A second explanation says the name comes from *atl* and *xolotl*, the words for 'water' and 'dog' in the Nahuatl, the language of the Aztecs. As the popular names of other species of salamander, such as snot otter and mud puppy, testify, the larger salamanders can look a little like dogs underwater. This would be all the

.. Princely counsel in his face yet shon, Majestic though in ruin: sage he stood With Atlantean shoulders fit to bear The weight of mightiest Monarchies; his look Drew audience and attention still as Night

The idea that the pelican feeds its young with its own flesh and blood was popular in medieval Europe, and the birds feature in bestiaries as a sign of piety and sacrifice and as a symbol of Christ himself. Caecilians do something similar for real. The young nibble fatty deposits on their mother's skin using special teeth unknown in other modern amphibians. The skin is so nutritious that the young can increase their weight up to ten times in the week after birth. It is the only known case of dermatotrophy – the deriving of necessary nutrients from the consumption of skin – in the animal kingdom.

more the case if your idea of a dog is of the 'hairless' breed common in Mexico.

The axolotl makes at least two entrances into the theatre of European taxonomy. The first is via the pen of Francisco Hernandez, a sixteenth-century Spanish naturalist who recorded its native Nahuatl name and came up with *piscis ludicrous* – the ludicrous fish. The second is in 1789 when the English zoologist George Shaw, who was also the first European scientist to examine a platypus, assigned it a place in the Linnaean firmament. In 1800 the German naturalist Alexander von Humboldt shipped two live axolotls, along with fossilized giant elephant bones and other goodies, to Georges Cuvier – he of the giant primeval swamp salamander – in Paris. Cuvier decided axolotls were the larval form of an unknown air-breathing species, and seems to have left it at that. It was not until sixty years later that scientists, also in France (and benefiting from their country's attempted conquest of Mexico), first studied one of the axolotl's most remarkable features: the fact that it was a reproducing adult even though it looked like a 'tadpole' – that is, a juvenile – but that it could also, mysteriously, transform itself into what looked like another species altogether.

When a new species evolves which has traits as an adult that were previously seen only in juveniles the phenomenon is known as 'neoteny'. It can be observed in a variety of animals. Adult ostriches, for instance, have tufty wee wings similar in proportion and appearance to those of the baby chicks of their ancestors. Humans are reckoned to have as many as twenty neotenic traits, including a small jaw and large head that make us look more like baby gorillas or chimps than 'proper' adult apes. But staying 'immature' doesn't mean you have to be small or sexually dormant. The ostrich is the biggest living bird, and humans are not exactly unsuccessful breeders.

The phenomenon of neoteny has been pressed into service to explain or connect all kinds of things, but it has not always been clear where science ends and where metaphors begin. Aldous Huxley, the

One of the most conspicuous differences between humans and other apes – brain size – is more accurately described as the result of heterochrony rather than neoteny. Brain and head growth in the chimpanzee fetus starts at about the same developmental stage and presents a growth rate similar to that of humans, but ends soon after birth. In humans, rapid brain and head growth continues for several years after birth.

author of *Brave New World* (1932), toyed with the increasingly fashionable idea that humans were neotenic apes and that if human life were extended indefinitely we would become like other apes – hunched, hairy and sitting in our own mess on the floor. His inspiration, at least in part, was actual experimental work on axolotls undertaken by his older brother Julian, one of the leading evolutionary biologists of the first half of the twentieth century, who turned them into something that looked very like their relatives the Mexican tiger salamanders by injecting them with a hormone.

Aldous Huxley was wrong about what would happen if humans were able to live indefinitely, but his theory was, perhaps, no less grounded in reality than another idea popular in his time and still influential today: recapitulation theory. This notion, first put forward in 1866 by the German naturalist Ernst Haeckel, and popularly known as 'ontogeny repeats phylogeny', holds that each creature replays the history of life in the course of its individual development up to the point at which its particular species first appeared. Humans, for example, start out at conception as tiny cells just like the first life, and progress via embryonic stages in which they are fish like, complete with gills, through a mammal-like stage, complete with a tail, before finally emerging as the 'advanced' beings we are today.

Recapitulation theory also seemed to fit with the idea of progress popular in nineteenth- and early twentieth-century Europe and as such was extended to support 'scientific' racism and imperial expansion: the children of the 'advanced' European race, it was believed, were on the same level as the adults of indigenous populations, especially those in Africa who, in Kipling's now notorious phrase, were 'half devil and half child'. And the swarthy natives were (supposedly) very like the apish proto-men of the distant past. White children passed through these stages on their way to becoming the most advanced form of human being.

Many of the most astute minds of the age bought into this theory. Sigmund Freud added a new parallel:

Some scientists think that chordates, the phylum including all vertebrates, evolved as the result of neoteny. Among the nearest living relatives of chordates are sea squirts, or tunicates – sack-like marine filter feeders that superficially resemble sponges. As a larva, the sea squirt swims about, wriggling by means of a notochord, a rod-shaped body made of cells from the mesoderm that resembles a primitive backbone similar to the one in chordate embryos. Maturing, they stick onto rock and lose the notochord. The geneticist Steve Jones compares this life cycle of a sea squirt to that of an academic given tenure: after an active life, it settles on the sea floor and absorbs its brain.

a healthy European child was going through the 'primitive' stage in which non-European adults and early man had got 'stuck' (as, he believed, had neurotic European adults). And an adult from a 'primitive' (non-European) culture and early man were, he said, like a normal modern child: they were 'trapped' in early stages of the unfolding. It inspired Freud's colleague, the Hungarian psychiatrist Sándor Ferenczi, to write a book called *Thalassa: A Theory of Genitality* (1924), in which he argued that that much of human psychology is explained by our unconscious yearning to regress to the comforting confines of the womb-as-sea. Ferenczi saw the full sequence of human life – from the coitus of parents to the final death of the offspring – as a recapitulation of the gigantic tableau of our entire evolutionary past. Impregnation recapitulates the dawn of life. The fetus, in the womb of its symbolic ocean, then passes through all ancestral stages from the primal amoeba to a fully formed human. Birth recapitulates the colonization of land by amphibians and reptiles, while the period of latency, following youthful sexuality and before full maturation, repeats the torpor induced by ice ages.

For the radical environmentalist philosopher Paul Shepard (1982), contemporary Americans were childish adults suffering from ontogenetic crippling – culturally induced neoteny gone wrong.

Haeckel's theory and the enthusiastic application of it in politics and psychology as well as in biology arose at the high point of European global expansion and conquest. The axolotl was present at a key time and place of that expansion's beginning: the Spanish conquest of Mexico. And though devastated by the consequences, it has survived as a captive (the axolotl reproduces very well in the lab and the aquarium) to play an unwitting role in the development of a more sophisticated world view which, we may hope, promises something better for both humans and salamanders.

Hernán Cortés and his men entered the great central valley of Mexico in November 1519. The chronicler records:

When we saw all those towns and villages built in the water, and other great towns on dry land, and that straight and level causeway leading to [the city of] Mexico, we were astounded. These great

towns . . . and buildings rising from the water, all made of stone, seemed like an enchanted vision . . . Indeed some of our soldiers asked whether it was not all a dream . . . It was all so wonderful that I do not know how to describe this first glimpse of things never heard of, seen, or dreamed of before.

It must have looked a little like Venice, only with the twin cities, or *altepetls*, of Tenochtitlán and Tlatelolco dominating Lake Texcoco, the largest of five shallow bodies of water in a broad valley surrounded by volcanic mountains rather than a marsh and lagoon on the edge of the sea. Tenochtitlán (which the Spanish called Mexico), Tlatlolco and the cities on the other lakes fascinated the Spanish with their rich markets, huge public buildings, hanging gardens, not to mention the prostitutes who painted their teeth black to enhance their allure.

The wealth of the cities, and their ability to muster armies numbering tens and possibly hundreds of thousands, depended on highly productive agriculture. *Chinampas* – sometimes called 'floating gardens' but actually artificial islands in the lakes – played a key part in this, supplying maize, beans, squash, amaranth, tomatoes and chilies in abundance. The waters surrounding them were rich in fish and other edible creatures, not least axolotls, which the locals ate with gusto.

The valley of Mexico is endorheic, which means it has no natural outlet to the sea. At a glance it looks flat but, like the bottom of a bathtub, one end is actually slightly higher than the other. The lakes that once covered much of it are all but gone, but when they did exist those at the higher end – Chalco, Xochimilco (both spring-fed) and Tlcopan – had the sweetest water. Downstream, the larger lakes and marshes of Texcoco, Xaltocan and Zumpango became saltier as water evaporated away.

The most productive agriculture needed the sweetest water, and this was also the favoured home of the axolotls (like almost all extant amphibians, they abhor salty water). Indeed Chalco and Xochimilco are their

only recorded habitat, and they appear to have thrived there even with a substantial human presence.

The Spanish conquest is one of the most dramatic events in recorded history: Cortés and a few hundred men defeated an apparently mighty empire able to muster tens of thousands of troops. Cunning, audacity, speed and ruthlessness were key; but (as Napoleon Bonaparte would have appreciated) Cortés was also *lucky*. Yes, he had horses, steel swords and guns (quite unknown in the New World). And yes, crucially, he had the help of many local enemies of the Aztecs. But even more importantly he had something on his side that no one had yet learned to control: smallpox. The indigenous people had no immunity to the disease and died in enormous numbers. (Just how many has been disputed, but it may have been as many as four out of ten people in a matter of weeks.) The toll included a lot of the best leaders and soldiers, and those who survived were often terribly weakened. Agriculture all but collapsed, and those who escaped the worst effects of the disease starved – or, if they survived, were deeply traumatized. To amalgamate Paul of Tarsus and Jared Diamond, 'So abideth these three: guns, germs and steel; but the greatest of these is germs.'

Contemporary accounts are harrowing. A Spanish monk wrote: 'as the Indians did not know the remedy of the disease they died in heaps, like bedbugs. In many places everyone in a house died and, as it was impossible to bury the great number of dead, they pulled down the houses over them so that their homes become their tombs.' When Cortés finally defeated the Aztecs in the last battle for Tenochtitlán, it was said the Spaniards could not walk through the streets without stepping on the bodies of smallpox victims.

Smallpox causes a painful rash on the skin and for the Aztecs the disease was *huey ahuizotl*, the great rash. *Ahuizotl* was also the name of a legendary lake creature that liked to eat human flesh – something like axolotl's horrible twin. It was said to look something like a dog or an otter, with human hands and an additional hand on its tail which it used to snatch prey and drag it beneath the water.

Fear, mystery and an ambiguous border between life and death have a long history in these lands. The Tlatilco culture, which occupied the western shore of Lake Texcoco and the eastern shore of Lake Chalco from about 1200 to 200 BC, left behind some extraordinary, beautiful and haunting artefacts, including figurines that are two-headed or otherwise deformed. The name 'Tlatilco' was given to this culture by Nahuatl speakers, who arrived long after it had disappeared. It means 'the place of hidden things'.

THE BOOK OF BARELY IMAGINED BEINGS

Ahuizotl

Mexico City has long since metastasized into a sprawling, heavily polluted megalopolis with more than twenty million inhabitants. This transformation would not have been possible without one of the largest drainage programmes ever undertaken. The diminution of Lake Chalco, the axolotl's stronghold, began in colonial times (already, in one of the key battles of the conquest, the Spaniards had demolished a great causeway that had separated sweet and brackish water) and it finally gurgled away like water down a plughole through massive artificial tunnels in the twentieth century. A remnant of Lake Xochimilco, the animal's other home, survived a little longer; it was serviceable for the rowing and canoeing events of the 1968 Olympics. But now all that remains of it are a few polluted canals and reservoirs in which a small and critically endangered population remains.

The neoteny of axolotls and other gilled salamanders may once have been an excellent survival strategy: the ability of breeding adults to continue to live underwater in the highland lakes may have given them an advantage over cousins that matured to the land-dwelling stage. Now it is a disadvantage: the lakes are drained, polluted or subject to other human pressures that are driving these animals to extinction in the wild. Their continued survival is probably down to their appeal and their usefulness to human beings.

Axolotls have this advantage over many other species in a human-dominated world: many people

find them cute. With strange, childlike faces and a resemblance to homunculi they are popular for the home aquarium trade. As for other uses, there are or have been two: food and scientific research. For centuries, axolotls were a valued part of local diets in Mexico. Whether or not they were once harvested sustainably, however, this is clearly no longer the case. As for their value to science, the picture seems more promising. The axolotl and other salamanders (and newts) are probably unique among vertebrates in being able to regrow a fully functioning arm or leg after an amputation. And they can do this repeatedly, regardless of how many times the part is amputated, and without a scar (sometimes, two will grow where one was before). They can even regrow parts of internal organs, including eyes and parts of the brain. Axolotls have the good fortune to be the easiest salamanders to breed, maintain and study in lab conditions. These properties, and others, make them ideal for the study of vertebrate limb development but, more than that, they have played a valuable role in the development of regenerative biology.

If a human loses a limb and survives long enough to heal, he or she will have a stump covered in scar tissue where the limb used to be. That makes us much like most other vertebrates. Salamanders (and particularly the axolotls on whom experiments are most often performed) are an exception. They somehow 'know' how much of a limb is missing and needs to be regrown. It happens something like this. Blood vessels in the remaining stump contract quickly and limit bleeding. Then, during the first few days, the wound transforms into a layer of signalling cells (called the 'apical epithelial cap'), while fibroblasts – cells that hold internal tissues together and give shape to a shape – break free from the connective tissue meshwork and migrate across the amputation surface to meet at the centre of the wound. The fibroplasts then proliferate to form a blastema – an aggregation of stem-like cells that become progenitors for the new limb.

The reconstruction of a limb by the blastema is similar to the formation that took place during the animal's original embryonic development, but with a

difference. In an embryo, the sequence of events in limb development always begins with formation of the base of the limb (the shoulder or hip) and is followed by progressive building of more distal structures until the process terminates with the making of fingers or toes. But in the case of the axolotl, the site of amputation can be anywhere along the limb and regardless of where the wound is located, only those parts of the limb that were amputated regrow.

For thousands of years people believed that salamanders knew the secret of fire. This is not true, of course. But these strange creatures – and most especially the axolotl – may hold clues to the flame of life. For this alone they surely deserve a place in a contemporary bestiary.

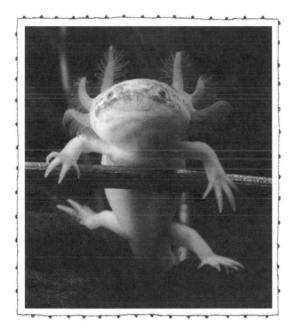

BARREL SPONGE

Xestospongia sp.

Phylum: Porifera
Class: Demospongiae
Conservation status: Many species:
Not listed

From computer-generated recreations of the Cambrian ocean to the wildest actually existing tropical reefs, brightly coloured giant sponges make good scenery. Few people, however, would give them a leading role in the drama. We may know that, strictly speaking, they are animals, but their lack of eyes, mouths, organs and the power of movement means that they don't really *seem* like animals. Such associations as do come to mind are more likely to concern bath-time, Sponge Bob Squarepants or a person who is always asking for money, rather than the marvellous or symbolic qualities typically attributed to creatures in a bestiary. This chapter aims to change that.

There are thousands of species of sponges, so choosing one is hard. A good candidate is Venus's Flower Basket. The silica fibres in its fine tubular body are arranged in a regular, lace-like scaffold of great elegance and intricacy. Victorian collectors marvelled, and paid very high prices for the best specimens. Its mystique was enhanced by stories that tiny male and female shrimp, which take up residence when it is immature, become trapped as it grows and closes over at the top. Locked inside, the shrimp spend the rest of their lives inside a translucent filigree cage. The Japanese take this as a symbol of eternal love and partnership. My choice of sponge, however, is at the other

end of the spectrum: a group of wonky giants known as barrel sponges that come in bruised lilacs, reds, maroons, greys and browns and are sometimes large enough for a human diver to climb inside. (Incidentally, you should not do this because it damages the sponge.) For the truth is that these odd-looking animals are masterpieces of design, and talismans for the emergence of all multicellular animals including ourselves.

For the seventeenth-century physician Thomas Browne, animals only made sense if they had a top, bottom, back and front, and for this reason he doubted the existence of creatures such as the Amphisbaena, a snake which supposedly had a head at both ends. Based on the evidence available to him, Browne's conclusion was reasonable at the time: all terrestrial animals visible to the naked eye, and virtually all fish, are symmetrical along a single plane. In contemporary classification they are known as 'bilateria'and are grouped with radially symmetrical animals, 'radiata', to form the 'eumetazoa' or 'true big animals'. 'Asymmetrical' creatures are only grudgingly included in the kingdom animalia with the qualification of either being 'mesozoa' (a 'wastebasket taxon'containing at least two unrelated groups, one of which, the rhombozoa, only exists in the kidneys of octopuses and squids) or 'parazoa' – 'beside animals' such as sponges and placazoa.

When something alive is not quite symmetrical, instinct tells us that it's most likely a fungus or a plant (leaves and flowers may be nearly perfectly symmetrical but the overall form of a plant seldom is). If, by contrast, an animal is markedly asymmetrical then we tend to assume it must suffer from some weakness or pathology. This rule of thumb holds good for most animals under the sea too: they are either bilaterally symmetrical (worms, walruses) or – a little weirdly, but still fitting the rule – radially so (jellyfish). But sponges are often stubbornly lopsided. This is surely one of the reasons we tend to see them as not fully animal, or 'primitive'.

Joseph Merrick, the Elephant Man, is thought to have suffered from Proteus syndrome, a rare disorder in which skin, bone and other tissues just keep on growing until the sufferer is scarcely recognizable as human. The photograph above, taken in 1889, was

Subliminally, humans register even the smallest variations in body layout and tend to see the most symmetrical human faces and bodies as the most beautiful.

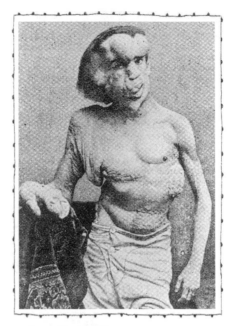

Joseph Merrick, 1889.

intended for dispassionate medical study but is hard to look at without twinges of horror and furtive fascination such as one might have felt at the freak-show where Merrick spent a part of his life. Look carefully, though, and you can see something important and moving. From his left eye, set between small areas of 'normal' temple and cheek (on the right hand side of the photo, of course), Merrick looks back at the viewer. He is calm and aware: a dignified human masked by stupendous deformity.

I sometimes think of this picture when confronting aspects of the natural world that seem especially strange. Pay a little more attention, the picture says to me, and you may see something remarkable and even beautiful in beings which prejudice tells you are ugly. To be clear, I am *not* suggesting equivalence between healthy sponges and humans, deformed or otherwise. The differences are obvious and substantial. But even a creature as weird and apparently boring as a sponge holds wonders if only you look closely.

All sponges rely on ambient water movement to

bring oxygen and food (which mainly consists of bacteria) to them, and to flush away waste. 'Leuconoid' sponges, which include barrel sponges and tube sponges, have made filter feeding into an art form thanks to a brilliant but simple natural design. A mature leuconoid sponge exploits the same effect as a chimney does: water, like air, moves more slowly close to the seabed, or ground, than it does just a little distance above it (on a reef this may not always be up: sponges grow on steep slopes and overhangs too). The circular opening at the end of the sponge furthest away from the seabed (the 'osculum' or 'little mouth') acts just like a chimney. The effect can be seen dramatically if a little dye is released into slow-moving water at the base of a sponge. Coloured water will shoot out of the top, like exhaust from the funnel of a steam train, much faster than the water that the sponge took in. In addition, leuconoid and other sponges increase the efficiency of 'burn' by circulating water within enormous numbers of tiny chambers – tiny 'stoves' that honeycomb its chimney-body. Each chamber is lined with specialized cells called choanocytes which, by synchronous beating of tiny, whip-like organs called flagellae, maintain a water current that brings in food particles and whisks away waste. This allows the choanocytes to ingest bacteria suspended in the water (and then pass nutrients on to other cells within the animal).

In making use of something as simple as a difference in water speed, barrel sponges are exploiting energy from currents and tides that ultimately derive from the gravitational pull exerted by the Moon and Sun. And, in an arrangement also adopted by corals and numerous other animals, many sponges in shallow waters also harvest energy from the Sun more directly by providing a home inside their bodies for photon-loving algae, which pay the rent with oxygen and metabolites that the sponge needs. In many cases the algae produce significantly more oxygen than the sponge can actually use, with the result that the ensemble of sponge and symbionts contribute to the vibrancy of the ecosystem of which they are part. (Not all sponges are so generous: there are carnivorous and parasitic species.) Some barrel

A study of Leuconia, a small leuconoid sponge about 10 centimetres tall and 1 centimetre in diameter, measured water entering each of more than 80,000 intake canals at 6 cm per minute. Inside more than 2 million flagellated chambers the water slowed to 3.6 cm per hour, just one hundredth the speed, maximizing time for choanocytes – specialized feeding cells – to extract food particles from the water. Waste water was expelled through a single osculum at about 8.5 cm per second – more than eight thousand times as fast as it circulated in the chambers and 85 times as fast as it entered the sponge in the first place.

sponges live to be two thousand years old – as venerable, if not as big, as a California redwood. Other species transport light deep inside their bodies through transparent tubes to provision sun-loving algae that live there. They are the only animals known to do this – a submarine instance of 'rainbow body' through which light passes with ease (a condition that yoga masters envisage for humans but probably not for 'lower' animals). Sponges are Moon-Sun-plant creatures. In the very different conditions that prevailed in oceans some 160 million years ago, their remarkable qualities enabled them to form reefs over an area stretching from what is now Spain to Romania, larger than the coral-made Great Barrier Reef today.

But perhaps the greatest wonder is the insight sponges offer into how animal and human life as we know it came to be. The story starts with the discovery, first reported in 1907, that some species can be strained through a mesh so fine that only individual cells pass through and yet – in the right circumstances – form a new, fully functioning animal. And it continues with the realization that choanocytes, the cells central to a sponge's functioning, closely resemble single-celled animals called choanoflagellates.

Choanoflagellates are plankton: tiny protozoans that feed on even tinier bacteria. Thousands or even millions will be in a bucket of water hauled from coastal seas. They often thrive on their own but they also tend to form colonies of cells that are all alike but benefit by sticking together. This characteristic is far from unique; many bacteria and single-celled organisms do the same. What is unique is that the genes choanoflagellates use to manufacture proteins that stick their cells together are very like the genes found in all multicellular animals for the same purpose. Indeed, the match is so close that it seems almost certain that we evolved from them.

Broadly speaking, a sponge only differs from a colony of choanoflagellates in that – in addition to choanocytes at the 'business end' of eating and excreting – it has multitudes of less than a dozen different kinds of cells that perform specialized functions such as building and maintaining a larger structure

Choanoflagellates also have the components for the three main functions of neurons: carrying electrical signals along their bodies, signalling to their neighbours with neurotransmitters and receiving those signals.

THE BOOK OF BARELY IMAGINED BEINGS

with collagen or silica rods, repelling pathogens or generating new cells. If you were reconstructing an early multicellular animal with just a few types of specialized cells that were easily derived from one basic cell type, it would look very like a sponge, albeit a small and simple one, not the giants such as barrel sponges we know today, which are adapted to modern environments. The sponge, it turns out, is a good model for the first multicellular animals to have evolved from single-celled ones. Eumetazoa – more complex animals than sponges – have also evolved extracellular digestion and seal epithelia, a nervous system, a mesoderm, symmetry and a one-way gut.

The cooperation between cells in multicellular animals is one of the most astonishing phenomena in nature. Humans are made up tens of trillion individual cells of about two hundred different types (plus about ten times as many micro-organisms) and for the most part these cooperate flawlessly for many years. But even as we contemplate – celebrate – this, we should not neglect the great realm of single-celled animals in which, abundant as they are, choanoflagellates are just a handful of the citizens. 'Protozoans' (from the Greek for 'first animals') exist in profusion alongside and inside all the animals in this bestiary, and embody more marvels than a bestiary could ever contain. At first sight they might seem like an ever-harder sell than paying memberships to a sponge appreciation society. Some of the best known protozoans are those which cause diseases such as amoebic dysentery, leishmaniasis and malaria. But the great majority are harmless, and some play vital roles in global ecosystem functioning. Others exhibit particular wonders. *Physarum polycephalum*, a slime mold without a neuron, is able to memorize patterns of events. *Noctiluca scintillans*, a tiny marine dinoflagellate, glows in the dark thanks to thousands of bioluminescent spherical organelles in its cytoplasm; gathered in millions, it can illuminate a whole sea at night. Foraminifera can be highly selective in the colour or shape of sand grains they choose to attach to their tiny shells. *Tetrahymena thermophilia*, a ciliate, has not two but seven sexes and since an individual can mate with others of any gender except

We need to keep in mind when looking at 'primitive' organisms such as sponges that we are not seeing their ancient ancestors, but something that for all its characteristically ancient features, has co-evolved to be part of the modern world. As Martin Brasier notes, the sponges that we see today are highly adapted to the world of worms, shrimps and brittle stars.

'Where cooperation fails, as it does in cancer, the disease's existence is a pathological mirror of our own. Down to their innate molecular core, cancer cells are hyperactive, survival-endowed, scrappy, fecund, inventive copies of ourselves.' (Siddhartha Mukherjee)

its own there are twenty-one possible sexual orientations. (For more on single-celled marine organisms, see Chapter 19: Sea Butterfly.)

Thousands of years ago men learned to dive deep into blue water to search for coral, pearls and sponges. Today we can deep-dive in time as well as space. In tracing the origin of sponges we can also appreciate more truly the dimensions of the present moment. But how far back do we need to go?

The idea that the world is vastly old took firm root in Western thinking following the publication in 1795 of James Hutton's *Theory of the Earth*. Hutton showed that diastrophism – the squeezing, tearing and subduction of the Earth's surface that produces continents, mountains and ocean basins – had begun very far into the past. He could not say precisely how far – famously noting only that 'we find no vestige of a beginning, no prospect of an end' – but he knew it was massively more than the few thousand years that most Europeans had previously thought.

The discovery of 'deep time', as we now call it, made possible Darwin's momentous idea, published sixty-six years after Hutton's *Theory*, that, given enough time, endless forms of life could evolve from a few or one. But the geological record also contained what seemed like an intractable puzzle, which became known as Darwin's dilemma: the earliest animal fossils (dating from the period we now call the Cambrian) were already abundant, diverse and anatomically complex. Could such life forms really have emerged fully formed as if from nothing?

Hutton's omission and Darwin's dilemma have now been largely addressed. By the last decades of the twentieth century scientists could divide the Earth's past as confidently as the crowns of Portugal and Spain had once divided the world beyond Europe between themselves, but with more justification and precision. All the fossils known to Darwin and his contemporaries belong to what we now call the Phanerozoic eon – the 'age of visible life' – that began a little over 543 million years ago. The Phanerozoic was preceded by an eon four times as long, called the Proterozoic, the 'age of earlier life'. And it is in traces of life across this vast

The intuition that the world is very old predates eighteenth-century Europe. Avicenna (Ibn Sina, 973–1037) and Shen Kuo (1031–1095) speculated that geological time was immensely long, as did Leonardo da Vinci. In Hinduism a single day of Brahma lasts billions of years. Greek philosophers believed the world was infinitely old.

For an explanation of the divisions in geological time see Appendix II.

THE BOOK OF BARELY IMAGINED BEINGS

length of time – made accessible with technologies and techniques developed in the late twentieth century – that the answer to Darwin's doubts has been found. Before the Proterozoic was the Archaean, which began 3.8 billion years ago following the formation of continental crusts formed on the molten planet. And before *that* was the Hadean, Earth's first eon since it reached its present size, perhaps after a collision more than 4.5 billion years ago with Theia, a Mars-sized body that smashed into the Earth, sheered off molten rock that became the Moon and sent our planet spinning.

Within this broad framework the key stages in the emergence of life before the Cambrian go as follows. Life as we know it may be nearly four billion years old. The first eukaryotes may have evolved more than 2.7 billion years ago. They may have been forming colonies between about 2.1 and 1.9 billion years ago. Over the next billion years or so – sometimes called the 'boring billion' – the deep seas were stagnant and sulphurous, thanks to bacterial waste products, and eukaryotes were limited to a thin layer of surface water in oceans. Even here, life was no picnic, thanks to low levels of oxygen for much of the time, a shortage of vital nutrients and frequent upwellings of toxic waters from the depths that killed eukaryotes en masse. At some point, however, relatively favourable conditions allowed for the evolution of simple, sponge-like multicellular organisms, which are distinguished from colonies by specialization of different types of cell within the whole. Exactly when this happened is debated, but some evidence points to as much as 900 million years ago. It is likely that the evolution of multicellularity occurred several times independently to produce plants, animals, fungi and chromista.

Even if we accept the idea of deep time as a reality, it is still hard to *understand* because its dimensions are so far outside our normal cognitive range. Many attempts to do so rely on analogy. So, for example, if all Earth history is a twenty-four-hour day then anatomically modern humans evolved about three seconds before midnight and Gilgamesh, the oldest known written story, was set down less than a tenth of a second ago. Or if the Earth's

history is the length of an old English yard (which is the distance from the King's nose to the tip of his outstretched hand) then one gentle stroke of a nail file on the middle fingernail erases the entire record of humanity. Or human history with respect to life on Earth is as deep as the displacement of the smallest seabird floating on top of a wave over the deepest part of the ocean.

Such analogies may help us think about deep time, but do they help us *feel* it? I'm not convinced. A better option is a walking meditation among ancient rocks so that their solidity and presence can be felt through vibrations in your feet, legs, hips and spine as you walk. And a good place for that is Scotland's far northwest, where in some places metamorphic rocks from the Archaean form a magical landscape. Promontories such Stac Pollaidh and Suilven rise from these older rocks like the foundations of our own vanishingly brief moments of awareness.

'Where the dust blows through these heights there once shone a silent sea.' (Han-shan)

There is no shortage of definitions of life out there. Biologists, though, typically define living organisms as systems that *do* certain things – among them, metabolize, grow, respond to stimuli, reproduce and evolve through successive generations. Of all these, metabolism (that is, the ability to extract energy from the environment and put it to work for the organism's own ends) may be the most fundamental and the most ancient. And on this count bacteria and another domain of microbes called archaea (together known as 'prokaryotes') are the amazing performing fleas in the big top of life. By comparison, all the 'higher' forms – animal and animalcules, plants, fungi and chromista (together 'eukaryotes') – are as pedestrian as, well . . . sponges. Microbes not only discovered the metabolic pathways that we eukaryotes later adopted (respiration, photosynthesis and fermentation) as well as at least one we did not (chemosynthesis), they also evolved a rainbow of biochemical variations on each that we do not begin to match. Microbes dominated the Proterozoic and arguably they still largely determine the course of life today. They are, as the microbiologist John Ingraham puts it, 'our inventors, progenitors and

keepers'. (They are also our disposers: death is not the end, it's just a case of being metabolically different.) In the big picture – the cycles of life on Earth – microbes are the beginning and end of all. Or, as the palaeontologist Andrew Knoll asserts, 'eukaryotes are the icing and prokaryotes are the cake'.

Is it really true that (to vary the metaphor from patisserie to brewery) life on Earth is basically a giant microbial vat and eukaryotic organisms are merely the bubbles on its surface? Are we – the froth – deluded in valuing ourselves so highly?

There's a story that Albert Einstein was asked whether Beethoven's Ninth Symphony could be expressed purely in mathematical notation. 'Of course!', he answered, 'but what would be the point?' Perhaps we can see prokaryotes as primal tones from which, as in the first bars of the Ninth, eukaryotes emerge in rhythms, keys, melodies, harmonies and other qualities

The sheer length of the first movements of the symphony of life known as the Proterozoic would try most listeners. Perhaps a better musical comparison than Beethoven's Ninth would be an extended version of the primordial sludge in the opening bars of the prelude to Wagner's *Das Rheingold*. Works that go a little further towards imitation of the actual time involved include John Cage's *Organ²/ASLSP*, which will take 639 years to perform, and Jem Finer's *Longplayer*, which will last a thousand years.

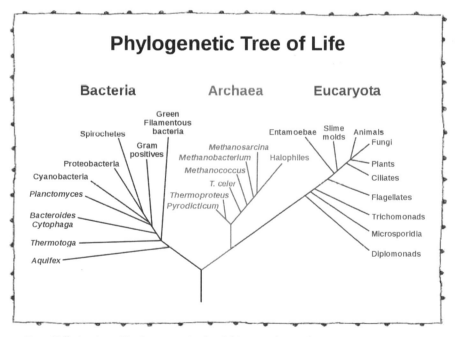

Phylogenetic Tree of Life

Bacteria **Archaea** **Eucaryota**

Green Filamentous bacteria
Spirochetes
Gram positives
Proteobacteria
Cyanobacteria
Planctomyces
Bacteroides Cytophaga
Thermotoga
Aquifex

Methanosarcina
Methanobacterium
Methanococcus
T. celer
Thermoproteus
Pyrodicticum

Entamoebae
Halophiles

Slime molds
Animals
Fungi
Plants
Ciliates
Flagellates
Trichomonads
Microsporidia
Diplomonads

From Hallucigenia to Kim Jong-un, animals exhibit stupendous and sometimes delightful diversity in bodily form. But in terms of genetic diversity we are only a twig on the tree of life (located in this diagram on the top of the right hand branch)

'It's as if we are dig-
ging through the
world's greatest sonic
masterpiece and only
finding parts of a
score here and there
in the fossil record.'
(Kevin Zelnio)

that did not previously exist. The deep resonances of microbial life continue even as the symphony of 'higher' life unfolds.

Demosponges, the class to which the barrel sponge belongs, are the oldest still existing multicellular animals for which there are unambiguous traces in the Cryogenian, or 'snowball Earth', period of the late Proterozic. These early sponges played some of the first chords in the transition to the full musical score of life as we know it today, and it is likely that all other multicellular animals are derived from an early off-shoot of this line. So next time you come across a sponge, consider that something that was more like this than it is like you was your direct ancestor. Consider that it is a being of untold wonders, and that it is we who depend on processes it pioneered: it is we, not it, who are the spongers.

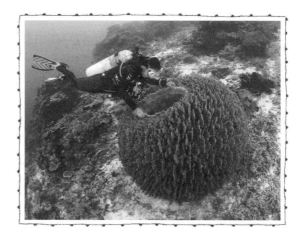

CROWN OF THORNS STARFISH

Acanthaster planci

Phylum: Echinoderma
Class: Asteroidea
Conservation status: Not listed

> If you look into infinity what do you see? Your backside!
> Tristan Tzara

Burroughs's story has a true and more comic precursor in the life of Joseph Pujol (1857–1945). Pujol, who became famous as 'Le Pétomane' (the fartomaniac), could inhale through his sphincter and release the air under control to produce a wide variety of sounds. His performances before royalty and the foremost citizens of the day included renditions of 'O Sole Mio', 'The Marseillaise', and an impression of the 1906 San Francisco earthquake. Pujol retired from the stage in horror at the inhumanity of the Great War and worked for the rest of his life in a biscuit factory.

The drug-addict, drunk, wife-shooter and writer William Burroughs used to tell a story about a man who teaches his anus to talk. The orifice eventually takes over his life and kills him. Wildlife can be as least as weird as the imagination of Burroughs. Consider the Crown of Thorns starfish. Instead of a head it has an anus on the top of its body, while its mouth – a round hole equipped with inward-pointing teeth at the centre of the radiating arms – is in the middle of its underside.

This positioning is less unusual than you might think. Having a mouth underneath and an anus on top is ideal if you want to eat crud on the seafloor, and this is how the ancestors of the Crown of Thorns started out. Many of its distant cousins, among them starfish and sea cucumbers, still pursue that lifestyle. (On the abyssal plains, the so-called desert of the deep sea floor, large herds of sea cucumbers are constantly grazing on the detritus that has fallen from above. They are the night-soil men of the deep in a holothurian heaven.) Unlike these animals, however, the Crown of Thorns is no longer a scavenger, having acquired a taste for living flesh. Dressed in brilliant shades of purple, blue, orange red, white and grey and with anything from seven to twenty-three (but usually about fifteen) rays around a central dome, it bristles with poisonous spikes – a submarine version

of Pinhead, the extradimensional being in the horror film *Hellraiser.*

Many creatures in the garden of earthly delights that is a tropical coral reef have more charm than the Crown of Thorns. (Pfeffer's Flamboyant Cuttlefish, which turn itself startling hues of purple and pink at will while posturing like an actor in Noh theatre, is one of my favourites.) But few are more compulsively unsettling than the Crown of Thorns, and few are as like us in their power to consume and destroy once they set to work.

The claim may seem odd in view of our obvious differences. The Crown of Thorns crawls over the reef on thousands of tiny podia – tube-feet, through which it also breathes, that extend and flex like hydraulic parts as they fill and empty with fluid from sacs inside the animal's arms. Gliding along about as fast as the minute hand on a clock (a little faster if it puts on a turn of speed), it moves more like a millipede than (as one might suppose) a severed human hand pulling itself by the fingers over the seabed. Once it gets into position around its favourite food of freshly growing coral, the Crown of Thorns wraps its arms around its object of desire in a grip of death, extrudes one of its two stomachs through its mouth and spews digestive juices over the polyps, turning them into a gooey mess which it sucks back inside itself. When Crown of Thorns starfish swarm in large numbers they can devastate a reef in a few days. And thereby hangs a true tale resembling many a B movie about monsters from the deep.

Sea stars digest with two stomachs known as the cardiac stomach and the pyloric stomach. The cardiac stomach is a sack-like organ located at the centre of the body and may be everted out of the organism's body to engulf and digest food.

Until the 1960s few marine scientists had seen, let alone studied, the Crown of Thorns starfish. It was known to eat coral but thought to be quite rare. Then a large-scale infestation was observed munching its way through the reefs surrounding a small cay on Australia's Great Barrier Reef that was popular with tourists. By the end of the decade they were reported in huge numbers on large areas of the GBR and seen attacking many other reefs throughout the Indo–Pacific.

The press cried apocalypse. In July 1969 the *New York Times* reported that the Crown of Thorns threatened the food supply and even the physical existence

of many tropical islands. It quoted the conservationist Richard Chesher: 'if the starfish population explosion continues unchecked, the result could be a disaster unparalleled in the history of mankind.' In November of that year *The Economist* reported that coral reefs across the Pacific were 'crumbling, and the economies of whole regions could crumble with them'.

It looked like precisely the kind of payback predicted by environmentalists such as Rachel Carson and Barry Commoner: human thoughtlessness was upsetting the 'balance of nature', transforming the hitherto obscure Crown of Thorns into a predator without limits by eliminating whatever it was that normally kept it in check or by altering nutrient and chemical balances in the seas. In the end catastrophe was averted: Crown of Thorns numbers crashed and many reefs made what looked like a full recovery. People discovered new respect for the resilience of coral reefs, and greater appreciation of how patchy is our understanding of them.

But, as in many a B movie (or indeed Dark Age epic such as *Beowulf*), a worse horror was waiting out of sight. By the first decade of the twenty-first century scientists were warning that, barring deep cuts in emissions of greenhouse gases, global warming and ocean acidification would devastate the world's remaining coral reefs within a century and for the indefinite future.

Since our early days we humans have been intimate with the sounds, smells and sights of forests and savannah, riverbanks and seashores; for hundreds of thousands of years we have lived, breathed and touched their moods and textures. By comparison, our feel for the underwater tropical world is recent and sketchy. True, for thousands of years communities living close to reefs have been perfectly able to identify many different kinds of fish and other animals living on the reefs. True, also, that for hundreds of years at the very least, some communities have understood the importance of protecting reefs from over-exploitation by not fishing at certain times of year in order to allow stocks to recover. Many have also experienced reefs as places of magic, myth and creation. But a sense, shared by large numbers of people who live nowhere near them, that

To take one example, the distinctions made among different marine and terrestrial creatures by the Groote Eylandters off the north coast of Australia correspond closely to distinctions drawn in modern biology.

THE BOOK OF BARELY IMAGINED BEINGS

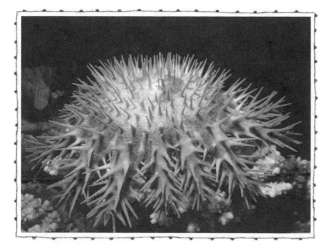

A Crown of Thorns starfish.

coral reefs are places of great beauty and worth only arose in the context of the scientific transformations of the last 150 years.

Early modern science paid little attention to tropical marine life, but such study as there was largely consisted of ever more detailed and sophisticated cataloguing of individual wonders once they had been hauled from the sea and pinioned on the collector's table. The *Ambonese Curiosity Cabinet*, published in 1705 some three years after the death of its author Georg Eberhard Rumphius, the 'blind seer of Ambon', is one of the great works of that time, containing hundreds of precise verbal descriptions and fine line drawings of tropical marine organisms that compare well with anything produced today. (Rumphius describes the Crown of Thorns, which he terms *Stella marina quindecim radiorum*, as 'found very rarely and 4 to 5 inches wide, divided all around into 12 or 14 branches ... with a russet shell, and covered with sharp spines about the length of a finger-nail ... It dwells in the very deep Sea, where it is full of rough stones ... If one is hurt by its spines it will cause very bad burning and great pain, which is why it is left unmolested.')

But work of this kind, remarkable as it is, explains next to nothing about how these forms originate and

Rumphius, a botanist for the Dutch East India Company, lost his wife and daughter to earthquake, his botanical drawings to fire, an entire book on animals to the sea, and his sight to glaucoma.

how they connect in the great web of birth, death and transformation. And it was only in the mid nineteenth century that scientists took the first steps in putting such a vision together. In the late 1830s Charles Darwin suggested that coral atolls accrete on gradually subsiding seamounts and volcanoes, keeping up with the sea surface as, in some places, the seabed falls over vast periods of time. (Subsidence is a natural process in parts of the ocean floor as the Earth's tectonic plates slide and jostle; corals grow to get closer to the sunlight.) Some of the humblest organisms in the sea – coral polyps – have evolved to thrive in such challenging circumstances with the consequence that they built the largest life-made structures on Earth, thousands of times bigger than the Great Pyramids. The hypothesis was daring in the extreme, and so far ahead of its time that it was only proved beyond reasonable doubt in the 1950s. It required a depth and breadth of vision – a grand view of life that unites the very large (the geological forces at work across oceans and continents) with the minute (a typical coral polyp is no bigger than the nib of a pencil) – that prefigured and informed the theory of natural selection which Darwin finally published twenty years later. Reefs achieve exuberant life as a result of intense struggle between organisms but they also exemplify symbiosis and cooperation among life forms – an apparent riddle at the heart of their ridiculous beauty.

That aesthetic appreciation of coral reefs grew alongside greater scientific understanding is evident in a description by Alfred Russel Wallace of Ambon Bay, the very same place from which Rumphius had hauled so many of his curiosities more than 150 years before. In Wallace's eyes these forms were part of a vivid living world rather than specimens on a dissector's table:

> The clearness of the water afforded me one of the most astonishing and beautiful sights I have ever beheld. The bottom was absolutely hidden with a continuous series of corals, sponges, actiniae, and other marine productions of magnificent dimensions, varied forms and brilliant colours . . . In and out of them moved numbers of blue and red and yellow fishes, spotted and banded and striped in

THE BOOK OF BARELY IMAGINED BEINGS

Charles Darwin saw that in some circumstances corals could accrete fast enough to maintain reefs and atolls close to the surface even as the mountains beneath them sank into the depths.

the most striking manner ... It was a sight to gaze at for hours, and no description can do justice to its surpassing beauty and interest. For once, the reality exceeded the most glowing accounts I had read of the wonders of a coral sea.

The rapture felt by Wallace went mainstream after World War Two when the development of scuba made it possible first for scientists and then for thousands of ordinary people to observe coral reefs with an intimacy that our ancestors could never have imagined. (Crossing this threshold can evoke an overwhelming sense of awe and set the heart racing, especially if – like me – you are a poor diver, never far from the edge of terror.) In little more than half a century we have come to know a whole new world much more different from our own than the Americas seemed to Europeans at the end of the fifteenth century, a place of unsurpassed richness: great 'forests' in miniature containing around a quarter of ocean biodiversity in much less than 1 per cent of the total area.

'The only line more definitive and mysterious than the one between the mirror-like surface of the sea and the world of the reef below is the boundary between life and death.' (Osha Gray Davidson)

But the discovery of this world was also when we witnessed its destruction. Since World War Two many of the world's richest reefs, especially in Southeast Asia and the Caribbean, have been all but destroyed by over-exploitation and pollution. In large parts of the Philippines, where reefs were once abundant, it is fair to joke, as does one travel guide, that 'if you dive here you may see some truly horrible things before you dissolve' in the sheer mass of chemical and human waste. For all the efforts, some of them heroic, to protect what remains (and there are still astonishing treasures tucked away), there appears to be a near inescapable trend towards destruction of this ecosystem faster than any other on Earth: a speeded-up Sixth Extinction before our eyes that leaves us holding onto a few pieces of broken wreckage.

Human activity, taken as a whole, has been vastly more destructive of reefs than any starfish run amok. Can we at least appreciate the Crown of Thorns not as destructive monsters but for what they actually are (or at least were): parts of a wondrous whole?

Star-shaped beings are not new on Earth. Rocks nearly two billion years old contain the beautifully named Eoastrion, or 'little dawn star', a tiny fossil that does indeed look like a microscopic star. And multi-pointed starbursts feature in the gallery of bristly and pointy entities in rocks laid down a billion years or so later. But neither, of course, was remotely like the sea stars we think of today. The first was a bacteria, the second an algal spore.

The earliest fossil sea stars found so far date from the Ordovician geological period (from about 488 to 445 million years ago). This was a time before fish had evolved jaws and when scorpions the size of basketball players lurked in the silt. Nautiloids with shells as much as three metres (ten feet) long were top predators. Trilobites, with eyes on stalks, sought safety under elaborate spiny armour. Animal life had not emerged onto land, and the land plants that did exist were mostly mosses and liverworts. Sea stars probably evolved from organisms that looked similar to crinoids: the enigmatic sea lilies and feather stars that still grow on the seabed today. Like the crinoids, they

are members of a phylum known as echinoderms, which first evolved no later than the Cambrian (542 to 488 million years ago) and which today comprise 6–7,000 species, ranging from sea cucumbers (lumpy sausages of enormous size and very strange habits) through sea urchins (the spikiest, bristliest things that you do not want to tread on) to the Basket and Brittle stars. Today, the Crown of Thorns is one of about 1,600 living species of sea star, or Asteroidea to give the class its correct scientific name.

The earliest echinoderms were bilaterally symmetrical – they had a left and a right, a front and back end – through their entire lives. Many echinoderms are still bilateral as larvae, and swim freely in the ocean like baby fish. At some stage early in the evolutionary history of the phylum, however, most species became sedentary as adults, attaching themselves to the seabed as do the sea lilies we know today. Later, the ancestors of sea stars stopped holding on to the seabed and started to move freely across it, but kept the new radial symmetry their ancestors had acquired. When a modern sea star larva matures, the left side of its body grows at the expense of the right side, and eventually takes over the whole to grow with pentaradial symmetry, in which the body is arranged in five parts around a central axis. Sea cucumbers start as bilaterally symmetrical larvae, go through a stage of fivefold symmetry as they grow, and become bilaterally symmetrical again as adults. Such metamorphoses – more imagination-stretching than most things in Ovid – show that Haeckel's theory of recapitulation theory (described in Chapter 1, Axolotl) only describes a small part of what occurs in the animal world.

And sea stars play amazing variations on an essentially pentaradial body form. Some, like the Crown of Thorns, have dense rows of spines for protection. Others have no spines at all. Some, like the Pincushion star, don't even have arms, and look more like pentagons. In most cases arms, also known as rays, are typically present in multiples of five up to as many as fifty in the case of *Helicoilaster*. (There is a sea-lily *Comanthina schlegelii*, with 200.) But other numbers, including odd numbers such as eleven, are also seen.

The echinoderm phylum shares some essential features with the chordate phylum, which includes axolotls, humans and zebrafish. As deuterostomes, we all, as embryos, develop an anus before we develop a mouth: we all come into being arse-first.

The length of the arms with respect to the body, and their shape also vary greatly. Members of the Zoroaster genus have long flexible ones resembling elephant trunks. The largest known sea star, the Sunflower starfish, could have come straight out of a troubled dream of Vincent Van Gogh. Ranging in colour from bright orange, yellow and red to brown and even purple, and typically radiating 16–24 velvet-textured rays, the Sunflower can span as much as a metre.

First cousins to sea stars are the basket stars and brittle stars, collectively known as Ophiuroids. These can be even more otherworldly than sea stars. *Gorgonocephalus*, or the Gorgon's Head, for example, really does resemble a seething mass of snakes. Other ophiuroids are more delicate: they pick, feel and spread themselves over corals, gorgonians and other organisms like courtesans in feather boas. Recently, explorers discovered a seamount near Antarctica covered in tens of millions of brittle stars packed ray tip to ray tip, in a massive underwater 'city', alongside other strange species such as giant bubble gum coral.

Unlike most chordates – or, indeed, our still more distant relations the molluscs, which include intelligent animals such as cuttlefish and octopuses – echinoderms have not gone to the trouble of evolving brains. Instead, they have a radial nervous system: a net of interconnected neurons spread throughout their body and are able to process some information. The absence of a concentrated knot of neurons, *aka* brain, does not mean they are completely unaware of the world around them. Sea stars are sensitive to touch, temperature and orientation through their tube feet, spines and pedicellariae (the small wrench- or claw-shaped structures on their skin). Each arm on a sea star has a short sensory tentacle at the end that responds to chemicals and vibrations in the water, and a tiny eyepot with which it can perceive light and movement, although it cannot form an image. Many starfish also have individual photoreceptor cells spread across their upper bodies. And there is at least one species of brittle star that is densely dotted with eyespots with sophisticated optics which may be united together via its nervous system to act like a single great compound eye. The

lenses of its eyes are made of calcite crystals, otherwise only found in the long-extinct trilobites. We can, literally, be seen by stars, using one of the oldest technologies of vision on the planet.

We humans credit ourselves with foresight and if we credit what the science tells us, the outlook for reefs and the people who depend on them is very bad. Direct pressures on tropical coral reefs such as destructive fishing practices and indirect ones such as global warming may, if not massively reduced, put most remaining reefs (which are already a much diminished remnant of what existed a few decades ago) at risk of destruction by around 2050. Nothing like this will have hit reefs in 55 million years, and recovery after previous catastrophes took millions of years. Still, the total collapse of coral reefs in the twenty-first century is not an absolute certainty. Some pockets may show surprising resilience, and when other pressures are removed reefs can recover even from a direct hit from a hydrogen bomb in a matter of a few decades. For this reason, conservation initiatives such as the establishment of networks of marine protected areas with local community involvement are well worth trying. In some circumstances, active intervention to regrow coral reefs may make sense.

Starfish are tough. Recent experiments show that at least one species – the Purple Ochre sea star, *Pisaster ochraceus* – may do just fine in the warmer, more acidic waters almost certain to be the norm towards the end of this century. The scientists who undertook the study caution that we cannot assume that other starfish will do the same. However, some sea stars, or their ancestors, survived the Ordovician–Silurian extinction event, the third largest in the Earth's history since life became multicellular and the Permian–Triassic extinction, the largest extinction event in the history of life in which 96 per cent of marine species were exterminated, as well the Cretaceous–Tertiary extinction that wiped out the dinosaurs, pterosaurs and plesiosaurs. Far into the Earth's future, starfish should be around to bury us, along with new forms even stranger than the Crown of Thorns.

'Mike', the world's first hydrogen bomb, vapourised Elugelap Island and other parts of the Enewetak Atoll on 1 November 1952. Despite the contamination, corals have recolonized much of the gap. This recovery depended on (among other things) the presence of large numbers of healthy corals elsewhere. More recently, dramatic coral-bleaching events, caused by unusually high temperatures and leading to morbidity and widespread death in many reefs, have on occasion been followed by dramatic recoveries, at least for now.

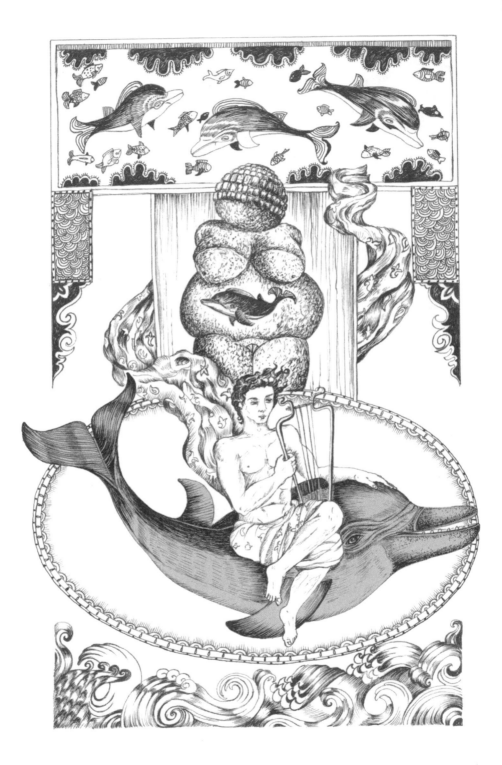

DOLPHIN

Delphinidae

Phylum: Chordata
Class: Mammalia
Order: Cetaceae
Conservation status: some species
Critically Endangered, others
Least Concern or not listed

Dolphins . . . follow men's voices, or gather in shoals when music is played. There is nothing swifter in the sea. They often leap over ships in their flight.

An English bestiary of the thirteenth century

For they work me with their harping-irons, which is a barbarous instrument, because I am more unguarded than others.

Christopher Smart

Some experiences can give rise to joy so powerful that it transforms your sense of what it is to be alive. Among these are surviving a brush with death, and witnessing acts of great beauty. Such, at least, is my experience. Once, I sailed in a small boat in a storm so violent that some of those on board with much more experience than I feared we would not get through. When, a couple of days later, we did make it into port – battered and exhausted but essentially fine – I felt as if reborn, my body made of sunlight. Another time, with a different crew and in a different place, I encountered wild dolphins at play. In calm weather and deep water just off a remote mid-ocean island we spent a good part of an afternoon in a dinghy watching a large pod put on an amazing show of jumps, somersaults, twists and other capers. Every now and then, one or two came right alongside us and gently splashed two young children leaning over the gunwales. The children would squeal with delight, and the dolphins would power away and then stop to look back at the hilarity they had caused.

These two incidents from my own direct experience have no particular connection except that both were transfigured by joy. The first didn't involve dolphins but, having experienced both, I understand a little better the power of stories that recur from ancient

times until today in which humans (and other creatures such as whales) are saved from drowning by dolphins.

Think of a dolphin and the chances are that the Bottlenose, *Tursiops*, comes to mind. These are the easiest to train and most often kept in captivity. But there are nearly forty other species, and they vary considerably in size, shape and colour. The smallest (Maui's dolphin) is the size of a wild boar, while the biggest (the orca) can grow as big as a bus. Several, including Common dolphins, have ballooning, melon-shaped foreheads and beaky snouts similar to the Bottlenose, but others (notably, some of the smaller species) have much less prominent snouts, and daintier faces. When it comes to skin colour, the gun-metal grey that we associate with the Bottlenose is not typical. Common dolphins are often dark slate along their spine, snout, fins and tail, but buff-to-mustard on their sides, and light grey on their hind flanks: curvaceous and muted variants of the dazzle camouflage of World War One fighting ships. Several species are black and white in the manner of Holstein cows but with the difference that the contrasting patches are symmetrical and elegantly shaped: on the Dusky dolphin, black and white curve around each other like flames; on the Hourglass dolphin a broad, horizontal, white band along each side of an otherwise black body is squeezed in the middle as if between a giant black finger and thumb.

We'll probably never know when or how people and dolphins first met. Early modern humans foraging along coastlines and estuaries would surely have encountered the beached bodies of river dolphins and pelagic dolphins that were dead or dying, and in some cases fed on them. (Neanderthals living in caves on the Rock of Gibraltar had already acquired a taste for them.) But people would also, over hundreds of generations, have spent a lot of time watching dolphins fishing and at play out at sea or in the wide rivers. And just as earlier generations of humans on the African savannah would have learned much about hunting and scavenging from watching other predators there, so early coastal foragers would have observed dolphins in pursuit of fish and learned from their

A dolphin saves Odysseus's son Telamachus when he falls into the sea. Herodotus tells of Arion, a poet-musician who is thrown into a raging sea by sailors who want to steal the prizes he has won by his talent. Before he is pushed overboard Arion is allowed to sing one last time. His music attracts dolphins to the ship, and one of them carries him safely to shore. In modern times there are numerous reports of dolphins buoying up swimmers who are near drowning and of dolphins driving sharks away from humans in the water.

techniques, such as corralling fish and driving them towards shore where they are easier to catch. It wouldn't have taken long for two such curious and intelligent species to have learned to work together. Far from being antagonistic, then, many of our earliest encounters may have been cooperative and playful.

Certainly, the practice of humans and dolphins fishing together was well established by the historical period. Pliny the Elder describes cooperative fishing for mullet in a marsh at Latera in what is now southern France, and gives a clear sense that the dolphins were as confident and in control of the situation as the humans. 'Dolphins', he writes, 'are not afraid of humans as something alien.' Similar interactions are reported on the coast of Brazil and Burma going back to at least the nineteenth century.

Respectful, and sometimes playful, relations with dolphins seem to have been common at one time or another in many places that the species co-exist. The Wurundjeri people of southeastern Australia, for example, held dolphins to be sacred. Killing dolphins was therefore forbidden and the Wurundjeri would only take fish they believed the dolphins did not need. They would also consult dolphins on important questions by the use of telepathy, and believed that the spirits of their dead would transform into dolphins and remain offshore to help and guide family members who stayed as humans on land. The anthropologist Douglas Everett reports that the Pirahã, a remote Amazonian tribe known for an exceptionally simple way of life and for having no concept of time, number or religion as we think of them, greatly enjoy games with river dolphins or porpoises. According to Aristotle, dolphins and small boys in the Greece of his day would develop strong mutual attachments and the dolphins would give the boys exhilarating rides.

The oldest known representation of a celebratory relationship with dolphins comes from the Minoan civilization centered on Crete. In the 'flotilla fresco' painted at Akrotiri about 3,500 years ago, dolphins are paired with running deer as great leaping animals, full of life, in one of the most beautiful and serene depic-

THE BOOK OF BARELY IMAGINED BEINGS

Humans also hunted dolphins in some circumstances. Aristotle describes techniques almost exactly the same as those used in Japan today.

Detail from the 'flotilla fresco' at Akrotiri on the island of Santorini – an image from the Minoan civilization circa 1,500 BC.

tions in the history of art of humans at home in the world. Later Greek civilization linked dolphins with the divine. Apollo, the god of harmony, order and reason, was said to have taken the form of a dolphin when he travelled from Crete to the mainland to establish the seat of the oracle at Delphi (itself named for the dolphin). When, in winter, Apollo left Delphi for Hyperborea, he would leave the oracle in the care of his brother Dionysus, the god of wine and ecstasy, who had the power to turn people into dolphins.

Today, most people will agree with the general proposition that dolphins are amazing animals, worthy of particular attention. But *what* exactly is special about them and *how* precisely we should treat them are matters of dispute. One of the sharpest differences of opinion concerns an annual cull in Taiji in Japan, in which thousands of dolphins are slaughtered (ostensibly to reduce competition for local fishermen, but also for sale rebranded as whale meat) and a smaller number are taken alive for sale to entertainment complexes and aquaria around the world. In 2006 leading marine scientists called for a moratorium on this practice. Dolphins, they said, are 'highly intelligent, self-aware and emotional animals with strong family ties and complex social lives ... [and] inhumane treatment and killing of these highly sentient mammals' must stop. But Japanese fishermen carried on, as the 2009 film *The Cove* showed. And other practices, which may be at least as destructive of dolphins in the long run but are more insidious, continue. Tens, perhaps

hundreds of thousands of dolphins die each year when they become trapped in nets set by fisherman who are trying to catch something else, or as a result of other human acts of carelessness. The effects on the health of dolphins (not to mention whales and other marine animals) of pollutants such as mercury and PCBs are uncertain but they are likely to increase the number of still births, developmental problems and general morbidity. And masking these horrors, as misleading as the 'smile' on a dolphin's face (which is not an expression of emotion but simply the shape of its mouth), are the aquaria and fun parks around the world where hundreds of thousands of people still flock to see captive dolphins – denatured, shrink-wrapped slaves – being drilled through acrobatic routines.

Is there a better way forward? Is it achievable? The philosopher Thomas I. White suggests that we confront two questions: what kind of beings are dolphins?; and what does our answer to *that* question say about the morality of human/dolphin contact? White concluded – in line with many marine scientists – that dolphins are 'non-human persons': different enough from humans that it's fair to regard them as something like extraterrestrial intelligences, but no less imbued with dignity or worthy of respect than ourselves. And the inescapable conclusion from *that* was that abuse of dolphins is indefensible.

Cynics will say that we've been here before. The claim that dolphins are 'not something to kill, but someone to learn from' has already been made by (among others) John Cunningham Lilly, an eccentric scientist who studied dolphins for forty years up to his death in 2001. The website archiving Lilly's work greets you with the smiling face of the late great man between dolphins rampant like heraldic beasts. Blobs of pinkish-purple light rotate and pulse across Lilly's forehead – a reminder of the mind-bending drugs and altered states he explored with friends such as Timothy Leary and Allen Ginsberg (as well as how bad web-page design could be a dozen years ago). Lilly, you may recall, is the model for the scientist played by George C. Scott in the 1973 science-fiction film *Day of the Dolphin*. Scott, clad in shorts much too small for a man of his

age, discovers that his groundbreaking work on human–dolphin communication is being perverted as the animals are suborned into a fiendish plot to kill the President of the United States. The dolphins save the day when Scott, chastened, tells them that man is evil.

Lilly certainly had some strange ideas. He wanted to build a floating lab-cum-living room through which wild dolphins and humans would be able to converse directly at times and places of their choosing. Believing dolphins to be morally superior, almost angelic beings, he said they should get representation at the United Nations as a 'Cetacean Nation'. Humans (such as himself, presumably) would act as their representatives until such time as the two species understood each other better.

Lilly made some claims he could not substantiate with data. But many of his essential intuitions about the intelligence, communicative abilities and emotional richness of dolphin lives were visionary and have been substantiated by various other researchers since his death. Perhaps Douglas Adams got it right when he satirized Lilly as Wonko the Sane.

And the questions posed by the philosopher Thomas White *can* be answered. We *do* have enough evidence to begin to build a sound understanding of dolphin nature, laid on the 'solid foundation . . . [of] experience and observation' (to borrow David Hume's phrase for a projected study of human nature). Through method we can add to whatever wisdom we find in myth and at the same time avoid a descent into sentimentality. This can help us overcome the present calamities inflicted on dolphins by humans. And it has the potential to help us develop a better sense of the world of which human consciousness is a part.

The earliest known attempt at what we would now call scientific description was made by Aristotle around 350 BC. Aristotle understood that dolphins are mammals – air breathers which suckle live young – and that they are highly gregarious both toward their own kind and humans. All the behaviour he describes in the following passage is plausible given what has been documented in recent years:

Many stories are told about the dolphin, indicative

James Rachels (1990) wrote: 'Plainly, the proper way to avoid anthropomorphism is not to forswear the use of "human" psychological descriptions altogether, but to exercise caution in their application, using them only where the evidence really warrants it . . . If anthropomorphism is a sin, we should also be wary of the companion sin: the similarities between ourselves and other animals may too easily be underestimated.'

There are no known written observations from China predating Aristotle. According to Sam Turvey (2008), the earliest surviving Chinese description of an animal that is unmistakably the Baiji, or Yangtze River dolphin, is from the early Han Dynasty, between 206 BC and AD 8.

of his gentle and kindly nature . . . The story goes that, after a dolphin had been caught and wounded off the coast of Caria, a shoal of dolphins came into the harbour and stopped there until the fisherman let his captive go free; whereupon the shoal departed . . . On one occasion a shoal of dolphins, large and small, was seen, and two dolphins at a little distance appeared swimming in underneath a little dead dolphin when it was sinking, and supporting it on their backs, trying out of compassion to prevent its being devoured by some predaceous fish.

But in the following description of their physical abilities Aristotle confuses hunting and display behaviour, and exaggerates the height they can jump out of the water, which seldom exceeds three metres, or 10 feet:

Dolphins can and do pursue fish as far down as about 160 metres, or 500 feet, but they usually hunt in shallower water. When returning from a deep dive they do not have the energy for high leaps, and are more likely to take quiet breaths at the surface. Leaps are for play and display.

> Incredible stories are told regarding [the dolphin's] rapidity of movement . . . It appears to be the fleetest of all animals, marine and terrestrial, and it can leap over the masts of large vessels. This speed is chiefly manifested when they are pursuing a fish for food; then, if the fish endeavours to escape, they pursue him in their ravenous hunger down to deep waters; but, when the necessary return swim is getting too long, they hold in their breath, as though calculating the length of it, and then draw themselves together for an effort and shoot up like arrows . . . and in the effort they spring right over a ship's masts if a ship be in the vicinity.

More than a century of modern research has added enormously to Aristotle's account. We know, for example, that dolphin sex is as exuberant as that of bonobo chimps. Dolphins court and make love the year round, and with lots of foreplay – they rub, caress, mouth and nuzzle each other's genitals. Both males and females have a genital slit, so penetration is possible in both sexes, and the penis, the tip of the nose (the beak), lower jaw, dorsal or pectoral fin, and tail fluke are all used. Female Spinner dolphins have been observed riding 'tandem' on each other's dorsal

THE BOOK OF BARELY IMAGINED BEINGS

fin, the female beneath inserting her fin into the genital slit of the other and the two swimming together in this position. Spinner dolphins of both sexes sometimes engage in orgies of more than a dozen individuals, known as 'wuzzles'. Some dolphin species engage in 'beak-genital propulsion'. Dolphins can make strong enough sounds to stimulate each other at close range. Spotted dolphins perform 'genital buzzing', in which an adult directs a rapid stream of low-pitched clicks at the genital area of another, usually a calf. Genital buzzing usually occurs between males, but also in heterosexual courtship in this species. Male Bottlenose dolphins even try to mate with other animals including sharks and sea turtles, inserting their foot-long hooked penises into the soft tissues at the back of the turtle's shell.

Along with all other cetaceans, dolphins are descended from animals that looked something like a

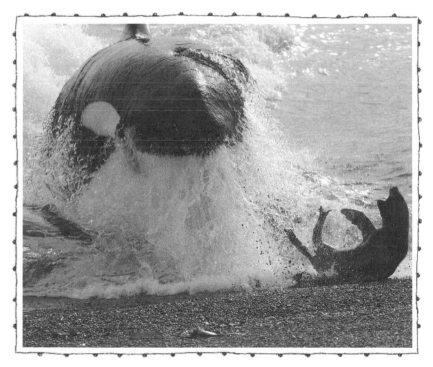

Killer whale hunting a seal.

cross between a wolf and an exceptionally agile hippo (which may be their closest relation on land). These ancestors evolved to hunt rather like crocodiles do, lurking in murky shallows ready to pounce. And their descendants are of course ruthless, brilliant hunters. Orcas, the 'killer whales' which are actually the largest members of the dolphin family, take this to a spectacular extreme when they rush up to grasp young seals basking on a beach or taking refuge on an ice floe. Sometimes an orca will repeatedly toss a broken seal, like a cat playing with a mouse. The prowess of dolphins as hunters means they only have to 'work' for a few hours a day, which is why they have so much time to socialize.

Just because dolphins are highly social does not mean that they are not sometimes extremely aggressive towards each other. Males gang up to rape females, and sometimes kill calves that are not their own. But in general they are great cooperators and communicators. Young dolphins are dependent for an extended period on their pod for care and education. Mothers in at least some species use a kind of 'baby talk' to communicate with their offspring, and 'carry' them by positioning them in their slipstream (as a result, the mother only swims three-quarters as fast for the same effort but the calf's average speed is increased by nearly a third). Mothers even share childcare with each other.

There's some evidence that, at least in some species of dolphin (and toothed whales), every individual has its own characteristic whistle sound to identify itself to others. Others in its pod will imitate that sound when responding or trying to get that individual's attention. In short, each dolphin has a name. It is also evident that not only are dolphins self-aware but they can have a keen sense of the capacities of others. When including a human in a game of tag or piggy-in-the-middle, for example, they will make allowance for the human's vastly inferior swimming ability, giving the human a chance to play in a game in which he or she would otherwise be hopelessly outclassed. They pass on group-specific knowledge – 'culture' – and are adept at teaching new things to each other and to humans. Researchers conclude that many species of dolphins

Eugene Linden (2002) describes experiments undertaken by Diana Reiss with a young captive female dolphin named Circe whose trainer signalled her dissatisfaction at Circe's failure to perform a task on command by taking a few steps back and standing still for a few seconds – in essence enforcing a 'time-out' as a mother might do with an obstreperous child. When Circe performed as desired, she was rewarded with a piece a fish, but it was known that she did not like the tail-end of a fish unless the fins were removed. On one occasion when her trainer forgetfully tossed her an untrimmed tail, Circe swam to the far end of the pool and positioned herself upright in a stock-still position – the same 'time-out' pose. She had appropriated the trainer's signal and was now training the trainer.

THE BOOK OF BARELY IMAGINED BEINGS

have a well-developed theory of mind.

Another aspect of dolphins' lives that we are still only beginning to appreciate is the role that sound plays in their lives. At a relatively trivial (but pleasing) level, dolphins often make a particular flat-toned whistle when they ride the bow waves of boats, which some marine biologists suggest is the equivalent of a child going 'wheeee!' But the matter goes far beyond that. In the sea, where sound travels four times as fast as it does on land and light dissipates in a short distance, sound serves them for both 'vision' and 'language'. And their ability to echo-locate with sound gives them powers of perception beyond anything so far achieved by humans with the most advanced technology. It opens a world of communication we are just beginning to understand.

To produce the sounds with which they 'see' objects, dolphins have a series of air sacs underneath their blowhole. They can use the air in these sacs to create clicks that last less than a thousandth of a second. These clicks are projected off the parabolic surface of the front of the skull and pass through fatty tissue shaped rather like a melon which the dolphin probably alters in shape rather as we do the lenses of our eyes. The clicks then pass out through the water, bounce off an object and return as echoes that are retrieved through the dolphin's lower jaw and pass along as vibrations to its inner ear. The clicks vary in intensity and frequency. Lower frequencies, which sound like a creaking door, give a rough sense of an object and are used for ones that are further away. Higher-frequency clicks, which sound more like a high-pitched buzz, produce more detail. Depending on circumstances, dolphins emit between 8 and 2,000 clicks per second. The most rapid clicks sound like a buzz to our ears. But dolphins can distinguish each one: they don't send out a new click until the first one returns.

Those clicks and squeaks – focused outwards through the forehead, bouncing off objects and received again as vibrations in the jaw from where they pass to the ears – can locate objects many kilometres away, but they can also penetrate the skin of a human or dolphin a few metres away to 'see' a

Humans can hear from about 20 Hz, a little lower than the lowest key on a piano, up to 20,000 Hz, which is about two octaves higher than the top key Bottlenose dolphins only hear down to about 150 Hz, but up to 150,000 Hz, about eight times higher than us.

beating heart or the movements of a baby in the womb. According to some reports, dolphins have recognized women as pregnant before the women themselves knew, treating the women as they do pregnant dolphins. They can distinguish textures and shapes of objects that are distant and hidden from view: small shapes made of wood from identical ones made of plastic or of metal, and discs made of copper from those made of aluminium. They can detect differences of thickness of just a few tenths of a millimetre (less than the thickness of a human fingernail) from ten metres, or thirty feet away, a feat that requires them to discriminate returning echoes less than a millionth of a second apart.

'Echo-location' seems like an inadequate word to describe these superhuman abilities, which resemble hearing and seeing but are also unlike either and in some ways surpass both. Occasionally humans approach delphic powers of perception. Ben Underwood, the 'dolphin boy', became completely blind as a result of retinal cancer at the age of two but learned to navigate around his neighbourhood with ease by clicking his tongue and listening to echoes bouncing off surrounding objects. He could even play table football merely by listening for where the ball was. The percussionist Evelyn Glennie, who is profoundly deaf but grew up surrounded by music, learned to register even the subtlest vibrations through her body and has become an internationally celebrated orchestral musician. Achievements like these are extraordinary in human terms but all dolphins habitually do much more.

The extent to which dolphins use sound to 'speak' is far less well understood than how they use sound to 'see' things. One researcher claims to have identified 186 different whistle types, of which twenty are especially common. The whistles, she says, can be put into five classes which are typically associated with different kinds of behaviours. There is good evidence that dolphins also communicate with each other by body position and gesture. Dolphins can clearly say more than 'it's me!' and 'wheeee!' but how much their utterances resemble human language or constitute a communication system of a quite different kind is not

yet clear.

According to some studies, Bottlenose dolphins in captivity have learned sixty or more different signals for (human) nouns and verbs – enough to construct around 2,000 sentences which they demonstrably understand. But as Carl Sagan (who died in 1996) put it, 'it is of interest to note that while some dolphins are reported to have learned English ... no human being has been reported to have learned dolphinese.' This may be about to change, or at least we may learn to meet them about halfway: at the time of writing, experiments were under way to 'co-create' a language that uses features of sounds that wild dolphins normally use to communicate with each other.

Although it now looks as if John Lilly may have been over-optimistic about our ability to communicate with dolphins, his view was at least an advance on one that was firmly entrenched in Western thinking until at least the late twentieth century. Even the iconoclastic philosopher Martin Heidegger (1889–1976) was conservative when he said that humans are the only beings on Earth that are 'world-forming'. Everything else was either 'without world' (inanimate objects such as stones) or 'poor in world' (all non-human animals). Non-human animals, said Heidegger, were entirely captive to their encircling environment and released into activity only by features of that environment that disinhibited their instinctual drives. Only humans, he said, freed from such captivity by their conceptual and linguistic powers, had the ability to stand outside life and see it 'as-such', aware of the finitude of life and the imminence of their own death.

Our growing understanding of dolphins (and other intelligent animals) casts some doubt on Heidegger's view. We can already see that dolphins have a communication system that is complex and subtle, and that their lives are rich in meaning. As the linguist James Hurford argues, 'mental representations of things and events in the world come before any corresponding expressions in language; the mental representations were phylogenetically prior to words and sentences'. And, as the philosopher Alasdair MacIntyre observes, dolphins may not use words but they do share our fate

as 'dependent rational animals'. They are extremely adept at the 'simple' things that, in the end, make humans happy too – notably, endless play. They are anything but 'poor in world'.

In the beginning, perhaps, was not the word but the gesture. And, as those in the emerging field of biosemiotics argue, we are beginning to see beyond the painted theatre-set where human language ostensibly directs meaning to a larger world in which human language is just one phenomenon in a web of meanings. Perhaps the revelation does not stop with dolphins.

Dolphins remind us that we too (and not we only) are essentially sympathetic creatures. David Hume had a musical metaphor for this facet of our nature: 'humans resonate among themselves like strings of the same length wound to the same tension'. This is not our whole truth, but it is part of it. We may recall the modest humanism of Boccaccio in the preface to the *Decameron*, which was written at a time of plague and betrayal: *umana cosa é aver compassione degli afflitti* – it is human to have compassion for the afflicted. Dolphins present us with possibilities of friendship and hope, which, as Artistotle's younger contemporary Epicurus suggested, may be the greatest virtues of all, even if he didn't have another species in mind.

EEL . . .
AND OTHER MONSTERS

Phylum: Chordata
Class: Actinopterygii (ray-finned fishes)
Order: Anguilliformes
Suborder: Muraenidae (morays)
Conservation status: Not listed

A spring of love gushed from my heart
And I blessed them unaware

I missed my chance with one of the lords of life

The Snowflake eel, a kind of moray, is harmless if you leave it alone and refrain from drinking its blood (which is toxic). With its delicate markings – black polka dot on grey-white ground or delicate mottling in black, white and yellow – it is a favourite with aquarists. But the beauty is an uneasy one, and something sinister lurks in the scientific name for their genus, *Echidna,* which is derived from an ancient Greek mythical being who, according to Hesiod, was both beautiful and terrible:

> fierce Echidna who is half a nymph with glancing eyes and fair cheeks, and half again a huge snake, great and awful, with speckled skin, eating raw flesh beneath the secret parts of the holy earth. And there she has a cave deep down under a hollow rock far from the deathless gods and mortal men.

Compared to this, the Snowflake and other Moray eels are pussycats. And yet many people shudder at the sight of them. Part of the reason for this is surely their superficial resemblance to snakes, which primates so readily fear. Another may be the eels' mouths, which are constantly open, suggesting that they are ready to strike. But this is not, I think, the whole story. An eel's eyes, bulging and unblinking, look like those

of a corpse, and the way the animal moves its body – gracefully, without limbs or prominent fins – is disturbingly sensual. Saltwater eels are uncanny.

Freshwater eels, the *Anguillidae*, tend to be significantly smaller and are generally regarded as less spooky. But they are still enigmatic. Even though humans have probably been trapping and eating them for as long as they have been fishing in rivers, it is only quite recently that people have worked out what they actually are and where they come from. Aristotle believed they were derived from earthworms which, he thought, themselves emerged spontaneously from mud. Only in 1777 did the Italian biologist Carlo Mondini prove eels to be fish, but even then their origin and life cycle remained obscure. A hundred years later a young medical student named Sigmund Freud dissected hundreds in a search for male sex organs and eventually gave up. And it was not until 1896 that the Italian zoologist Giovanni Battista Grassi saw a leptocephalus – a tiny, transparent leaf-like creature which had long been regarded as a different species – transform into a glass eel (the translucent juvenile form of an eel that is recognizably related to the adult), proving that the two creatures were the same. The following year Grassi identified the gonads of the male eel: a looped, frilled ribbon inside the animal that had been noticed by previous biologists but not recognized as the testes.

Finally, in 1922, the Danish scientist Johannes Schmidt discovered that the leptocephali of the European eel (*Anguilla anguilla*) were born in the Sargasso Sea, as much as 7,000 kilometres (4,000 miles) away, and the main pieces of the puzzle locked into place. Mature eels swim all the way from Europe to the Sargasso. There they spawn, and from the fertilized eggs emerge the leptocephali, which then ride on currents all the way back to Europe. As these tiny creatures approach the coasts and rivers that their parents had left more than a year before, a combination of chemical and temperature cues triggers them to transform into glass eels. When these glass eels enter freshwater they transform again into elvers – miniature versions of the adult eels. As the elvers grow they become, first, brownish-yellow and then, after five years or more, silver and

The psychologist Ernst Jentsch (1906) suggested a feeling of the uncanny arose in a context of 'doubts [as to] whether an apparently animate being is really alive; or conversely, whether a lifeless object might be, in fact, animate.' Sigmund Freud (1919) argued that a sense of the uncanny was often created by entities that aroused sensations we wish to keep hidden, especially sexual ones. In Hentai, a tradition in Japanese pornographic art, a woman is sometimes depicted in a tub full of Japanese eels, *Anguilla japonica*, being penetrated through various orifices.

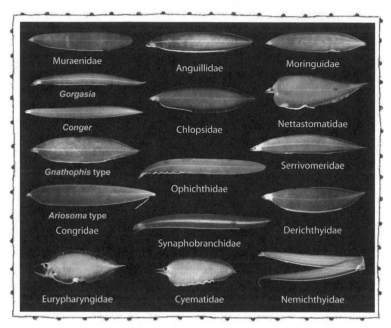

The larvae of eels – leptocephali – vary greatly in form, and grow to sizes ranging from about 60 mm to more than 200 mm. They are totally transparent. This image shows leptocephali of freshwater eels of the family *Anguillidae* and 12 families of marine eels.

Eels are 'catadromous': they spend their adult lives in freshwater and return to the ocean to breed.

One fact beyond doubt is that the number of 'common' European eels is between one and five per cent of what it was in the 1970s. This is a result of overfishing, habitat destruction and pollution. The species – a much-prized food for millennia – is now critically endangered.

white, and sexually mature. It is these silver eels that migrate back to the Sargasso to spawn. Freshwater eels undertake a journey no less epic than salmon, which mature in the ocean and return to their native river to breed, but they do it 'the other way round'. But while the broad terms of the freshwater eel's life cycle are clear, the processes governing these metamorphoses are still far from fully understood. In some respects the eel is no less mysterious than it was.

There are many variations on the theme 'eel'. The *Anguillidae* are just one of nineteen families in the *Anguilliformes*, or true eels, an order that evolved in the time of the dinosaurs and has around 600 extant species today ranging from rivers, coasts and coral reefs to abyssal depths. Some of their names say more, perhaps, about the imagination of the marine scientists who thought them up than they do about the creatures themselves, but they are worth entertaining. There's a

THE BOOK OF BARELY IMAGINED BEINGS

whole group of eels with bill-like protuberances known as Duckbilled eels (one of them is 'the black sorcerer'). There is an eel whose jaws are shaped into an elegant curved 'beak' resembling that of an avocet. There is an Abyssal cutthroat eel, whose larvae have telescopic eyes. There is a Rusty spaghetti eel. There is a Froghead eel. Some species in the Conger family grow up to three metres (ten feet) long and are bold predators, but the family also includes the Garden eel which clusters together with others of its kind in groves that resemble seagrass: at the first sign of danger, they withdraw rapidly and almost simultaneously into the sand like the horns of a thousand snails recoiling to a distant vibration. Recently, a vast congregation of strange, greenish-white eels was found living happily right next to scorching hydrothermal vents on the sides of a giant underwater volcano rising from the depths of the Pacific. Some families of eels, having lost even vestigial fins, look very like actual sea snakes and often mimic their markings. Others look like large worms.

Then there are creatures which look like eels but are really something else. These include the Electric eel (which is more closely related to catfish), the Rubber eel (a caecilian, or amphibian, also misleadingly known as a Sicilian worm), the Wolf eel (more closely related to a perch than an eel, its stony face is one of the scariest of any living thing), and the Umbrella mouth gulper (which tempts prey by dangling its own glowing-pink, flashing-red, tentacle-covered tail in front of its huge mouth). There is even an 'eel shark': truly, this animal looks like something arising from the very lowest reaches of the human brain; its 'misshapen' teeth and twitching, jerky movement give it the appearance of something not really alive at all. And, of course, there are hagfish: blind, jawless, four-hearted creatures with cartilaginous skeletons, they produce large quantities of slime and are particularly fond of burrowing up the anuses of dead animals which they then devour from the inside.

Snowflake eels are members of the morays, the largest of eel families with about two hundred member species, most of them living in the shallower parts of warmer seas. Morays tend to be similar in shape, with a

narrow fin running all the way along their backs from head to tail, but as adults the species vary greatly in size: some are shorter than your arm, a few are more than twice as long as a human is tall. They are night hunters (of small fish and invertebrates), and they have wide jaws and sharp teeth suited to ripping prey. (Their teeth are regularly and assiduously cleaned by shrimp that nimble in and out of the moray's mouth like ballet dancers in the jaws of a mechanical stage dragon.) Many are well camouflaged right down to the inside of their gaping mouths, but colouration varies according to habitat. The Zebra moray is chocolate black with vertical white stripes. The Dragon moray (also known as the Leopard or Tessalated moray) has shimmering black, yellow and red markings and two tubular nostrils sprouting just forward and above its eyes. The Giraffe moray has markings very like those of ... you guessed it. The Golden dwarf needs little further description. The Ribbon moray has a body of gorgeous royal blue and golden yellow jaws when it is young (and male) and turns yellow all over as it becomes older (and female). It lures its prey with leafy green appendages like fishtails on the front of its top jaw, waving these in the current while it conceals its powerful body in the sand.

Until very recently the conspicuous success of morays was something of a mystery. Most carnivorous fish engulf prey into their mouths by opening them quickly from a closed position and thereby creating a sucking effect. But morays' mouths are already open most of the time. Further, their visible jaws are actually quite small and weak given the animal's size. How, then, do they sustain themselves? The answer, observed in 2006 for what was believed to be the first time, is bizarre. Moray eels have a second set of jaws deep at the back of their throat which shoot forward at high speed, grab the prey and rapidly protract backwards again, pulling the prey down into the oesophagus as the animal closes its mouth. This extraordinary ability to 'vomit' up a second set of fearsome teeth gives the moray the best of both worlds: it can reach out to grab its prey without moving far from its narrow hiding place.

There is nothing else in the world quite like these

THE BOOK OF BARELY IMAGINED BEINGS

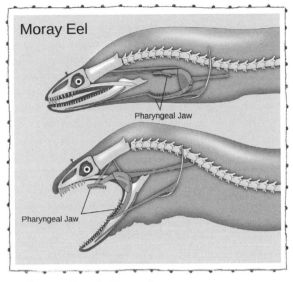

Pharyngeal jaws of a Moray eel.

highly mobile pharyngeal jaws. Snakes are able to ratchet prey down their throats by alternately pivoting their left and right jaw arches over it, but they do this with just a single set of jaws. Some other bony fish have a set of crushers deep at the back of the throat, but these remain firmly in place behind the head. The only thing that comes close to the moray is an imaginary being created with the aim of arousing the maximum horror and disgust in its viewers: the monster in the 1979 film *Alien* and its sequels. In trying to imagine something truly horrific – a being that 'rapes' and impregnates with a nightmare 'embryo' which in turn feeds on human viscera like a medieval demon before it bursts out and destroys – the creators of *Alien* summoned something that resembles, at least in part, a natural being – the eel – that in evolutionary terms is highly successful.

We may suppose that for at least as long as we have been humans we have feared monsters of one kind or another. Some, especially earlier in our history, were dangerous animals that those of us living today would recognize as real. Others we would now class as imaginary: creations of the human mind that might

H.R. Giger, the Swiss artist who created the monster for the film director Ridley Scott, said that he had no knowledge of the eel's pharyngeal jaws. One of the models for his monster, at least in its 'baby' version, is the set of figures depicted in Francis Bacon's *Three Studies for a Crucifixion* (1944). These have grey eyeless heads that are mostly a mouth emerging from a long writhing neck. Certainly, the monster in *Alien* is more than just eel. It also combines features like those of an insect and a humanoid skeleton like the figures in Pieter Breugel's *The Triumph of Death*.

incorporate elements of real animals but which are also fantastic or supernatural – man-beasts and giants, chimaeras and hybrids. As humans have settled the planet ever more densely, so the animals that prey on us or compete with us for food have steadily been eliminated. Of the few that remain, many are vulnerable to extinction: objects of concern and conservation efforts rather than fear. Even the last wild lions in Africa are likely to be eliminated in the next few decades. The animals most dangerous to humans today are, overwhelmingly, other humans. Perhaps this has always been the case. Whatever else is true, it seems that as dangerous non-human animals have become remoter from our direct experience, the shapes of imaginary monsters have shifted. Inchoate fears have vested in new forms.

A hundred years before *Alien*, the nature writer Richard Jefferies seems to have experienced similar emotions to viewers of the film when contemplating real but to him unfamiliar animals:

> How extraordinary, strange, and incomprehensible
> are the creatures captured out of the depths of the
> sea! The distorted fishes; the ghastly cuttles; the
> hideous eel-like shapes; the crawling shell-encrusted
> things; the centipede-like beings; monstrous forms,
> to see which gives a shock to the brain.

This passage appears, rather surprisingly, in *The Story of My Heart* (1883), a memoir infused with a sense of transcendental bliss and oneness that Jefferies experienced in the Wiltshire hills of his childhood and youth. In this remarkable work, Jefferies reaches for a new vocabulary as he tries to describe the 'soul-life', the 'mind-fire' that, he believed, lay beyond anything revealed by the religious or scientific orthodoxies of his day. 'There is so much', he enthused, 'beyond all that has ever yet been imagined'. But something was straining, near breaking, in this sensitive man, and his 1885 novel *After London* imagines a cataclysm wiping out much of humanity and flooding vast tracts of land so that marsh and forest reclaim the city for wilderness. Perhaps Jefferies – repelled by the rapid industrialization and urbanization he saw around him – found in

recently reported discoveries a corollary for his fears. The *Challenger* expedition of 1872-6 had hauled up more than 4,000 unknown species from the depths of the world ocean, a realm previously believed to be largely dead. But where many of his contemporaries of a more scientific turn of mind were fascinated by revelations from the abyss, Jefferies saw only 'miserably hideous' creatures from outside and beyond the world.

Maybe Herman Melville, a generation older than Jefferies, was more subtle and insightful. In *Moby-Dick* (1851), the monster is ostensibly a great white Sperm whale. As the narrative unfolds, however, it becomes clear that the drive and obsession of Captain Ahab in pursuit of the whale is itself a destructive force. For D. H. Lawrence, writing in 1923, the symbolism of *Moby-Dick* was clear: 'a maniac captain of the soul, and three eminently practical mates [with the non-white races in thrall as crew] ... All this practicality in the service of a mad, mad chase ... America!' Their ship, the *Pequod*, is 'the soul of an American', and the terror betokened by the whiteness of the whale is, Lawrence suggests, the doom of 'our white day', the industrial civilization of Europe and North America: 'That great horror of ours! It is our civilization rushing from all havens astern.'

Some modern commentators find this interpretation too crude. But recall that Lawrence was writing shortly after the end of World War One, 'the world wide festival of death' (in Thomas Mann's phrase) when Europeans had killed each other on a scale matched only by their destruction of native peoples in the previous few decades. Whatever the boons of Western civilization, its dark side was fully apparent by the time, twenty-two years after Lawrence wrote his essay, that nuclear weapons were deployed. Europeans had already begun to practise mass murder on a scale never seen before. But the Bomb took things a stage further: the highest achievements of Western science had led directly to a means of destroying tens or hundreds of thousands of people in a fraction of a second. Man had created a new kind of monster. William L. Laurence, the official reporter onboard the flight that dropped an atomic bomb on Nagasaki at just after eleven on the morning of 9 August 1945, wrote:

The Final Solution was envisaged as one small step towards Generalplan Ost, which would have organized the elimination of many tens of millions of Slavs and others in Eastern Europe.

When the US arsenal peaked in 1960 it was the equivalent of 975,714 Nagasaki-sized ('Fat Man') bombs (at 21 kilotonnes) or 1,366,000 Hiroshima-sized ('Little Boy') bombs (at 15 kt). The Soviet arsenal of deliverable nuclear weapons was significantly smaller than the American one in 1960, but grew fast. By 1964 it had reached about 1,000 megatonnes, or about 13 per cent of the US total. By 1982 it was nearly 75 per cent greater than the US 'throw weight' in that year, but less than the Americans had had in 1964. The largest single thermonuclear weapon ever tested, the Soviet 'Tsar Bomba' in 1962, yielded 52,000 kt or nearly 2,500 times the yield of Fat Man.

'A nuclear holocaust, widely regarded as "unthinkable" but never as undoable, appears to confront us with an action that we can perform by cannot quite conceive.' (Jonathan Schell, 1982)

Awe-struck, we watched [the giant ball of fire] shoot upward like a meteor coming from the earth instead of from outer space, becoming ever more alive as it climbed skyward through the white clouds. It was no longer smoke, or dust, or even a cloud of fire. It was a living thing, a new species of being, born right before our incredulous eyes.

Within fifteen years the United States nuclear arsenal was sufficient to destroy Nagasaki a million times over. (The Soviet Union was some way behind but eventually caught up and overtook the US.) The threat of these weapons became a part of everyday reality and indeed was strongly advocated on several occasions by commanders such as Curtis LeMay. Here, truly, was something that, in Melville's fateful words, 'stabs us from behind with thought of our own annihilation'.

But while the danger was real enough, it was resistant to imagination. Iconic monsters from the period – from Godzilla to the radiation-giganticized ants in the 1954 film *Them!* – now look as quaint as the more implausible monsters in medieval bestiaries such as the Bonnacon or the Manticore. The enormity of full-scale nuclear war – 'unthinkable' but never undo-able – was, for the most part, too much for direct representation in the arts or popular culture.

Today at least half a dozen nations assign nuclear weapons to war-fighting roles in their military planning that go well beyond deterrence. For all that, the risk of large-scale nuclear war is probably lower than it was during the Cold War, and monsters in contemporary works of imagination tend to reflect other concerns. Some of these had never really gone away, of course. The monster in the *Alien* films, for example (of which there were four between 1979 and 1997), have been interpreted in many ways, not least as a manifestation of fear about the vulnerability of the human body to pollution, pesticides, food additives and man-made cancers – the self could change, mutate and become monstrous. A notable trend in the first decade of the twenty-first century has been an increase in the popularity of zombies, vampires

and other beings that are partly human or horrendously degraded and corrupted humans. These creatures, raging with unquenchable appetite, speak at least in part to our fears of such things as overpopulation and starvation, pandemic disease and even climate change. That they are half human is precisely one of the things that makes them so frightening and so compelling.

Some good may come of this. Stories that locate the monstrous as close to humans as the jugular vein let other animals off the hook; they reduce the obstacles to seeing non-human animals *for what they are* and not as metaphors for something else. Creatures of the deep such as abyssal eels, hagfish, devil fish or giant isopods may continue to arouse unease, especially when we see them for the first time. This is understandable. Their faces were never 'designed' to be seen by anything on the planet's surface, and they *are* strange to us. Seeing them undoubtedly fires odd connections in the brain. But if we look a little deeper into their nature and their evolutionary origin we can move beyond the kind of dismay felt by Richard Jefferies. These 'monsters' of natural selection, existing in spaces and over periods of time we are only beginning to appreciate, can actually help us expand our sense of beauty, or at least what it is to be astonished.

Zombies and vampires are not the only humanoid representations of terrifying evil, of course, nor are they new: in *Capital*, Karl Marx envisages capitalism as a vampire feeding on the life blood of the people. 'Monsters' that are totally human appear in works such as Cormac McCarthy's *The Road* (2006). In science fiction the most monstrous beings tend to be partly human and partly either the products of our own worst fears (e.g. *Forbidden Planet*, 1956) or the products or slaves of technology. In *Alien Resurrection* (1997), for example, the heroine Ripley has been genetically combined with the monster, and in *Star Trek* the Borg are half-human, half-robot. Even the pigoons – the vengeful genetically modified pigs in Margaret Atwood's grimly comic *Oryx and Crake* (2003) and *The Year of the Flood* (2009) – have human tissue in their brains.

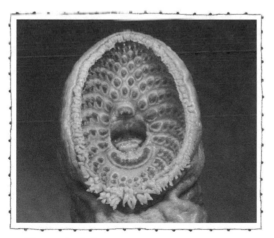

The mouth of a Lamprey.

It is interesting to contemplate a tangled reef, teeming with many forms of life, some brilliant and ostentatious, others flitting in sunlight between branching coral, and still others, like the moray eel, lurking in hidden places. And the moray, undulating gently in the water and working its open jaws, embodies at least two realities arising from the natural laws acting upon that reef.

First, its two sets of jaws are a superb example of how the struggle for life leads to astounding novelty. From a relatively simple beginning – the 'first terror with teeth' resembling, perhaps, an arrow worm – through tentacle-mouthed ancestors that may have looked like hagfish, through jawless but fearsomely toothed wonders akin to lampreys and on to the jawed fish from which we ourselves are descended, almost endless forms have evolved. We may intuitively feel morays to be 'primitive,' but they still hold surprises. Evolution itself holds future wonders.

Second, the snake-like movement of the eel is an example of the tremendous endurance of some phenomena over vast periods of time. The lateral wriggle is one the most efficient ways of moving that animals have ever developed, one that has evolved and persisted in species after species for more than half a billion years. Precursors to the vertebrates such as conodonts (ancient, now-extinct chordates vaguely resembling eels), distant cousins such as hagfish and, of course, relatively recent arrivals such as the snakes (which only evolved a few tens of millions of years ago, after the demise of the dinosaurs): for all their differences these animals have all employed a wriggling, rippling, flame-like motion that may be older than earthly fire. Here, then, in a motion that always changes but always endures, is an image of life itself.

The earliest trace of fire in the fossil record dates to about 470 million years ago. At this time, the Middle Ordovician, vegetation on land was dense enough and the atmospheric concentration of oxygen (a waste product of plants) sufficient for fire to be possible.

THE BOOK OF BARELY IMAGINED BEINGS

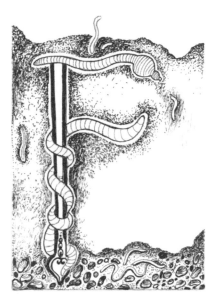

FLATWORM . . .
AND OTHER WORMS

Phyla: Acoelomorpha and
Platyhelminthae
Conservation status: Not listed

Let Job bless with the Worm – the life of the Lord is in Humiliation, the Spirit also and the truth.
Christopher Smart

'We are all worms,' Winston Churchill said, 'but I do believe that I am a glow-worm.' The quip would earn him an F in biology (most glow-worms are a kind of fly or beetle) but an A for insight into how humans often feel. We know ourselves to be tiny specks in the universe but we can't help feeling that we are really rather special. Or the loop of thought can run the other way: we're amazing! ... but there's no escaping it, we are one with the worm. As the geneticist Steve Jones puts it, 'every one of us, however eminent, is a ten-metre tube through which food flows, for most of the time, in one direction.'

Whichever way you put it, however, the fact is that in everyday life few of us spend much time thinking about worms. Beyond the rarefied worlds of evolutionary biology and parasitology, general attitudes to worms have changed little since people were writing bestiaries seven hundred years ago: there are various things out there which are wormy, the ones in the soil are good but most of the rest are to be avoided and ... well, that's it. This, I will argue, is a pity because it means people are missing out on many things that are remarkable and beautiful as well as repulsive and unsettling. When you get beyond the yuck factor, a whole world of delights – and frights – opens up. From arrow worms to spoon worms, and from

THE BOOK OF BARELY IMAGINED BEINGS

peanut worms to penis worms, every human can benefit from contemplating the riot, the carnival, the salmagundi of worms.

In an account that was widely accepted for much of the twentieth century, complex animals – that is, creatures with organs such as hearts, guts and eyes, and made up of billions or even (as humans are) trillions of cells – were generally supposed to have evolved from single-celled organisms over a few million years from about 542 million years ago. This was the Cambrian explosion – the first great flowering from obscurity in what the evolutionary biologist Bill Hamilton called 'the vast psychedelic drug enterprise of nature.' But, as noted in Chapter 2 (Barrel Sponge), it is now clear that relatively simple multicellular forms had already existed for a hundred million years or more when the Cambrian began: the explosion had a long fuse, and during this earlier fizzling life experimented with various ways to big up. One was to be a sponge – an option which, as we have noted, continues to this day. Another was explored by the Ediacarians – a diverse group (or set of groups) ranging from the repeatedly branching (fractal) frond-like *Charnia* to the ribbed cushion-like *Dickinsonia* and the tri-radially symmetrical *Tribrachidium*, which resembled a triskelion mounted on a pizza. Truly, the Ediacaria, some of which grew to a metre (three feet) or more across, evolved beyond psychedelia. As Italo Calvino's hero Qfwfq says in *Cosmicomics*, 'When you're young, all evolution lies before you ... If you compare yourself with the limitations that came afterwards, if you think how one form excludes other forms, of the monotonous routine where you finally feel trapped, well, I don't mind saying, life was beautiful in those days.'

Alas, many paleobiologists now think that, for all their glory, the Ediacarians left few or no descendants in the Cambrian. For whatever reason they were superseded by various animal phyla including our own, the chordates, and many that were wormy. What exactly *these* were all descended from is not known, but one possibility is suggested by an enigmatic trace in 600-million-year-old rock which some

Ediacarian animals are the earliest known complex multicellular animals. They were mostly bottom-dwelling organisms, resembling variously, fronds discs, tubes, mud-filled bags or quilted mattresses. They thrived during the Ediacaran period about 635–542 million years ago and were largely extinct by the early Cambrian. Their fossils have been found all over the world.

Those were his first
 steps on a white sheet
Clutches of wriggling
 letters in black lead
Like tracks of worms on
 the Precambrian mud.
(*Caspar Hauser* by David Constantine)

interpret as the fossil of a creature they call *Vernanimalcula* or 'spring animal'. This (probably) worm-like thing, if it was an animal, was no thicker than a human hair. But it was only with the passing of the Ediacarians that the descendants of *Vernanimalcula*, or whatever it was that gave rise to all the complex animals we know today, came into their own.

The great diversification of life in the Cambrian most likely resulted from a combination of factors. Rising levels of oxygen in the ocean, which allowed animals to get bigger, probably played an important role to begin with. The evolution of eyes may have then driven an arms race between predators and prey. And the emergence of new, more efficient means of predation and foraging – 'terrors with teeth' with a through-gut (an early, small version of the 'tube' which Steve Jones reminds us we all are) connected to an anus, which could process what they ate with more efficiency than any previous animal – may have been even more important than the evolution of eyes. But whatever the cause, the result was the spectacular radiation into virtually all the forms we see in the world today. Whether or not most of philosophy is a footnote to Plato, much of life since the Cambrian has been little more than a footnote to the step-change achieved by these early creatures in their ability to eat, digest and excrete the world around them.

Some of the earliest creatures to acquire sharp teeth, efficient guts and anuses were worm-like. The first 'terror with teeth' may have been a kind of arrow worm or Chaetognath. One of the commonest fossils found in some Cambrian shales, observes Martin Brasier, resembles a novelty condom with an organ inside. *Paraselkirkia* had a bulbous head ornamented with a spiky helmet. Its head was attached to a long wrinkled body and the whole was protected by what looks to have been a rubbery organic sheath. *Paraselkirkia* was a kind of Priapulid, or penis worm – a phylum of animals that lives in mud and eats it too. Another creature that appears to have been quite widespread is *Hallucigenia*. This creature met with fame after its discovery in 1977 because of the bizarre appearance it was thought to have had and which had inspired

THE BOOK OF BARELY IMAGINED BEINGS

its name. *Hallucigenia*, it was believed, had long rigid spikes instead of feet on its underside and must have moved around as if on multiple stilts, with little tentacles waving on its back. Later analysis showed, however, that this animal was being imagined upside down: the tentacles were small legs and the spikes were protection on its back, rather as we see on some caterpillars today. *Hallucigenia*, it turns out, may have been a kind of Onychophor, or Velvet worm. Others in this remarkable phylum including *Microdictyon* evolved huge false compound eyes – mimicry to warn off would-be predators.

Velvet worms may have been quite common in the Cambrian. Indeed, this may have been their golden age. Nowadays they are mostly found under rocks or in rotting trees in remote parts of the southern hemisphere, and until recently they have been neglected or had something of a bad press. In his magisterial *Life: An Unauthorised Biography* (1997), Richard Fortey called them 'primitive'. Today, however, Velvet worms are recognized as remarkable beasts, and many biologists, including Fortey, are more sensitive of their virtues. They are highly social and live in close groups with clearly established hierarchies. They cooperate to hunt and tend to be hostile to other groups. Their mating rituals – the male has a penis-like organ on his head, which he inserts into the female – and their virtuoso ability to squirt sticky slime in the face of enemies and prey have made them popular as pets. Even more strikingly, modern varieties appear to be very similar to fossils as much as 540 million years old.

Velvet worms also have teeth of a kind. Deep within the oral cavity lie sharp, crescent-shaped mandibles that resemble the claws of their feet but are strongly hardened. The mandibles are divided into internal and external sets and each is covered with fine toothlets. They move backward and forward to tear apart prey.

For all the success of Velvet worms in the Cambrian, however, other creatures evolved even more formidable features for attack and defence. Arthropods, which share a common ancestor with Velvet worms, developed

Velvet worms are classed as panarthropods, which means that, like Waterbears (see Chapter 23), they are more closely related to insects, spiders and mites, and crustaceans, than are any other creatures.

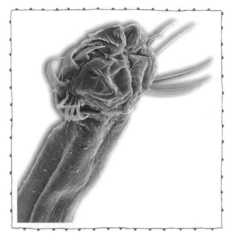

A Chaetognath.

armour and jointed limbs which gave them a huge advantage over their softer and squidgier cousins. Early Chordates, deriving from a common ancestor with Ragworms, developed comparatively sophisticated brains, and in time skulls to protect them. The result may have looked a little like a hagfish – a kind of halfway house between worm and fish (or perhaps a lancelet). Later, still other creatures evolved from these to have spines and other bones on which to anchor stronger muscles. These, the first vertebrates, were the earliest true fish: jawless Ostracoderms in the late Cambrian and the Ordovician and then, from the early Devonian, the Placoderms – large animals with powerful jaws mounted in their heavily armoured heads. Placoderm armour is made from exactly the same material as teeth.

But even with the rise of larger animals – the vertebrates (such as fish), molluscs (snails and cephalopods), arthropods (crustaceans and insects) and echinoderms (starfish) – several phyla of worm-like creatures continued to evolve and proliferate. Many indeed, made their homes as parasites in these other animals rather as their ancestors had made their homes in the mud and silt of the Cambrian seabed. In addition to those already mentioned, Jaw worms, Acorn (or tongue) worms, Horsehair worms, Ribbon worms (also

THE BOOK OF BARELY IMAGINED BEINGS

known as Proboscis worms), Horseshoe worms and Peanut worms all flourished and continue to do so today. (These are named for their appearance, not where they live: many are residents of the deep sea.) Many are microscopic (and parasitic), but a few are huge. Bootlace worms, which are a kind of Ribbon worm, can grow to thirty metres (ninety-eight ft) long. With an evertible proboscis – a bit like an elephant's trunk that turns inside out – they scavenge the seabed for small sponges, jellyfish, anemones and fish. As one of the longest animals in the world they sound like a terrifying predator until you learn that their bodies are no thicker than a pencil. Ribbon worms are no mighty dragons; happening upon a typical species on the seabed you might think you had run into a pile of spilled intestines.

But there are three phyla of worms that, in terms of diversity and abundance, tower over all the rest: the Roundworms (nematodes), the Annelids and the Flatworms. And before coming to the third of these, a few words of celebration of the first two phyla are in order.

Roundworms may be the most diverse and numerous of all the wormy phyla. Many are parasites, and so it's easy – perhaps too easy – to pass over them with a shudder. But others achieve remarkable feats without feet: the splendidly named *H. mephisto* was recently discovered where multicellular life was thought impossible, nearly 3,000 metres (9,000 ft) beneath the surface of the Earth in a goldmine. And at least one species is likely to add greatly to the sum of human happiness: *C. elegans* – a transparent and easily reproducible being (it is a self-fertilizing hermaphrodite that matures to a 1 mm-long adult in three and half days to produce around 300 offspring, a few of which are male) – has been a favourite model organism in labs for many years, used in research into the fundamentals of gene expression, development and other processes seen across the animal kingdom. In 1998 it became the first creature to have its genome (one of the smallest of any animal) sequenced. Its simple nervous system was the first to be fully mapped; it works fine with only about 300 neurons. *C.*

elegans is truly elegant for doing so much with so little. At least four Nobel Prizes in physiology or medicine have been awarded since 2000 for research that has depended on this tiny worm.

Annelids, the segmented worms, are also a large and tremendously diverse group, ranging from the most familiar of all worms – garden earthworms and seaside lugworms – to some of the most bizarre-looking species yet discovered, such as the two-metre-long tube worms and the smaller Pompeii worms which bathe in scalding temperatures on volcanic vents in the deep ocean, and the bristly Christmas tree worms that achieved fame in impossibly large but otherwise largely accurate translation to the planet Pandora in the film *Avatar*. Earthworms were the first worms to be the subject of sustained and serious scientific interest, when Charles Darwin undertook to study their behaviour and effect on their environment in the garden of his home in Kent. Darwin appreciated, in a way that almost no one had done before, that it was earthworms which *made* the earth. He also observed, to his considerable surprise, that they demonstrated significant powers of reason, making intelligent decisions as to what shape of leaf to use to block their holes, and how.

And so to the flatworm. Broadly speaking, this is an animal with no body cavity in which to house a heart, lungs or gut: its insides have no inside, and as a result it is restricted to flat shapes that allow oxygen and nutrients to pass through by diffusion. But 'flatworm' is a generic name for many thousands of species that fall into at least three groups and the differences between them are as great as the similarities. This is one of the reasons I chose them for this bestiary. They are a reminder that big differences and subtle details are often hidden by language and thinking that is too blunt. (Such, at least, is the case with me: until I started researching I had little idea what flatworms were, still less how they differed.) Some flatworms have evolved life cycles as gruesome as any imaginable. Others are among the most brightly coloured members of the animal kingdom. Still others engage in what may be the most startling sexual practices on the planet. With their dark, light

'Darwin's brief on behalf of worms was not part of some general campaign to attribute intelligence to all creatures. . .[He] observed that other lowly animals do not show the same degree of intelligence.'
(James Rachels)

THE BOOK OF BARELY IMAGINED BEINGS

and bizarre sides, these various organisms with a mis-
leading singular label make a good talisman for
meditation on life and death.

Flatworms are actually creatures from two different
phyla. They can also be divided into three groups
according to lifestyle. One group, comprising more
than half the species in one of the two phyla, the
platyhelminths, consists of parasites. The other two
groups are free-living. One of these, the Turbellaria,
also consists of platyhelminths. But the other, the
Acoelomorpha (or Acoels), is probably no more
closely related to platyhelminths than it is to us.
Typically the width of a peppercorn and as flat as a
pancake, Acoels have no brain or ganglia but a
network of nerves beneath the skin that is slightly
more concentrated towards the front end. They have
a simple organ for balance called a statocyst that
works a little like the vestibular system in the human
inner ear, and some species have simple eyespots for
detecting the presence or absence of light. Unlike, say,
the eight-eyed box jellyfish, which looks the same in
every direction, Acoels would probably pass the
threshold set by Thomas Browne for non-mythical
animals – that they have a front end and a back end, a
left and a right. But at least one species has virtually
given up being animals. In youth, *Convoluta roscoffensis*
swallows green algae with all the enthusiasm of
teenagers on alcopops and never bothers to feed
again, relying entirely on the photosynthesizing algae
to nourish it. On its native shores, *Convoluta* rises from
the damp sands of the intertidal zone as soon as the
tide has ebbed, and the sand becomes blotched with
large green patches of 'slime' composed of thousands
of worms, which photosynthesize in the sunlight
until the flood returns and they disappear beneath the
sand again. Remarkably, a colony of these worms in
an aquarium or laboratory tank will continue this
behaviour, seeking sunlight twice each day. Rachel
Carson writes: 'Without a brain, or what we would
call a memory, or even any very clear perception,
Convoluta continues to live out its life in this alien
place, remembering, in every fibre of its small green
body, the tidal rhythm of the distant sea.'

It is possible that
Acoels resemble the
earliest bilaterally
symmetrical animals.
Such, at least, was
the majority view
until 2011. Recent
evidence suggests,
however, that Acoels
evolved their rela-
tively simple form
after having split
from a deuterostome
ancestor. See Amy
Maxman (2011).

Convoluta is sensitive
to approaching
human footfall. 'As
you creep up on
them, the "slime"
hides! (by disappear-
ing into the sand)',
says one observer.
'Very strange to see.'

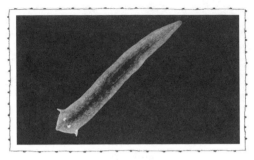

A googly eyed planarian flatworm (*Dugesia*).

Several species among the Turbellaria (or Planarians, as free-living platyhelminths are also known) have a goofy pair of little eyes, making them perhaps the cutest of all worms. Like other platy-helminths (that is, all flatworms apart from Acoels), their lack of an inside, or coelum, is 'secondarily derived,' which means they are descended from organisms that had one but have abandoned it along the evolutionary way as so much unnecessary baggage, rather as humans have for the most part abandoned fur and tails. Some Turbellaria have adopted the daz-zling and diverse colour patterns of nudibranchs, sophisticated and agile molluscs to which they are not related. Nudibranchs are often poisonous, so mimick-ing them has clear advantages. And when it comes to combining two of humanity's favourite activities – sex and combat – nothing beats Turbellaria. These ani-

Sparring flatworms try to pierce each other with the paired penises mounted on their fronts.

THE BOOK OF BARELY IMAGINED BEINGS

mals, which are hermaphrodites, engage in spectacular penis fencing, using two phalluses mounted on their chests as weapons with which they attempt to pierce and impregnate each other.

The other large group of platyhelminths (and more than half of the thousands of the known species of this phylum) are parasites – flukes, tapeworms and other lovelies. Some do great damage to humans and other animals. Trematodes are responsible for schistosomiasis, the second most devastating human disease caused by parasites after malaria (which is caused by protists of the genus *Plasmodium*). When larvae of *Taenia solium*, the pork tapeworm, penetrate the human central nervous system they cause neurocysticercosis, a particularly nasty form of epilepsy. Tapeworms that live in the human gut may look scary but they are benign by comparison.

Few things are more intimately horrible than a tapeworm – creatures which take up residence in our guts, our livers, even our brains and gorge on our lifeblood. (When, a few years ago, a senior editor on the *Wall Street Journal* was looking for a really nasty epithet for Google, he called it a tapeworm, following a long-established practice of equating things we truly hate and fear with parasites.)

Our fear and loathing for parasites is obviously adaptive. But this fear can itself mutate into a psychopathology – a phenomenon well documented in different times and cultures. Notably, there is a condition called delusional parasitosis, in which an individual hallucinates parasites crawling out of every orifice. Anxiety and fear can also be captured by others and turned to political ends. The Nazis cultivated anti-Semitism, for example, by associating Jews and other out-groups with parasites.

Summoning any kind of enthusiasm for parasitic flatworms (or any sort of parasite) is, then, hard to do. But if we cannot be enthusiastic, can we not at least learn to appreciate them – where 'to appreciate' means 'to better understand their importance and impact' rather than 'to like'? For one thing, tapeworms have been our constant companions. *Homo ergaster*, the earliest member of the human genus, Adam had'em. Some of the pathogenic bacteria in our gut

'Anti-Semitism', declared Heinrich Himmler in April 1943, 'is exactly the same as delousing. Getting rid of lice is not a question of ideology. It is a matter of cleanliness.' How, asks Hugo Raffles (2009), could Himmler have come to make this equation? Obviously, he was drawing on a long history of fear and hatred in which many Christians had associated Jews with diseases and depravities of all sorts. The Black Death of the fourteenth century had been known as *Judenfeber* ('Jew fever') in German lands. But, notes Raffles, Nazi beliefs were also grounded in the perversion of the actual history of health catastrophes of World War One. Vast numbers of refugees and prisoners of war had succumbed to typhus and other diseases borne by parasites, and the victims of these diseases were often blamed rather than the diseases themselves. Zyklon B – the chemical used to gas Jews, gypsies and others in death camps – had originally been developed for delousing.

Peter Ackroyd
describes Blake's
world view as one of
'exuberant hopeful-
ness', born out of
passionate rage at the
world he saw around
him. But parasitism
has its own twisted
poetry, as Blake also
recognized: the 'dark
secret love' of the
'invisible worm'
sickens and destroys
the rose.

may date vastly further back as they are shared with organisms living at the bottom of the deep sea.

'Everything that lives is holy / Life delights in life', wrote William Blake. But the truth is that life often delights in the death of other life and – even more disturbingly – eating other things while they are still alive is the most popular lifestyle on Earth. Virtually every multicellular animal that lives is loaded with parasites. Expressed in terms of biomass – sheer weight – parasites actually outweigh large predators, from sharks to lions, in some ecosystems, sometimes by as much as twenty times. This reality may seem horrific at first, particularly when one considers the effect of some parasites: hollowed-out or deformed bodies, chemical castration, brainwashing and bizarre behaviour that makes an infected animal more vulnerable to being eaten by others. The whole world can start to look diseased, like the vision of death in life experienced by Coleridge's Ancient Mariner before his redemption. Ray Lankester, an influential zoologist of the generation after Darwin, believed parasites were a contemptible outcome of evolutionary degeneration (in which an organism becomes dependent upon others) – a fate which he believed was awaiting Western civilization too.

From the larger, evolutionary perspective, the view is rather different. Parasites are frequently harmless and may even be beneficial to a species and the ecosystem of which they are part. Their presence in large numbers can actually be a sign of health. And some of them – contrary to Lankester's prejudice – are enormously sophisticated. The parasite that causes toxoplasmosis, which is present in as many as a third of all humans, 'knows' how to access certain specific circuits in the amygdala of its target host, which is actually the rat, so that it will lose its fear of the odour of its predators. In some respects 'toxo' has a better understanding of how mammal brains work than neuroscientists do. Even more significantly, if the hypothesis is true, parasites may have played a role in driving the evolution and persistence of sex in the animal world: only by giving birth to offspring that are not genetically identical are so many species able to find new ways of combatting the endless assaults of parasites.

THE BOOK OF BARELY IMAGINED BEINGS

For all that, in most human experience parasites are one of the many heralds of death: the reality – or end to reality – often said to be humanity's greatest puzzle and challenge. But just as we can broaden our knowledge of flatworms beyond the nasty tapeworms so, maybe, we can take a wider view of death.

A drive to overcome death has dominated much of our behaviour for as long as we have been human. Other animals may share our hair-trigger awareness of dangers but none, it seems, has our ability or our tendency to imagine the opposite of vivacity so vividly and relentlessly. This 'tragedy of cognition', in a phrase coined by the anthropologist Scott Atran, has been part of us since, perhaps, around 500,000 years ago when the beginnings of language began to enhance our awareness of absent others. Death has always been a looming presence, a lurking, silent interlocutor behind a bewildering variety of masks, with whom we have an intermittent but unending dialogue in our heads.

Perhaps we need to entertain different thoughts about death almost as if we were replaying the evolution of the most flamboyant marine flatworms, and trying on different colours as we go. Who knows which we will find most compelling, or which colours we will be wearing when oblivion finally unmoors us? In the interim should we live as if death is nothing, or keep it constantly in mind? Can we find one attitude, or a combination of attitudes, that will be vaguely adequate in the face of reality? Will even our best shot be a kind of anasognosia, a complex form of denial with many layers to it? In a surviving fragment of *Niobe*, Aeschylus writes:

> Alone of gods, Death has no use for gifts
> Libations don't help you, nor does sacrifice
> He has no altar, and hears no hymns;
> He is not amenable to persuasion.

Even for those who consider themselves eminently rational and for whom death holds no mysteries, there are still factors beyond rational control to

'The idea of death, the fear of it, haunts the human animal like nothing else; it is the mainspring of human activity – activity designed to … overcome it by denying in some way that it is the final destiny for man.' (Ernest Becker, 1973)

Montaigne almost died after falling from his horse when he was only in his thirties. Concussed, he passed into a state where, as Sarah Bakewell describes it, 'Montaigne and life were about to part company with neither regret nor formal farewells, like two drunken guests leaving a feast too dazed to say goodbye.' On the case for stoicism in the modern world, see William B. Irvine (2009).

The three laws have been humorously restated as (1) You can't win. (2) You can't even break-even. (3) You can't get out of the game.

So daunting is the idea of entropy, suggests the physicist Vlatko Vedral (2010) with only three-quarters of his tongue in his cheek, that just thinking it through may have been enough to do in some of the most brilliant minds of the late nineteenth century such as the physicists Ludwig Boltzmann, Paul Ehrenfest and Robert Mayer and the philosopher Friedrich Nietzsche. 'A disclaimer is appropriate here,' continues Vedral; 'should the reader wish to continue reading about the second law they do so at their own risk and I am accepting no liability.'

contend with. One's own death may be fairly easy to accept, for example, but the death of a beloved (or one's greatest hope) can be almost unbearable. After the death of his daughter Tullia in childbirth, Cicero looked to the doctrine of Stoicism, which holds that one should practice indifference to things one cannot control. But he found it wholly inadequate to the emotional realities. 'It is not within our power to forget or gloss over circumstances which we believe to be evil,' he wrote. 'They tear at us, buffet us, goad us, scorch us, stifle us — and you [Stoics] tell us to forget about them?' Montaigne found his own first close brush with death relatively untroubling but was devastated by the death of his friend Etienne de la Boétie.

The second law of thermodynamics dictates that every physical system tends towards maximum disorder. Life is just a system, and even life must eventually end. Eternity does not exist. Everything will become very dark and very cold – that is, almost as bad as England in winter. Some of the least deceived minds of the late nineteenth century found this harsh truth at the heart of physical law almost too tough to accept. (In this respect, physics proved to be the opposite of something Marx had said about religion – that it was 'the heart of a heartless world'.)

Writing early in the twentieth century Bertrand Russell, a stubborn Englishman if ever there was one, advocated heroic defiance:

> . . . all the labours of the ages, all the devotion, all the inspiration, all the noonday brightness of human genius, are destined to extinction in the vast death of the solar system, and that the whole temple of Man's achievement must inevitably be buried beneath the debris of a universe in ruins – all these things, if not quite beyond dispute, are yet so nearly certain, that no philosophy which rejects them can hope to stand. Only within the scaffolding of these truths, only on the firm foundation of unyielding despair can the soul's habitation be safely built.

For Russell this foundation was enough for a life well lived. Fifty years later it still supported him as a human dynamo behind what became known as the Russell–Einstein Manifesto, which challenged the omnicidal policies embraced by the superpowers during the Cold War and stands as one of the great statements of humanism. It is a good example of asserting the value of the 'little' Earth we have actually in front of us – the Pale Blue Dot, as Carl Sagan was later to call it – rather than appealing to some invisible transcendent.

Scientific advances during Russell's lifetime have cast new light on the nature of reality such that the austerity of the Second Law is a little more bearable. For one thing, we now think the universe has vastly longer to go than people believed at the end of the nineteenth century: several billion years at the least rather than a few million. For another, advances in the biological sciences allow for ever-increasing apprecia- tion for the nature of life – not least the extraordinary conjuring trick it pulls off by drawing order from the stream of increasing disorder in the universe around it. This trick affords life astounding possibilities for a future that is, if not indefinite, at least almost unimag- inably long. As Russell himself said, in what for him was an almost mystical statement, 'the world is full of magical things patiently waiting for our wits to grow sharper.'

After an unexpected brush with death in what he had thought should have been only the middle of his life, the earth systems scientist Tyler Volk set out to understand his own mortality and the world's. His answer, in the end, is a simple one. At a material level, life cannot exist without death: recycling of organic matter in the biosphere makes it about two hundred times more productive than it would otherwise be. Our bodies, too, must become tilth. At the emotional and spiritual level, the key is acceptance. In Blake's phrase, 'He who kisses the joy as it flies, lives in eter- nity's sun rise.'

As we prepare to return to the material stuff of Darwin's 'one long argument', the process of dying can be genial, as David Hume showed in the humour

and insight he brought to his last days. And even the state of death itself can – if the writer and fanatical gardener Karel Čapek is any guide – be looked forward to with something like gusto: 'After his death the gardener does not become a butterfly, intoxicated by the perfumes of flowers, but a garden worm, tasting all the dark, nitrogenous and spicy delights of the soil.'

Whether or not one believes in life after death, it is the case that an entire Planarian flatworm can be regrown from a single cell taken from the body of an adult. Evidence enough that there are miracles in life.

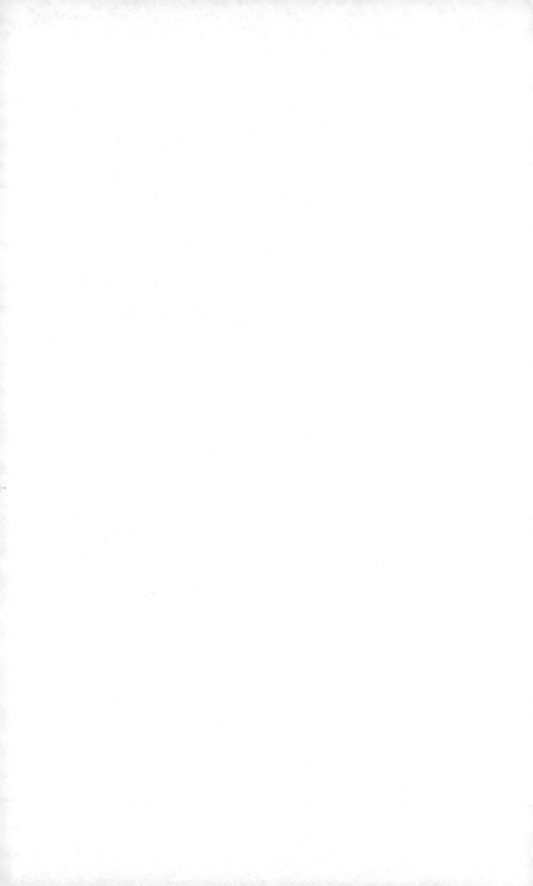

GONODACTYLUS, THE 'GENITAL FINGERED' STOMATOPOD

Gonodactylus smithii

Phylum: Arthropoda
Subphylum: Crustacea
Order: Malacostraca
Class: Stomatopoda
Conservation status: Not listed

The real voyage of discovery consists not in seeking new landscapes,
but in having new eyes.
Marcel Proust

I t has the fastest genitals in the West and will use
them to smash your head with massive force.
The shock wave that follows the initial punch
will tear your innards to shreds. Fortunately for
humans, *Gonodactylus smithii* – a stomatopod, or
mantis shrimp – is about the size of a gherkin, and its
prey are mostly small snails, crabs and oysters. Still, it
could break a bone in your finger or arm if you got
too close to one of the nooks on the tropical seabed
where it lives, and a wise diver will keep his distance
from this fan-tailed crustacean when it dances across
the seabed in a flowing, agile motion.

Gonadactlyus means 'gonad digits'. But the forward
protuberances that give this beast its name are not
genitals but club-like limbs. Their appearance when
folded up tight to the animal's body may have amused
the mischievous biologist who named it, but they are
no joke. The strike these raptorial appendages deliver,
as they accelerate in a fraction of a second to nearly
the speed of a bullet, is probably the fastest of any
animal and, coming to as much as 1,500 newtons
(1,500 kg per second per second) of force, may be the
greatest of any animal in proportion to its mass. The
strike is powered by a 'spring' at the base of the limb
formed like a hyperbolic parabaloid – that is, saddle-
shaped – which human architects and engineers also
exploit for its great strength under compression. The

THE BOOK OF BARELY IMAGINED BEINGS

movement of the limb is so fast that it creates a partial vacuum in the water behind it – an effect known as cavitation – which acts like a second blow when this too strikes the victim.

Gonodactylus, the perfect killing machine, is one of about 400 living species of stomatopod that are divided, broadly, into two kinds: the smashers, which, like *Gonodactylus*, club their victims to death, and the spearers, which impale them on sharp barbed points on their front limbs. Although there has been variation, stomatopods have thrived with little change in their essential design for more than four hundred million years. But the success of this creature depends on something even more extraordinary than its formidable appendages. *Gonodactylus* has what are by some measures the most complex and sophisticated eyes in the animal kingdom.

Each of this animal's eyes, which is mounted on an independently moveable stalk, is made up of about 10,000 ommatidia (eye units). This is only about a third of the number found in some dragonflies, which have excellent vision, but stomatopods do more with the ones they have, and are extraordinary in at least three ways. Firstly, they have super-fine colour-discrimination. Most animals with colour vision typically have two to four different kinds of receptors (humans, by and large, have three; a minority of women have four); stomatopods have eight to twelve, enabling them to see subtler changes in colour shades than any other animal on the reef. Secondly, each compound eye is divided into three regions, each of which contributes to a composite view from a slightly different plane. It's almost as if each whole eye were made of multiple sets of 'trinoculars', thereby rendering the view with the greatest conceivable precision as to depth and distance. Thirdly, a stomatopod's eyes are able to see circularly polarized light, an ability unknown in any other animal. And this ability – which was only discovered in 2008, and is not known to exist in any other animal – is analogous to the improvement afforded by stereo over mono vision in terms of information capacity. This, as the zoologist P. Z. Myers notes, is powerful stuff – mantis shrimps

Typically, sunlight is scattered but in certain conditions it is polarized in a plane. (Think of a piece of string attached at one end to a wall and waved up and down but not side to side: this is linear polarization.) As light passes through otherwise transparent materials, such as a transparent animal swimming through the ocean, it can become polarized. This is a useful property to take advantage of if you are hunting for small, nearly transparent animals to eat, and numerous animals can discriminate light polarized in this way. Circular polarization, in which light propagates in a helix, also occurs, and evidently the stomatopod has adapted to take advantage of this. *Gonodactylus* has specialized ommatida (eye units) packed with light-sensitive cells called rhabdoms arranged in groups of eight. Seven sit in a cylinder and each of these has a tiny slit through which polarized light can pass if it is vibrating in the right plane. The eighth cell sits on top with its slit angled at 45 degrees to the seven below it, and converts the circularly polarized light into a kind that the animal can then see.

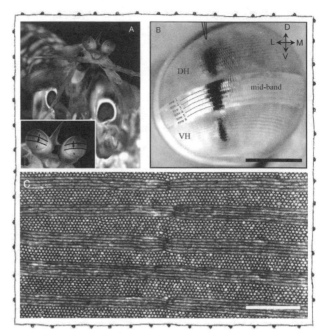

Gonodactylus has stalked apposition compound eyes divided into dorsal and ventral hemispheres by a mid-band of enlarged and structurally specialised ommatidia (marked out by curved dark lines in the inset). C shows an electron micrograph of a longitudinal section through a mid-band row. The white scale bar is 1 micrometre (a thousandth of a millimetre).

moving through a visual world rich with details beyond our imagination, able to detect qualities of light outside our experience.

In the hyper-competitive, dangerous world in which it lives, a stomatopod's eyes are its greatest weapon, enabling it to identify, track and strike with speed, accuracy and precision. But stomatopods are more than diminutive marine Grendels that use their amazing vision simply to detect, smash and dismember prey on which to gorge themselves. They also use their eyes to guide them in their social lives which, like those of humans, are often dominated by territorial displays, ritualized fights and the delicate arts of courtship and love-making. Stomatopods signal mood, intention and – perhaps – much else with subtle changes in posture, as well as their impressive markings, which in many

THE BOOK OF BARELY IMAGINED BEINGS

species include a pair of meral spots that can look like giant eyes.

Do the powers of perception and the complex behaviour of these (and other arthropods) indicate intelligence? The very suggestion may strike some people as odd, even repellant. We can just about accept the idea of an intelligent cephalopod, as so many people did, albeit jokingly in the case of Paul the octopus, who enjoyed fame for his supposed psychic powers during the 2010 Football World Cup; we do seem to be relatively at ease with imagining a kindred presence behind eyes that remind us of human ones (see Chapter 15). But a thinking *arthropod* is too bizarre for many people. Its compound eyes seem just too alien, machine-like and anyway its brain and ganglia look far too small for such a task. But the fact is that stomatopods are remarkably cunning creatures.

Light travels faster than anything else we know of, but neither light nor life are ever in a hurry. 'The Sun', wrote Galileo, 'with all those planets revolving around it and dependent upon it, can still ripen a bunch of grapes as if it had nothing else in the universe to do.' And for at least 2.5 billion years (and perhaps well over three billion), sunlight has driven a green fuse on Earth. Bacteria, then algae and later plants learned to capture energy from sunlight and make sugars from carbon dioxide. In doing so they released oxygen and, over time, transformed sea, land and sky. Many early life forms were able to tell the direction from which the light came, and in some cases its intensity and wavelength, but for around four-fifths of life's history on Earth the world has been blind. The first eyespots – tiny patches of photosensitive proteins that generate an electrochemical signal – may have evolved less than 600 million years ago.

Eyespots do not, of course, provide an animal with energy but they do help their owner – in the early days most likely a single-celled organism – follow circadian rhythms, locate lighter (or darker) places where prey (or predators) are more likely to be found, or find a better place to soak up the sun. And such adaptations, modest as they may seem, can deliver substantial benefits over having no eyespots at all. Still, the differences between an eyespot that merely senses light and a fully formed

Reflecting on the mental faculties of Man and other animals, Charles Darwin (1870) marvelled at the cerebral ganglia ('brains') of ants, which share many features with those of stomatopods: 'It is certain that there may be extraordinary mental activity with an extremely small absolute mass of nervous matter: thus the wonderful diversified instincts, mental powers, and affections of ants are notorious, yet their cerebral ganglia are not yet so large as the quarter of a small pin's head. Under this point of view, the brain of an ant is one of the most marvellous atoms of matter in the world, perhaps more so than the brain of man.'

eye which creates sharp images are considerable, and many people still find it incredible that the latter could have evolved from the former without the intervention of a designer. The evidence, however, overwhelmingly supports an explanation in which tiny changes from generation to generation which incrementally improve the capacity to gather information about the outside world (for example, greater precision in detecting the direction from which light is coming) benefit an organism, and are therefore likely to be selected in many circumstances. There need be no end-point of a fully developed eye, with variable focus lens, 'in mind.' Fully functioning eyes could have evolved from the simplest light-sensitive patches in as few as 400,000 generations – or less than half a million years – in early organisms.

The smallest eyes on Earth belong to the dinoflagellate *Erythropsidium,* which is only 50–70 μm across – less than the width of a human hair.

It is likely that the first simple eyespots belonged to dinoflagellates similar to those alive today such as *Euglena gracilis,* an algal flagellate that uses them to detect and swim towards the light, where it can photosynthesize. Where light levels are lower, it survives by eating like an animal does.

Precisely how and when eyes developed in multicellular animals and what those animals were like is less sure. (A fairly wild idea, suggested by the biologist and co-originator of Gaia theory Lynn Margulis, is that a metazoan in the early Cambrian or shortly before ate a dinoflagellate with eye spots and incorporated them into its own body!) What is certain is that behind the enormous diversity of eyes in animals today there is a common genetic inheritance: a gene governing eye development in a mouse, Pax6, can be transferred into a fruit-fly embryo and direct the embryo to produce a fly's eye at the point of insertion.

The origin of Pax genes predates the origin of eyes and even the nervous system; very similar genes have been identified in sponges.

The oldest eyes able to form images of which fossil evidence has been found date to about 543 million years ago. They were compound eyes like those of many modern insects and crustaceans, and they belonged to trilobites – a class of arthropods that looked something like horseshoe crabs or giant woodlice. The lenses – made of calcite crystals and essentially the same material as the animal's exoskeleton, only transparent – were rigid, and thus unable to pull focus as do the soft lenses in the eyes of humans or octopuses. But they

THE BOOK OF BARELY IMAGINED BEINGS

provided good depth of field, so that images of objects were sharp over a range of distances.

Many creatures in the Cambrian were voracious, and the advantages of having sophisticated eyes – the better to see your prey or your pursuer – were considerable. Only six out of thirty-six phyla evolved image-forming eyes, but species in those phyla – the arthropods (crustaceans, insects, spiders), cnidaria (specifically, some jellyfish), molluscs (snails, octopuses and others), annelids (such as ragworms), onychophora (velvet worms) and chordates (hagfish to humans) – have been key players in most ecosystems ever since, and have constituted the great majority of the animal species that have ever lived.

There may be nothing alive today quite as strange as *Opabinia*, a Cambrian animal that had five eyes on stalks, not to mention a proboscis equipped with scissor-like teeth, but the marvels that exist today are almost endless and no less worthy of contemplation. Take cnidaria, the phylum which include corals and jellyfish. Radially symmetrical, lacking brains as we typically define them and possessing only one orifice that doubles as anus and mouth, they seem like implausible candidates for eyes. But even coral polyps have some, albeit very limited, powers of visual perception. Eyespots allow them to track the moon and when the moon is full and the water temperature is right, they erupt in an 'upside-down snowstorm' of semen and eggs. When this happens on Australia's Great Barrier, usually once a year, it must be the world's greatest orgy. And there is at least one class of cnidaria, the Box jellyfish, that includes species with well-developed eyes. *Chironex fleckeri* has eight, with sophisticated lenses, retinas, irises and corneas. It also has eight slit-type eyes and eight simple eyespots, showing thereby three stages of eye evolution in one body. The three different kinds of visual organ are distributed evenly around the crown so that the animal has a 360-degree view. We humans use as much as a third of our highly developed cortex to make sense of the input from just two eyes. *Chironex* and other Box jellies – which have what scientists used to think was a simple neural net but are now beginning to appreciate is a set of neuronal condensations arranged in a complex

architecture – somehow manage to process information from eight, or twenty-four if you include the slit eyes and eyspots. What they make of what they see is as hard to imagine as a Zen koan. But they do perform complex things by jellyfish standards such as navigate their way back to the mangrove roots under which they shelter, not to mention swim after prey (rather than just wait to bump into it) and couple in ways that would make fans of the *Kama Sutra* blush.

Eyes are common among molluscs. Gastropods (the slugs and snails which are by far the largest class of molluscs) span the ophthalmological gamut from eyespots to fully formed eyes. An ordinary garden snail has tiny, beady eyes, lenses and all, mounted on the ends of the longer two of its four stalks. To protect the eyes, the snail pulls them up inside its tentacles rather as one might withdraw a hand inside a sleeve. Giant clams, which are bivalves, the second most abundant class of mollusc, weigh hundreds or thousands of times as much as most snails but, cemented to the seabed, they make do with several hundred simple, lensless 'pinhole' eyes dotted along the edge of their mantles. It can be disconcerting to look down into these eyes while swimming above the clam's open 'jaws', lined with what look like flouncy labia in brilliant blue and purple.

The most sophisticated molluscan eyes are those of some modern cephalopods (octopuses, squid and cuttlefish). Early animals in this class probably had simple 'pinhole' eyes like the ones Nautiluses still have today (see Chapter 14). But many living cephalopods, especially octopuses, have eyes uncannily like our own (or at least superficially so: there are important underlying differences, and in some respects cephalopod eyes are superior; they can, for example, read patterns of polarized light that are invisible to us). These enable them to engage in advanced signalling, deception and play (see Chapter 15). And the largest eyes to have existed (matched only by a prehistoric giant sea lizard called Ophthalmosaurus) belong to a cephalopod: those of the Colossal squid are larger than footballs.

No arthropod has eyes as big as those of the largest cephalopods. But this phylum, which includes insects, spiders and crustaceans, has evolved every known kind,

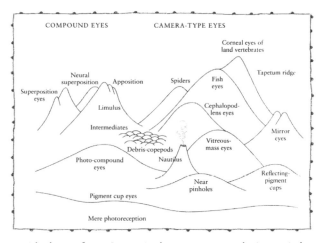

A landscape of eyes. Once a visual system starts to evolve in a particular direction – towards, say, the compound form or the simple 'camera' type – it tends to remain committed to that particular direction, represented here by a mountain which becomes the only one it can climb.

ranging from simple photosensitive spots in deep-sea shrimp (which are actually a reversion from a more complex organ), to single-lens/single-chamber 'camera-type' eyes in spiders, to a huge array of variations on the compound eyes we're familiar with in flies. Insect and spider eyes are remarkable enough (and worth a whole chapter in themselves; Chapter 13 has just a little on those of spiders) but the diversity and ingenuity of crustacean eyes is especially breathtaking. I especially like the stalked 'periscope' eyes of the Fiddler crab, which give it a panoramic view all the better to appreciate the outrageously pumped up left claws of its waving fellows. Another favourite are the double pairs of compound eyes of the small but sinister Pram bug, which allow it to scan for prey and danger at the same time. The eyes of stomatopods may be unrivalled in their complexity and sophistication but those of some other crustaceans rival them for elegance and ingenuity.

Vertebrates are limited to two eyes each, but the variations they have played on this plain vanilla starting point are an object lesson in how much can be made from a little. Some of the most stunning excursions occur in the dark deep of the ocean. The Brownsnout spookfish, which is usually found more than a 1,000

'There is much graduated diversity in the eyes of living crustaceans' (Charles Darwin, 1859)

The Fiddler crab's outsize claw demonstrates the fitness of the individual, making it an attractive mate, while the stalk eyes are an adaptation that help it to see far. But in at least one other arthropod, the Stalk-eyed fly, it is the sheer length of the stalks themselves, which can be longer than the animal's body, which make the male attractive to females.

metres down beneath tropical-to-temperate waters, looks as if it has four eyes, but there are really just two that are each split into two parts, as if by grotesquely exaggerated bifocal spectacles, with one part looking upward and the other downward. (The interior of its eyes contain mirrors that focus the light onto the retinas, the only known case of an animal that uses mirrors instead of lenses to do so.) The Loosejaw dragonfish sends beams of red light out from special organs known as photophores just below its eyes. The dragonfish has evolved to be able to see red, which most other creatures in the deep cannot (most bioluminescence is blue or green); in effect, it has short-range night vision – living headlights undetectable to its prey. And there is an even stranger creature that brings me close to doubting my hold on reality altogether: the 'barrel-eye' fish *Macropinna microstoma* houses its two tubular eyes capped by bright green lenses inside a transparent, fluid-filled bubble that occupies most of the upward part of the front of its body. The lenses sit there like two cushions on the seats in a helicopter cabin awaiting the posteriors of a pilot and navigator.

Above the waves, the most remarkable eyes surely belong to birds. Some hawks and eagles that hunt by day have around a million cones per square millimetre in the retinal fovea, the sweet spot where vision is most acute. This is more than five times as many as humans. Even more astoundingly, some migratory birds may be able to register quantum effects with photosensitive proteins in their eyes, enabling them to see Earth's magnetic field.

For those of us humans who are sighted, nothing is more immediately a part of our experience of life than vision: we do not (or so it seems to us) need to *think*, we simply *see*. In everyday speech, seeing and understanding are synonymous. (Sanskrit *véda*, which means knowledge or wisdom, and Latin *videre*, which means to see, have the same root. In German, a profound insight is a *Scharfblick*: a 'sharp look.') Optical studies in ancient China and Greece, the Islamic golden age and Renaissance Europe seemed to confirm this direct connection when they showed that the human eye resembles what came to be known as the *camera obscura*,

a device which projects, via a small hole in an opaque barrier, an exact likeness of the world onto its screen (in the case of an eye, the pupil and the retina respectively). The eye, it seemed, was a mechanism that, without mediation or interruption, revealed the world.

A moment's thought, however, shows that the analogy with a camera is inadequate. What (or who) is looking at the images projected on the 'screens' at the back of our eyeballs, and how? If it (he or she) has eyes then is there someone or something else at the back of *those* eyes looking at the images inside them, and so on ad infinitum? Clearly, there is more to it than this. For centuries it was unclear what, and only in recent decades has neuroscience really begun to get to grips with the stupendously complex processes behind the construction of vision in the brain – processes that are far too great to be accessed in conscious experience while we are seeing. As the German mystic Meister Eckhart said in the thirteenth century, 'we cannot see the visible except with the invisible.'

Even without technologies such as functional magnetic resonance imaging, which are beginning to show us fundamental processes in the brain, we can still become more aware of aspects of vision that are easy to miss in the normal run of life. Our eyes (when healthy) seem to give us such a whole and perfect view of the world, but a simple experiment described by the writer Simon Ings shows that this is not the case. If you hold your thumb vertically at arm's length in front of your face it fills about two degrees of your visual field. And you will find, if you look carefully, that your eyes only bring an area slightly narrower than this into perfect focus. Keeping your gaze fixed on that central point, you will find that one degree away from your centre of vision – barely the distance to the edge of your thumb – your visual acuity (that is, the ability to distinguish fine detail) is halved. At five degrees it is quartered. Beyond a five-degree radius (if you keep focusing on the middle of your thumb) you will not be quite sure what you are seeing. And at twenty degrees off-centre your visual acuity is the same as that of someone who is legally blind. Without being aware of it you have, essentially, tunnel vision.

You make up for this by moving your eyes almost continuously. Ings brings this reality to our attention in a comparison between his own perception of a statue as a sighted person and that of Helen Keller, who was blind and deaf:

> You might say that from where I stand, I see the whole sculpture in one go – a single glance – whilst Keller senses the object only where it touches her skin. But you could just as easily reverse the emphasis, and point out that Keller can curl her fingers around the object whereas, to perceive it from different angles, I have to move my body.
>
> And while I might like to think that I can take in an object 'at a glance', in reality my eyes are never still. Every third of a second, they jolt or 'saccade', moving my gaze from one part of the object to another. My 'single glance' is a multitude of little fixations, not unlike the twitching of an insect's antennae, or a mouse's whiskers – or Keller's busy fingers, come to that.

During the time that our eyes saccade, which can be up to a fifth of second, and for up to a tenth of a second after they stop, the brain does not process information coming from them. Since our eyes make tens of thousands of saccades in a normal day, that means we are effectively blind for a significant part of the time, but the brain fills in the gaps with inference and we are usually quite unaware of it. Looking at a stomatopod, which rapidly swivels and repositions its eyes so conspicuously, gives us an exaggerated image of what we ourselves do, and throws into relief some of the extraordinary and intricate mechanisms on which our own vision is based.

Just as, in everyday life, we give no thought to constant movements of the eyes within their sockets so we are also perfectly used to perceiving objects such as trees or buildings as stationary while we move past them. And yet, as the neuropsychologist Chris Frith points out, this too is a phenomenon constructed in our brain. You can easily disrupt it in a way that every child probably knows but most adults have probably forgotten: close one eye and, while staring at a sta-

Lawton (2011) notes: 'Exactly how your brain weaves such fragmentary information into the smooth technicolour movie that we experience as reality remains a mystery. One idea is that it makes a prediction and then uses the foveal "spotlight" to verify it. We create something internally and then we check, check, check. Essentially we experience the brain's best guess about what is happening now.'

In addition to the saccades described, the human eye is constantly vibrating in tiny oscillations called micro-saccades at a rate of 30–70 Hz. These movements, roughly one five-thousandth of a degree, refresh the image being cast onto the rod cells and cone cells at the back of the eye. Without them, staring fixedly at something would quickly cause the vision to cease because rods and cones only respond to changes in luminance.

THE BOOK OF BARELY IMAGINED BEINGS

tionary object with the other, push very gently upwards on the fold of skin just below the open eye. It will seem as if the world is moving downwards even though you know perfectly well that it is not.

These, and other examples, point to some essential facts about vision. One is that, as Ings puts it, 'the eye is not a lonely miracle' but one of a suite of senses and organs for perceiving the world. Another is that our perception as a whole is not of the world but of the brain's model of the world. It is a model which (while we're awake) the brain is constantly adjusting in a loop of predicting and updating in the light of new information of which we are largely unaware. As Chris Frith explains, 'the brain embeds us in the world and then hides us.'

How does the brain do this? Part of the answer is that some characteristics, including certain ways of seeing, having been naturally selected, are inherent in us as we develop. It is thanks to these characteristics that a baby born into a cacophony of sensations is able to make sense of them within a fairly short time. Our visual system, for example, is – like that of all animals – largely organized to detect change and motion. One of the things that helps is that the eye necessarily pays particular attention to and even exaggerates the edges to objects. Infants are also well prepared, with 'mirror neurons' and specially dedicated areas of the brain, to respond to eyes and faces, which are of course among the first things they see, and to look for 'agents' – animate beings – in the world around them. By four months of age, for example, they prefer to look at spots of light that form a moving figure rather than at spots moving in the same way but randomly placed in relation to one another.

As children and as young adults we never stop learning to see. And ordinary people can develop exceptional powers of vision when the circumstances are right. Children of the Moken tribe, who live on islands in the Andaman Sea, learn to constrict the pupils of their eyes deliberately when underwater in order to sharpen the image that is otherwise blurred because of water pressure on the eyeball. In an experiment this skill was taught to children from Sweden who had no experience of diving. Before the modern industrial era, Western

Another disruption in which people directly experience some of the mechanisms underlying vision are hallucinations caused by migraine and some other patholo-gies. Oliver Sacks (2008) writes: 'Hallucinations reflect the minute anatomical organiza-tion, the cytoarchitecture, of the primary visual cortex, including its columnar structure — and the ways in which the activity of millions of nerve cells organizes itself to produce complex and ever-changing patterns. We can actually see, through such hallucinations, something of the dynamics of a large population of living nerve cells and, in particular, the role of what mathematicians term deterministic chaos in allowing complex patterns of activity to emerge throughout the visual cortex. This activity operates at a basic cellular level, far beneath the level of personal experience. They are archetypes, in a way, universals of human experience.'

A contemporary
nineteenth-century
account claims: 'As to
[Kaspar's] sight, there
existed for him, no
twilight, no night, no
darkness ... At night
he stepped every-
where with the
greatest confidence;
and in dark places, he
always refused a light
when it was offered
to him. He often
looked with astonish-
ment, or laughed, at
persons who, in dark
places ... sought
safety in groping
their way, or in laying
hold on adjacent
objects. In twilight,
he saw much better
than in broad day-
light. Thus, after
sunset, he once read
the number of a
house at a distance of
one hundred and
eighty paces, which,
in daylight, he would
not have been able to
distinguish so far off.
Towards the close of
twilight, he once
pointed out to his
instructor a gnat that
was hanging in a very
distant spider's web.'

sailors on the high seas were able to make out the planet
Venus in full daylight, and this ability is said to persist
among some people who live far from cities today. And
an enduring ability to see well in dim light following
incarceration in darkness – attributed to Edmond
Dantès, Count of Monte Cristo – is not merely a matter
of fiction: Kaspar Hauser, who had been confined for
fifteen years to a dim cellar, had it too.

Eyes are not the only things with which we see.
They are also things by which we are seen. This is true
of other animals as well: and some fish, caterpillars,
moths and other creatures take advantage of it by
evolving large fake eyespots on their bodies to scare
away potential predators. Primates signal submission
by lowering their eyes (something that humans still
do). But humans have evolved a characteristic that
allows us to be especially sensitive to the eye movements
of others. The whites, or sclera, of our eyes are much
larger and more conspicuous than those of any other
mammal, including all of the more than 200 other
species of primates. As a result, we can detect very
small changes in the direction of another human's eyes
from some distance away by registering fractional dif-
ferences in the position of the irises within the whites
and so tell with remarkable accuracy where the person
is looking. In this way, we communicate important
information without speaking and often reveal infor-
mation about our mental state without realizing it.

Shortly after my seventeenth birthday I spent part
of the summer hiking with a group in the far north of
Norway. Mostly it rained, except when it drizzled.
One evening on the long journey back south we
camped next to a lake beneath some sizeable moun-
tains. The weather was mild and I headed off into
the indefinite light for a few hours on my own. I
squelched across unpathed bog towards a distant
ridge and, on reaching its base, began to scramble up
until I could find no way to continue. Contouring to
the side I stumbled onto a patch of level ground
where wildflowers glowed against the black-grey
stone. It occurred to me that no one else had ever
seen or ever would see these particular flowers, or
experience the specific surprise and joy I felt at seeing

them at that moment. The flowers would of course have existed if I had never come, but for a few moments my reality was joined to theirs. Was their beauty, hitherto seen only by insects, birds and other animals, made more real by my presence? Was I made more real by their beauty? Turning back to camp I decided to go the long way around the lake. Arriving at the shore, I came to a grove of birch trees on a promontory above the water. The trees seemed tall after a season further north where little grows higher than your knee; big enough, at any rate, to look up into. And as I did so the sun broke through the clouds. Brilliant light burst across the lake and lapped on their bark and leaves in flakes and dapples of gold. Looking, listening, breathing, I felt transformed as if I were resonating with all life. A line from Heraclitus that I read later describes the experience well: 'It ever was, and is, and shall be, ever living fire, in measures being kindled and in measures going out.'

According to Arthur Schopenhauer, the hopes of youth are invariably met with an ugly, painful, boring and disappointing reality, and the only sensible response is disengagement. Others have looked for hope to a God or gods that are somehow outside nature and humanity. I don't go with either view, but I did gain from my experience by that Norwegian lake a stronger sense of the nature of vision, attention and presence. 'Thought', wrote D. I I. Lawrence, 'is a man in his wholeness, wholly attending.'

The astrophysicist Jocelyn Bell Burnell is fond of pointing out that, as humans, we are all 'electromagnetically challenged': only a tiny part of the spectrum of electromagnetic waves is available to our senses. Now, of course, our civilization uses thousands of devices to enhance our vision. We can see everything from a molecule to a galaxy that came into being not long after the beginning of the known universe. In that sense, nothing surpasses us: we are a technological stomatopod, equipped with formidable 'extra' eyes. Borges' *Book of Imaginary Beings* recalls Ezekiel's vision of Haniel, Kafziel, Azriel and Aniel: beasts or angels (the prophet cannot tell which) which are 'full of eyes round about them ... before and behind them'. So it is with us.

We continue a project begun by early creators of optical instruments, many of whom shared Robert Hooke's belief that the microscope and the telescope were stepping-stones on a path to the recovery of the perfect senses that humanity had supposedly lost after the expulsion from Paradise. But where are we actually going? A lobster's eyes have, it's claimed, recently inspired the design of an X-ray detector for an astronomical telescope, while the stomatopod's ability to detect circularly polarized light may inspire a new generation of data-storage devices. Such advances may prove wonderful, but where will they lead? What will be the inner vision without which all this is blindsight? So long as we remain human we still see with eyes that were shaped by tens of millions of years looking for ripe fruit in the forest. Let us not forget what sight can be when it is not mediated by machines. As the poet Bashō wrote:

My eyes following
until the bird was lost at sea
found a small island

HUMAN

Phylum: Chordata
Class: Mammals
Order: Primates
Family: Hominidae
Genus: Homo
Conservation status: Not listed

> For the story of Orpheus is of the truth.
> Christopher Smart

Arachne, Daphne, Acteon and Adonis.

In Ovid's *Metamorphoses*, women are changed into spiders and laurel trees, men into stags and anemones. But you only have to look at your feet to see a transformation almost as strange. Where most primates have a respectable pair of grasping rear hands we have two changelings: long arched pads with rounded chins at one end and stumpy thumbs straight-jacketed to baby fingers at the other.

Human hands are among the most wonderful parts of the body: sensitive, flexible and supremely *able*. They can build whole worlds – even if, as is the case with the character Linus in the cartoon *Peanuts*, they have jelly on them.

Observing possums – marsupials which last shared a common ancestor with primates more than 50 million years ago – the zoologist Jonathan Kingdon speculates that fine manipulative skills may have emerged very early in the mammalian line. He writes:

> when I watched possums expertly finger-drumming bark to locate larval burrows or manoeuvring witchetty grubs out of holes and into mouths, I suspect that I was witness to some of the most ancient skills that distinguish not just possums but, maybe, archaic mammals as a whole. Touching, gauging, gouging, probing hands and fingers are so closely coordinated with smelling, seeing, hearing, and tast-

THE BOOK OF BARELY IMAGINED BEINGS

ing that their refinements have as much to do with serving senses and feeding appetites as with clambering through branches. If, as most evolutionary biologists would contend, human anatomical history is made up of successive increments, perhaps we need look no further than our hands to discover a legacy that could stretch back 140 million years.

But feet? Feet resemble hands that have been squeezed and warped by the cruel binder of evolution into 'plates of meat' (as Cockney rhyming slang has it). Unlike those of our ape relatives, they're quite incapable of getting a decent grip on a branch and good for nothing much, it seems, except stomping around on. (This is not just a result of being horned into shoes: the feet of someone who has lived without shoes are tough and calloused but for all that look surprisingly like those of someone who has worn shoes all his or her life.)

But take a different line of approach and human feet start to look like a marvel. The comedian Billy Connolly once said that Scotland's contribution to world history was staggering. Well, it is feet, Scottish or otherwise, that make staggering possible. And even without the aid of whisky, humans can perform some of the most delightful dances on them of any biped except perhaps the Blue-footed Booby (a frabjous bird that lives on the Galapagos Islands). Our feet – along with the other adaptations that make us at ease on two legs – enable us to walk enormous distances without strain and, in the right conditions, outpace even the fleetest quadrupeds. No other ape or monkey comes close. For our nearest cousins, chimpanzees and gorillas, walking a few paces on two feet takes as much effort as it does for us to run around on all fours.

Is it absurd to say that going around on two feet is what makes humans unique? According to an often-told story, the ancient Greek cynic Diogenes certainly thought so. When Plato defined man as a 'featherless biped', Diogenes presented him with a plucked chicken and said, 'Here is your "Man".' Plato hastily amended his definition to 'featherless biped with broad nails'. It's easy to imagine Diogenes laughing at that too, but add one more qualifier to Plato's definition – an erect

Human legs are much stronger than their arms but a few have taken arm strength to astonishing degrees. In 1900 an Austrian named Johann Hurlinger, who presumably had nothing better to do, walked 870 miles from Paris to Vienna entirely on his hands. It took him 55 days, travelling ten hours a day. But Hurlinger's amazing, and daft, achievement only underlines how bipedal we really are. A walker with reasonable fitness would be able to cover twice the distance in the same time, while a strong runner would be more than five times as fast.

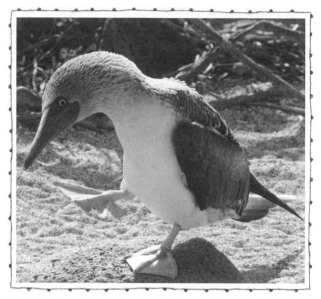

A Blue-Footed Booby dancing. Like those of the Jumblies, the bird's feet are blue – or more precisely azure.

back – and it starts to look almost sensible. Idealized as Leonardo's Vitruvian man – straight-backed with limbs spread across square and circle, his legs exactly half his total height, and two paces equal to that height – upright man is Hamlet's 'paragon of animals', a comparator against which other worldly beings have often been portrayed as comic or sinister distortions.

The debate as to what distinguishes humans from other animals dates back at least two and a half thousand years. Some religious traditions speak of an invisible essence in every individual: a human soul. But there has also been no shortage of attempts to define us by externally observable traits and behaviours. Man is, variously, a political animal (Aristotle); a laughing animal (Thomas Willis); a tool-making animal (Benjamin Franklin); a religious animal (Edmund Burke); and a cooking animal (James Boswell, anticipating Claude Lévi-Strauss and Richard Wrangham). Man has also, at one time or another, been defined as an animal which is able to reason and form opinions, an animal which carries a stick, a philosophical animal,

a deceiving animal, a story-telling animal and the only animal that likes hot chili sauce. Humans, observes the poet Brian Christian, appear to be the only animals anxious about what makes them unique.

Research in recent decades has shown that many behaviours and capabilities once thought to be unique to humans – tool-use, theory of mind, culture, morality, personality – are present to at least some degree in other species. We do, however, continue to claim such things as art, religion, cooking, sport and – arguably – humour as uniquely ours. (These, incidentally, make a good starter list of the things that people care most about – apart from sex and affection, which animals also crave.) There may also be mileage in defining us by negatives. The cognitive neuroscientist Michael Gazzaniga, for example, claims that 'much of what makes us human is not an ability to do more things, but an ability to inhibit automatic responses in favor of reasoned ones . . . we may be the only species that engages in delayed gratification and impulse control'.

Which brings us to what is often said to be the most obvious thing that make us unique: a big, complex brain and, arising from it, language. But, this chapter will argue, our big brains wouldn't exist without our big feet. And language wouldn't exist without one of our profoundest, most enigmatic and (perhaps) oldest of art forms – music. In answer to the question posed above, going around on two feet is not what makes us human, but unless our ancestors had started to do so, we would never have become human.

As bipeds go, humans are very much the new kids on the block. The world's first terrestrial two-leggers were probably proto-dinosaurs that evolved about 230 million years ago. One of the earliest known has been given the wonderful name *Eoraptor lunesis* – the Dawn Hunter from the Valley of the Moon. (It was an early predator, and its fossils were discovered in a valley in Argentina named for the Moon.) For about 165 million years afterwards little got in the way of the descendants of *Eoraptor* and other dinosaurs, until a brick wall otherwise known as the Cretacious–Tertiary extinction event. Ever since, bipedalism has been a minority pursuit among reptiles. One of the very few lizards that does it

today is the Plumed basilisk, a real animal from Central America that shares a crown-like crest with its mythological namesake. Moving like a super-charged Charlie Chaplin, the basilisk can run for quite some distance on two feet on the surface of a lake or river, with the consequence that it's known locally as the Jesus Christ lizard. But even the basilisk prefers a quiet life on all fours.

Birds, which are of course direct descendants of dinosaurs, walk on two feet. But for the great majority of them, it is just one of the ways they get around. Flightless birds that have thrived often have other unusual abilities. Penguins, for example, are superb swimmers. Away from the ocean, birds such as ostriches have evolved exceptional size and ground speed, but only exist today on sufferance from humans. The great majority of other flightless birds have gone the way of the Dodo. The most successful survivor today is the chicken (the closest living relative, as it happens, of *Tyrannosaurus rex*). There are upwards of twenty-four billion of them on the planet at any one time but they thrive only because they have been enslaved and engineered by humans.

Few mammals are exclusively bipedal, and those that are – such as the Kangaroo mouse of North America and the true kangaroos and wallabies of Australasia (a group of animals known, gratifyingly, as *macropods*, which means 'big feet') – have a very different way of walking from us. In what is known technically as bipedal ricochet gait, they deploy both legs simultaneously as giant springs: a kangaroo is a marsupial pogo stick. Bears, monkeys, apes and a few other animals can walk on two legs, but they tend to do so only for short distances and with a limited range of movement.

Just when and why our progenitors started walking around on two legs most of the time is not known. Footprints preserved in fossilized mud at Laetoli in Tanzania show that about 3.7 million years ago Australopithecines of the species known as 'Lucy' were walking, upright, on feet quite like ours and in a way quite like ours. For all that, the differences between 'Lucy' and ourselves are striking. She had longer arms and shorter legs than we do in proportion to her size (adults were slim, and about 1.3 metres, or

Plato never met a kangaroo. But one of the finest minds of the eighteenth century took to them immediately. In 1773 Samuel Johnson amazed his hosts in Inverness, and strengthened the eternal bonds of amity between the English and Scottish peoples, by his impersonation of this animal, first seen by Europeans three years earlier. James Boswell wrote: 'The company stared . . . nothing could be more ludicrous than the appearance of a tall, heavy, grave-looking man, like Dr Johnson, standing up to mimic the shape and motions of a kangaroo. He stood erect, put out his hands like feelers, and, gathering up the tails of his huge brown coat so as to resemble the pouch of the animal, made two or three vigorous bounds across the room.'

four foot, tall) and, of course, a much smaller skull, containing a brain about a third the size of that of a modern human. Watching 'Lucy' walk – with her short legs, long arms, and head and face at least as reminiscent of chimpanzees as humans, yet moving with such a human-like gait quite unlike the waddle of a chimp – would be fascinating, perhaps uncanny.

'Lucy' may have been adapted both for living in the trees and travelling some distance on the ground, and this versatility would have enabled her species to persist for almost a million years even as climates and environments changed. But another hominin – and the first member of our genus – appears to have been adapted to living full-time on the ground: *Homo habilis* first turns up in the fossil record about 2.3 million years ago and thrived for about 900,000 years. *Habilis* means 'handy', a name given to the species after the first discovery of fossils in the 1960s: it was thought they had been the first species to make stone tools. Certainly, *habilis* was a dextrous tool-maker. He also differed from 'Lucy' in having longer legs and narrower hips. These, and other anatomical innovations, would have made walking and running less effortful and more efficient (although not efficient enough to prevent *habilis* from often being lunch for the sabre-toothed cat *Dinofelis*). And these differences were further accentuated in the larger brained *Homo ergaster* and successor species such as *erectus* and *heidelbergensis*, whose limbs and trunk were proportioned very like those of modern humans.

Early humans liked to eat meat. The protein and energy it provided helped feed their growing bodies and large brains. But meat has a habit of running away from you when it's alive or being eaten by somebody larger and more powerful than you when it's already dead. So what to do? According to the endurance-running hypothesis, early humans evolved a new way to compete on the African savannah: the ability to run long distances, often in the hot sun. In this way, cooperating in small groups, humans could either chase quadrupeds to exhaustion or get quickly to the carcasses of fresh kills left by other animals retiring to the shade in the heat of the day. For many

Habilis tools, usually referred to as Oldowan technology, were typically large stones that were chipped to create a sharp edge. The first species to have made them may actually have been *Australopithecus garhi*, which lived about 2.5 million years ago, but the technology clearly flourished in the hands of *habilis* and, later, *ergaster*. *Homo erectus* inherited Oldowan technology from *ergaster* and, from about 1.7 million years ago, began to refine it into more sophisticated sharp edged stone tools known as the Acheulean industry. Acheulean tools remained a major human technology for about 1.4 million years – well over half the history of our genus.

hundreds of thousands of years before the development of effective spears and other distance weapons, argues this hypothesis, man thrived, and learned to think, because (he) was born to run.

Several uniquely evolved features of human physiology and morphology are cited in support of this idea. Notably, the large tendons in our legs store energy like springs when we run, improving the efficiency of gait by more than 100 per cent. (Earlier species such as 'Lucy' may have had Achilles and other tendons, but their legs were shorter and much less powerful.) We also have an effective cooling system in the sweat glands spread widely over our bodies. Each *gluteus* on our bottom is so *maximus* because this helps us to run well, balancing us rather as a tail does in the case of every other running biped and contracting to prevent our bodies from falling forwards as each foot strikes the ground. Other features (on a list of about twenty-six) include short toes that do not get in the way and the nuchal ligament which stabilizes the head when it is in rapid motion.

It's also argued that running is central to what keeps us most human and healthy – that in running, humans experience *funktionslust,* the joy of doing what we are designed to do. Animals are naturally proficient at, and tend to enjoy, doing things important for their survival, and so it is (or was) with running for humans. It has also been suggested that running and tracking animals stimulated the evolution of many of the mental processes that make science possible. Whatever the truth of that, for more than 99 per cent of human history near-constant movement has been our lot. As Marshall Sahlins put it, 'the first and decisive contingency of hunter gathering is continual movement'. Hugh Brody writes of the nomadic peoples of western Canada: 'everything about [them] points towards a readiness to change and to move . . . a resolute indifference to any accumulation of [material] wealth'.

But there is more to being human than running around and sticking sharp objects into things we want to eat or people we don't like. Whatever the cynics may say, we have a vastly greater capacity to communicate and cooperate – at least with those in our own

group – than any other primate. Human language – which allows us to make an almost limitless number of propositional statements about the world, and greatly facilitates recall of the past and anticipation of the future – is central to making this possible. But language is extremely complex. How did it arise, and why? Why would we have wanted to speak in the first place? The answer, say some evolutionary psychologists, is that over the last few million years our ancestors evolved a particular talent and a desire for 'deep intersubjectivity' (which roughly translates out of jargon as 'knowing each other very well'); we developed an enhanced capacity for 'mind-reading' (that is, understanding what is going on in the minds of others without having to ask them), underpinned by empathy (shared feelings) and sympathy (shared goals). All these qualities, which confer collective advantage on the group, would have been enhanced by the acquisition of language. But none of them would have developed as they did and language itself would not have become possible had they not been preceded by and evolved from earlier ways of communicating. And it's here, goes one line of argument, that something very like music played an essential role. Music and dance share an origin with language. Not only that, they remain crucial to human wellbeing.

Such at least is the case made by the anthropologist Steven Mithen, who says that early humans would have found advantage in using their increasingly flexible voices as a part of a system of communication he calls 'hmmmmm' (one h and five m's): holistic, manipulative, multi-modal, musical and mimetic. All these forms of expression, Mithen points out, are observed in other primates, but separately; only early humans combined them to create something more complex and sophisticated than anything found among non-humans. Relying as it did on gesture, facial expression and other signals as well as sounds, 'hmmmmm' was neither music nor language, but it was music-like. Only comparatively recently – perhaps as little as 100,000 years ago in a genus that had already been around for the best part of two million years – did music and language take entirely separate paths. By that time, the capacity of music-like

Language enables us to 'make hypotheses that die in our stead' (as Karl Popper put it); that is, to test possibilities in our minds without necessarily taking physical risks. It also gives us the ability to communicate the discoveries that may result to others.

A version of this argument goes back to at least the eighteenth century. Étienne Bonnot de Condillac (1715–1780) wrote: 'When the original language of gesture and dance gave way to the language of speech, the character of the original form of expression was preserved. Instead of violent bodily movements the voice rose and fell in an emphatic way. Indeed, in the earliest languages these rises and falls were so distinct that a musician could have notated them. So one could say the vocal sounds were more akin to chant than speaking.'

sounds to elicit shared emotions and cooperation was deeply entrenched in the foundation of our being. We are, in the phrase of the psychologist Colin Trevarthen, 'born with a kind of musical wisdom and appetite'.

Explanations like this are not universally accepted. In the 1990s the linguist Steven Pinker famously described music as 'auditory cheesecake', implying that it was an accidental by-product of evolution that humans now use to tickle their fancy but that it had no adaptational significance. Certainly, music has long been seen as an anomaly. Back in 1870 Charles Darwin wrote that 'as neither the enjoyment nor the capacity of producing musical notes are faculties of the least use to man, they must be ranked amongst the most mysterious with which he is endowed'. Darwin concluded that music is a form of sexual display, like a peacock's tail. As we would put it today, the rock star always gets the girl, or boy.

But it's also pretty clear that 'cheesecake' and sex are not the whole story. In every human society music and dance exist in other contexts, and serve other purposes such as rites of passage, spiritual and religious practices, mourning and expressions of solidarity and of sheer collective joy. For virtually all humans except those with certain neurological disorders or genetic abnormalities, music and dance provide substantial, non-frivolous benefits. They are above all social activities that enable us to interact and bond by facilitating coordinated movements such as working and marching together. (The phenomenon is known as 'entrainment'.) Music and dance also benefit the individual, manipulating mood and physiology more effectively than words alone can to excite, energize or calm us. Mother-song to baby, and the musical babble of a baby to its parents, are where we begin, and a channel of some of the most powerful emotions of which we are capable. And, as Oliver Sacks and others have documented, music can act on the brain in subtle, deep ways, helping sometimes even to restore speech and movement for those who have lost them. All this suggests that music is not only essential to our present nature but has deep roots in the human past.

Few other animals show much ability to produce

Shamans often achieve trance states via dance and song, and music and rhythmical movement tend to be integral to prayer. The Jewish tradition of 'davening', which entails rocking lightly while reciting prayers, is one example. Even Salafism, which is generally hostile to music, welcomes it in prayer.

Aristotle's term for 'soul' did not refer to the kind of invisible and incorporeal essence that, as later conceived by Christian writers, separates from the body at death. Rather, he meant something more like 'life-force', or organizational process of life. An analogy could be made with the 'will' as envisaged by Schopenhauer and Nietzsche, who both believed it was powerfully expressed in music.

or imitate a variety of regular rhythmical and musical patterns, and those that do tend to arouse especial affection in us. This is most obviously the case in songbirds but it has also become true of whales since we first began to hear their songs less than half a century ago. The apparent musicality of some pets is also beguiling. Christopher Smart believed his cat Jeoffry could 'tread all measures upon the musick'. A dancing cockatoo called Snowball has wowed half the world via the Internet with his ability to dance in time to the Back Street Boys.

Our closest cousins, the other great apes, have very limited musical and linguistic abilities. And the origin of this difference between us and them may originate in the habit of walking on two feet. Fully upright walking and running require the spinal chord to join the brain case from directly below rather than from behind. This arrangement leaves less space between the spinal cord and the mouth for the larynx, the muscular valve that seals the lungs while we swallow food. As a result, the larynx is positioned lower in the throat, which has the incidental effect of lengthening the vocal tract and increasing the diversity of sounds it can produce. Early humans were, as a consequence, capable of a greater range of sounds than, for example, chimpanzees can manage. (It looks as if the human vocal tract had already evolved into something very close to its modern form by half a million years ago.) Bipedalism also freed us from a rigid link between stride and breath. Most of us can walk and talk (and even chew gum) at the same time – something that other apes cannot do because of the forces pressing through their frames as they move. Also, human walkers and runners can adopt different stride/breath ratios. A runner, for example, may choose four steps to one breath, three to one, five to two, two to one, three to two, or one to one, with two to one being the most common. The net result: mastery of rhythm, song and speech (and, incidentally, our species' characteristic laugh). 'Poetry', said George Seferis, 'has its roots in human breath.'

Sometimes, the music of one human culture is almost unrecognizable as music by people from another who have not heard it before. On occasion people have

disputed that there is a single thing that can be called music. That said, every culture makes something like music and there are some essential similarities. Just about every culture bases their musical scales around the octave, for example, and most also use the perfect fifth (although there is at least one that does not use octaves, and there are some that omit fifths). But looking for similarities in form and content may be something of a wild goose chase. The more important point is what musics *do* rather than what they *are*.

The Babenzele, a Pygmy tribe in the Congo, combine polyphony (voices singing different melodic lines simultaneously) and polyrhythm (beating more than one rhythm at the same time; for the Babenzele, it may typically be eight, three, nine and twelve beat sections combined in a complex overlapping whole). Many Westerners find this kind of music hard to follow and appreciate. But this initial bewilderment can soon be overcome. A good place to start, says the anthropologist Jerome Lewis, is to listen first to the forest where the Babenzele live. Various animals – monkeys, songbirds and others – make different sounds at different times; combined, these are the sounds of the forest. For the Babenzele, polyphony and polyrhythm are ways of echoing and embodying their world, of learning its secrets. 'What they are really interested in', says Lewis, 'are synergies: technologies of enchantment, where you lose your sense of self and become aware of a greater community.' When the human voices intertwine just right, he says, a sense of calm euphoria arises, 'a blissful state in which you have forgotten yourself completely and are lost in the beauty of sound'.

People have long been puzzled how it is that music, though not representational in the way that language is, 'speaks' so directly to us. 'How is it', asked Aristotle, 'that rhythms and melodies, although only sound, resemble states of the soul?' Part of the answer may be as follows. As we have seen, music depends on essential aspects of our physiology and physical being in the world – heartbeat, breath, pace, emotion, cognition and more. But it also, as the music of the Babenzele reminds us, depends on the attention

'Rather than being an evolutionary adaptation, is music a "technology" that, like fire, has been essential to human development?'
(Aniruddh Patel)

My heart is so joyous
My heart flies in
 singing
Under the trees of
 the forest
The forest, our
 home, our mother
In my net, I have
 caught
A little bird
A very little bird
And my heart is
 caught
In the net with my
 little bird
(A song celebrating the birth of a child sung by the Efé, a Pygmy tribe of the Congo)

THE BOOK OF BARELY IMAGINED BEINGS

we pay to phenomena such as forest sounds beyond our own immediate physical bodies and those of our immediate human group. Music brings the two together in ways that enhance (or entrain) our sense of vitality and will. It enlarges consciousness as individual identity is both made more vivid and at the same time absorbed, however temporarily, into something quite other than itself.

It has been suggested that consciousness exists because it is evolutionarily adaptive: the (mostly) marvellous experience of being aware strongly motivates us to want to continue and invest in what we love. Whether or not this suggestion is right (and it has been vehemently challenged), music is surely an innovation that enhances consciousness and commitment to life. Experimentation with rhythm, dynamics, harmony and timbre is a way of exploring and expanding the nature and boundaries of consciousness itself.

We are, then, a musical animal – or, to be more precise, an erect, musical, featherless running biped ... sometimes given to staggering. Music is a channel for essential aspects of our existence, if not a source of it. But there remains the question of what we *do* with these capacities. And on this matter, consider Orpheus.

As the tale goes, Orpheus makes such beautiful music that the birds and beasts are enchanted, the trees and rocks dance, and even rivers change course in order to get closer to him. But then his beloved wife Eurydice is bitten by a snake and dies. Orpheus, inconsolable, sings so sadly that the gods and nymphs of the upper world weep. At their suggestion he travels down to Hades, where he begs the king and queen of the dead to restore his love to life. Never before have the rulers of the underworld been moved by the pleas of a mortal man, but Orpheus's music softens their hearts and they agree to allow Eurydice to return with him to life on condition that he walk in front and not look back until both reach the upper world. Orpheus sets off, with Eurydice following. As soon as he reaches the upper world he turns to look, forgetting that she too needs to have reached the top of the path from Hades for the pledge to be fulfilled. Eurydice vanishes for ever and Orpheus is left alone.

'Since music is the only language with the contradictory attributes of being intelligible and untranslatable, the musical creator is a being comparable to the gods, and music itself the supreme mystery of the science of man.'
(Claude Levi-Strauss)

A pretty tale to be sure, but what use is it? In what sense is it, as Christopher Smart wrote, 'of the truth'? Myths are not merely about messages and meanings. Still, here are three to hazard. The first – which I have already outlined and is in any case so obvious that it hardly needs stating – is that music can be one of the most astounding forces in life: so powerful that, in the heightened states of emotion to which it takes us, it can seem to bring us close to overcoming death itself. Music emanating from the non-human world – not least the songs of great whales – overturns a long-established self-centredness (rather as did the first photographs of the Earth taken from space), suggesting the possibility of profound changes and expansion of human consciousness.

'Music is something for the sake of which it is worthwhile to be on Earth.'
Friedrich Nietzsche

A second 'message' in the story of Orpheus is a warning. At the critical moment Orpheus fails to exercise self-control and as a result loses what he most loves. The lesson, then, is that we should sometimes restrain our impulses even when this is the hardest thing in the world to do. Another mythical traveller to Hades learns a similar lesson. Odysseus is warned twice, once by the shade of the prophet Tiresias, a second time by the nymph Circe, to resist the temptation to steal and eat the cattle of the Sun. Odysseus, 'a man endowed with the gods' own wisdom', manages to resist but is unable to control his companions, and they – good men who have come with him through many trials – are lost to disaster.

A third take on the Orpheus myth is 'never look back'. But this is, I think, wrong. The point is *not* that we should forget the past, but rather that we should know *when* and *how* to look back. Nietzsche's doctrine of eternal return, as expressed in *Zarathustra*, is often also interpreted wrongly. It does not mean that we should be endlessly repeating the past. Rather it means we should will – in the sense of fully inhabiting and being at peace with – all that has made us what we most essentially are, including our evolutionary origins and our kinship with other animals.

It follows that we should embrace our human ancestors much more fully than we often do. This doesn't mean getting romantic or sentimental about

THE BOOK OF BARELY IMAGINED BEINGS

the Stone Age; enthusing about the 'paleo-terrific' has on occasion led people in some strange directions. It does mean more fully imagining the lives and worlds of genus *Homo*.

The scientist and writer Jared Diamond has written dismissively about humans before the advent of 'behavioural modernity', the great leap in technological and cultural achievement that took place over the last few tens of thousands of years. How much can you say, he asks, about a creature whose stone tools were 'only marginally more sophisticated' than the sticks chimpanzees use to extract termites from their nests, tools which progressed 'at an infinitely slow rate, from extremely crude to very crude'? Until about forty thousand years ago, Diamond says, we were 'just another species of big mammal' – and not necessarily the most impressive: 'still much less widespread than lions'.

This view lacks imagination. Better, the approach taken by the sculptor Emily Young:

> For hundreds of thousands of years we have made
> stone tools: people sitting together under the trees,
> chipping and tapping and knapping their flint,
> their obsidian, their jasper. And their multiple
> rhythms, together with the sound of cicadas, and
> birdsong, would have been musical.

The earliest peoples did not live on the harshest margins of the world as do a few surviving groups of Bushmen, Australian aboriginals and Inuit today. Rather, as Jonathan Kingdon has pointed out, they lived where other life forms were often abundant to an extent that we would find incredible today. If we listen hard we may catch hints of their 'music' every day in a hundred little unremembered acts. And if we can – on the basis of sound evidence, carefully interpreted – better imagine the details and qualities of this deep past, allowing voice to those who are long since mute, then the life we do know and can imagine for the future is sure to become a little more astounding. Our ancient ability to walk and run huge distances in virtually every terrestrial environment and our music, song and dance will have carried us there.

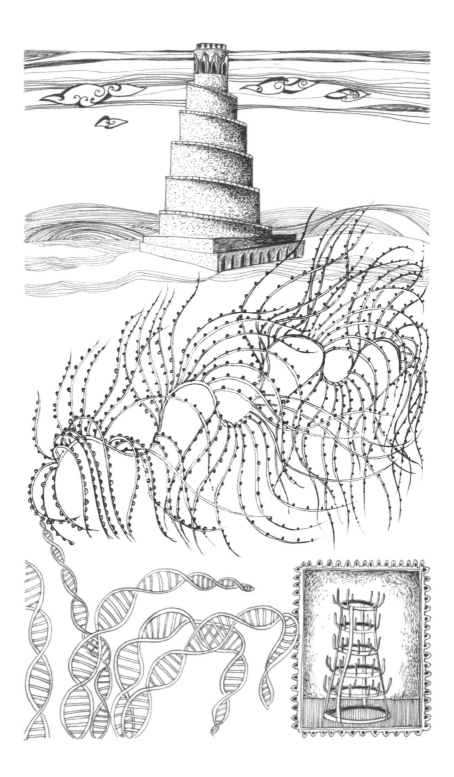

IRIDOGORGIA POURTALESII

Phylum: Cnidaria
Order: Gorgonacea
Suborder: Holaxonia
Conservation status: Not listed

For in my nature I quested for beauty, but God, God hath sent
me to sea for pearls.
Christopher Smart

Two very different
kinds of animals are
named after the
Gorgon, the snake-
headed monster of
Greek myth. Quite
distinct from cnidar-
ian gorgonians are
the *gorgonocephalidae*,
or Gorgon's Head
Basket stars, which,
like the Crown of
Thorns starfish, are
echinoderms. The
best known of these
writhes like a thou-
sand wormy snakes
radiating from a cen-
tral core.

People have long been fascinated by symmetry,
beauty, and why they exist in the natural
world. Just about the last place most of us
would think of looking is at the bottom of
the deep blue sea. And yet it is from this vast place, long
thought to be lifeless and beyond knowing, that the
first great oceanographic expedition, undertaken by
HMS *Challenger* from 1872 to 1876, hauled up a creature
that may help us get closer to the heart of the matter.

Iridogorgia is so strange to look at that it is hard to
believe it is a thing living on this planet. It is a sea fan:
a gorgonian in the phylum cnidiaria. Jellyfish and stony
corals are its distant relations. Like the stony corals,
the gorgonians you can see are colonies of tiny polyps:
small cylindrical organisms with mouths surrounded
by tiny tentacles. Unlike stony corals and other anthozoa,
whose polyps have sixfold symmetry, the polyps of a
gorgonian have eightfold symmetry. They tend to form
fan- or candelabra-shaped structures on top of a narrow
central stem made of a horny material. Some gorgoni-
ans, living in shallow, sunlit waters, tend to be brightly
coloured – gold, purple, red – and flex softly in the
currents. Others, living in the deep sea, tend to be stiffer
and taller, and (lacking partner organisms that photo-
synthesize) muter in colour but weirder in form. One
of *Iridogorgia*'s cousins, *Metallogorgia*, looks like a delicate,
pink acacia on top of an impossibly thin trunk. *Iridogorgia*,

THE BOOK OF BARELY IMAGINED BEINGS

Iridogorgia

which lives on the seabed a mile down, gets its name from the iridescent sheen it has when lifted up from eternal darkness into the light. In 1883 a marine scientist compared its colours to burnished gold, mother-of-pearl and the most brilliant of tropical beetles. This comparison is apt, but what remains most striking about it is the symmetry of the whole structure: its elegant corkscrew spine with regularly placed feathery branches make it seem more like something from a mathematical theorem than the animal kingdom.

Looking at this gorgon, as unearthly to human eyes in the twenty-first century as it was in the nineteenth, won't turn you to stone, but it may cause palinopsia – an echo-image which remains in the brain after you look away. To my mind, that after image resembles two well-known twentieth-century man-made objects: the bottle rack 'readymade' created by Marcel Duchamp in 1914, and the model of DNA built in 1952 by Francis Crick and James Watson. These two, for all their obvious differences, share some common themes with each other and with *Iridogorgia* itself. They are emblematic of revolutions in the arts and sciences whose consequences are still being played out, and they help redefine where we look for and how we conceive beauty. For Duchamp, the point of readymades was to move beyond what he called 'retinal art', which is concerned with appearances,

and engage directly with the viewer's mind. For Crick and Watson and the others who helped to discover the structure of DNA, the point was to better understand the 'code' at work behind the appearances of visible life forms.

Duchamp and his contemporaries in Dada challenged the entire tradition of European art, from classical works that tried to imitate reality to the Impressionists' attempts to more closely engage with how the human eye sees, but his readymades also speak to a tradition which goes back to Plato, and actually predates him, of looking for forms that embody essential truths. (Duchamp, an avid chess player, was fascinated by mathematics and patterns.) For Plato, five regular geometrical shapes – the tetrahedron, hexahedron, octahedron, icosahedron and dodecahedron – were beauty itself and the foundation of existence. This idea has inspired both artists and scientists, including astronomers and cosmologists, ever since. In his *Mysterium Cosmographicum* of 1596, Johannes Kepler suggested the ratio of the orbits of the planets around the sun could be represented by the successive nesting of the five 'Platonic solids' within spheres. As late as 2003 the cosmologist Jean-Pierre Luminet suggested that the entire universe might be shaped like a finite dodecahedron. And ideas of symmetry – albeit extremely subtle and hard for non-specialists to understand – continue to entice voyagers into the deep structure of the world. The physicist Michio Kaku describes his discipline like this:

> . . . we are slowly reconstructing the original symmetries that existed at the instant of the Big Bang, uncovering bits and pieces of new symmetries along the way. If this picture is correct, all the beauty and symmetry we see around us, including sea shells, ice crystals, galaxies, molecules, even sub-atomic particles, are nothing but the pieces of the original symmetry that broke at the instant of the Big Bang.

Many biologists, too, have been enchanted by the idea that the symmetries so admired by Plato and others are at the core of life. Entities at what seemed

like the borderline of life appeared to offer clues. Until the mid eighteenth century, many people thought that rock crystals – which are regular, geometrical and self-creating (that is, they will assemble themselves from materials around them) – were alive. Carl Linnaeus classified them in a fourth kingdom of life after animals, plants and fungi. And similarities between snowflakes, which are all variations on a hexagonal grid, and organisms from flowers to sea creatures sparked astonishment and fascination that only increased as improvements in microscope technology made their intricate structures ever more apparent.

One group of living organisms in particular – the radiolaria – seemed to offer the most tantalizing evidence that Plato's elementary forms somehow governed the shape of living things. Radiolaria, which are single-celled plankton, are abundant in all regions of the world ocean and older than multicellular life. They get their name from the skeletal spines that radiate from a central point of the organism in some common species, but as a group they also include many kinds that are vastly more diverse in shape than this name suggests. They first came to widespread attention thanks to Ernst Haeckel's monograph of 1862 and his report of 1887 on discoveries made by the *Challenger*, both of which contained stunning illustrations of their skeletons. (Haeckel's best known book, *Art Forms of Nature*, finally published in 1904, contains what are now his most famous pictures of radiolarians.) In Haeckel's rendering, some radiolaria look like what we now call geodesic domes and Buckyballs, while others look like wildly exuberant Samurai helmets and *Jugendstil* lampshades, others like pollen grains and still others like quadruple-edged swords. Arguably, Haeckel – who influenced and was influenced by developments in the architecture and design of his time – did more for our ability to appreciate creatures too small to be seen with the naked eye than anyone since Robert Hooke in his *Micrographia* of 1665. And his work was an inspiration for, among others, the Scottish biologist D'Arcy Wentworth Thompson, who undertook one of the most ambitious single attempts ever made to understand the role of geometrical structures in the living world.

Ironically, when researchers began to study radiolaria in detail in the early nineteenth century the pendulum had swung so far the other way toward the assumption that nothing crystalline could be alive that it was initially concluded that the regular forms produced by radiolaria could not possibly be a product of life.

Drawings of radiolaria by Ernst Haeckel.

At the cosmological scale, M-theory suggests that particles in our universe may be like bubbles on the surface of a world with extra dimensions.

Haeckel enthused about the diversity of radiolaria, writing that 'nature has created an inexhaustible wealth of wondrous forms whose beauty and diversity far exceed anything that has been created by man.' A follower of Darwin, he nevertheless believed all of nature was pervaded by an almost mystical creative, organizing force. D'Arcy Thompson took a more empirical view. He thought that behind the mind-boggling diversity of forms were simple mechanical forces such as those operating on a film of soap as it makes bubbles around a wire framework. He believed this was not only true for relatively simple organisms such as radiolaria. 'Throughout the whole range of organic morphology', he wrote, 'there are innumerable phenomena of form which are not peculiar to living things but which are more or less simple manifestations of ordinary physical law.' Thompson thought that the chemical and biological processes underlying evolution and development were of secondary importance to physical forces, and his aim, in the monumental *On Growth and Form* (1917), was nothing less than a geometrical interpretation of the shapes of all living creatures.

THE BOOK OF BARELY IMAGINED BEINGS

Images from *On Growth and Form* (1917). Spirals, soap films within wire forms compared to planktonic shapes, and the morpho-space shared by the skulls of chimp, baboon and human.

Writing in the 1990s Stephen Jay Gould called his theory a hybrid of Pythagoras and Newton, in which the ideal geometries beloved by classical Athens pervade organic form because natural law favours such simplicity as an optimal representation of forces.

Thompson looked for evidence in what has been called his theory of transformations. This entailed taking the outline of an animal or plant (or of one of its component parts such as a bone or a leaf), tracing this onto a regular square grid of the kind found on school graph paper (this was six or seven decades before computer graphics) and then stretching or distorting the grid to produce rhombi, diamonds and other shapes. In many cases, the outline of the organism pinioned to the distorted grid looked like another, sometimes quite distantly related, species. The transformations seemed to show the 'fixed' shapes of different species as single frames in a continuous sequence of possible forms largely determined by physical forces pulling and pushing the organisms in various directions.

Spirals seemed to offer another tantalizing clue. Thompson marvelled at their ubiquity in living things,

In both radiolaria and another group of plankton called Foraminifera, writes Thompson, 'we seem to possess [a] nearly complete picture of all the possible transitions between form and form, and of the whole branching system of the evolutionary tree: as though little or nothing of it had ever perished, and the whole web of life, past and present, were as complete as ever'.

from the florets of a sunflower to the coil of an elephant's trunk and even in animal behaviours such as the flight path of a moth around a flame. Particularly striking is the sheer diversity and near geometrical perfection in the shells of molluscs. From the Queen conch to the nautilus, these grow in equiangular and logarithmic spirals of almost every conceivable angle and pitch. Here, Thompson suggested, was a supreme example of 'the great variety of nature at play' (*magna ludentis naturae varietas* as Pliny had called it); a world not of grim competition but endless creativity, counterpoint and fugue:

> It leads one to imagine that these shells have grown according to laws so simple, so much in harmony with their material, with their environment, and with all the forces internal and external to which they are exposed, that none is better than another and none fitter or less fit to survive.

The human fascination with spirals is old and enduring. They appear, albeit quite rarely, among symbols painted on cave walls more than 20,000 years ago, and are a common motif in many later cultures of the prehistoric and historical periods. Early depictions are often variations on the 'simple' (Archimedian) shape. The parabolic, or Fermat, spiral decorates objects about 6,000 years old including the buttocks of a clay female figure from the Danube Valley civilization. Triple spirals were etched on a great entrance stone at the Newgrange complex in Ireland, which was built around 5,000 years ago. One of the most remarkable man-made structures of all time is the 52-metre (170-foot) high Malwiya Minaret at Samarra in Iraq, built between the years 848 and 852 and not significantly damaged until US forces arrived after the invasion of 2003. It takes the form of a conic spiral – so it is partly a helix, partly a spiral.

There are probably several reasons why we are drawn to spirals. One may be that, even before science showed just how widespread they are, people intuited that they were a manifestation of forces at work in the natural world: spirals as constant forms appearing in what is always moving, approximating Carl Woese's metaphor for life itself: 'organisms [as] resilient patterns in a turbu-

'Imagine a child playing in a woodland stream, poking a stick into an eddy in the flowing current, thereby disrupting it. But the eddy quickly reforms. The child disperses it again. Again it reforms, and the fascinating game goes on. There you have it! Organisms are resilient patterns in a turbulent flow.' (Carl Woese)

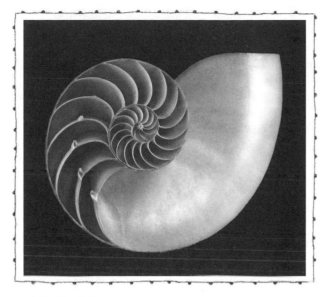

A Nautilus shell

lent flow'. Whether or not this is the case, once you *do* have the maths and the evidence before you, the presence of self-similar forms such as logarithmic spirals in everything from cauliflowers to cyclones and from marine shells to star formations is astonishing. We now know that spirals and helices exist where they cannot be directly seen; there are, for example, Ekman spirals in the winds and in deep waters under sea ice, and Langmuir circulations beneath ocean surface waters. At least one of the rings of Saturn is actually a spiral.

Thompson's *On Growth and Form* greatly enriches the reader's appreciation of the range of spirals and other forms that arise in living things. As a work to arouse wonder it has few equals. As an explanation for how life evolves and develops, however, it is inadequate. Thompson acknowledged as much, writing that his work took us 'only to a threshold'. But even as in the years up to his death in 1948 Thompson was preparing an expanded edition, other scientists were starting to understand metabolism, photosynthesis, heredity and development in new ways: molecular biology was being born.

The geneticist Jack Szostak (2010) has suggested that 'simple physical forces' such as those that cause cell membranes to form and divide may yet play a role in attempts to reconstruct the origins of life.

One of the signal achievements in this revolution was, of course, the discovery in 1953 of the structure of DNA, and the realization that this double helix – a mathematical cousin of the spiral – carries the genetic 'blueprint' of every living thing. Because the double helix seems so familiar, we sometimes fail to register just how astonishing is the vision it offers: all of life, in its stupendous diversity, unfolding generation after generation from the relatively simple and undeniably beautiful geometry of an 'aperiodic-crystal' in which sets of atoms in hexagonal configurations are joined into base pairs that are layered as in a twisting staircase.

The phrase 'aperiodic crystal' appears in Erwin Schrödinger's *What is Life?* (1944) The 'hexagonal configurations' are the nucleotides Adenine, Cytosine, Guanine and Thymine. Conjoined as A–T and C–G they form the base pairs of life's 'digital code.'

Consider the age of DNA. It formed the genetic code of the last common ancestor, which lived between 3.8 and 3.5 billion years ago. Very few rocks on the Earth's surface are as old as this: DNA is older than virtually all of the hills. Your hand – holding beach pebbles that may be hundreds of millions of years old – contains within itself and has been formed by a pattern that is vastly more ancient. But DNA is also forever young: in virtually every living organism it is continually being synthesized from other chemicals. Over time the sequences and the proteins for which they code change – otherwise there would be no evolution – but there are some remarkable continuities too. Both a human newborn and a placazoan (an animal even more distantly related to humans than are Barrel sponges), for example, have some virtually identical sequences such as one coding for a tumour suppresser gene called p53.

The oldest known 'hill' (surface rock) so far discovered, at Nuvvuagittuq in northern Quebec, is about 4.28 billion years old, but the vast majority of the Earth's surface is much younger than this.

Then there are its dimensions in space. If the DNA in a single cell in your body – almost 3.2 billion nucleotide bases crammed into forty-six chromosomes – were unpacked and joined into one continuous molecule it would be almost two metres long. Since you have about ten trillion cells in your body (not counting about ten times as many microbial partners), this means you have enough DNA to span the 149 million kilometres (93 million miles) between the Earth and the Sun hundreds of times. The DNA in a few thousand people, joined in a single chain, would reach the nearest star.

A corollary of the large number of base pairs in the genome is that while the potential for varying their sequence is not infinite, it *is* almost fantastically large. To

get a sense of how large, think of an imaginary animal – the Babel fish, Douglas Adams's piscine *Übersetzer*, will do – and suppose that it has a genome the same size as a human (this is not a wild assumption: the Marbled lungfish and some species of salamander have one forty times as big). Suppose, further, that we make variations in 1 per cent of its DNA, selecting only from sections that are non-coding. (This has already been tried in mice with no apparent ill effects.) The total number of variations that can be made is: $2^{32000000}$ or $10^{9632960}$. To get a sense of the size of that number, the entire visible universe packed solid with grains of sand would hold about 10^{90} grains. The nearest exact copy of you in the multiverse may be no more than 10^{128} metres away.

Inserting sequences that code for text into non-coding DNA is not new. In 2007 a team led by Masaru Tomita wrote $e = mc^2$ into the genome of a bacterium, and in 2010 a team led by Craig Venter announced they had coded three short texts into their 'new' bacterium, including a line from James Joyce: 'To live, to err, to fall, to triumph, and to recreate life out of life.' The space available for encoding text in 1 per cent of the Babel fish genome is considerably greater than in a bacterium – although not enough, perhaps, to accommodate the text of all of the $10^{1834097}$ books in the Library of Babel imagined by Jorge Luis Borges.

Putting this aside, differences amongst genomes that *do* code for phenomena in the visible universe make possible an fantastic diversity of living things, from lampreys to Lady Gaga. So much so that attempts to capture it in words tend to the grandiloquent. 'From subtle rearrangements along its tiny ancient spiral,' writes Kevin Kelly, the self-described Senior Maverick at *Wired* magazine, 'DNA projects the majesty of a strolling sauropod 60 feet high, the delicate gem of an iridescent green dragon fly, the frozen immaculacy of an white orchid petal, and of course the intricacies of the human mind.' Better is the terse humour of George Wald, who won a Nobel Prize for his work on the foundations of vision: 'If [the genome] wants to swim in the ocean, it makes itself a fish; if [it] wants to fly in the air, it makes itself a bird. If it wants to go to Harvard, it makes itself a man.'

The other two were: 'See things not as they are, but as they might be,' from a biography of the physicist Robert Oppenheimer; and 'What I cannot build, I cannot understand,' by Richard Feynman.

Wald was talking figuratively, of course. He did not mean that the genome or its constituent genes literally have intentionality. But the idea that genes are in charge proved to be a powerful one. It seemed to follow from what Francis Crick, the co-discoverer of the structure of DNA, called 'the central dogma of molecular biology': that DNA instructs RNA, and RNA builds proteins that make an organism, and that information only flows one way. Richard Dawkins makes a dramatic, extreme, statement of it in his 1976 book *The Selfish Gene*:

> Now [genes] swarm in huge colonies, safe inside gigantic lumbering robots, sealed off from the outside world, communicating with it by tortuous indirect routes, manipulating it by remote control. They are in you and me; they created us, body and mind; and their preservation is the ultimate rationale for our existence.

Others see this as a distorted picture of how life works. A better explanation, they say, sees the organism (more precisely, the phenotype: the ensemble of traits and characteristics of an organism) rather than the genes within it as the principal unit upon which natural selection acts. Genes, in this view, are more a way of retaining and passing on knowledge about aspects of the world than entities which control it. The physiologist Denis Noble argues that Dawkins is not making an empirical statement but pulling a rhetorical trick, and suggests that the description can be rephrased with equal validity as follows:

> Now [genes] are trapped in huge colonies, locked inside highly intelligent beings, moulded by the outside world, communicating with it by complex processes, through which function emerges. They are in you and me; we are the system that allows their code to be read; and their preservation is totally dependent on the joy we experience in reproducing ourselves. We are the ultimate rationale for their existence.

Whatever one's view on this debate, it has become apparent that a map of the genome such as that

attempted in the Human Genome Project is far from being a complete map of life. You can better explain the evolution, development and functioning of an organism if you also take into account a host of other factors and – among them, the ways in which genes are expressed at different times in developmental and physiological processes and the interactions that take place between all the active proteins in a cell (collectively known as the proteome). But even setting all that aside, the genome itself has yielded surprises that not many anticipated a few decades ago. For one thing, the emerging field of epigenetics is showing that cells read genetic code in DNA more like a script to be interpreted than a computer programme that replicates the same result each time. For another, much of the DNA that we supposed essential is not so at all.

Initially, researchers had assumed that virtually all of the DNA in the human genome coded directly for the proteins that build our bodies. By the early twenty-first century, however, it was clear that less than 2 per cent did. Although parts of the rest appeared to have other functions, large parts seemed to do nothing at all. Further, at least 8 per cent of the genome is made of copies of the genes of alien invaders. These genes once belonged to endogenous retroviruses, or ERVs – a family of entities whose more recent variations include the human immunodeficiency virus that causes AIDS – that have now become embedded in their host organisms and their descendants. Unlike HIV, the genes of these ERVs are now either inert or (as we will see) perform essential functions in the maintenance of their new homes.

The picture that emerges is disturbing, but it is also fascinating and even beautiful. Looked at negatively, the human genome – along with that of virtually all other animals and plants – bears the scars of relentless onslaughts over tens and hundreds of millions of years by viral 'automatons'. As recent experience with HIV/AIDS, particularly in southern Africa, reminds us, retroviruses can wreak havoc on their hosts. Other viruses may inflict even greater damage, as a future global flu pandemic may yet show. On a bad day, the Cold War-era words of the molecular biologist

A great number of viruses, including herpes, have capsids (protein shells) shaped like icosahedrons (that is, regular polyhedrons with twenty identical equilateral triangular faces). Such a shape can be built with repeated use of the same protein, thereby requiring little space in the viral genome. There are also many viruses with helical shells. Some viruses, however, have shapes that, at first sight, are just plain odd. There are bottle-like shapes, viruses with tails at both ends, viruses that look like droplets and viruses with stalk-like filaments.

Joshua Lederberg do not seem far wrong: 'the single biggest threat to Man's continued dominance on this planet is the virus'. And whether or not Lederberg was right about naturally occurring varieties, deliberately engineered 'superflu', smallpox-like or other viruses may be capable of causing disaster without precedent.

On the reasons-to-be-cheerful side, however, there is the adaptability and resilience of many species, if not individuals, in the face of such onslaughts. And there is also a terrific beauty in the viruses themselves; the fact that such tiny and apparently simple entities, many of them encased in crystalline icosahedrons and even, rather like miniatures of *Iridogorgia*, in helical shells, are able to exploit more complex organisms, including ourselves, for their own benefit. Viruses are amazing *mechanisms*. They are able to evolve a million times faster than their hosts. They use more varied biochemistry than cellular life, storing their genetic information as both single- and double-stranded DNA as well as RNA. There are probably more than a hundred million different types of viruses, and more viruses that infect bacteria (known as bacteriophages) alone than there are other life forms put together. There are more viruses on Earth than there are stars in the universe. They are found in every environment on Earth from hot springs to deserts and from lakes beneath Antarctic ice to rocks 2,000 metres below ground – everywhere there are life forms to infect. In the words of the molecular biologist Luis Villarreal, they represent 'the leading edge of all evolving biological entities'.

Viruses also appear to play fundamental roles in the way that entire ecosystems (that is, assemblages of life interacting with the geochemistry and climate of the Earth) function. Consider the sea. Hundreds of millions of viruses are present in virtually every drop (millilitre), and in the world ocean as a whole they kill about a hundred million tonnes of microbial organisms every minute. (Microbes, ranging from bacteria and archaea to eukaryotic phytoplankton and zooplankton, typically weigh a tiny fraction of a gram each; a single drop of seawater may contain many thousands and even millions of them.) When a microbe is killed by a virus it bursts open, or 'lyses', releasing new viruses and cellular debris

which become food for new generations of microbes. In this way, and in others, viruses create new life by fomenting death. Indeed, viruses may have played a role, billions of years ago, in the evolution of programmed cell death, the process by which multicellular organisms purge old and diseased cells, and without which complex life as we know it would not exist.

Also on the plus side, viruses have long partnered with bacterial and eukaryotic life to create new kinds of beings. A dramatic example is a pivotal event in the evolution of modern mammals: a gene essential to the formation of the placenta comes from an endogenous retrovirus. As one scientist joked, 'without viruses, human beings would still be laying eggs'.

And there's more. Viruses appear to have played crucial roles in the evolution of our immune system's ability to respond rapidly to pathogens it has never encountered before – something that researchers consider one of the most important biological innovations of the past five hundred million years. Sequences derived from ERVs also appear to be heavily involved in gene regulatory networks, which control when and where genes are switched on and off. Again, this makes them a key driver of evolution: the main difference between closely related species is not in genes themselves but how they are expressed.

These strange entities, neither living nor dead, have shaped the evolution of every other life form we know. The genomes of humans and other animals are not, or at least not only, self-sufficient 'a-periodic crystals' undergoing mutation in their own time, with natural selection acting upon the results. They are endlessly being reformed by outside forces, including viruses. Viruses decentre us: they enable us to see ourselves as creatures originating from interaction between different things – manifestations of what Buddhists call 'dependent arising' or 'interbeing'.

Life is information, but it is also matter: about 60 per cent, or by weight about 65 per cent oxygen, 18 per cent carbon, 10 per cent hydrogen, 3 per cent nitrogen, 1.5 per cent calcium, 1 per cent phosphorous and less than 1 per cent other elements. Each human is a substrate for about a hundred trillion bacteria, not to mention an even

larger number of viruses. But none of these truths is the whole story. Emergent properties and complex adaptive systems are no less real than the material, energy and information flows from which they are made. The late works of Chopin (to take just one example) are, among other things, marks on paper, vibrations in air caused by hammers striking piano strings and bytes stored in an electronic memory. But these facts do not fully describe or explain them. A dancer is more than DNA.

What is beauty and why does it matter? Some evolutionary psychologists think they have a plausible answer. There are, on this account, four interlinked phenomena. First, we see in a man-made object (art, music or whatever) signals of the qualities of another human being that would make them a good mate (this is George Santayana's 'the whole sentimental side of our aesthetic sensibility . . . is due to our sexual organization, remotely stirred'). Second, we see beauty in patterns and behaviours of other life forms that would say something good about their creator if they were actually man-made; when – in the wings of a butterfly, the dance of the grebe, the colours of the coral fish, the song of the nightingale – 'biology speaks the language of courtier and troubadour'. Third, there is a convergence between our sense of aesthetically 'good form' and nature's selection of evolutionarily 'stable form'. And fourth, universal laws governing complex non-living systems result in 'attractor states' which exhibit harmony and order (for example snow-crystals, or the phases of the Moon), and humans – highly social beings who tend to see evidence of intentional agents in everything around them – see these natural non-living phenomena as evidence of the existence of spirits, gods or other forces that we hold in awe.

This account may go some way towards an explanation. But it has limits. For one thing, our sensibilities are formed not only by our evolutionary inheritance but also, as David Hume pointed out, by historical circumstance. The word 'beauty' itself comes to us laden with cultural baggage and associations. By the time it entered mainstream Western thought in the fifth century AD through the writings of Plotinus and Augustine of Hippo, 'beauty' was seen as a creative force identified

THE BOOK OF BARELY IMAGINED BEINGS

with the cosmos itself; but its meaning and associations continued to develop in relation to other factors in our historically contingent awareness, including related concepts such as the sublime in the eighteenth and nineteenth centuries, or the assertion made by some artists and others from the twentieth century onwards that physical beauty no longer matters.

Another gap in evolutionary psychology's account of beauty is that it doesn't tell us much about what beauty *feels* like. Beauty has a way of helping us see that things exist independently of our own attachments and emotions, however powerful those may seem. It also obliges us to pay complete attention. Both these qualities are conducive to gains in science and in human wisdom.

Looking at *Iridogorgia* can help bring these issues, and others, to mind and keep them there. The animal has beauty in its own right. Living in an environment where food is scarce, it has made itself into its own web around its helical centre, pearled along its fronds like a spider's web with dew. In doing so it has adopted a form of self-similarity seen on many scales in the universe. Its discovery and the continuing torrent of discoveries in the deep ocean – three new kinds of *Iridogorgia* in 2007 alone – can spur creativity and playfulness in the human imagination. (Perhaps, as the biologist Stephen Cairns suggests, the diversity of much of the life we see today in shallow waters originates in the deep places that are out of sight.) The discovery of these new forms and new worlds, and the realization that they are being destroyed by human action much more quickly than we had appreciated hitherto, confronts us with new challenges and new responsibilities to protect: new possibilities for right action – or beautiful action, as Spinoza would put it.

The astrophysicist Martin Rees has observed that medieval Europeans believed the universe to be much smaller and of vastly shorter duration than we now know it to be and yet some of them still dreamed magnificently, devoting their lives to the construction of great cathedrals that, for the most part, they would never see finished. Today, with our vastly greater knowledge and technical capacities, what might we yet conceive?

'In physics, beauty does not automatically ensure truth, but it helps.' (Martin Gardner)

JAPANESE MACAQUE

Macaca fuscata

Phylum: Chordata
Class: Mammalia
Order: Primates
Family: Cercopithecidae
Genus: Macaca
Conservation status: Least Concern

Since we cannot predict how ethics will develop, it is not irrational to have high hopes.
Derek Parfit

We are monkeys with guns and money.
Tom Waits

The air temperature may be twenty below but the Japanese macaques sit like Zen monks in contemplation, luxuriating in the hot spring waters and sublimely indifferent to the cold. These, it's clear, are smart monkeys: among the most adaptable and resourceful primates on the planet. What the picture doesn't tell you, though, is that only the top monkeys in the troop are enjoying the water. Those lower in the hierarchy are strictly excluded. Huddling against the cold air nearby, they are clearly miserable, and their lives are typically shorter and more full of suffering. So while the picture has charm it also speaks of a world of cruelty and exclusion: Snow monkeys, as Japanese macaques are also known, can behave more like *yakuza* (gangsters) than monks.

Japanese macaques have long red faces and eyes that are close-set like those of George W. Bush. The thickness of their fur, which is typically silver-grey or brown, shows that they are well adapted to the mountains. In winter, it plumps up all over their bodies and heads like a parka, and protects them as they eke out a living in the snow-laden forests and along the edges of freezing rivers that are their typical habitat. This fur is a truly remarkable adaptation: no other primate apart from man has adapted to such a cold climate, and man came with clothes and fire.

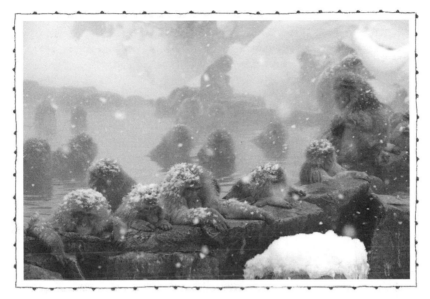

Members of the club. High-rank macaques enjoy a hot bath on a cold day.

(Hot-spring bathing seems to be quite a recent discovery, encouraged by humans after World War Two, and practised by only a few troops.) But the macaque genus as a whole is remarkable. Its various species were, at least until the advent of man, the most widespread and successful primates on Earth, with more than twenty different kinds spread across Eurasia and Africa. Many, such as the Celebes crested macaque, which is famous for its all-black punk/goth style, are now critically endangered, but both the Japanese macaque and its mainland cousin the Rhesus macaque are still thriving thanks to their ability to charm us or, where they don't charm us, to manipulate or outwit us.

The primates are an order of mammals. They include lorises, lemurs, Old and New World monkeys, and lesser and great apes.

Back at the hot tub, where space is tight, life is harsh. This, in miniature, is a world of ruthless competition in which might is right and loyalty extends no further than close members of the family group, and sometimes not even that far. As in all macaque troops, there is a dominant family, which gets first dibs for the choicest spots and best food. The family is headed by

an adult female assisted by a male to whom she grants privileges in return for enforcement duties. She will usually have several offspring by this male or previous paramours unless he becomes too old or weak, in which case he is thrown out. The dominant family's position at the top of the troop's hierarchy is such that even senior members of other families will defer to even its most junior members – although they will try to sneak in some bullying when they think no one is looking. From time to time, other families in the troop may make tactical alliances and attempt a coup against the ruling family, which, if defeated, sinks to the bottom of the heap.

The grimmer aspects of this way of life, which Japanese share with rhesus and other macaques, has led the primatologist Dario Maestripieri to say that this genus are exemplars of 'Machiavellian intelligence' in reference to Niccolò Machiavelli's *The Prince* which supposedly serves as the manual for amoral power seekers everywhere. Maestripieri sees an equivalence between macaques and humans. In both cases, it is what is most instrumental and ruthless in us that has made us successful. Teasing his readers, he writes:

> By the time human beings start the global nuclear war that will destroy our civilization, there won't be any great apes left for Earth to become the Planet of the Apes. But chances are there will still be plenty of rhesus macaques around.

The behaviours that Maestripieri documents in rhesus macaques are real enough and plentifully corroborated by other primatologists. Even within the ruling families there is enough manipulation and machination to make a Borgia blush. His take-home message – that brute power politics is the root of, and the route to, success – looks like corroboration of 'veneer theory' which holds that while humans may often seem caring and cooperative they are in truth 'wicked', motivated only by self-interest, narrowly defined. But this is not a complete picture, either of macaques or humans across all environments and circumstances, and it is a poor basis for imagining our future.

'If [macaque] mothers helped their older daughters,' notes Maestripieri, 'the power of daughters in the family would grow as the number of daughters increased and they could eventually revolt against their mother. Instead, by always supporting the youngest daughter, the mother ensures that the power of the older daughters is reduced rather than increased with the birth of each female offspring, and that the youngest daughter will always help her mother if her older sisters attempt to revolt against her ...'

Attitudes to primates (the order of mammals that include lemurs, monkeys and apes) have varied greatly across cultures and across time. In the Hindu tradition, reverence for Hanuman the monkey god means that most Indians treat macaques as sacred. In old Japan, too, Snow monkeys were held in high esteem and sometimes had shrines dedicated to them, while in China gibbons were especially prized for their beautiful songs. But, in a pattern seen in many parts of the world, both the Chinese and Japanese also depicted them as symbols of human folly. Scroll paintings of monkeys reaching down into the water to try and catch a reflection of the moon remain popular. In Europe and the Mediterranean world, attitudes have gone through cycles well described by Ray Corbey as 'an alternation of humanizing and bestializing moves with respect to both apes and humans.' The ancient Egyptians regarded at least one primate, the baboon, as worthy of respect and even divine status. The Romans were more hostile, and in the Europe of the Middle Ages and early modern period, apes and monkeys, which were not distinguished from each other, were largely seen as either disgusting and devilish (medieval bestiaries often describe apes as the image of the devil himself), as images of unbridled sexual appetite (Shakespeare's Othello, reduced from eloquent dignity to jealous raving, shouts 'apes and monkeys'), or as the very picture of human arrogance and folly (Isabella's words in *Measure for Measure*: 'Man, proud man/Drest in a little brief authority,/Most ignorant of what he's most assured,/His glassy essence, like an angry ape,/Plays such fantastic tricks before high heaven/ As make the angels weep').

Attitudes shifted a little as, from the seventeenth century onwards, Europeans started to learn of the existence of the species that we now know as members of the Great Ape family. The close anatomical similarities to humans evident in chimpanzees (first seen by Europeans in the seventeenth century), orang-utans (in the eighteenth) and gorillas (in the nineteenth) made a strong impression on natural philosophers. Could these apes be 'proof' of old stories of wild men and, as the Scottish eccentric Lord

Monboddo suggested, our close relatives? Such questions led to a more sympathetic attitude towards apes and monkeys, at least among *philosophes*. Monboddo, for example, suggested that man and orang-utan were united in their capacity to feel shame. But the enduring European unease was hard to shake. For a hundred years after their discovery in the late nineteenth century, gorillas were usually represented as especially vicious, subhuman monsters – an image that is almost the polar opposite of the true nature of these gentle vegetarians.

What the eighteenth-century *philosophes* suspected, Charles Darwin and the biologists who followed him demonstrated beyond reasonable doubt: on the tree of life apes and humans evolved relatively recently from a common ancestor. A jotting in Darwin's private notebooks in 1838, nineteen years before the publication of *The Origin of Species*, sums up his entire project and its consequences: 'Origin of man now proved ... metaphysic must flourish ... He who understands baboon would do more towards metaphysics than Locke ...' Like many a shorthand note-to-self, this one is a little cryptic to others. It means, roughly: 'The theory of natural selection proves that man is part of the animal kingdom. Understand those animals closest to us (with 'baboons' here as shorthand for apes and monkeys) and you do more to enhance our understanding of what it is to be and to know than have great philosophers such as John Locke.

Darwin saw that the new understanding would cast light on a burning question of his time (and ours): what is inherent and unchangeable in human nature, and what is subject to formation by external forces, including reason? Locke suggested that the human mind started as a 'blank slate': generalizations from experience were all that was used to build a picture of the world. Others, including Immanuel Kant and Samuel Taylor Coleridge, argued that the ready-made, instinctive aspects of human nature dominate our development. Darwin's own intuition, as expressed in another note in 1838, was that reality is somewhere between the two for both animals and man:

[It is] hard to say what is instinct in animals & what [is] reason, in precisely the same way [it is] not possible to say what [is] habitual in men and what reasonable . . . as man has hereditary tendencies, therefore man's mind is not so different from that of brutes.

Darwin's thinking is subtle and profound, but it is vulnerable to selective attention and misinterpretation. One theme that commanded attention at the time, and still does today, is the vision of a struggle for existence outlined in Chapter 3 of *The Origin of Species*. This has nature not as an idyllic English country festival but as a universal war in which every species reproduces as much as it can. 'Lighten any check, mitigate the destruction ever so little, and the number of the species will almost instantaneously increase to any amount.' For this reason the destruction wrought on every species by predators, disease, climate and others of its own kind was to be welcomed.

The frame of mind that sees a world of brutes as, well, brutal was deeply entrenched in the thinking of Thomas Huxley, Darwin's great champion. For Huxley, man's achievement, and his ongoing task, was to rise above our bestial past. Out of 'the darkness of prehistoric ages',

Today we can see that to take competition and struggle as explaining everything about life, including the motivations and psychology of highly evolved beings, is as mistaken as to suppose that because the pistons in a car engine move rapidly up and down *therefore* the motion of a car is also rapidly back and forth. This was far from obvious to many people, either at the time or now, although Darwin himself certainly saw that his theory was capable of accommodating the origins of morality and did not see any conflict between the harshness of the evolutionary process and the gentleness of its products.

man emerges with the marks of his lowly origin strong upon him. He is a brute, only more intelligent than the other brutes, a blind prey to his impulses, which as often as not lead him to destruction . . . he is attended by infinite wickedness, bloodshed and misery.

It was only, Huxley continued, by the power of reason and the 'marvellous endowment of intelligible and rational speech' that:

[man] has slowly accumulated and organized the experience which is almost wholly lost with the cessation of every individual life in other animals; so that he now stands raised up as on a mountain-top, far above his humbler fellows, and

transfigured from his grosser nature by reflecting, here and there, a ray from the infinite source of truth.

Dignity, in this view, was not inherited from our animal past but was won by our own ceaseless efforts. Underneath a thin veneer of 'civilization', animal urges – always cruel – never ceased to rage and had to be kept in check. But so long as these urges were contained, man could remake himself into virtually anything he wanted in accord with the dictates of reason.

This kind of thinking, together with the social Darwinism outlined by Herbert Spencer, has informed or reconfirmed prejudices behind much cultural and political thought and action right up to the present. The dualism which pits morality against nature and humanity against other animals is present in Sigmund Freud's thinking, which thrived on contrasts between the conscious and subconscious, the ego and the superego, Love and Death. Like Huxley, Freud saw struggle everywhere. He explained the incest taboo and other moral restrictions as results of a violent break with the freewheeling sexual life of the primate horde that had culminated in the collective slaughter of an overbearing father by his sons. Civilization, he argued, arose out of the renunciation of instinct, the gaining of control over the forces of nature and the building of a cultural superego.

The idea of titanic struggle also appealed to communists. Karl Marx was an early fan of Darwinism as he understood it. His Bolshevik and Maoist heirs (or debasers) took things to an extreme. In accordance with their scientific laws of history – and by sheer will, under the guidance of the Party – man was to be remade in the image of socialism. All who stood in the way of progress could justifiably be sacrificed.

The eagerness of the Soviets to prove that their methods were scientific and that they had a better grasp of evolutionary theory than the imperialists led to episodes that look today like something out of a forgotten story by Mikhail Bulgakov. In 1926 a scientist named Ilya Ivanov received approval for an experiment

to show that humans were descended from apes: he was to breed a human-chimpanzee, or humanzee. Ivanov travelled to a French research station in West Africa where he inseminated three female chimpanzees with human sperm. He didn't use his own because he shared the colonial belief that Africans were more closely related to apes than were Europeans. Ivanov stayed in Africa long enough to learn that his experiment had failed and then contacted a Cuban heiress, Rosalia Abreu, who had been the first person to breed chimps in captivity and had a large menagerie outside Havana. Ivanov asked if any of her male chimpanzees might be available to inseminate a Russian volunteer known to posterity only as G. (There was no issue, and G has disappeared from history.)

Social Darwinism was eagerly embraced by ultra capitalists in the United States, where it could be accommodated with religion or not according to taste. For John D. Rockefeller the triumph of the large corporation was 'merely the working out of a law of nature and of God'. For the avowedly atheist Ayn Rand, her world view was as much inverted Leninism as grossly trivialized Nietzsche: 'What are your masses but mud to be ground underfoot, fuel to be burned for those who deserve it?' All could worship at the church of the dollar, with or without God – a view crystallized in the words of Gordon Gekko in the 1987 film *Wall Street*: 'The point is, ladies and gentleman, that "greed" – for lack of a better word – is good. Greed is right. Greed works. Greed clarifies, cuts through, and captures the essence of the evolutionary spirit.'

Wall Street prefigured the financial culture that flourished in the 1990s and 2000s but it was made during the last hurrah of the Cold War and as such was a product of a culture that for decades had been underwritten by the threat of mutually assured destruction. Both the Americans and the Russians had the capability to launch attacks that would destroy most human and animal life within twenty minutes – something that the young Fidel Castro, tumescent with internationalism, had enthusiastically recommended to the Soviets in 1962. The best way

In *The Fog of War* (2003), the former US Defense Secretary Robert McNamara recalls a 1992 discussion of the missile crisis with the Cuban president:

'Mr President, I have three questions to you. Number one: did you know the nuclear warheads were there? Number two: if you did, would you have recommended to Khrushchev in the face of a US attack that he use them? Number three: if he had used them, what would have happened to Cuba?

[Castro] said, 'Number one, I knew they were there. Number two, I would not have recommended to Khrushchev, I *did* recommend to Khrushchev that they be used. Number three, What would have happened to Cuba? It would have been totally destroyed.'

to maintain that peace, American military thinkers had determined in the 1950s, was to follow game theory in which each player was a ruthless self-maximizer – the mathematician John Nash's 'Fuck you, buddy.'

Following World War Two it did not seem irrational to conclude that, far from being able to keep his bestial instincts under control, man was the killer ape *par excellence*. 'Civilization,' the Israeli prime minister Menahem Begin observed, 'is intermittent.' The sense that unending struggle is our essential reality is captured chillingly in the words of the Judge in Cormac McCarthy's 1985 novel *Blood Meridian*.

In the 1990s, the bosses of the Enron Corporation, inspired by Richard Dawkins' book *The Selfish Gene*, devised a system called 'rank and yank', which pitted employees against each other in an incentive and firing framework based on the idea that there are just two drivers in human behaviour: greed and fear. This turned into a self-fulfilling prophecy, creating a corporate culture defined by ruthlessness and dishonesty within and barefaced exploitation outside. Enron, which was run by George W. Bush's favourite business associate, imploded in 2001.

Another error rooted in partial truth was behaviourism, a twentieth-century version of the idea that man is a blank slate on which anything can be written. In George Orwell's novel *1984*, O'Brien tells Winston Smith: 'You are imagining that there is something called human nature which will be outraged by what we do and will turn against us. But we create human nature. Men are infinitely malleable.'

For Mao Zedong, the Chinese people were 'a blank sheet of paper ... the newest and most beautiful words [can] be written on [them], the newest and most beautiful pictures ... painted'. One consequence of his belief was the Great Leap Forward in which 20–45 million people starved to death. Nothing so terrible occurred in the West, but behaviourism continued to be influential until at least the 1970s when its most famous proponent, the psychologist B.F. Skinner, was still insisting that all mental activities were an 'explanatory fiction'. Internal psychological

experiences – thoughts, feelings, intentions, goals – were, he said, superfluous to any study of what actually governed behaviour and, implicitly, did not really matter.

Experiments to test the extent to which humans and animals were blank slates took their perpetrators down some dark corridors. In the late 1960s two American psychologists decided to find out whether the foundational bond of mammalian existence – that between an infant and its mother – could be broken. The psychologists placed newborn Rhesus macaques in cages with a series of cloth and wire dolls with vague resemblances to nursing mothers:

> The first of these monsters was a cloth monkey mother who, upon schedule or demand, would eject high-pressure compressed air. It would blow the [infant macaque's] skin practically off its body. What did this baby monkey do? It simply clung tighter and tighter to the mother, because a frightened infant clings to its mother at all costs . . .
>
> However, we did not give up. We built another surrogate monster mother that would rock so violently that the baby's head and teeth would rattle. All the baby did was cling tighter and tighter to the surrogate. The third monster we built had an embedded wire frame within its body which would spring forward and eject the infant from its ventral surface [i.e., its front]. The infant would subsequently pick itself off the floor, wait for the frame to return into the cloth body, and then again cling to the surrogate.
>
> Finally we built our porcupine mother. On command, this mother would eject sharp brass spikes over all of the ventral surfaces of its body. Although the infants were distressed by these pointed rebuffs, they simply waited until the spikes receded and then returned and clung to the mother.

The experimenters found that they could only successfully 'achieve psychopathology' (that is, cause

mental breakdown) in an individual monkey if they raised it from birth in complete isolation.

How could so many intellectuals, politicians, corporations and indeed whole societies get things so catastrophically wrong? Did Darwin? Towards the end of *The Origin* he had written that a consequence of his work would be 'far more important researches' in which 'psychology [would] be based on a new foundation, already well laid by Herbert Spencer . . . '. Spencer, the most celebrated philosopher in the world of his day, was, as has been mentioned, the originator of what we now call social Darwinism. In the event, however, Darwin's own researches were to lead him beyond the view of life as nothing more than a Malthusian struggle for existence. The ground is sketched in his next major work, *The Descent of Man* (1871):

> Any animal whatever, endowed with well-marked social instincts, the parental and filial affections being here included, would inevitably acquire a moral sense or conscience, as soon as its intellectual powers had become as well developed, or as nearly well developed as in man.

Darwin marshalled such evidence as he could find in support of this thesis:

> [My correspondent in Abyssinia] encountered a great [troop] of baboons which were crossing a valley: some had already ascended the opposite mountain, and some were still in the valley: the latter were attacked by the dogs, but the old males immediately hurried down from the rocks, and with mouths widely opened roared so fearfully, that the dogs precipitately retreated. They were again encouraged to the attack; but by this time all the baboons had reascended the heights, excepting a young one, about six months old, who, loudly calling for aid, climbed on a block of rock and was surrounded. Now one of the largest males, a true hero, came down again from the mountain, slowly went to the young

one, coaxed him, and triumphantly led him away – the dogs being too much astonished to make an attack.

With no full-time primate-watchers in the field, still less trained primatologists, reports like this could only be anecdotal, but it is characteristic of Darwin's good judgement that he put faith in them. In so doing he was going against the prejudices of his time (and not only his time: nearly a hundred years later Robert Ardrey was describing the baboon as 'a born bully, a born criminal and candidate for the hangman's noose'). We now know that many species of monkeys as well as apes often act altruistically and on occasion heroically, as in the story Darwin relates, on behalf of others who are not necessarily their kin. One case from the immense body of evidence assembled over the intervening years is that of a troop of Japanese macaques ranging free in the mountains which included a female named Mozu who was born without hands or feet. Despite the handicap, Mozu was fed and protected by her fellows. She lived a long life and successfully reared five offspring. Another example is a set of tests on Rhesus macaques held in laboratory conditions who consistently refused to pull a lever that would deliver them a reward when they saw that this caused pain to another monkey.

Baboons, which are significantly more intelligent than macaques, offer numerous instances of sympathetic and cooperative behaviour. One particularly striking example is that of a young female named Ahla who found employment on a farm in South Africa in the 1950s:

> When Ahla comes home in the evening after feeding, she will go . . . through a door to the lambs' enclosure. From here, she can only hear the adult sheep but not see them. Once she hears from inside the voice of a lamb that is calling for its mother, she will retrieve the correct lamb and jump through the opening . . . and put it underneath its mother so it can drink. She does this flawlessly even when several other mothers are

calling and several lambs are responding at the same time . . . She also retrieves lambs and brings them back even before mother and infant have begun calling. Mrs Aston [the farm's owner] noted that 'No [human] person would be able to assign correctly the twenty or more identically looking lambs to the mothers. But Ahla is never wrong.'

It would be as great as mistake to suppose that primates are always kind and gentle as to suppose that they are always ruthless and violent. Almost every species contains individuals and groups who commit acts of extreme violence against their own kind. (Such acts are usually rare but they are never random.) That said, there is evidence that sympathetic responses and the behaviours they engender are hard-wired into the primate brain. The now-famous 'mirror neurons', for example, which fire in our brains both when we perform a specific action and when we see others do the same thing, were first discovered in the brains of Rhesus macaques.

What is true of monkeys is equally true of Man. As Lord Monboddo's contemporary Adam Smith put it at the beginning of his *Theory of Moral Sentiments*:

How selfish soever man may be supposed, there are evidently some principles in his nature which interest him in the fortune of others, and render their happiness necessary to him, though he derives nothing from it except the pleasure of seeing it.

Prose of this calibre can almost set a circle of virtue rolling by itself. But whether or not humans express and act upon the sympathetic emotions depends on context, as Smith well knew. Certainly, we are able to cooperate with each other for longer and on more complex tasks than any other species of primate and – in contradiction to what anthropologists used to believe – kinship is often by no means the only or even the main determining factor: reputation and reciprocity can be more important. It's also the case that we tend to place an extremely high value on

A new-born macaque 'mirrors' an adult human sticking out his tongue.

what we see as fairness. But these characteristics are not necessarily determined by generosity of spirit: we also calculate what is in our own best interests as far as we understand them. And there can, of course, be a darker side to our cooperative urges. On occasion, many of us accept norms that require us to crush whatever empathy we may feel. The tendency to stick to the rules can trump everything else. Such, at least, is the implication of the experiments conducted by Stanley Milgram in the early 1960s. He showed that around two-thirds of his subjects – ordinary people – were prepared to administer electric shocks up to and including what they had been led to believe were lethal levels to another person who failed a memory test because they were told by a figure of authority that it was the right thing to do. (In reality, the other person was unharmed.) Milgram had predicted that only 1 per cent of subjects would follow the order, and that they would be psychopaths.

Our biological nature, says the primatologist Frans de Waal, who coined the term Machiavellian intelligence, 'holds us on a leash and will only let us stray so far from who we are. We can design our life any way we want, but whether we will thrive depends on how well the life fits with human predispositions.' So what are those predispositions? 'Like other primates,' says de Waal, 'humans can be described either as highly cooperative animals that need to work hard to keep selfish and aggressive urges under control, or as highly

competitive animals that nevertheless have the ability to get along and engage in give-and-take.' Another way of putting it is that we have two 'inner apes'. One is a 'hierarchy enhancing personality', which believes in law and order and strict measures to keep everybody in place. The other is 'hierarchy attenuating', meaning it seeks to level the playing field. For de Waal, the point is not which tendency is more desirable, because it's only together that they create human society as we know it; 'our societies balance both types, having institutions that are more hierarchy enhancing, such as the criminal justice system, or more hierarchy attenuating, such as movements for social justice.'

Much of what de Waal says is plausible, but in that last assertion he conflates two different things. Individuals and institutions are not the same, and in so far as the latter have personalities they are a result of the process we generally call 'politics.' And communities of individuals can, perhaps, deliberately create institutions in which the less aggressive and more cooperative parts of our individual personalities are to the fore. This – ironically or not – may be what Machiavelli himself was trying to do. There is a school of thought that says *The Prince* is a satire, one of the first in a tradition that includes Jonathan Swift's *Modest Proposal*, which advocated the consumption of 'surplus' babies, and George Orwell's dark visions of subjugation. On this account, *The Prince* is the *1984* of 1513. Machiavelli's own beliefs are actually better reflected in his *Discourses on Livy*, a work less well known today, which argues that a republic in which people can speak and contend freely and peacefully is a far superior form of government to despotism.

Whatever Machiavelli's own hopes, the imago that he made has remained compelling for 500 years. Our world appears to be no less corrupt and characterized by the abuse of power than it was in the age of the Italian city states. The only difference is that the special interests, classes, ethnic groups and nations operate on a larger scale. Is such pessimism mistaken? Some contemporary scientists and thinkers seek evidence for a more hopeful view. The linguist Steven Pinker argues that human societies are becom-

ing steadily less violent over time. The neuroscientist David Eagleman says the new forms of communication, conflict resolution and smart decision-making facilitated by the Internet may allow our civilization to elude the fate of earlier ones. How well founded these claims are has yet to be seen. The philosopher Derek Parfit may be onto something when he says that it is possible to identify an objective basis for ethical action. This does not mean, however, that we will actually do what is objectively right. More convincing, perhaps, is the argument made by the mathematician and biologist Martin Nowak, who says that the anarchist Prince Peter Kropotkin was right: mutual aid *is* a factor of evolution. In Novak's terminology, cooperation – 'the snuggle for existence' – is the third pillar of evolution along with mutation and natural selection. This truth alone does not, however, guarantee our future well-being; cheaters and defectors will always seek opportunities to exploit cooperators. The key factor in determining an outcome is the relative rate at which cooperators meet up with other cooperators, and defectors gang up with other defectors. And this, argue Nowak and others, is something that we *can* do something about.

The Earth systems scientists Tim Lenton and Andrew Watson say that there have been eight major revolutions in the nature of life since it began: cellular compartments; chromosomes; the genetic code; eukaryotes; sex; cell differentiation in eukaryotes; truly social colonies; and human language. Each revolution was different but they share essential features: each involved major reorganization of the Earth system as a whole, and with each the system moved stepwise towards greater energy use, greater recycling efficiency, faster processing of information and higher degrees of organization. But, say Lenton and Watson, each revolution was also characterized by near-catastrophe, with no certainty of a successful outcome. The revolutions only appear inevitable because we would not be here if they had failed. The consequences of the most recent of them – the development of complex symbolic (natural) language by humans – is still being played out.

Parfit says that what matters now is that the richest societies should cut back on the consumption of luxuries, cease to overheat the Earth's atmosphere, and take care of this planet in other ways so that it continues to support intelligent life.

One of Gyatso's most astute political moves may prove to be the appointment (or even the election) of a new spiritual leader of the Tibetan people under what is known as the emanation system. This means that another adult would be able to take charge immediately upon Gyatso's death: a home run around the Chinese Communist Party, which has declared itself supreme in the matter of reincarnation.

When somebody finally plucked up the courage to tell the Dalai Lama the joke about what the Dalai Lama said when he walked into a pizza seller's ('make me one with everything'), he didn't get it. But Tenzin Gyatso, as he is named, is a wily old bird. Concerned about the fate of the oppressed and exiled Tibetan people, Gyatso once asked Elie Wiesel what had helped the Jews. Wiesel identified three things: a book, solidarity and memory. If, as a global community, we are serious about protecting what is best in ourselves we too might look to such things. To promote solidarity across tribal boundaries it would help if the book were less amenable to sectarian interpretation and contained more truth about the world than the Bible. No book answers this requirement better than the 'book of life' itself, which humans are beginning to read, and in which the common origin of all of us is plain to see. Like any good story it demands moral imagination because it requires us to consider how other animals are like us and how they differ. As Anton Chekhov is reported to have said, 'Man will become better when you show him what he is like.'

A better understanding of the book of life could enhance our appreciation of our responsibility towards other living beings, not least the primates to whom we are so closely related. The twenty-first century is a bad time for most of them. Rhesus and Japanese macaques may be doing alright for now, but about half of the 634 extant species of monkeys, ape and lemurs are in imminent danger of extinction. You could, says one study, fit every individual of the world's twenty-five most endangered species in the seats of a single football stadium and have plenty of seats to spare.

One of the species that has little prospect of surviving in the wild is the most gentle of apes, the orang-utan. Already, a large proportion of the small number that remained until recently in the rainforests of Indonesia have been burned to death or otherwise killed. Thinking of this, I recall John Berger's observation of one mother and child orang-utan at the zoo:

Suddenly, I think of a Madonna and Child by Cosimo Tura. I'm not indulging in sentimental confusion. I haven't forgotten I'm talking about apes any more than I've forgotten I'm watching a theatre. The more one emphasizes the millions of years, the more extraordinary the expressive gestures become. Arms, fingers, eyes, always eyes . . . A certain way of being protective, a certain gentleness – if one could feel the fingers on one's neck one would say a certain tenderness – which has endured for [millions of] years.

There is little chance that humans will become totally benign in future: little chance that the 'cuckoo clocks and no Italian Renaissance' vision of boredom that Harry Lyme derides in *The Third Man* will come to pass. And in any case, as the philosopher Anthony Appiah drily notes, it's likely that there will be slave owners or slave traders on both sides of your family ancestry. But science, in its most complete sense of knowledge and imagination fully applied, is on the side of 'the better angels of our nature' because it requires complete honesty and the constant search for better ways not to fool ourselves. Or else we are no wise monkeys.

KÌRÌPʰÁ-KÒ AND TʰÌK'ÌLÍ-KO: THE HONEY BADGER AND THE HONEYGUIDE

The Honey Badger, or Ratel
Mellivora capensis

AND *The Greater Honeyguide*
Indicator indicator

Phylum: Chordata
Class: Mammalia
Family: Mustelidae
Conservation status: Least Concern

Phylum: Chordata
Class: Aves
Family: Indicatoridae
Conservation status: Least Concern

Cet animal est très méchant. Quand on l'attaque il se defend.
French maxim

Quick, said the bird, find them, find them,
Round the corner. Through the first gate,
Into our first world . . .
T.S. Eliot, *Burnt Norton*

'We don't need no stinking badges,' appeared in *The Treasure of the Sierra Madre* (1948) and is reprised in *Blazing Saddles* (1974). In Basra, evidence later emerged that some British units had engaged in brutal treatment or torture of at least 200 prisoners and killed a number of them.

Basra in July is hot. Daytime temperatures regularly top 40°C (105°F) and sometimes reach 50°C (122°F). The year 2007, the fourth year of the British occupation, was no exception, and the heat was matched by horrendous violence. Militias had taken control of large parts of the city and were hauling women off the streets and dumping their dead bodies in gutters for the crime of not covering their faces. British troops, who had taken Basra in just a few days in 2003, had largely withdrawn to the relative safety of a fortified base at the airport. Rumours started to circulate among Basrites of animals with heads like monkeys and bodies like dogs that rampaged at night. These beasts had torn a living cow to pieces. They had broken into sleeping homes, terrifying the inhabitants and easily dodging hails of retaliatory bullets. Some people said that the British had unleashed specially trained badgers on the civilian population in revenge for their humiliation. The British denied it. 'We can categorically state that we have not released man-eating badgers into the area,' deadpanned an Army spokesman. One blogger glossed this as, 'We don't need no stinking badgers.'

Like many urban myths, there was some reality at the heart of this episode. The Honey badger (*Al Girta* in Arabic), though only the size of a small dog, *is* fierce and fearless; one might call it the pit bull terrier of the badger world except that it is lither and even more muscular. It looks more like a cross between a

THE BOOK OF BARELY IMAGINED BEINGS

weasel and miniature bear than the cuddly European badger. And it *can* be trained by humans, although tame ones are usually friendly and playful. But if Honey badgers were causing a spot of bother in Basra that summer it is more likely that this was because the war had driven them out of their natural habitat, the scrub and marsh around the city, than that they had been recruited by perfidious Albion.

Garbled stories about the Honey badger are nothing new. In *The Histories*, written in the fifth century BC, Herodotus tells of a ferocious animal in the deserts of India, larger than a fox and smaller than a dog, which digs for gold in the sands. When people go to raid the gold, he writes, they must ride their swiftest camels and flee while the animal is still mustering its forces because these can outpace all but the swiftest camels. If this story (which is reproduced in the *Physiologus*, a sixth-century AD sourcebook for medieval bestiaries) has any ground in reality then the animal in question is most likely the Honey badger, rather than, as some have suggested, the marmot: a large but timid rodent that likes to burrow in sand. (Adding to the confusion, the animal is described as a kind of 'ant' but this is probably the result of an etymological muddle.) Honey badgers still live in wilder places in India, and the 'gold' may have referred to the honey they crave (yes, that's why they have the name) and which is sometimes found in holes in the ground colonized by bees.

Modern zoologists confirm that the Honey badger can be as ferocious in real life as it is in tall stories, whether from India 2,500 years ago or Iraq in 2007. The most authoritative guide to the animals of East Africa (for the animal has a wide range: its Latin name *Mellivora capensis* means 'honey eater of the Cape [of Good Hope]') reports that the Honey badger can drive lions away from the carcass of a wildebeest. Thick, loose skin around its throat protects it from the bites of other Honey badgers. To get around this obstacle, Honey badgers have been observed biting the testicles off rivals, who subsequently bleed to death. It is almost immune to bites from extremely venomous snakes and is largely indifferent to bee

Another English name for the Honey badger is the Ratel (rhymes with 'startle'), which is derived from the Afrikaans for 'honeycomb'.

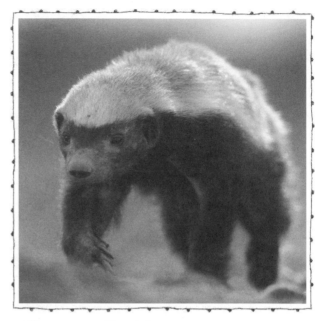

The crazy, nastyass Honey badger.

stings. In any case it can usually send a swarm of angry bees reeling with a secretion from a gland near its anus that has an overpowering stench. For a less technical description, find the video 'The Crazy Nastyass Honey Badger' on the web.

Honey badgers are also protected from bee stings and other insults by dense fur which varies in colour according to which of sixteen subspecies the animal belongs. Some are almost completely black but most are only black on the underside while their upper fur ranges from grey to off-white. At least one subspecies looks as if it has put its head into a tin of white paint, while another has a handsome white line down each side. Honey badgers are mostly solitary but sometimes live in a pair. (All badgers, by the way, are members of the mustelid family, which includes otters, weasels, martens, polecats and wolverines.)

Tough as it is, the Honey badger is ultimately vulnerable to the destruction of its habitat and to being hunted down by people who do not appreciate its depredations of their chickens and its taste for the

honey in their hives. Still, I'd like to think that this ornery hellion could be one of the few fair-sized mammals with a good chance of surviving the worst that humans can throw at it in the twenty-first century without cosseting from conservationists. It would be nice to have animal company that is not under our thumb and has more charisma than the cockroach, the super-rat and other 'super species' which, some predict, will dominate a degraded future environment.

We should also esteem the Honey badger because of its enduring partnership with the Honeyguide, a small bird of the woody savannah of East Africa. The Honey badger's relationship with the Honeyguide resembles, and may even have been the model for, one which humans have also developed with this bird and which may have been important in making us what we are.

The Honeyguide, or *Indicator indicator* (yes, really), is distinguished more by its name than its appearance: it is small and fairly drab-looking. It has an appetite for beeswax but is too small to breach a hive and doesn't like getting stung, so it has found a way to get badgers and humans to do the hard work on its behalf. (The badger or the human gets the honey as pay-off.) To do this it acts as follows. It lands on a branch near to its intended helper and makes a series of distinctive, repeated calls. Once it has the animal's or the human's attention, the Honeyguide performs a series of short, swooping flights in the direction of the hive, alighting frequently on trees along the route, flashing its light-coloured tail feathers to make sure its companion can see it, and returning to its previous position if he fails to follow. Arrives at the hive, it gives a call that is easily distinguishable from earlier ones, and waits patiently for the groundling to crack open the hive, take the honey and leave the beeswax behind.

The Honey badger loves honey but is not known to take any special trouble to locate the Honeyguide. Humans, however, have taken the partnership a stage further by learning to let the bird know where they are in the first place. The Boran people of

northern Kenya and southern Ethiopia use a penetrating whistle called the *Fuulido* which can be heard over a kilometre away to summon it. This is reckoned to double the rate of encounters. With the Honeyguide's help, the Boran typically find a hive in about a third of the time it would otherwise take – an average of about three hours rather than nine.

We will probably never know whether humans first learned to follow the Honeyguide by watching it interact with the Honey badger or whether they learned from – perhaps one should say *were taught by* – the Honeyguide directly. Nor is it ever likely to be possible to determine when people in East Africa, where the practice is observed today, starting following the bird. The earliest European record dates from their arrival in the area in the seventeenth century but rock carvings show it was happening at least 2,000 years ago. There is, however, evidence consistent with a much longer history than that – one that may date back to the beginnings of fully modern humans.

A clue may be in the names given to the Honey badger and the Honeyguide by the Hadza people of Tanzania, and used to title this chapter. The Hadza language is probably one of the oldest in continuous use, and their names for these creatures – *Kìrìpʰá-kò* and *Tʰik'ili-ko* – may have an etymological connection to each other. Hadza ancestors may have been among the first modern humans to describe the partnership between badger and bird. Perhaps they were among the first to copy it too.

This suggestion is speculative but it is not unreasonable. The ancestors of today's Hadza have probably lived in the same place for fifty thousand years, and perhaps much longer. (This is far longer than most neighbouring ethnic groups; the Hadza's closest relatives are the Bushmen of southern Africa, and both are among the oldest genetically distinct groups of humans.) In all of that time they have been hunter-gatherers – raising no crops, keeping no livestock, and making no permanent shelters. What we can say for sure is that the Hadza value honey highly (about 80 per cent of their diet by weight is vegetable matter

Genetic and linguistic evidence suggests that the first split between the ancestors of two extant populations of *Homo sapiens* may have been the one that occurred between those of the Hadza and the now geographically distant San peoples, or Bushmen of southern Africa.

THE BOOK OF BARELY IMAGINED BEINGS

such as wild tubers and berries, but the 20 per cent obtained from honey and meat is disproportionately significant as a source of energy and nutrition), and it is likely their ancestors have been following the Honeyguide ever since they discovered that it saved a lot of time to do so.

Getting one's tongue around the clicks and stops in the Hadza names for the badger and the bird is hard. To be honest, I don't think I have. But I want to try because I think it is a way of showing respect to the Hadza people and also because it is a means of calling to mind some profound and important things about how human cognition and language are embedded in the relationship with the natural world.

On the matter of respect, anthropologists and other outsiders who have spent time with the Hadza marvel at their physical and mental toughness. The live in an environment that is so harsh that until recently no one else wanted to seize it, and they do so joyfully. They have resisted concerted attempts by first the colonial administration and then by the Tanzanian Government to settle them against their will. More recently, they have faced a land grab on behalf of foreign interests. In their way, the Hadza are as stubborn as any Honey badger. They are also, however, tender and gentle – at least for most of the time – with each other. According to the anthropologist Sarah Blaffer Hrdy, whose work on shared parenting has revolutionized thinking on how humans care for and love each other, Hadza women and men share activities like childcare to a greater degree than most other groups of humans. (The adults of both genders find time to relax as well: in the case of the men this seems to largely consist of sitting around and gambling with poisoned arrows.) We should also respect the Hadza because fewer than a thousand now follow the traditional ways, and without active outside support the chances that these survivors will be swept away are even greater. Words such as *Kirìpʰá-kò* and *Tʰik'ilí-ko* may outlast the people who created them. In remembering the words we can honour the people who have followed what are probably the oldest extant ways of human being and knowing in the world.

Chapter 8 of this book ('Human') explored the case for a common origin for language and music. But whatever the relationship between those two really is, language surely has several roots. And the Hadza's interaction with T*ik'ili-ko, or Honeyguide, is a tantalizing piece of circumstantial evidence suggesting that the ways of communicating that define us as humans have developed at least in part as a result of partnership with other animals. Perhaps representation, story and performance have an origin in the kind of bird/man interaction we can still see between man and Honeyguide today. For the Hadza, who do not keep livestock or pets, this kind of partnership may be as close a relationship with another species as they have had. It is a kind of relationship that predates and differs from our concept of tameness. It is, after all, one of near-equals. It may be a good example of what the poet Edwin Muir called 'the long lost, archaic companionship' between human beings and other creatures.

'Tameness', suggests the biologist Tim Flannery, is only a faint echo of the first relationship that humans had with many animals in many parts of the world.

Anthropologists report that the Hadza like to celebrate a successful day with the Honeyguide in a 'traditional drama' in which one man whistles the part of the bird while another takes the part of a man following and imitating the bird's whistles. (Similarly, after the killing and sharing of an animal carcass, which may be anything from a baboon to a giraffe, Hadza men will tell the story of the kill, especially if it has been difficult or dangerous.) Such re-enactments are probably among the oldest forms of entertainment and, along with the partnerships they celebrate, may have played an important role in the development and refinement of human language in the first place. Language is at least partly rooted in attending to the calls of other creatures such as the Honeyguide or minding the signs that they leave (such as the tracks of prey), and is made more reflexive and enriched by retelling and celebrating those calls and signs.

An adequate description of human language and an account of its significance could fill many books. If you had to be brief, though, you could do worse than 'a system for encoding and decoding information that uses a large vocabulary, a rapid and robust transmission

system, and the ability to combine words by means of fixed rules to create a virtually infinite set of meanings'. Most linguists think that, whatever is claimed for dolphins, no animal apart from man has language in this sense, and that language increases our capabilities so greatly that we really are 'a different thing' from other animals. By some accounts, the development of language is as momentous as the evolution of DNA itself.

For much of the time since the study of language emerged as a formal discipline, theories as to its origin and evolution have largely been 'just-so' stories that could neither be proved nor disproved. In the last few decades, however, discoveries in genetics and archaeology mean that these theories have become increasingly testable. In 2001, for example, it was suggested that a small variation in a gene known as FOX2P that was apparently unique to modern humans played an important role. This new variant seems to have swept rapidly through the entire human population less than 200,000 years ago. (A few people alive today without a working copy have great difficulty with aspects of language and speech.) More recently, however, there has been evidence to suggest that Neanderthals also had the new variant. This suggests either that they were capable of language and speech very much like our own or that the gene is only one of several factors that make language possible.

A likely resolution to this matter may come from closer examination of the archaeological record. The anatomy of the species we call *Homo sapiens* has changed hardly at all in the last 200,000 years. 'Behavioural modernity', however – which includes the manufacture of very finely worked tools, long-distance trade and the creation of art and symbols – only started to emerge about 100,000 years ago, and (the archaeology shows) was only embedded irreversibly in all the human populations that have left descendants 50–40,000 years ago. The development of language as we know it was almost certainly essential to the kind of 'cognitive fluidity' that made these new behaviours possible.

Whatever the precise trajectory of the origin and development of language, it did not take place in a

Earlier members of our genus must have had ways of communicating and cooperating that allowed them to persist and expand over large areas of Africa and Eurasia before one million years ago despite their physical weakness as individuals in comparison to many other animals. Their protolanguages would, at various times, surely have included many or all of the elements that go to make what we consider fully evolved language.

vacuum. The Hadza and other pre-agricultural peoples remind us that humanity evolved in commun(icat)ion with other animals as well as with each other. Though their lives were and are brief, and very tough, the way of the Hadza enacts something at the core of our being. As David Abram puts it, 'We are human only in contact, and conviviality, with what is not human ... the complexity of human language is related to the complexity of the earthly ecology – not to any complexity of our species considered apart from that matrix.' This is one of the reasons why the destruction of the few remaining Stone Age cultures such as the Hadza is such a terrible thing.

People are capable of applying the languages of our so-called advanced civilization to a stupendous variety of ends, some of them beneficial. Henry David Thoreau honed it into an unsurpassed tool for merely noticing, recording in his journal even as he neared his death how rainfall on stones tells the way that the wind had passed. But our languages also have obvious limits. We have a tendency, as the Chinese poet Wang Wei said, to 'roam the delusion of words'. And even in the best case there is a gap between what we know of the richness of experience and the narrow, linear bandwidth language affords. This is also true of our other forms of symbolic communication such as picture- and map-making, which may go back as far as language. Perhaps our linguistic and cognitive maps are as yet little more advanced than the Erdapfel, a beautiful globe made in Germany in 1492, before Columbus had returned from his first voyage and which has no representation of the Americas on its surface.

In future, perhaps, better means of communication will become available to us. But what will they need and what may they miss? With that greater power will come the greater ability to abuse it. We would do well to recall a text written in Basra in the tenth century for a Sufi brotherhood dedicated to the peaceful pursuit of knowledge and wisdom. In *The Animal's Lawsuit Against Humanity*, the creatures protest before the court of the King of the Djinn against their treatment by humans. The court concludes that the latter have no licence to enslave and destroy.

Taking this lesson on board, we may better appreciate that some things that matter can only be fully experienced when we are not entirely reliant on our own symbolic representation of them. Birdsong is a good example. Our species came to self-awareness surrounded by birds, observes the writer Graeme Gibson. Perhaps there is truth in the poetic thought that paying attention to birds, being mindful of them, is being mindful of life itself. But we'll need the toughness of the Honey badger and the agility of the Honey guide to survive, and we should celebrate and honour them both.

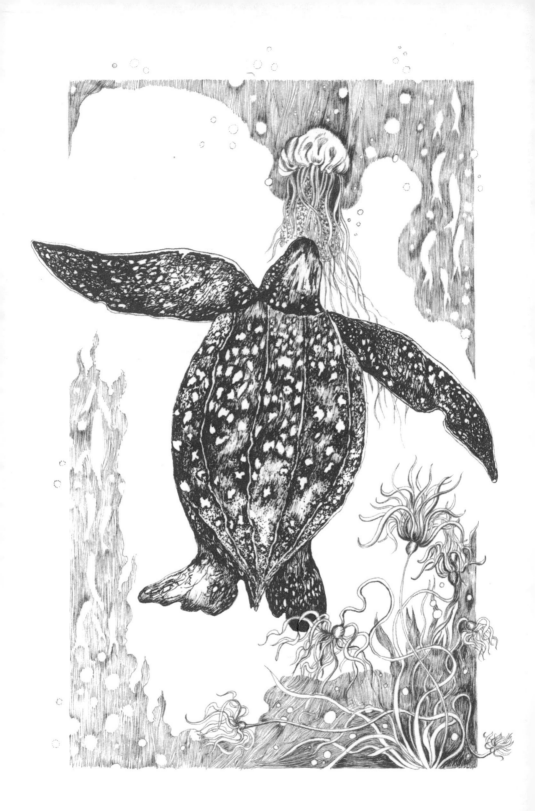

LEATHERBACK
TURTLE

Dermochelys coriacea

Phylum: Chordata
Class: (Sauropsida) Reptiles
Order: Testudines
Conservation status: Critically
Endangered

The perpetual ideal is astonishment.
Derek Walcott

T he stars are largely hidden by clouds. Behind us the forest is steaming. In front of us the beach and the surf are grey and indistinct – visible only a few metres in each direction but audible far into the distance as waves slap and roll on the sand. Hours pass and then blobs of concentrated darkness begin to emerge through the roar, hiss and bubble of the shallows. Leatherback turtles are coming ashore to lay their eggs on a beach in West Papua, Indonesia, which is one of their last known nesting sites in the entire Western Pacific. It is July 2006, and I am part of a small group come to watch this increasingly rare event.

At sea, where they spend more than 99 per cent of their lives, Leatherbacks are fast and powerful swimmers. On land, though, gravity crushes down on them; their own mass – often half a tonne or more – becomes a cruel joke. They (and their eggs) are absurdly vulnerable to human hunters and their dogs. As well-wishers we stand well back while the first Leatherback to come ashore begins to lever her body, almost as big as a small car, up the beach on her huge front flippers. Each move forward seems to require enormous effort, and she stops frequently, breathing hard and deep. I am reminded of a workman levering an enormous stone, or my own experience carrying a

heavy pack above 5,500 metres in the Himalaya range, where every step was like hauling a grand piano.

Satisfied that she is high enough up the beach that seawater will not seep through the sand and drown her nest, the Leatherback starts to dig her nest. With her front flippers – so large they would better be called wings – she starts to scoop away sand. Left flipper, right flipper, pushing backwards in powerful arcs. Sometimes her limbs cut too deep into the sand so that they get stuck, sometimes they fail to get a proper purchase and jerk backwards sending a thin spray of sand through the air. It all looks a little clumsy but the action is more efficient than it looks and soon she has dug a shallow depression large enough to cup her body. Then she starts on the most delicate stage of the process: digging a chamber for her eggs. By this time, we are told by our expert guide, she has gone into a trance-like state and is oblivious to human presence; so it's possible to get close and even to touch her shell without disturbing her. (I do and she's warm.) She now digs with her back flippers, which are much smaller, more flexible and almost delicate in comparison to her front ones. These rear limbs actually resemble human arms as they would look if they were flattened, broadened into paddle shapes and gloved inside elephant skin. Working entirely by touch – the rear fins are quite out of sight to the turtle herself – she excavates a deep, narrow-necked jug-shaped hole in the damp sand. The precision and dexterity with which she reaches down and scoops out sand and then pats the inside of the chamber to make its sides firm is as great as that of a master potter or sculptor. When, finally, she is satisfied with the result, she extends her fleshy, beak-like ovipositor into the jar and slowly lays her eggs: several dozen of them, white ping-pong balls in a rich, transparent mucus. When she's done she covers the chamber, gently at first with the back flippers and then, turning slightly, using her powerful front flippers to move large amounts of sand. Finally she sends showers of sand flying in random directions, perhaps in an attempt to conceal the site of the nest.

Touching this Leatherback holds all the magic of

'Natural Selection...is as immeasurably superior to man's feeble efforts as the works of Nature are to those of Art.' (Charles Darwin, *The Origin of Species*)

childhood. The animal is vividly alive in a realm that is largely beyond our reach and our imaginations. Later, I recall a phrase attributed to Zhuangzi: 'all the creatures in this world have dimensions that cannot be calculated'.

Every member of our small group – scientists, conservationists, photographers and others from rich industrial countries – are in a state of euphoria and awe, jumping around like children. These animals are as beautiful and extraordinary a sight as we may hope to see in our lifetimes. They are also very strange. The front flippers: gigantic, proportionately, as those of a humpback whale. The shell: streamlined so that the whole body is shaped like a tear or an almond, but with seven long ridges from head to foot resembling the ribs on the back of a lute. The leathery surface of the shell: dark grey to black and mottled with whitish spots, it feels like rubbery leather or the dense foam of a computer mousemat. The anapsid skull: snub-nosed like an artillery shell, shockingly powerful and primitive. The beaky mouth: wrinkled with two horn-like kinks and slots. The throat – we know but cannot see – is densely lined with sharp, backward-facing spikes: parts of a formidable kit for snaring and swallowing jellyfish. (Bland, noxious or highly poisonous for humans, jellyfish are bread and butter to a Leatherback.) The thick tears falling from her slanting eyes – so easy for humans to misinterpret; they are actually a way for her to excrete the salt taken in with her diet. With every breath, every rise and fall of the shell, you can sense the size of the lungs and an extraordinary strength. A crocodile this size would terrify us, but because we know this beast is harmless we feel no fear.

Looking back on this encounter I wonder how much we learned and whether it matters. Certainly, we were awed by the *presence* of the Leatherbacks. But our emotions and thoughts were also shaped by prejudices, assumptions and events of which we were only peripherally aware, if at all. We saw ourselves as 'good' people even though we are the beneficiaries of a civilization that is destroying these animals. It was too easy to turn the spotlight of blame for environmental destruction on *other* people – for example

One of the names for Leatherback in Spanish is *tortuga laud*: lute turtle.

THE BOOK OF BARELY IMAGINED BEINGS

those directly involved in stripping the indigenous people of their rights and the surrounding land and seas of their resources. We had our private joys and griefs, our public sentimentalities and imprecations. But what, really, were we seeing and touching?

'Life in the oceans must be sheer hell,' declared Werner Herzog in one of his gloomier phases; 'a vast, merciless hell of permanent and immediate danger. So much of a hell that during evolution some species ... crawled, fled onto some small continents of solid land, where the Lessons of Darkness continue.' But this framing says more about the legendary German film director than it does about the natural world. In truth, land-based species have been returning to the oceans for more than 200 million years, and once there, flourishing and proliferating into a variety of astounding forms. For tens of millions of years during the middle of the period we call the age of the dinosaurs, sea reptiles such as ichthyosaurs, plesiosaurs and mosasaurs roamed from the Arctic to the Antarctic, frequently evolving to enormous size. The end Cretaceous catastrophe that killed the dinosaurs 65 million years ago did for these animals too and the oceans were quieter for a while, but within fifteen million years or so the ancestors of dolphins and whales were exploiting the rich seas of the Eocene. Sirenia (sea cows), pinnipeds (seals, walruses), sea otters, penguins, marine iguanas and others which started on land followed. For all its dangers, the sea is a good place to be: a place for lessons of life as well as death.

Sea turtles were early movers in this re-invasion, and have been the most enduring. Their last terrestrial ancestors probably lived about 225 million years ago at around the time dinosaurs were beginning their 160 million-year reign and all the world's continents were fused into Pangea – the original turtle island long ages before North America acquired the name. By about 220 million years ago a species called *Odontochelys* was spending much of its life in shallow seas. This animal, whose name means 'toothed turtle with a half shell', had bony plastron on its underside but no carapace on top (perhaps it was leathery instead). Over the next

British English distinguishes: tortoises, which live all their lives on land and have flat feet; terrapins, which live in fresh water and have fins, and turtles, which have fins and live in the sea. In American English they're all turtles. Some languages have especially felicitous names for tortoises. In German they're called *Schildkröte*, which means shield-toads and in Hungarian *tecknösbéka*, which means bowl-frogs.

hundred million years, as Pangea split and the continents started to drift apart, successors to this proto-turtle, or species very like it, proliferated. Many had a full bony jacket – the top and bottom body armour with which we're familiar. But others evolved to have just a tough skin stretched over a lattice of bone. *Archelon*, the biggest known, grew to more than four metres (thirteen feet) across – larger than the turret of a modern main battle tank. Thanks to its relatively light frame, *Archelon* was fast and had a good chance of not meeting a premature end as lunch for a mosasaur (perhaps the most ferocious marine predator of all time). And with a large beaky mouth it clearly thrived on the living bouillabaisse of the Cretaceous ocean.

The Leatherback (which resembles *Archelon* in having a leathery skin stretched over a bony frame, but is probably not descended from it) evolved between 110 and 90 million years ago and has changed little since. Individuals very like the ones we saw laying eggs on a beach in Papua were doing the same thing when *Tyrannosaurus rex* (rather than today's shadow of ethnic cleansing and ecological devastation) was lurking in the forest behind us. They swam through seas covering what are now the Sahara and Great Plains of North America.

Somehow, Leatherbacks and the ancestors of the other living sea turtles survived the Cretaceous extinction that killed off almost all other large reptiles except crocodiles. Superb hydrodynamic form and an undemanding palate probably helped. The ridges on a Leatherback's shell act like keels, stabilizing the body, improving water flow and increasing swimming speed. As a consequence it can propel itself with its huge front flippers with very little effort over great distances, and guzzle its own body weight in jellyfish in a day. (Jellyfish are low in energy and nutrients – weight for weight, about 2 per cent that of fish – but found just about everywhere. One Leatherback was observed to eat sixty-nine Lion's mane jellyfish in three hours. A typical Lion's mane is about the size of a car tyre, although they can grow much larger, and weighs about 5 kg.) The Leatherback can also generate heat as it moves and once it reaches a decent size it can retain that heat under a thick layer of fat. This enables it to swim further north and south

into colder waters than any other living reptiles, and harvest the jellies. (Adult males, which are usually bigger than females, generally retain heat better: the largest individual recorded was seen on the coast of Wales.) It is one of the deepest-diving vertebrates too; perhaps only Sperm whales go deeper. And thanks to an ability to sense lines in the Earth's magnetic field it is a superb navigator, able to find its home beaches after travelling halfway across the planet and back. Long before the Central American seaway was closed by continental drift, the Leatherback spread around the globe to the regions we now call the Pacific, Indian and Atlantic oceans and the Caribbean Sea.

Much of what we now know about the Leatherback – the location of many of its major nesting grounds, the fact that small changes in temperature determine the gender of its offspring, the scale and nature of its migrations – has come to light in just the last few decades. It was only in 2006 that scientists learned that some individuals regularly swam all the way from beaches in Southeast Asia such as the one I visited to the coast of North America and back, covering tens of thousands of kilometres on their journeys.

But these remarkable discoveries have not been made in some pristine space. Today, the plight of the Leatherbacks is dire (as, in varying degrees, are those of the other six extant sea turtles: the Flatback, the

A baby Leatherback turtle heading for the sea.

Green, the Hawksbill, Kemp's Ridley, the Loggerhead and the Olive Ridley are all classified as threatened). 'To list the many ways they die is to despair,' writes one reporter: 'tangled and drowned in fishing gear, choked on drifting plastic bags, struck by ships, slaughtered for meat, doomed even before they can hatch when nests are dug up and the eggs sold as food or aphrodisiacs.' By the year 2000, with data suggesting a 90 per cent fall in numbers in the previous twenty years, scientists were predicting their imminent extinction. Further, their recent precipitous decline follows a longer historical trend: people have been steadily eliminating large populations of Leatherbacks and other turtles for at least the last five hundred years. Early European accounts describe teeming abundance that sounds like crazy exaggeration today, but modern biologists say there is good reason to believe that in many cases these accounts are true. Sailing among the islands of the Jardines de la Reina off southern Cuba, Christopher Columbus and his crew were amazed:

> Throughout the voyage they saw that there were many turtles and very large. But in these twenty leagues, they saw very many more, for the sea was all thick with them, and they were of the very largest, so numerous that it seemed that the ships would run aground on them and were as if bathing in them.

Later European colonists marvelled at the turtles' navigational abilities. In *The History of Jamaica* (1774) Edward Long writes:

> The instinct which directs the turtle to find these islands, and to make this annual visitation with so much regularity, is truly wonderful. The greater part of them emigrate from the gulph of Honduras, at the distance of one hundred and fifty leagues, and, without the aid of any chart, or compass, perform this tedious navigation with an accuracy superior to the best efforts of human skill; insomuch that it is affirmed, that vessels, which have lost their latitude in hazy weather,

The story for giant tortoises on land was similar but it happened longer ago. Until a few thousand years ago, giant land tortoises roamed across South and Southeast Asia and Australia. They were easy targets for humans and were all consumed long before recorded history. The exceptions were isolated populations in places such as the Seychelles and Galapagos.

THE BOOK OF BARELY IMAGINED BEINGS

have steered entirely by the noise these creatures make in swimming, to attain the Caymana Isles.

The turtles that these commentators describe would have included other species besides Leatherbacks, such as Green turtles, but Leatherbacks had long been present in the Caribbean in large numbers, and colonists killed all species of turtles in much larger numbers than indigenous people had done. Hence these reports – to us, almost incredible – of turtles abundant enough to 'bathe' in or navigate by. Today, to see a single turtle breaching in these waters is an unusual sight.

But the end of this story has not yet been written. For one thing, the catastrophe is unevenly spread. In the Pacific, Leatherbacks have either disappeared from their historical range or come very close to it. In the early 1980s around 75,000 females nested in Mexican beaches facing the Pacific. Now the numbers are in the low hundreds. Beaches in Malaysia once famed for their abundance are today completely deserted. The Leatherback I touched on that beach in West Papua was a member of one of the last viable populations in the entire Western Pacific, numbering in the hundreds to low thousands in all. In the Indian Ocean, too, Leatherbacks have all but disappeared. But in the Atlantic and Caribbean there are some signs that, having come close to extermination, a few populations are making a slow recovery. The number nesting on beaches of the island of St Croix in the Caribbean, for example, grew from about twenty in 1980 – an historic low – to 200 in the year 2000, and the number of hatchlings increased from about 2,000 to 50,000.

There is no guarantee that such recovery as there has been in St Croix and a few other places will continue, but neither is it necessarily a false dawn. In his 2007 study *The Voyage of the Turtle*, the marine biologist and writer Carl Safina says 'the question I'm wrestling with is not, What are all the problems? The question I'm now asking is, Can we cause recovery?' And the answer, he thinks, is yes: 'Various lines of evidence converge on a single point: things local people can control on beaches can, in many cases, bring turtles back. And have.' A population that has

The tendency to disbelieve accounts of abundance in past eras is now a well-recognized phenomenon, and is known as Shifting Baseline Syndrome. People take as a baseline, or reference point, the abundance, variety and size of animals and other organisms which they knew in their youth and assume that this is the way the world has always been. As, over successive generations, natural resources are depleted, the 'baselines' of old-timers begin to seem like tall stories to younger generations.

crashed, like that in St Croix had by 1980, can start to recover solely by intensive protection of nests from poachers and dogs, says Safina; saving just a few eggs year after year and protecting nests that would have been doomed buys time to face longer-term challenges such as reversing destructive fishing practices.

'Fixing' fisheries is a pretty tall order. About two *billion* hooks on long lines are deployed in the Pacific each year to catch tuna but in practice also catching turtles. And even if hazards such as this are better controlled, other factors endangering Leatherbacks may intensify. These include choking on plastic, sand that regularly becomes too hot to incubate their eggs as average temperatures rise, and even greater disruption to remaining nesting sites by human development. If the apparent decline in plankton density in many parts of the world ocean over recent decades is real and the trend continues, then the food chain on which Leatherbacks and almost every other large sea creature depend could be greatly impoverished.

In such circumstances, small steps such as protecting a nesting site may seem inadequate. But they are a start. The creation of networks of marine protected areas – repeatedly shown to be the best way to allow marine ecosystems to recover, at least in the near term – may follow. There is no guarantee that such measures will be anything like enough: no surety that Leatherbacks will squeeze through the bottleneck of the great Anthropocene extinction and swim far into a future that does not include us. But, as Carl Safina puts it, 'You dodge despair not by taking the deluge of problems full bore. You focus on what can work, what can help, or what you can do, and you seize it, and then – you don't let go.'

Sea turtles play important roles in myths from North America to China and from Mesopotamia to Polynesia. This can easily be overlooked when we repeat, almost on reflex, the old and now rather tired joke about the person insisting to a cosmologist that the Earth is not turning in space but sitting on the back of a great turtle. (When the cosmologist asks what the turtle is resting on, the person answers 'turtles all the way down'.) But even as pre-scientific ideas are dis-

Disruption to nesting can result from developments that are distant from the beach. One of the bright hopes for Atlantic Leatherbacks is a population of as many as 30,000 females, nesting on the beaches of Gabon in West Africa. These may, however, be vulnerable to the large number of stray logs washing up on the beaches at times – the result of the recent explosive growth of poorly managed logging in Central Africa. The logs prevent the turtles from reaching their preferred nesting sites or they lay their eggs close to the waterline, where the eggs are killed by saltwater.

THE BOOK OF BARELY IMAGINED BEINGS

carded, our minds never totally escape the power of myths and symbols, which offer us clues to (among other things) the nature of mind and processes within us that we do not wholly control. We need new stories about the way the world is and will be.

The Leatherback can easily carry a story we like to hear, in which cruelty, folly and waste are on the rampage but just as things are at their bleakest there is the prospect of a dramatic reverse (in this case, a population to be brought back from the brink of extinction and an ecosystem to be restored). Such, at least, is the story conservationists want to be able to tell. It is, of course, a variation on an old standard: loss, recovery, new wisdom and a new flourishing. And it's no worse for that. Indeed, it may be our essential story. But I think there's more, and in any case a modern bestiary should be able to accommodate multiple meanings and contradictions just as a medieval one did. We may, for example, take the Leatherback as an object of meditation when contemplating the nature of being itself.

In the *karesansui*, or Zen gardens, of Japan, rocks and vegetation are arranged in gravel or sand which is in turn scored with lines and patterns. To some observers a *karesansui* is just twigs, rocks and grit. But to others it is a 'gateless gate', a window onto mountains seen through clouds, tigers in a river, islands amid the waves of the sea. The objects in the garden are static, of course; movement takes place in the mind. And so, I'd like to suggest, it can be with the Leatherback which, for all its movement over huge spaces and countless cycles of generations, has endured largely unchanged fifty times as long as our genus and five hundred times as long as our species.

Seen while swimming underwater, a fully grown Leatherback is (I am told) like a great rock. It looms towards you, a solid concentration of mass amid the shifting water and light, drawing your attention as surely as gravity before it passes by effortlessly and at speed to merge again with the blue. The experience resembles consciousness itself: a passing show that lends dimension to the present moment, a focus for attention that requires you to ignore other phenomena in the world around you.

The Czech poet and immunologist Miroslav Holub put the 'dimension of the present moment' at a little less than three seconds – the time it takes to speak a line of poetry.

Douwe Draaisma (2004) observes: 'Objective, "clock" time passes at an even rate, like a river running through a valley. At the beginning of his life man runs briskly along the bank, moving more quickly than the river. Towards evening, as he tires, the river flows faster and he falls behind. In the end, he stands still and goes to lie down beside a river that continues along its course at the same imperturbable rate at which it has been flowing all along.'

An individual Leatherback may have very little of what we would recognize as consciousness. This is, after all, an animal with a brain the size of a grape. The memory and intelligence required for its stupendous feats of navigation and delicate nest building are encoded into the routines of its nature. But in their unknowing, sea turtles enact something like grace. It is not just endless forms of life that have been and are being evolved as this planet cycles according to the law of gravity; it is pattern and dance, long preceding us and, perhaps, extending far into the future, rounding our little lives with beauty. Leatherbacks swim steadily, unceasingly through Okeanos (Ὠκεανός, which the Greeks believed to be a great river encircling the land). In our short flash of life, by contrast, we hare off, running hither and thither at first, then slow and finally stop.

The idea that the world we know is supported on the back of a turtle or even an infinite pile of them is not, when taken as metaphor, completely absurd. Most cosmologists think that the matter and energy in the universe that is visible to us, and therefore something of which we are to some extent conscious, is, like a great turtle in a vastly greater ocean, just a small fraction of the whole, with dark matter and dark energy making up by far the greater part. And if, as many cosmologists now believe, our universe is just one in a level 1, level 2, level 3 or level 4 multiverse then we can say that in a sense it really is 'turtles all the way down'. The turtle we can actually see becomes a talisman for Brahman, taken here to mean an infinite, transcendent reality which is the ground of matter, energy, time and space.

I return in memory to the remote beach on which we stood those few years ago watching the Leatherbacks. The cloud is breaking up and the starlight is beginning to come through. Soon the sky clears completely and the starlight is bright enough to cast shadows. The sea becomes calm. We begin to see flickering in the sand. Baby Leatherbacks, each of them small enough to sit on the palm of your hand, are emerging from eggs in other nests dug some weeks previously and are making for the lip of the sea,

determined as tiny rugby players going for a touchline. On the back of each one are pearly spots, spread in a tear-shaped pattern like the Sun's analemma seen from the surface of the planet Mars.

I remember a story I heard once from my late friend, the architect and marine engineer Wolf Hilbertz, who hoped that human aspirations could be met without trashing the planet. Wolf dreamed of building by way of demonstration an 'ecotopia' – an artificial island made of minerals extracted by electrolysis from the ocean using the power of waves and sunlight – on a submarine bank in a remote part of the Indian Ocean. Wolf recalled a preliminary expedition to the proposed area with his colleague, the marine biologist Tom Goreau:

> We encountered a unique meteorological phenomenon on the North Bank: the sea was flatter than a mirror, a cloudless night sky, and the stars were so brilliantly reflected by the sea surface that one was deceived into thinking one saw the sky there. The horizon had shifted and all the gods were enjoying themselves. This clearly was a once-in-a-lifetime and profound experience. Tom can make the scientific explanation available to you.

Watching the baby Leatherbacks going like the blazes for the black waters where the majority of them would be eaten by other animals before they grew any bigger than a child's fist, and where most of the survivors would probably be chewed up in the meat grinder of human civilization, it was nevertheless possible to feel that Schopenhauer's vision of the world as a place of endless pain and suffering was mistaken. Some small proportion of these young turtles might just survive and return as adults and haul the heavy rock of their own being, now two thousand times as heavy as when they left, once more up the beach. As the stalwart atheist Albert Camus put it, one must imagine Sisyphus happy. And it seemed possible that somewhere, in the innumerable universes, the gods were smiling.

MYSTACEUS:
A JUMPING SPIDER

Phidippus mystaceus

Phylum: Arthropoda
Class: Arachnida
Family: Salticidae
Conservation status: Not listed

You need only change your direction.
Franz Kafka

A few years ago a message from God was found in a tomato in Yorkshire. The Arabic letters were clearly visible, for those who could see them, spelled out in two halves of mesocarp, endocarp and seeds cradled within mandalas of indigestible skin. At least two explanations come to mind. One is that the Supreme Being sees fit to make Himself visible in produce no less than He does in whirlwind and quasar. Another is that those who saw the message experienced apophenia – the tendency to see meaningful patterns and connections where they are not in fact present.

Whatever the truth of that tomato, it is certainly the case that human beings regularly see things which are not there. All of us have seen faces in what are actually inanimate objects, a phenomenon known as pareidolia. Evolutionary psychologists argue that there is a good adaptive reason for this. If an ambiguous shape in long grass turns out to be a rock rather than the face of a lion, the cost of having wrongly identified it as a dangerous animal is likely to be trivial compared to the cost of making the opposite mistake. Furthermore, as hyper-social beings we dedicate substantial attention to scrutinizing and interpreting each other's facial expressions and the changes, sometimes extremely subtle, in them. Neuroscientists have found that a substantial part of the visual cortex, the

fusiform face area, is largely dedicated to these complex and demanding tasks.

What then to make of a creature like *Mystaceus*? It certainly has a face, complete with snow-white whiskers around its mouth and pointy black tufts on top, but the two pairs of front eyes, known as the anterior median and the anterior lateral, both claim our attention, and our gaze will tend to flicker between one pair and the other as points on which to anchor a sense of its face. There's something here like the duck–rabbit illusion which never resolves one way or other: an arachnid *trompe l'œil*. (In addition to their four front ones, four posterior eyes, one pair of them tiny and one rather larger, are placed further back on *Mystaceus's* cephalophorax, like the bubbles that housed the turret for the mid upper gunner on a Lancaster bomber.)

The duck/rabbit illusion.

Mystaceus, which lives in North America, is a jumping spider. It is one of about 5,000 species in a highly successful family of arachnids (eight-legged, air-breathing, venom-fanged arthropods) that thrive almost everywhere except Greenland and Antarctica. Britain alone has thirty-six different kinds. Jumping spiders, which are smaller than your little fingernail, have remarkable eyesight, a very particular kind of hunting style and an appetite for bees, bugs and – quite often – other spiders. Some kinds have better visual acuity than cats, which are more than a hundred times their size, and, though

Jumping spiders are by far the largest of the approximately 110 families of spiders, and account for nearly one in seven of all spider species.

Mystaceus, a jumping spider.

each of their pairs of anterior eyes has a limited field of view, the full complement of eight allows them to scan large sections of the world around them. (Like most spiders, they also have acute hearing, mediated by tiny hairs on their legs which are sensitive to the smallest vibrations.) They are also much more powerful jumpers with respect to their size than cats are, able to pounce up fifty times their body length and land with precision. And they have a safety rope: a silk thread tethered to the launch point in case they misjudge their leap and fall short. A jumping spider is a voracious panopticon, bungee-jumper and *traceur* in one.

Nor are *Mystaceus* and other jumping spiders cowering timorous beasties when it comes to love. The males of many species sport outrageous colours for courtship. The male *Audax*, a close cousin of *Mystaceus*, has palps (frontal appendages) as splendidly hued as the feathers of a bird of paradise – for what girl can resist a boy who has technicolor genitals in the middle of his face? – while *Hentzia palmarum* makes do with brilliant-

orange facial hair all around its four anterior eyes. Each species of jumping spider taps out its own distinctive dances of intimidation and seduction – three or even seven-act shows that combine features of a semaphore, flamenco and South African gumboot dancing.

Still, the beauty of some jumping spiders is more apparent in their brains than their bodies. The drabbest genus contains some of the cleverest species known. Among them is *Portia labiata*, a jumping spider of South and East Asia that lives solely on the flesh of other spiders. (All jumping spiders, and all spiders more generally, are carnivores but most go for easier prey than other spiders; the only known vegetarian exception is the delightfully named *Bagheera kiplingi*, which lives in South America.) *Portia* varies and adapts its behaviour according to the characteristics of the species it is hunting, observing and then mimicking rhythms tapped out by species it has not encountered before in order to deceive them, and plotting devious lines of attack if a full frontal assault looks too risky. *Portia* may spend an hour or more scanning the tangles of vegetation and gaps between itself and its intended victim, calculating the best route for a surprise attack. Scientists believe the reason *Portia* takes so long to do this is because, for all its excellent vision, it has very limited ability to take in and process information. So it systematically scans small sections of the surroundings with its anterior eyes, gradually building up enough information in its memory to build a mental map which it can then use. It's a little like trying to download a large and fine-grained picture over a very slow Internet connection. Once the map is complete, however, *Portia* will usually execute without fail, rapidly retracing its course if it finds it has started going down a blind alley, choosing the correct option and finally swooping on its prey like a special forces ninja.

The human brain, too, has to cope with a flood of information that it receives from the senses, especially the eyes, and a good part of the work that it does lies in deciding what to ignore. The narrow focus of *Portia*'s eyes may do much of this filtering by default. So what seems like intelligent decision-making in the spider

Jumping spiders enhance their vision by allowing their retinas to vibrate slightly from side to side, thereby taking in more information than the animal would otherwise be able to do without moving its body, because its eyes are fixed in its head. This trick was studied during research to enhance vision systems for robotic rovers on Mars.

may actually be down to its being far less distracted by extraneous information.

The differences between jumping spiders and people (or most of the people I know, at any rate) are obvious enough. Not least, we have much more 'bandwidth' and processing power: about 100 billion brain cells compared to their mere 600,000. And, of course, we multiply our capacities through cooperation, creating webs of support and information between us that are vastly more powerful and intricate than anything that one of us can manage. But for all our differences we exist in continuity with them, and like them we live in a narrow zone with respect to the world as a whole. 'A human being is capable of taking in very few things at one time,' observes Kris Kelvin in Stanisław Lem's novel *Solaris*; 'we see only what is happening in front of us only here and now.' Just as jumping spiders overcome some of their limitations through a mental map of what they need to know, we too apprehend the world by unconscious integration within the brain of fragments of perception, memory and supposition: a conjuring trick that gives us a rough model of what is actually going on but which we believe to be the real thing. (See Chapter 7: Gonodactylus.)

Memory is one of our most treasured capabilities. We build our identities and our cultures with it. But while memory and the things we do with it can be extraordinary, especially when we have not had too much to drink, they are still part of a continuum with the rest of nature, not separate from it. Memory, when defined as the ability to retain information for later use, is foundational to life itself.

The RNA world hypothesis holds that life based on ribonucleic acid (RNA) pre-dates the world of life based on deoxyribonucleic acid (DNA) and proteins. RNA is able both to store genetic information like DNA, and to catalyse chemical reactions like an enzyme protein. 'RNA world' may have emerged from multiple, earlier, self-replicating molecular systems, which it outcompeted. Thus, the first pre-RNA proto-living forms are 'forgotten'.

The first living systems, perhaps those hypothesized for an RNA world, would have been distinguished by (among other things) precisely this: an ability to record in their chemical codes, and reproduce later, properties that enabled them to thrive. And all organisms alive today retain subsystems that were first encoded during the early days of DNA-based life roughly four billion years ago. Every moment your cells are replaying routines that existed in the Archaean eon. Most of the memory in the world continues to be entirely unconscious and does not even require a brain. The immune

system is a good example: it 'remembers' the viruses, bacteria and other nasties that you've encountered during your lifetime. The way it works is complicated, but essentially what happens is that when you are exposed to a pathogen, special cells in the immune system form a memory of what it looks like. If you encounter the same pathogen again, the 'memory' cells will recognize it and your body will be able to mount a faster immune response. Plants do this as well as humans and other animals.

Human memory can be rich, varied and subtle in ways that, as far as we can tell, no other Earthly beings experience. Our abhorrence at memory's fraying and dissolution is, perhaps, second only to our abhorrence of death itself. But it is also possible to remember too much. In a story told by Jorge Luis Borges, a young farmhand named Ireneo Funes falls from a horse and is severely concussed. When he comes to, his powers of perception and his memory are 'perfect'. By comparison all of his previous life seems like a dream in which he had looked without seeing, heard without listening and forgotten virtually everything. In his new life, Funes can recall 'the forms of the clouds in the southern sky on the morning of April 30, 1882, and ... compare them in his memory with the veins in the marbled binding of a book he had only seen once, or with the feathers of spray lifted by an oar on the Rio Negro on the eve of the Battle of Quebracho'. But so intense is the rush of impressions and memories that Funes is unable to cope, and he never stirs from his bed, 'his eyes fixed on the fig tree behind the house or on a spiderweb.' He becomes incapable of generalizations and abstract ideas, which require little acts of forgetting to become possible. He becomes almost incapable of making sense of the world, of *thinking*.

To function effectively, then, we have to forget most things. This fact has long been recognized by psychologists and philosophers. William James, writing in 1890, quoted from his colleague Théodule-Armand Ribot: 'Without totally forgetting a prodigious number of states of consciousness, and momentarily forgetting a large number, we could not remember at all. Oblivion ... is thus no malady of memory, but a condition of its

health and life.' More than two hundred years earlier Thomas Browne had reflected: 'To be ignorant of evils to come, and forgetful of evils past, is a merciful provision in nature, whereby we digest the mixture of our few and evil dayes and, our delivered senses not relapsing into cutting remembrances, our sorrows are not kept raw by the edge of repetitions.' Friedrich Nietzsche, in 1886, was more terse: 'Blessed are the forgetful: for they also get over their stupidities.'

Perhaps sanity depends on steering a course between remembering too much and remembering too little. But even this middle way is vulnerable to delusions. Neuroscience has recently proven what David Hume recognized nearly three hundred years ago – that remembering is an act of re-creation and therefore subject to distortion and fictionalization: 'real' memories become tales, and tales become 'memories'.

And there is a tension, if not a paradox, at the heart of (at least some of) the conscious experiences that we value most. On the one hand, we want to be completely present in the moment; as the young Ludwig Wittgenstein put it, 'only a man who lives not in time but in the present is happy'. On the other hand, we want to build and retain the fullest possible picture of the world around us and this must, if it is to be durable, include an coherent map of its deep past and foundations. So, for example, the historian R. G. Collingwood asserted that 'history, and the same is true of memory ... is the mind's triumph over time. In the ... process of thought, the past lives in the present, not as a mere "trace" or effect of itself on the physical organism, but as the object of the mind's historical knowledge of itself in an eternal present.'

Sometimes it seems to me that some of the most important moments of our existence are spent in attempts to bridge the gap between the two states of (on the one hand) trying to live utterly in the moment, and (on the other hand) trying to live in memory and reflection. We want, somehow, to experience both at once, and we look from the one to the other and from the other back to the one, rather as we do when switching attention between the two

'As an idea of the memory ... may degenerate to such a degree as to be taken for an idea of the imagination; so ... an idea of the imagination may acquire such a force and vivacity as to pass for an idea of the memory, and counterfeit its effects on the belief and judgment.' (David Hume)

Marcus Chown (2007) suggests that at the Omega Point (a condition hypothesized by the cosmologist Frank Tipler as the time when technology makes possible a state of being indistinguishable from eternal life), the greatest imaginable joy any human could experience would be to return to the 'eternal' summer days of childhood, when your favourite dog was alive and your parents were young and full of life. Something like this, perhaps, is evoked in the final scenes of Terrence Malick's 2011 film *The Tree of Life*.

pairs of eyes on the front of a jumping spider. The 'face' is blank: it does not tell us where to look and, like the cat in *A Little Fable* by Franz Kafka, the spider would eat us up if it could.

NAUTILUS

Nautilus spp.

Phylum: Mollusca
Class: Cephalopoda
Subclass: Nautiloida
Conservation status: Not listed, but
populations declining

All that was needed was for one of us to manage to make an endless
spiral and time could exist.

Qfwfq in *Cosmicomics* by Italo Calvino

So the whole world blooms continually
within its true and hidden element,
a sea, a beautiful and lucid sea
through which it pilots, rising without end.

from *Bathysphere* by Don Paterson

N ot many living things leave a beautiful
corpse. Among those that do are the
ancient oak trees still found in a few pock-
ets of woodland in the British Isles, and
the Nautilus, a distant cousin of squid and octopus
that lives in tropical waters. In the case of an old oak,
the folds and twists in its trunk and boughs continue to
express, suspended as in a sculpture, forces that shaped
the tree during its five hundred years of life. In the case
of the Nautilus, the animal that accreted the shell had
a relatively brief existence, typically less than ten years,
but what remains – in cross section a logarithmic
spiral – manifests perfect symmetry. The oak is like a
massive, turbulent musical score; the Nautilus shell is
like a chord resolved.

The spiral in a
Nautilus shell is loga-
rithmic but it is not
'golden'. A golden
spiral is a special case
of a logarithmic
spiral which gets fur-
ther from its origin
by a factor of φ –
that is, the 'golden
ratio' of $(1+ \sqrt{5})/2$ –
for every quarter-
turn it makes.

I first saw one of these shells cast up on a sandbar
off a small island in Indonesia (many hundreds of
miles from where, years later, I saw Leatherbacks), a
place so quiet and untouched that it was possible to
believe one had awoken in an age before – or after –
humans. (This was, of course, an illusion: the island
was inside a conservation zone policed to exclude
masses of hungry people just over its borders.) The
shell was broken, but even so it stood out to my eyes
almost as if it were a three-dimensional object in a flat
world. I felt a surge of wonder – a childish sense that
it was a sign from the deep.

THE BOOK OF BARELY IMAGINED BEINGS

The Nautilus shell that I saw was, of course, no token from the gods: no trace on the Rhodian shore. But a closer look at the animal of which it was once part does cast light on real and enduring wonders. This chapter explores three of them. The first concerns time: an individual Nautilus has a short lifespan but the spiral form its shell creates is much older than that of an oak or any other tree, and forms from which it evolved helped in the discovery of the age of time itself.

Greek and Roman philosophers believed that seashells turned to stone and embedded in rocks were the remains of ancient creatures deposited on the floor of a sea that had once covered the land. This idea was all but lost in Europe with the collapse of Roman civilization, and by the time of the Renaissance, when Christian doctrine held that the world was only a few thousand years old, there were two main theories to explain these shells. One claimed that they were non-living structures that had grown spontaneously, like crystals, within the rock. (The fact that they mimicked living creatures wasn't considered too strange: it was simply thought to reflect the harmony that existed between the various realms of nature.) The other theory claimed that the shells were the remains of sea creatures that had been deposited on mountaintops during the great flood described in the Bible. A few people questioned both ideas, but discreetly. In one of his secret notebooks, written in the early sixteenth century, Leonardo da Vinci observed that fossils were generally found in several superposed layers which looked as if they had been deposited at different times. A single flood could not, therefore, account for them all. He also queried the idea that stony shells grew from 'seeds' within rocks because they would not be able to expand, as the growth bands on their shells showed they had, without fracturing the material surrounding them.

More than 150 years after Leonardo, Robert Hooke (sometimes known as the 'English Leonardo') had similar doubts when he examined a variety of spiral shapes that were abundant in some rock formations. Hooke believed that these forms, known as ammonites,

Ammonite derives from the term used by Pliny: *ammonis cornua*, or the 'horns of Ammon'. The Egyptian god Ammon, or Amun, was normally depicted with the tightly coiled horns typical of a ram. In medieval Europe, fossilized ammonites were thought to be petrified snakes.

Robert Hooke's illustration of fossils, circa 1705.

were the mineralized shells of marine organisms. But he was puzzled because, in contradiction to the Christian doctrine that animals were eternal and unchanging, these ones bore little resemblance to most known shells. Hooke sought out every conceivable living analogue and lighted on the Nautilus, which in his time was a rarity in Europe. Its shell had a similar spiralling shape to that of many ammonites but whereas ammonite shells were mostly corrugated or even covered in spikes, the Nautilus shell was smooth. Hooke's conclusion was simple and, for its time, daring: 'there have been many other Species of Creatures in former Ages, of which we can find none at present; and 'tis not unlikely ... but that there may be divers new kinds now, which have not been from the beginning'. He was directly challenging the belief that nothing had become extinct and that no new species had emerged since the first act of Creation.

Hooke's assertions were a signal of a profound shift in European thinking. Over the following century

THE BOOK OF BARELY IMAGINED BEINGS

natural philosophers studying fossils and geology in ever greater detail began to see that there was only one coherent explanation for their discoveries: a huge past from which humanity was completely absent. The revelation of what we now call 'deep time' was breathtaking for those who first experienced it, like a swoop into stereoscopic vision for someone who has previously only seen in two dimensions and suddenly finds himself on a high promontory above a chasm. 'The mind [grew] giddy by looking so far into the abyss of time', wrote John Playfair, a friend of the geological pioneer James Hutton, in 1788.

Erasmus Darwin, a contemporary of Hutton and the grandfather of Charles, was among those who argued for a very long past that allowed ample time for complex life to have evolved from simple beginnings. As to *how* exactly evolution worked, however, Erasmus Darwin was vague – his motto was *E conchis omnia*, or 'Everything from shells'– and it was left to his grandson to propose natural selection. So while Charles Darwin's theory was not inspired directly by speculation on the relationship between Nautilus and ammonite, it was made possible by an appreciation of the existence of deep time, and this ultimately rested on the work of Hooke and others who had first wondered about the similarities of the Nautilus to these enigmatic, fossilized spirals.

The Nautilus, it turns out, is not descended from an ammonite but is actually a member of an even older subclass of cephalopods known as nautiloids, which first appear in the fossil record around 490 million years ago. About 2,500 different species have evolved since then, but all of those alive today belong to a handful of species in two genera. Today's Nautiluses are quite different from other living cephalopods such as cuttlefish, squid and octopuses. Most obviously, they still live in their shells, a practice that other cephalopods abandoned tens of millions of years ago. They also have a much simpler nervous system and brain. (They compensate to some extent for their lack of smarts with muscle: up to ninety tentacles – many more than other cephalopods – arranged into two circles around a horny beak.) Unlike other cephalopods, the tentacles of the

Nautilus have no suckers but they are ribbed, and when wrapped around prey – a favourite dish is a lobster that has just shed its old shell, and is soft – they exert a powerful grip until the animal can start to nip into the flesh of its victim. The Nautilus, floating through the water thanks to gas-filled internal chambers, may wobble and bump into things as it pushes itself through the water, but it is a deadly enough hunter of its chosen prey when the opportunity arises, jet-propelling itself at some speed by sucking water into a cavity in its mantel and then expelling it with a muscular contraction through a directable funnel known as a hyponome, or siphon.

Ancient nautiloids used their tentacles to great effect, becoming major predators in the oceans during the Ordovician period (roughly 488 to 443 million years ago). Many but not all had straight, conical shells like witches' hats or British traffic cones, and some grew to enormous size: Orthocones and Cameroceras grew at least as long as a man is tall, and perhaps as big as a giraffe. They were the pointy-headed aquanauts of the Ordovician. It's likely that the baroque spikes on the backs of some trilobites such as *Ceratarges* may have evolved in order to make them less attractive to such beasts.

The world these creatures 'ruled' was very different from ours. The planet span faster on its axis than it does now. A day lasted 21 hours and there were 417 days in a year. The Moon was closer too, and one may picture it, bright and pendulous over the sea, moving fast, seemingly close enough to reach up and touch (as it actually is in Italo Calvino's absurd and beautiful story, 'The Distance of the Moon'). The greater proximity of the Moon meant that tides were both higher and lower than we experience today. Growth rates in marine organisms were affected. In the modern Nautilus, tiny ribs or laminations are secreted daily in relation to the lunar-tide cycle. It is these that slowly build up the spiral shell. Today, the creatures typically have twenty-nine or so growth laminations per chamber, corresponding to the length of the lunar-tidal month. The further back in the fossil record you look, the fewer laminations you find. Nautiloids in the Ordovician appear to have had eight or nine per chamber, suggesting the lunar month at that time was only a little longer than a week today

The water that the Nautilus sucks in to propel itself is passed across the gills before it is expelled. So the animal breathes as it moves.

Nautiloids were top cephalopods (and top ocean predators) for tens of millions of years, but from the late Silurian onwards ammonites became much more common, and it was these which evolved into the abundant and diverse species which so impressed Hooke and others, and later helped geologists to reconstruct Earth history. Over their roughly 335 million years of existence, ammonites 'explored' the boundaries of size and shape, mapping large parts of the morphological space available to any entity that grows by accretion. Most ammonite shells were flat spirals. Some were tiny but at least one species grew to more than 2 metres across. Others were helical in shape. A few, such as the bizarre-looking *Nipponites*, took wildly irregular forms. (*Nipponites* brings to mind what Samuel Johnson said of *Tristram Shandy*: 'Nothing so odd will do long.') But as a group ammonites were remarkably tough, recovering from every punch nature could throw including the end Permian extinction which killed off about 95 per cent of species in the seas until, finally, in an almighty prang at the end of the Cretaceous, they joined the choir invisible.

In another of the stories in Calvino's *Cosmicomics*, the protagonist, whose name is Qfwfq, spends a long time as a lowly mollusc condemned to a moment-by-moment existence, a prisoner of the eternal present. Days and nights crash over him 'like waves, all interchangeable, identical or marked by totally fortuitous differences'. In an attempt to separate his present from all other presents, Qfwfq starts to build a shell, hoping to lay down markers in spiral accretions as if he were making his own clock. He tries to create an extremely long, unbroken shell-time, but an infinite spiral proves impossible: the shell grows and grows and at a certain point stops – and that's it, finished. Thousands of others molluscs try too but the effort is wasted: 'time refuses to last, the shells are friable, destined to crumble into pieces. Theirs are only illusions of time that last as long as the length of a tiny shell spiral, splinters of time that were detached and different from each other.' Eventually, Qfwfq realizes, someone else has to try 'to ensure that everything that was left or buried [becomes] a sign of something

The ancestors of the modern Nautilus somehow scraped through. Perhaps it was their simplicity that allowed them to survive, eking out an existence as scavengers on the margins: the Nautilus has a slow metabolism and only needs to eat about once a month.

else'. That someone else, Calvino does not need to say, is us: by seeing the links between vast numbers of interrupted spiral shells, and identifying each variety as a sign or marker in evolution, humans have put together a continuous spiral we call Earth history. The geological record is something that other species have lived but no species apart from humans know.

A second wonder of the Nautilus is the internal architecture of its shell. Chambered compartments within, *camerae*, act as flotation chambers which can be filled or emptied of gas or fluid through an opening called a siphuncle to adjust the animal's buoyancy. This remarkable adaptation dates back to the animal's origin. Long before fish evolved swim bladders, nautiloids evolved these chambers as a means to float without effort above the seabed, and to rise and fall as they chose. And this, combined with the ability to control horizontal movement by forcing water through their siphons, enabled the early nautiloids to become the first great death from above.

Flotation chambers may be old hat in the animal kingdom but they are a relatively new and valuable technology for humans. Today they allow us to dive deep in the seas and remain there for long periods. By contrast, diving bells, the first submersibles, merely held a pocket of air whose pressure could not be controlled and whose oxygen would rapidly deplete, and relied on weights and ropes to descend and ascend. The first submersible to sink and rise by flooding and emptying a separate chamber (allowing water into a bilge tank, and pumping it out by hand) was probably the *Turtle*, developed by David Bushnell in Connecticut in 1775 in order to attack British ships. (Moving through the water, the *Turtle* may have wobbled and rocked around its low centre of gravity, rather as a Nautilus does; it failed completely as a fighting vessel.) Robert Fulton's *Nautilus*, developed between 1793 and 1797 for the First French Republic, was significantly more sophisticated than the *Turtle* but was no more successful as an engine of war. Its name was probably taken from a supposed similarity – when it was on the surface and under sail – to the Paper Nautilus or Argonaut, which is actually a kind of

The modern Nautilus already has about four empty *camerae* in its shell, and is living in a fifth, outermost one when it emerges from the egg. Over its lifetime it adds successively larger chambers to accommodate its growing body.

octopus whose female builds a papery 'shell', shaped rather like the shell of an actual Nautilus, and which was believed to sail by hoisting two webbed tentacles above the surface. Whatever else is true, the felicity of the Nautilus name for a submersible was entrenched in the 1870s when Jules Verne gave it to his imaginary vessel in *Twenty Thousand Leagues Under the Sea*. And the resonance was strengthened when the world's first nuclear-powered submarine, launched in 1954, was named USS *Nautilus*. This marked an important step towards the goal, achieved subsequently, of craft that are almost undetectable – always-ready delivery platforms for Intercontinental Ballistic Missiles. A single 'boat' armed with ICBMs can destroy most of the great cities on an entire continent and is a must-have for any power aspiring to global reach. So from wobbly beginnings in the eighteenth century, a mechanical-chambered beast has become the ultimate in death-from-below in the twenty-first.

There have been other hopes for submarines besides the perfection of new means of destruction. The first submarine driven by combustion rather than human muscle-power, the *Ictineo II* of 1864, was developed by

Made from olive and oak wood with cooper bindings, *Ictineo II* remains the ultimate in Steampunk *avant la lettre*.

The *Nautilus*, a submarine designed by Robert Fulton, 1793–7.

Narcís Monturiol, a Catalan artist, engineer and utopian socialist who hoped his creation would save the lives of coral harvesters and help bring prosperity and peace to mankind. In recent decades, submersibles used in scientific research have helped to transform our sense of what and where non-human life can be, providing glimpses of creatures that are stranger than humans have ever imagined.

A third wonder of the Nautilus is its eyes. And the marvel here is the opposite of the *Gonodactylus* discussed in Chapter 7: these are the simplest eyes of any large living animal – lensless 'pinholes' that project a hazy and rather dim image onto its retinas. Much smaller creatures such as the common European land snail, the winkles and the periwinkles have lenses in their eyes even though those eyes, at no more than a millimetre across, are a tenth of the diameter of those of the Nautilus. The Nautilus's pinholes allow it to tell day (when it hides in the depths) from night (when it rises to feed near the surface) and to orient itself with respect to large objects such as rocks when it is near the surface. But that seems to be about it. Measured by maximum resolvable spatial frequency, they have worse acuity than those of a horseshoe crab (3.6 cycles per radian compared to 4.8), less than a hundredth that of a goldfish (409), and well under a thousandth those of an octopus, human or eagle (2,632, 4,174 and 8,022 respectively). Smell probably plays a larger role in guiding their beaks and radula ('tongues' embedded with tiny teeth) towards food: rhinopores below the Nautilus's eyes are capable of detecting odours up to ten metres away. Its tentacles also have chemoreceptors, which allow them to detect prey close by.

Crude as they are, however, pinhole eyes are evidently useful to the Nautilus, and something like them has probably gazed at the world (albeit murkily) for nigh on 500 million years. Any natural history of vision needs to take them into account. Further, their persistence can stand as a reference point in our own development of 'artificial eyes' – the cameras and image-recording systems that were initially extremely crude but which have profoundly affected the ways in which we perceive and value the world.

The first step towards the creation of a mechanical eye entailed the harnessing of a natural phenomenon that people have probably been noticing since they became people. On a bright day, little images of the sun are sometimes projected through small gaps between the leaves of a tree onto the ground below. In the late fifth century BC the Chinese philosopher Mozi and his followers built what they called a 'locked treasure room' which projected an image of the bright outside world through a tiny hole onto a dark wall: the first *camera obscura*. (Mozi taught logic, self-knowledge, authenticity and universal compassion; his work was energetically suppressed.) In Greece, Aristotle and others also had a good grasp of the principles of this device, and increasingly sophisticated versions were described or made over time, possibly in Byzantium and certainly by natural philosophers of the Arab golden age such as Alhazen, as well as in China. By 1591 a version existed in Italy which had a lens rather than merely a pinhole, and by 1600 Johannes Kepler in Germany was using one to observe the Sun and the transit of Mercury. More compact and portable versions were developed later in the seventeenth century, and used increasingly widely thereafter by draftsmen and painters.

The images of the world created by a camera obscura continue to flow exactly as the world around the camera flows. But an image that is fixed on a medium such as photosensitive film can create something different, and remarkable: the impression that an actual moment (or at least something true to it) has been removed from the flow of time and placed beyond it. A camera that records images seems to be a kind of time machine. Today we are so accustomed to this phenomenon, whether in stills photography or moving images, that we usually don't give it a second thought. But there is something extraordinary and profound going on here, and it is worth trying to look at it afresh.

As for many people my age, making a pinhole camera and taking a picture with it was a standard project in science class when I was about thirteen.

The relationship between the camera obscura and cinema is noted in the film *A Matter of Life and Death* (1946), in which one of the characters watches goings on in the village through the device. Everyday life is made new, and seen with compassion and joy.

We were each given an empty tin can with one end removed, and a tool to pierce a small hole in the centre of the other end. Then we covered the hole with a 'shutter' of masking tape, and in darkness sealed a strip of unexposed film on a card inside the open end of the tin. And then we were allowed *out* (!) on a bright sunny day to look for places to take pictures. I positioned my camera and exposed the film onto a view from the top of a building at the corner of a square with the two towers of Westminster Abbey beyond. When, the following day, we developed our films, we found that most of us had been successful. In my attempt you could see the receding horizontal and vertical lines of the roofs edges, walls and windows quite clearly, thanks to sharply contrasting shadows and bright patches. I was entranced: the image captured a moment on a sunny day and somehow carried it forward into the next, which happened to be grey and overcast. This image was not 'merely' memory or imagination in the human brain but to all appearances something *real*. Streams of actual photons that had been part of the material reality of that day had left an enduring mark. Heraclitus is reported to have said, 'all things move and nothing remains still'. Our photos made this seem not quite true.

'Ever-newer waters flow on those who step into the same rivers.'

The conundrum of movement-and-stillness is apparent from the beginning of photography. The *View from the Window at Le Gras* taken by Nicéphore Niépce in 1825, which shows the prospect across an open space between two buildings according to established Western ideas of composition and perspective, is in many respects a simple and crude image. But this photograph, grainy in the extreme, carries a powerful charge for us today because we know it to be the first freezing of a moment, however mundane, in a photograph, a moment that passed long before the memory of anyone alive. Also, as an incidental result of the primitive technology used to make it, the image enables us to reflect on what constitutes a moment in time. Niépce had to expose his film to bright sunlight for eight hours or more to capture an impression and as a result sunlight and shadows fall on both

Nicéphore Niépce's *View from the Window at Le Gras* (1825). This is the earliest surviving photograph. It was taken with a camera obscura.

sides of the view. The moment in this image is therefore simultaneously a second or so – the time it takes the viewer to look at it – and eight hours long. It is a view such might be seen by an infant lying in a cot and learning to organize the stream of impressions flooding in, or by an adult immobilized by grave illness and on the threshold between reality and death.

Within twelve years Louis Daguerre had discovered how to record an image with film that only needed to be exposed for eight minutes. His view of the Boulevard du Temple in Paris is vastly superior to Niépce's earlier work in clarity and detail and, momentously, was recorded quickly enough to capture what is probably the first photographic likeness of human beings. You can see them in the lower-left quadrant: a man standing patiently with his leg up and thrust forward onto a stool while another, seated, shines his shoe. Any passers-by on this busy street have left less impression than ghosts. These two figures are, perhaps, the first example of what Roland Barthes, writing in the 1970s, called a 'punctum', by which he meant a spark of contingency which punctuates both the homogeneity of a photograph and the emotional

The Boulevard du Temple by Louis Daguerre (1838) is the first photograph known to contain an image of human beings. A man is having his shoes shined by another in the lower left quarter of the picture.

detachment of the viewer. The image of the Boulevard du Temple is where photography begins to find itself as an extension of human consciousness.

In David Octavius Hill's 1843 portrait of himself and his daughter the punctum is Hill's right hand, placed firmly and lovingly on the girl's head. The immediate contingency here was the need to hold the little girl's head still for the several minutes that the exposure required. The poignancy, however, arises inevitably in the mind of the modern viewer who learns that Hill could not save his daughter from an early death and who also knows that Hill, for all his tenderness and strength, is also long gone. In the words of Barthes' contemporary Susan Sontag, 'photographs state the innocence, the vulnerability of lives heading towards their own destruction'.

Reflecting on the nature and significance of photography some fifty years before Barthes and Sontag, Walter Benjamin had suggested that the earliest surviving photographs shared something of the 'aura' of older religious objects and works of art because they

David Octavius Hill with his daughter Charlotte circa 1843.

remained unique; special precursors to the contemporary age of mechanical reproduction. Later, Benjamin changed his view, maintaining that even a photograph taken in the age of mass production could have an aura – a 'magical' quality of preserving a sense of immediacy even across temporal distance. It is this latter view that makes more sense. The really important matter is *what* is being recorded. For Benjamin this was particular people (notably, Franz Kafka as a small boy): 'To do without people is for photography the most impossible of renunciations.'

For most of us most of the time, Benjamin's observation remains true: photos of those we love are usually the most precious images we have. But photography, film and other image-capturing technologies have, of course, also evolved vastly beyond what Benjamin ever contemplated. Digital imaging now makes possible the creation of increasingly convincing

images of worlds that never were or will be, and simulacra of past and future realities we will never see. What the impacts of these developments will be has yet to be fully determined, but already, at the very beginning of the age of moving images, H. G. Wells in *The Time Machine* (1895) anticipated some of their disruptive power and the sense of vertigo that results:

Alfred Tennyson anticipated Wells: 'The hills are shadows, and they flow From form to form, and nothing stands; They melt, like mist, the solid lands, Like clouds they shape themselves and go.'

> The twinkling succession of darkness and light was excessively painful to the eye. Then, in the intermittent darkness, I saw the moon spinning swiftly through her quarters from new to full, and had a faint glimpse of the circling stars. Presently, as I went on, still gaining velocity, the palpitation of night and day merged into one continuous greyness; the sky took on a wonderful deepness of blue, a splendid luminous colour like that of early twilight; the jerking sun became a streak of fire, a brilliant arch in space; the moon a fainter fluctuating band . . . I saw trees growing and changing like puffs of vapour, now brown, now green; they grew, spread, shivered and passed away. I saw huge buildings rise up and pass like dreams. The whole surface of the earth seemed changed – melting and flowing under my eyes.

One characteristic of image-capture technologies is that instead of revealing reality to be solid they help to show that the world is always changing. Yet, in a seeming paradox, these technologies also reinforce our sense that moments of time – snapshots – may be 'all' that there is, or at least all that matters to us because consciousness is situated only in those moments – a feeling vividly delineated in Chris Marker's 1962 film *La jetée*.

With photography, motion pictures and the rest, we have both enhanced and altered our sense of what it is to be. And yet we also learn that on the scale of things *as they really are* the view available to us as conscious beings is not much better than that of countless generations of the Nautilus floating through black water under an obscure moon before they are cast up, lifeless, on a shoal of time.

THE BOOK OF BARELY IMAGINED BEINGS

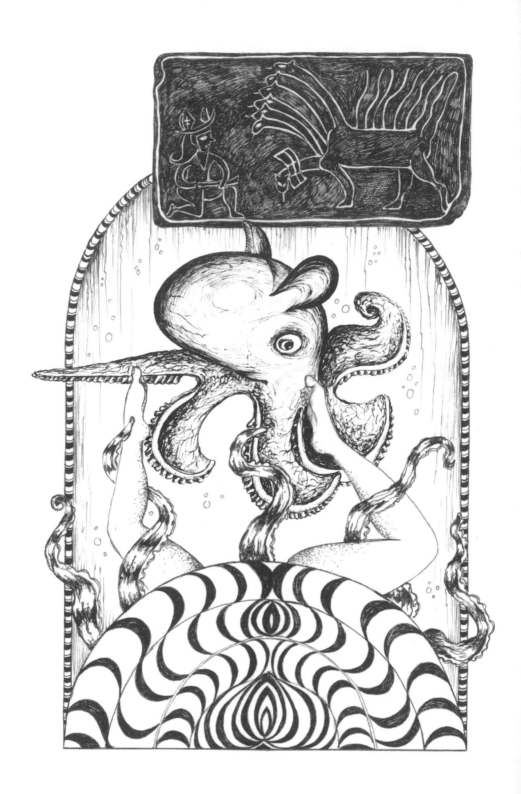

OCTOPUS

Octopus vulgaris and other species

Phylum: Mollusca
Order: Octopoda
Conservation status: many
species, ranging from Critically
Endangered to Least Concern or
not listed

For EARTH which is an intelligence hath a voice and a propensity to speak in all her parts.
Christopher Smart

In a celebrated poem Ogden Nash begs the octopus to tell him if its limbs are arms or legs. Textbooks have a no-nonsense answer: they are arms, not legs (and emphatically not tentacles). But no single term does justice to these appendages. The Australian octopus guru Mark Norman calls them 'super lips', strong enough to run around on. But super tongues would be at least as good. Each octopus arm is a muscular hydrostat, like a human tongue, and each of the tens or hundreds of suckers on it is lined with tens of thousands of chemoreceptors – taste buds to you and me – and a comparable number of nerve endings that provide an exquisite sense of touch. The next time someone tries to impress you with that trick of touching the end of their nose with their tongue (something that happens to me disturbingly often), tell him or her that an octopus has eight tongues sprouting out of their cheeks which they can double or halve in length at will.

And even 'super tongues' doesn't do justice to the nature of octopus arms. Fifty million neurons inside each make them more like extendable brains, or a network of semi-autonomous body-brains, capable of complex independent action. Each arm can extend and contract, twist and bend on its own, and each sucker on that arm can move, grasp, extend, contract

THE BOOK OF BARELY IMAGINED BEINGS

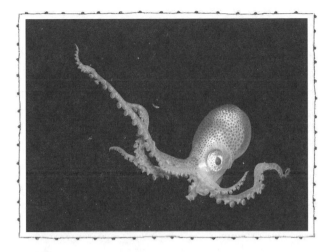

A deep sea octopus.

and exert suction independently. As an ensemble they can manoeuvre the animal's entire body through a space the width of its eyeballs or its beak, or work out jointly how to unscrew a jar with something tasty inside. In the case of some of the bigger octopus species, they can wrestle and defeat a small shark.

And, like the fractal known as a Mandelbrot set, the closer you look at octopuses, the more you see. Consider its anatomy: the 'head', a sack resembling a human scrotum that can shift through the entire colour spectrum; the three hearts pumping blood that contains copper rather than iron; the eyes so very like human ones and yet radically more elegant in design. Or consider its intelligence: at least equal to that of a dog. In experiments carried out with the Common octopuses, individuals are faced with five opaque doors, only one of which has a crab, which they love to eat, hidden behind it. Different symbols are visible on each door. After a few tries, the octopus accidentally chooses the correct symbol. In subsequent trials, the octopus quickly recognizes the symbol and opens the correct door, even when they are all moved around. If a crab is placed behind a door with a different symbol the octopus quickly learns the new symbol. In other experiments octopuses have shown ability to distinguish symbols about as well as a three- or four-year-old child.

The plural of octopus is octopuses. Octopi is not correct because the word is of Greek origin. The plural in Greek is octopodes.

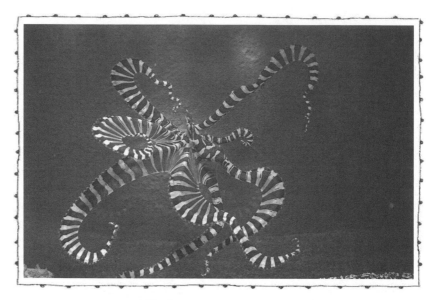

A Wunderpus.

And in another study, octopuses learned to solve maze puzzles by watching from a distance as other octopuses that have been trained do so. When introduced into the maze, those that have observed the trainees solved the problem faster than other untrained octopuses. Octopuses also play – there is no other word – with objects that are of no apparent use to them, such as little balls thrown into their tanks. These behaviours, and others, are unique among animals without backbones, and more sophisticated than any displayed by fish as well as many reptiles and mammals.

Their intelligence is all the more striking because it has evolved completely independently of the line that gave rise to us: our last common ancestor – perhaps some simple, slug-like creature – lived well over 540 million year ago. Humans are more closely related to starfish and sea cucumbers. And yet across a chasm in evolutionary time we encounter a creature with some striking resemblances to ourselves: a mind that calculates and even, perhaps, a form of awareness. In some ways, as we will see later in this chapter, their abilities surpass ours.

There are more than three hundred different octo-

THE BOOK OF BARELY IMAGINED BEINGS

pods (that is, species of octopus). They vary greatly in size, shape, appearance and behaviour, and are adapted to almost every ocean environment from the deep ocean around Antarctica to warm, shallow, tropical reefs. The largest known species can grow as big as a car while the smallest is full grown at 2.5 cm, or one inch. One species, the Blanket octopus, has the most extreme divergence in size between the two sexes in a single species of any animal: females weigh 10,000 times as much as males. Having sex must take imagination, as well as skill. There is even a species living very near hydrothermal vents on the sea floor, where the water, under pressure, approaches 100° Centigrade. (It looks a bit like a bleached version of the cartoon character Marge Simpson.) *Stauroteuthis*, which lives in open water 2,000 metres below the surface, glows in the dark to attract prey, and inflates its webbed pink arms to make what is probably the world's only bathypelagic tutu. The deepest living octopus discovered so far – typically 3–4,000 metres down – is *Grimpoteuthis*, popularly known as the Dumbo octopus because large flaps on its body resemble the ears with which the cartoon elephant flies. The Vampire squid – which is actually an octopodiform and not a squid, and looks like an apparition from an impossibly ancient dream – is harmless to humans. But the tiny Blue ring octopus, which lives in shallow waters around Australia, is one of the most venomous animals in the world despite being only a few inches across. The Mimic octopus, which was only discovered in 2005 in shallow Indonesian waters, can rapidly morph its body to resemble a flounder, a sea snake, a lionfish and almost anything else it sees. Its cousin *Wunderpus photogenicus*, discovered in 2006, is not so flexible but the contrast between its white stripes and the rich red-brown background of its body is nature's answer to the op art of Bridget Riley. There is even a Glass octopus that aspires to look like nothing at all by being almost completely transparent.

Compared to this reality, our cultural imagination is massively impoverished. Octopuses are more likely to appear as an item on the menu, as a scary monster in a creaky horror movie, as a participant in Japanese soft porn, or as an item of World Cup infotainment than as

The Blue ring octopus produces tetrodotoxin, a neurotoxin 10,000 times more toxic than cyanide, from bacteria that live in its salivary glands. A tiny dose causes paralysis, respiratory and cardiac arrest within minutes of exposure.

emblems of the wonders of existence. Appetite, loathing and lust have certainly played big parts in human imaginings of these beasts. But we should take a cue from the Minoans who portrayed them in images that, even after 3,500 years, almost sing out loud in celebration of their strangeness and beauty, as well as from humane and forward-thinking scientists at work today.

After the Minoans the octopus seems to have only played a bit part in the ancient Mediterranean imagination. Homer compares Odysseus to one, but only when he is at his most vulnerable, about to be dashed to pieces on a rocky shore. Protean as it is, the octopus does not appear in what may be the most sensual and violent series of animal transformations in world literature: those in Ovid's *Metamorphoses*. Perhaps the most significant role for a cephalopod in Greek and Roman myth is as an inspiration for the Scylla, a monster which seizes sailors between three sharp rows of teeth mounted in each of six heads at the end of six long necks. The mythical Scylla could be inspired by real-world giant squid which do have teeth embedded in the suckers of their long club-like tentacles, as well as formidable hooks. Large varieties were known in the ancient world – Aristotle records specimens up to five ells, or about two and half metres long, and much larger ones exist far out to sea. But even if Scylla is partly inspired by sightings of these, it is also a chimerical monster, knotted together in the depths of the human mind from many forms. The same goes for Lotan, a seven-headed sea monster of Phoenician myth.

The nearest we come in the ancient world to something claiming to be a factual account of a monstrous octopus is in Pliny's *Natural History*, written about AD 77. Pliny reports that no animal is more savage in killing a man in the water than this 'Pourcuttle or Many-feet Polypus', as the octopus is called in a translation of 1601:

> for if [this animal] chaunce to light upon any of these dyvers under the water, or any that have suffered shipwracke and are cast away, hee assailes them in this manner: He catcheth fast hold of them with his clawes or armes, as if he would wrestle with them, and with the hollow concavities and

Lotan is a creature of Yaw, an ancient Semitic god of the deep. Its biblical analogue is Leviathan which, according to the Book of Job, is more like a giant serpent than a whale. Leviathan 'maketh the deep to boil like a pot' and seems to be bioluminescent: 'he maketh a path to shine after him: one would think the deep to be hoary'. The Lernaean Hydra slain by Hercules also had seven heads. One possible analogue in the natural world is the so-called Seven-arm octopus, *Haliphron atlanticus*. This animal does not actually have seven arms, but in males a specially modified arm used in egg fertilization is coiled in a sac beneath the right eye and can easily be overlooked.

THE BOOK OF BARELY IMAGINED BEINGS

nookes betweene, keepeth a sucking of them; and so long he sucketh and soketh their bloud (as it were cupping-glasses set to their bodies in divers places) that in the end he draweth them drie.

Pliny continues with the story from a place called Carteia of an octopus that used to come in from the open sea to raid uncovered tanks on a fish farm and forage for salted fish. Frustrated by the continual theft, human overseers put up fences to keep it out, but the octopus learned to climb over them by means of the overhanging branch of a tree. At last it was cornered and fierce dogs were set on it but the animal almost got the better of them, and it was only finally dispatched by several men armed with tridents. The animal's arms were almost thirty feet long, says Pliny. Its carcass weighed nearly 320 kg (700 lb).

This begins to sound like urban legend, the Roman equivalent of rumours of alligators in the New York sewers. As Pliny himself writes, 'it may seeme rather monstrous lies and incredible, than otherwise'. There could, however, be some truth in it, at least regarding behaviour if not size. Octopuses can be determined hunters and they often make short journeys across land between tide pools in search of food. Some can go for twenty or thirty minutes out of water so long as their gills are wet, and there are several well-documented accounts in recent years of individuals escaping from tanks in aquaria and laboratories, climbing up and down furniture and slipping into other tanks some distance away to eat their inhabitants. (At first, keepers and scientists were often puzzled: arriving next morning or after a lunch break, they would find crabs and other tasty mortals eviscerated while the octopuses – for all the world as innocent as lambs ... or T.S. Eliot's Macavity, the mystery cat – basked in their own tanks on the other side of the room. In some cases it took a hidden camera to catch an octopus squeezing through unbelievably small spaces in and out of their own tanks and those of their victims, and back again.) There are credible stories, too, of octopuses climbing on board fishing boats at sea and stealing crabs out of the hold.

In general, however, there appears to have been little

The largest known octopus today, the Giant Pacific octopus, typically grows to 45 kg (100 lb), although an individual captured in 1967 weighed 70 kg (155 lb) and was 7.5 metres (23 feet) from arm-tip to arm-tip.

horror of the octopus in the sunlit world of the ancient Mediterranean. Above all they were – as they still are – a food much enjoyed by both rich and poor. A mosaic from Pompeii captures a sense of this. The octopus sits at the centre of a vibrant, and edible, riot of sea life. It's an image you might expect in an upmarket fishmonger.

It is not until about fifteen hundred years after Pliny that another European tried to describe the octopus dispassionately. Around 1595 the Italian naturalist and polymath Ulisse Aldrovandi compiled all the information he could find as part of his monumental encyclopedia and 'theatre' of natural history. Octopuses live, Aldrovandi declared, on land as well as at sea, moving with as much ease over rocky ground as they swim underwater. They are stronger than the eagle and fiercer than the lion. They are voracious eaters and when not chasing fish and crustaceans are partial to fruit (especially figs), olive oil, the odd human and even their own arms. They can turn every colour except white. Eaten without garnish they are an aphrodisiac; cooked in wine, an abortifacient.

Viewed today, Aldrovandi's account is a sundae of bizarre imaginings topped with a few accuracies. It is, however, at least an attempt to relay facts rather than symbolic meanings, and the illustrations in his book are remarkably accurate. But even as Aldrovandi was writing, stories circulated in Europe of a huge and terrifying beast that would have more impact on popular ideas of the octopus than any number of scientific studies. In northern Europe great water beasts date back at least as far as the Norse sagas, in which Thor battles a giant sea serpent called Jormungander. Other stories tell of eight-legged monsters known as the Kraken, a name derived from *krake*, a Scandinavian word for an unhealthy animal or something twisted. ('Crooked' in English comes from the same root, as does the modern German name for an octopus.) Over time, the imaginary is conflated with the strange but real. A multi-armed 'fish' appears on the Carta Marina, a 1539 map of Scandinavia and surrounding seas notable for its detailed and accurate depiction of geographical features and natural phenomena as well as its fantastical representations of sea monsters. Linnaeus thought the

Kraken sufficiently credible to include it in the 1735 edition of his *Systema Naturae* (although he dropped it in later editions). And in his 1752 *Natural History of Norway* Pontoppidan, the bishop of Bergen, said it was the size of a floating island, and that, while not given to attack, it could create a whirlpool when diving that would drag down a passing ship.

Linnaeus and Pontopiddan were not completely deluded. Giant squid such as *Architeuthis* (ten metres long) and *Mesonychoteuthis* (fourteen metres) do exist – a fact that biologists only finally accepted in 1857. But they are extremely elusive: even today only a very few have been caught, and a great number of very strange species still lurk on the threshold of human knowledge. It's easy to see how, in earlier times, a brief glimpse of a living one – or of its boneless, twisted remains – could have been mistaken for a giant version of the more familiar octopus. Pontopiddan's reports of disappearing ships may also be based on actual events, albeit events without giant cephalopods. They could be cases of a rare phenomenon, contested by some commentators, in which a sudden out-gassing of methane from the seabed sends up a giant bubble that lowers water density at the sea surface so much that a ship is no longer buoyant and sinks like a stone down a mineshaft.

A video channel maintained online by the Monterey Bay Aquarium Research Institute features (among other things) a marvellous anthology of Deep Sea Squids.

Because they were so elusive, giant cephalopods were excellent fodder for fabulists. In the early 1800s the French malacologist Pierre Denys de Montfort published an account of a British ship of the line that he claimed had been sunk, and its crew devoured, by a Colossal octopus, or Kraken. De Montfort was ruined when his fraud was exposed, but the images he created endured, inspiring among other things a compelling sonnet by the young Alfred Tennyson in 1830 and a fountain of schlock horror monsters ever since. Herman Melville hardly mentions giant cephalopods, but he was after truth and had no eye for the market. By contrast, Victor Hugo and Jules Verne – two hugely popular writers in their day – immediately saw their appeal.

In Hugo's 1866 blockbuster, *Toilers of the Sea,* the hero is caught in the grip of a giant octopus. The creature is 'the very enigma of evil, a viscosity with a will, a boneless, bloodless, fleshless creature with one orifice serving as

both mouth and anus, a medusa served by eight snakes, coming as if from a world other than our own'. Hugo seems to have read his Pliny, but he pulls out all the stops in wild exaggeration and extreme anatomical confusion:

> It is a pneumatic machine that attacks you. You are dealing with a footed void. Neither claw thrusts nor tooth bites, but an unspeakable scarification. A bite is formidable, but less so than such suction. The claw is nothing compared to the sucker. The claw, that's the beast that enters your flesh; the sucker, that's you yourself who enters into the beast. Your muscles swell, your fibers twist, your skin bursts beneath this unworldly force, your blood spurts and frightfully mixes with the mollusk's lymph. The beast is superimposed upon you by its thousand vile mouths; the hydra is incorporated in the man; the man is amalgamated with the hydra. The two make one. This dream is upon you. The tiger can only devour you; the octopus, what horror, breathes you in! It draws you toward itself and into itself, and, bound, stuck, powerless, you slowly feel yourself emptied out within that horrendous sack, that monster. Beyond the terror of being eaten alive is the ineffability of being drunk alive.

Monster ocotopods live on in great works of art such as the film *Mega Shark Versus Giant Octopus* but the 'biggest', in the sense of most famous, octopus so far in the twenty-first century has been a diminutive inhabitant of a provincial German aquarium. Paul, a Common octopus, shot to global fame after appearing to predict the winners in a series of matches up to and including the final of the 2010 Football World Cup. (He was offered a choice between two boxes both containing a mussel as a snack, each box marked with the flag of the country of one of the two opposing teams in an upcoming match. He consistently went to the box with the flag of the team that went on to win.) It was a story that everybody loved. At one point Prime Minister José Luis Rodríguez Zapatero of Spain offered to take Paul under state protection, while the Iranian president Mahmoud Ahmadinejad identified

him as conclusive proof of the decadence of the West.

Paul's 'predictions' can, of course, be explained by chance, bias and other factors. But what this episode shows – apart from the rather unsurprising fact that German zoologists have a better sense of humour than conservative Iranian politicians – is that it *is* possible for an octopus to capture the popular imagination without being a monster. Having got *this* far, perhaps there is a chance that more people can learn to see ordinary octopuses as remarkable creatures *without* the packaging of clairvoyance and football.

One place to start is the ability of many octopuses and other cephalopods to vary the colour and texture of their skins. Once you start to appreciate what is involved, this is truly astounding. 'Man is the only animal that blushes – or needs to,' quipped Mark Twain. But he was only half right. Ocotopods blush in a dozen hues of their choice. They can open and shut tens of thousands of chromatophores – pigment-containing and light-reflecting cells – on their bodies to form arrays that precisely match subtle, continuous changes in the environment. Simultaneously, the animal can contract and contort its skin surface in three dimensions to mimic the texture of a rock, coral or some other object. The powers of perception and control involved are greater than anything humans can manage with their bodies and are matched only by what we can do in the symbolic realms of language and the arts. (Although octopuses have a remarkable capacity to learn new things, these particular abilities are instinctual.)

The computer scientist, musician and virtual reality pioneer Jaron Lanier is a big fan of cephalopods. '[They] taunt us with clues about the potential future of our species ... [Their] raw brain power seems to have more potential than the mammalian brain ... By all rights, [they] should be running the show and we should be their pets.' The reason that this is not the case – as Lanier and others point out – is that almost all cephalopods are very short-lived. The Common octopus typically lives less than a year and even the largest species only live three to five years – and die before their young are born. As a consequence,

Paul started to receive international recognition after he correctly predicted Germany's win over England. After that he made four correct predictions. The odds of doing this were the same as a human correctly predicting four coin tosses in a row: 16–1. A Guatemalan data analyst calculated that only 178 individuals are needed to have someone correctly predict all the winners from a series of eight matches. Many other supposedly oracular animals failed where Paul succeeded. These included Leon the porcupine, Petty the pygmy hippo, Jimmy the Peruvian guinea pig, Mani the parakeet, Harry the crocodile, Apelsin the Red River hog and at least two other octopuses, Pauline in Holland and Xiaoge in Qingdao, China.

they do not get a chance to pass on what they learn to the next generation. Cephalopods have no culture: no childhood in which they are guided by their parents. They must start from scratch in every new generation.

Still, argues Lanier, we have a lot to learn from the octopus. Its impressive ability to communicate complex meanings by altering the colour and texture of its skin – to literally embody meaning – could be an inspiration for what humans may one day achieve in the realms of 'post-[linguistic] communication', which would give rise to a 'vivid expansion of meaning'. Lanier was anticipated by Michel de Montaigne, who noted in 1567 that 'the octopus assumes whatever colour it likes to suit the occasion, hiding, say, from something fearful or lurking for its prey'. Taking this as an example of how other animals sometimes far surpass us in certain abilities, Montaigne suggested that we consider that our familiar ways of perceiving the world may be stunted, and that we might learn much more if we could sense in new ways: 'We have fashioned a truth by questioning our five senses working together; but perhaps we need to harmonize the contributions of eight or ten senses if we are ever to know, with certainty, what Truth is in essence.'

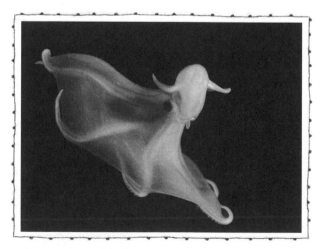

Deep sea cirrate octopod.

THE BOOK OF BARELY IMAGINED BEINGS

The authors of medieval bestiaries inherited an ancient belief that every land animal had its counterpart in the sea. If one were to revive this discredited idea today a favoured candidate for a marine counterpart to humans would probably be the dolphin (see Chapter 4). But maybe the octopus would be a better fit. Perhaps we can learn to treat them not as fiends – or as lunch – but as mentors in the arts of escapology, adaptability and self-expression, and as ambassadors for the proposition that it is never too late to have a happy childhood.

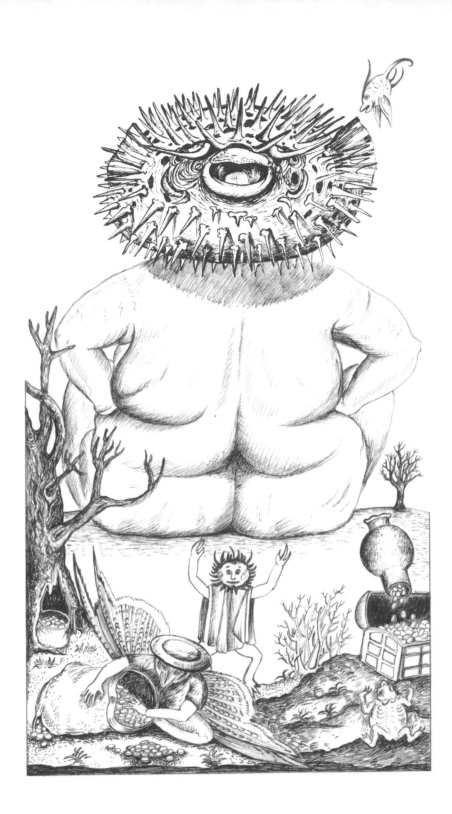

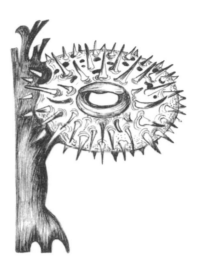

PUFFERFISH

Tetraodontidae

Phylum: Chordata
Class: Actinopterygii (Ray-finned fishes)
Order: Tetraodontiformes
Conservation status: Many species. Not listed

Men are troubled not by things, but by their opinions about things.
Epictetus, quoted by Laurence Sterne as the epigram for
Tristram Shandy

Balloonfish, blowfish, bubblefish, globefish, swellfish or toadfish: the Pufferfish and its close cousins featured in half the *Wunderkammern*, or 'wonder rooms', of Renaissance Europe. Today people keep them as pets in tanks rather than as curiosities in cabinets. But in some ways attitudes have changed little. Pufferfish are still seen as funny-looking oddities: ugly and a little ridiculous. Bloat, the Pufferfish in *Finding Nemo* who, when startled, inflates as suddenly as an automatic life jacket, is a good example. And it seems that even dolphins share our view, deliberately provoking Pufferfish so that, inflated, they can be used as balls to toss through the air in the dolphin version of water polo.

Ridicule aside – and this fish can be far from ridiculous when threatened – the Pufferfish and its cousins really are strange. Known collectively as the Tetraodontiformes after the characteristic four fused teeth that form their beaks, the 360 or so species in this order have abandoned the streamlined, flexible bodies that characterize most fish and become rigid and globular – or box-shaped, or triangular – and move by 'rowing' with their caudal and pelvic (tail and side) fins rather than by undulating their whole bodies. This is known as ostraciiform locomotion. It's somewhat as if humans walked by swivelling their feet rather moving their whole legs, or swam by

THE BOOK OF BARELY IMAGINED BEINGS

flapping only their fingers and toes. And it is explained by their adaptation to an ecological niche: around forty million years ago their ancestors started to graze on coral and an ability to hover somewhat like a hummingbird was more important than the ability to cover distance. Nimble nibblers, they could choose the best angle from which to bite off pieces of the hard coral and crusty algae with their formidable and ever-growing beaky front teeth.

Pufferfish also seem less ridiculous when you consider their defences. The swift inflation to an almost spherical shape, which is achieved by rapidly distending their stomachs and filling them with water, makes them too large for most fish on the reef to swallow. The spines radiating from the inflated bodies of many species are sharp enough to pierce the throat of any large animal, such as a turtle, that tries to eat them. (Sometimes, the Puffer may then literally eat its way out.) Many species are also loaded with tetrodotoxin, the same fantastically potent poison used by the blue-ring octopus. Nor are Pufferfish angels to their own

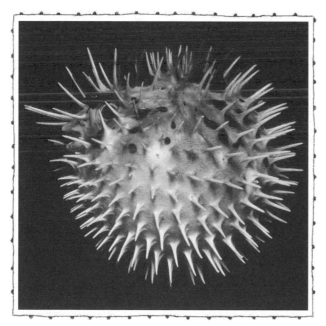

Black-blotched Porcupinefish (*Diodon liturosus*).

kind. As soon as larvae grow their first teeth they start to bite chunks out of their smaller brothers and sisters, frequently killing them. The extra food accelerates their growth; these cannibalistic fish are likely to be faster and more agile, and so deal better with predators.

Prickliness, toxicity and ferocity have served the Pufferfish and its relatives well in the exuberant but ruthless ecosystem of the coral reef. But at least one member of their order has unhinged itself entirely from this tangled world and morphed into something even weirder. The Ocean sunfish (*Mola mola*) is a pufferfish that has expanded to stupendous girth. At well over a tonne, and sometimes more than two, and 3.3 metres (11 feet) across when fully grown, the Ocean sunfish is the world's heaviest bony fish. It was too big to have any predators until humans appeared, and if left alone seems to be quite happy sailing along, soaking up sun and snarfing salps, siphonophores and jellyfish. It resembles a disembodied head with unaccountable frills at the back and wrongly placed wings or sails sticking out top and bottom.

In medieval bestiaries animals are seen as symbols of virtues, vices and other qualities that carry lessons for humanity. We tend not to think like this today, but I still find it hard to look at a Pufferfish or a Sunfish without certain associations and feelings coming to mind.

First, their strange appearance puts me in mind of those times when our own species can seem physically odd. Most cultures celebrate human beauty, but we can be a strange-looking bunch. With our knotty ears, rapidly changing faces and oversized heads tottering on improbably vertical bodies, there are times when we can seem to be completely without grace.

Second, the Pufferfish reminds me of the ways in which our appetites can get out of control or can become perverted. This animal is, as we have seen, a voracious consumer in its own right but it is also, as *fugu*, a premium extreme food for humans. In a world in which hundreds of millions of people are obese and in which chefs are always finding new things to eat and new methods of preparation – whether it be

THE BOOK OF BARELY IMAGINED BEINGS

animal penis restaurants in China, fat and corn syrup by the bucketful at the US Major Eating League, or fritters made from the paws of still-living bears in Southeast Asia – *fugu* prepared by a Japanese master chef remains the ultimate challenge. Part of the thrill is that the dish is prepared so that just enough poison remains in its flesh to numb the eater's lips, and that if the chef makes even a tiny mistake the eater can easily die.

Psychologists and others have long tried to understand what it is that drives people to extremes of consumption, either in novelty or quantity. Adam Phillips suggests that 'the excess of appetite we call greed is actually a form of despair ... it is not that appetite is excessive; it is that our fear of frustration is excessive'. Our excesses, Phillips writes, are 'the best clue we have to our own poverty, and our best way of concealing it from ourselves'. This may be right: we are looking for a fix that will transform us into something different, better or more potent. In practice, however, we often end up looking stupid and weak, like Homer Simpson, the hero with a thousand vices, who eats ill-prepared *fugu* and resolves to live his final hours rightly, justly and compassionately ... only to fail spectacularly on every count.

Aristotle warned that 'without virtue, man of all animals is the most unholy and savage, and worst in regard to sex and eating'. Unless we learn to manage our appetites in more intelligent and creative ways we risk turning ourselves, the seas and much else into something greatly impoverished, and we won't even have the Pufferfish to wonder and to laugh at.

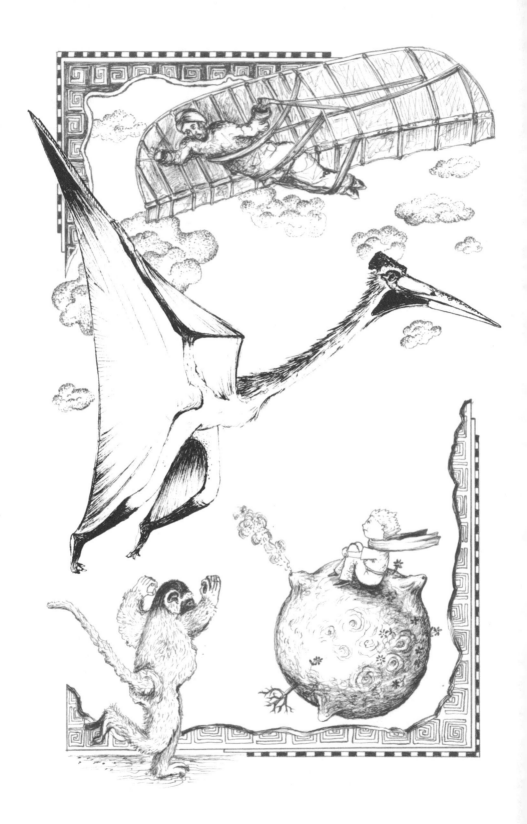

QUETZALCOATLUS

Quetzalcoatlus Northropi

Phylum: chordates
Order: Pterosauria
Conservation status: Extinct

Flight consistently features in human dreams. Some of the earliest surviving written documents – Assyrian cuneiform texts of the second millennium BC – feature extended commentaries on dream flight. Islamic tradition has *Tay al-Ard*, a 'folding-up of the earth', in which teleportation is effectively instant. Shakespeare's Puck puts a girdle round the Earth in forty minutes. One of my favourite dream flights in recent years occurs in a film called *The Sea Inside* from 2004, in which the hero, a quadriplegic played by Javier Bardem, imagines rising effortlessly from his bed and soaring in sunlight over wooded hills to the sea.

Most of us will never see Earth's most magnificent creatures in person. We will never swim with a Blue whale. The closest we'll get to a Snow leopard at play is a few minutes of documentary film. But there is one marvel that almost all of us can see just by stepping outside: feathered flying dinosaurs. Every Swift on the wing, every treetop Blackbird in song is a reminder that the descendants of these massive reptiles took to the air in flight.

Humans can fly too, of course, thanks to sophisticated and heavy machines that consume huge external reserves of energy. But free flight, using our own bodies and muscle power, seems likely to remain a dream, albeit an endlessly compelling one.

There have, however, been real creatures whose natural history indicates just how strange something that weighs as much as a human probably has to look in order to be capable of powered flight. These are the pterosaurs – winged lizards that lived at the same time as the dinosaurs – and, specifically, the greatest giants of the order such as Quetzalcoatlus (pronounced Ketzal-co-at-lus). This late-Cretaceous beast was as tall as a giraffe and had the wingspan of a Spitfire but probably weighed no more than a heavyweight boxer.

Before picturing Quetzalcoatlus in more detail, it's worth reflecting on just how extraordinary it is for

THE BOOK OF BARELY IMAGINED BEINGS

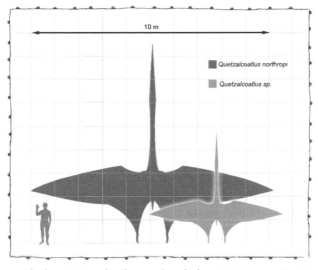

The largest Quetzalcoatlus may have had a wingspan as great as a Spitfire but it weighed no more than a large human being.

something that weighs as much as we do can fly. Humans are picayune compared to elephants or whales but we are behemoths compared to almost every being that can fly: most birds and bats weigh only a few grams. And being large is a huge handicap if you want to take to the air. A thought experiment suggested by Richard Dawkins shows why. Imagine a hippopotamus shrunk a thousand times so that it is about the size of a flea. Because mass shrinks by the third power (the cube) while its surface areas only reduces by the second power (the square), the flea-sized hippo will weigh one billionth (a thousandth *times* a thousandth *times* a thousandth) as much as its full-size cousin but have one millionth (a thousandth *times* a thousandth) its surface area. Thus, its surface area will be one thousand times as great as its full-sized cousin with respect to its weight. The happy result is that a flea-sized hippo can hitch a ride on a passing gust and float through the air with the greatest of ease. Of course, we might not notice it passing.

There is a strict upper limit to how much energy animal cells can generate, and it is far below what can be achieved by the combustion of high-grade aircraft

Evidently, this is not intuitively obvious. If it were then Chinese dragons and European angels would look very different. Mainly, they'd have much bigger wings and much smaller bodies; putti are halfway there.

fuel. This means that even the largest flying creatures tend to be surprisingly light. The world's biggest flying mammal, for example, is the Golden-capped fruit bat (also known as the Giant golden-crowned flying fox). This gentle fig-eating beast, which lives in remote forests in the Philippines, has a wingspan of about a metre and half (five feet) – about five-sixths the length of outstretched human arms – but it weighs just 1.2 kg (3 lb). That's not much of a meal once the wings and bones are removed, but these bats are prized for their taste and have been hunted to the verge of extinction. Once, on a small island far from the main Philippine archipelago, I met a seventeen-year-old crack shot called Stalin famed for supplying city restaurants with these bats. Everyone said Stalin's marksmanship would earn him a place as a sniper with the US Army in Iraq. And so it proved.

Giant mythological birds include the Garuda in the Hindu tradition, so large it could block out the sun; the Ziz of Jewish lore, which could do the same; and the Roc of Arabian tales, which could carry an elephant in its talons.

The most massive flying bird still in existence is probably the Great bustard. Once common in grasslands from Mongolia to Spain, bustards are now vulnerable to extinction thanks to the conversion of the grasslands that they like into farmland, and their tendency to fly into electric power lines at high speed. Adult males can have a wingspan of 2.4 metres (8 feet) and weigh around 12 kg (26 lb), but have supposedly been recorded at up to 21 kg (46 lb), or roughly the weight of

The Great bustard (*Otis tarde*) is the heaviest extant bird that can fly. But this male is just showing off.

THE BOOK OF BARELY IMAGINED BEINGS

a five-year-old child. In the breeding season, having no chins, they grow splendid feathery beards on their necks, like Victorian gentlemen gone slightly awry.

Andean condors can have bigger wingspans than Great bustards – in some cases more than 3 metres (10 feet) – but none have been recorded at more than 15 kg (33 lb) in weight. The biggest recorded wingspans among living birds, at up to 3.5 metres, or 12 feet, are those of the Wandering Albatross and the Southern Royal Albatross: adult males in these species can weigh 11 kg. Long before man, there were birds even larger than this. The biggest found so far in the fossil record are the teratorns. One of them, *Aiolornis incredibilis*, had a wingspan of up to 5 metres, or about 20 feet.

In recent years Andean condors have dwindled in numbers but they are faring better than their slightly smaller California cousin, which has almost crashed out of existence. Like the Great bustard, the California condor did not find twentieth-century civilization amenable: so many of them got zapped on power lines that by the mid 1980s less than two dozen remained out of what had once been a population of thousands. (By some accounts, native peoples had already put the bird into steep decline in pre-industrial times by killing so many in order to use their feathers in ceremonial head-dresses.) Since 1986, however, the California condor has made a modest comeback thanks to a captive breeding programme. One highlight in my very short non-career as a natural history radio reporter was an assignment to visit condor chicks being raised at the Los Angeles Zoo, slap bang in the middle of several hundred square miles of concrete. The wee ones were receiving early lessons in life skills such as power-line avoidance from Condor adults that were actually glove puppets. I was warned to stay well out of sight because if the chicks see a human they fall hopelessly in love with you.

Flapping wings in flight is hard work for a creature as big as a condor or an albatross, and for by far the greater part of the time they are in the air they are not strictly speaking flying, but gliding and soaring. How improbable, then, that a creature that weighs four to six times as much – as a typical human adult does – should ever take to the air.

The condor had mythic powers for the native peoples of California. The Wiyot say that Condor recreated mankind after Old Man wiped out humanity with a flood. The Mono believe that Condor seized humans, cut off their heads and drained their blood in order to flood the home of Ground Squirrel. The Yokut say that Condor ate the moon, causing the lunar cycle, and made eclipses with his wings.

Active flying means a movement upwards with respect to an air mass. Gliding is a kind of delayed fall: technically, any descent path through the air at more than 45 degrees to vertical. Soaring is a matter of maintaining position with respect to an air mass, which is itself rising.

Giant flying reptiles first turned up in a dusty cupboard in 1757, when a man named Karl Theodor was rummaging around in a cabinet of curiosities in the palace at Mannheim in Germany and stumbled on some bones he couldn't identify. Seven years later Cosimo Collini, a Florentine who had been Voltaire's secretary, decided the bones were those of a seagoing creature that had used its long front limbs as paddles. In 1801 the French naturalist Georges Cuvier (who we met in Chapter 1) examined the 'paddles' and decided, correctly, they were hugely enlarged fingers that supported the wings of a great flying reptile which he called 'pterodactyl' (for 'winged finger'). This astonishing insight turned out to be correct. Since then, scores of different species of what are now called 'pterosaurs' ('winged lizards') have been discovered all over the world – including, in 1971 in a quarry in Texas, the biggest yet.

Quetzalcoatlus probably weighed at least 60 kg (130 lb) and may have exceeded 100 kg (220 lb), which would have placed it well above the International Boxing Federation's threshold for heavyweights. But even though it was supremely fit and would have had a very long reach, Quetzalcoatlus would probably have been a hopeless boxer. For one thing, its 'fists' – its first three fingers – were halfway down the front wings, which were suspended from vastly elongated fourth fingers. A full-grown individual, with a wingspan of 11–12 metres (36–40 feet), was as broad as a 44-tonne trailer truck, the largest vehicle allowed on British roads, is long. (US 66-tonne trailer trucks are a bit longer: typically up to 14.6 metres, or 48 feet.) So even though an adult Quetzalcoatlus weighed about as much as Muhammad Ali in his prime, it would have looked extraordinarily thin to us, like a giant version of Suppen-Kaspar, the boy who would not eat his soup in the Struwwelpeter tales.

A bird called the Resplendent Quetzal, which lives in Central America today, is also named after the Mayan god. Its iridescent green tail feathers are venerated by indigenous peoples, who regard it as a symbol of goodness and light.

Quetzalcoatlus, named after the Mesoamerican sky god and creator Quetzalcoatl, did not (to mix godly allusions) spring fully formed from the head of Zeus. Its pterosaur ancestors had already been around and evolving for at least 150 million years by the time it appeared. More than twice as much time separates those first flying reptiles from Quetzalcoatlus as

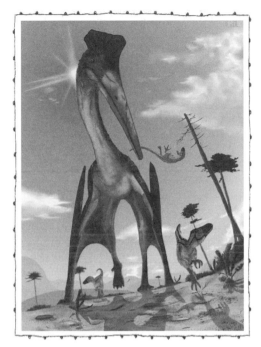

Lunch.

separates Quetzalcoatlus from us. But precisely what
the first pterosaurs evolved from, and when, no one is
sure, because no convincing proto-pterosaur fossils
have yet been found. One suggestion – appealing, but
now alas considered unlikely – is *Sharovipteryx*, a small
lizard of the Triassic that looked like a cross between
a delta wing fighter and a lizard in bloomers, thanks
to large membranes stretched between its back legs
which enabled it to glide from branch to branch. A
more plausible candidate is said to be a small, lanky
and fast-running beast called *Scleromochlus*, a general-
ized ancestor of both pterosaurs and dinosaurs, but
being so generalized it doesn't tell us anything in par-
ticular about the unique pterosaur lineage. What is
certain is that pterosaurs were one of only four
groups of animals to master flight and the first verte-
brates to do so. They predated the first flying bird by,
perhaps, 45 million years and the first bat by about 150
million years.

Insect flight predates
pterosaur flight. In
the Carboniferous
and Permian periods
dragonflies the size
of large seagulls ate
everything up to and
including salaman-
der-like amphibians.
These enormous
creatures were, how-
ever, long gone by
the time pterosaurs
evolved in the late
Triassic.

Early pterosaurs thrived on a rich diet of insects plucked from the Triassic skies. As they broadened their diet to include fish, crustaceans and other animals so they increased in diversity and form. In all more than a hundred species, ranging from the size of a blackbird to that of a small aeroplane, flourished and died out over many tens of millions of years.

So many different kinds over such a long period of time. It's not surprising that some people muddle them up. Take that pinnacle of British film-making, *One Million Years B.C.* When Raquel Welch, as Loana the Fair One, bathing one day, is snatched into the air by a *Pteranodon* (the one with a very pointy back to its head) which drops her bleeding into the sea after it is itself attacked by a *Rhamphorhynchus* (the one with the long tail ending in a lozenge), the sequence is not precisely historical. *Rhamphorhynchus* died out some fifty million years before the first *Pteranodon* evolved, and Raquel Welsh is not nearly that old.

The real pterosaur story goes something like this. First came the genus *Dimorphodon*, the short-wing big heads, and *Anurognathus*, the fabulous flying frog heads. Then came *Eudimorphodon*, the first of the long snouts, and *Rhamphorhynchus*, the true prow-beaks. Then came *Pterodactyloids*, long-armed and short-tailed, and *Ornithocheiroids*, soarers resembling albatrosses and frigate birds (but bigger: some had wingspans of 7 metres, or 22 feet). Then came the *Ctenochasmatoids*, which had long legs for wading, flexible necks and bills for straining (at least one species, *Pterodaustro*, was probably bright pink thanks to a diet like a flamingo's), and *Dsungaripterus*, shell-crackers with tough beaks resembling giant tweezers. At last came the *Azhdarchoids*, the group of giant toothless wonders that is named collectively after a mythical Uzbek dragon and included Quetzalcoatlus. And after that came no more: pterosaurs were ptoast.

And what a shame that is. Pterosaurs were something apart from other reptile orders, as bizarrely different from them as the platypus and echidna are from other mammals today. Start with the giant fourth finger that supported each wing. Imagine your ring finger – for the pterosaur's fourth fingers were

homologous to ours, with the same number of bones – growing until it is longer than all of the rest of your arm and hand put together, and sprouting a wing membrane from finger tip to shoulder that joins all the way to your knee. You'd be webbed for flight and wedded to it. Now imagine that your bones are 'hollow', not just in the sense that they have a marrow but in that their main structure is filled with air cavities like styrofoam, and have walls as thin as a credit card. Now imagine two 'pteroid' bones – small extra struts extending forward from each wrist to support a front flap, or 'patagium', on each wing. Imagine the entire body covered with hairy skin very much like that of the forearms of an adult male human. Imagine all of this and you start to see the oddness of these animals.

The pterosaur of cliché – a primitive glider on tough leathery wings – is exactly wrong. These animals would have astounded us with their agility in the air.

Even stranger ways to almost-fly have included a 'biplane' reptile, with separate wings on its legs and arms. No creature has actually turned its ears into wings like Dumbo the elephant, although a little mouse-like creature called the Long-eared Jerboa looks like a cartoon version of one.

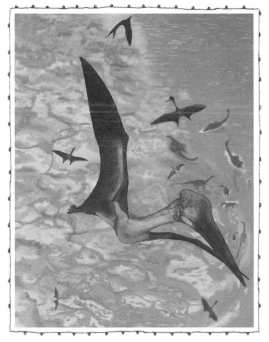

Quetzalcoatlus in flight.

This wasn't just down to powerful muscles which they used for flapping, important as those were. Sandwiched in their wings was a broad but thin membrane threaded with hundreds of long batten-like fibres. The ensemble could be tensed or slackened by striated muscle (muscle under voluntary control) within the wing, while nerve endings in this muscle known as proprioceptors monitored every part of the wing many times per second and relayed this information to the floccular lobes in the brain that monitored body position, and which was bigger in pterosaurs, relatively speaking, than in any other animal including birds.

'Equipped with such a system,' says David Unwin, a leading researcher, 'pterosaurs would have been able to perceive exactly how the wing was performing during flight. And by altering wing shape through localized contraction and relaxation of muscle fibres within the [wing] membrane, they could respond extremely rapidly to changes brought about, for example, by snatching up [a large] fish or flying into turbulent air.' This is sophistication of which the most advanced military researchers can only dream.

But pterosaurs were no Einsteins: their brain-to-body ratio – a crude but useable indicator of intelligence – puts them somewhere between reptiles and birds. It's unlikely, therefore, that they were anywhere near as intelligent as modern crows or parrots; but when it came to awareness of body position with respect to the world around them, pterosaurs may have been as exquisitely sensitive as any t'ai chi master.

These animals were quick and agile on the ground as well as in the air. Fossilized tracks, most notably those of two individuals nicknamed Lucien and Emile by investigators, show they could scamper and lollop around on all fours – back legs then winged arms – with the greatest of ease, more like a combination giraffe, rabbit and bird of paradise than a lizard. David Unwin compares them to saddle-sore cowboys walking on crutches. The three claws they had roughly halfway down the front edge of their wings acted as front feet, while the fourth fingers pivoted round on a double-jointed knuckle and stuck straight up in the air, gathering the wing in folds up against their bodies.

Anticipating recent fossil discoveries, the evolutionary biologist John Maynard Smith suggested that over time pterosaurs evolved to become more aerodynamically unstable, allowing for ever greater manoeuvrability in the air.

THE BOOK OF BARELY IMAGINED BEINGS

Nothing now alive moves anything like a pterosaur: to see one today would surely alter one's sense of what is possible.

And when it comes to bizarre skull shapes no animals have outdone pterosaurs, although the Hallucicrania, knobbly headed beasts of the Permian, come close, as do some of the relatively tiny chameleons alive today. Pteranodons are immediately recognizable, and popular, for a hugely elongated skull crest resembling the hood of a Spanish *penitente* or American Klansman. But some of the Azhdarchoids (the genus that includes Quetzalcoatlus) whose remains have been discovered in Brazil had the most outrageous headgear of all. Tapejara, whose name means 'old being' in the language of the Tupi peoples of the Amazon, had a crest five times the height of its skull, while Tupuxuara had a beak as long as a javelin and a huge sail-like crest. It's likely that many pterosaurs besides the Azhdarchoids had brightly coloured crests, but none were anything like as large. Truly, these were carnival animals, with heads and faces as mesmerising as the greatest African masks.

The more science reveals about pterosaurs, the stranger and more fascinating they become. So it shouldn't be a surprise that they have found a good home in imagined worlds. The trend may have started in 1856 when, in a practical joke, the *Illustrated London News* reported that a pterodactyl with a three-metre (nine foot) wingspan had emerged alive from within a rock dislodged during the construction of a railway tunnel at Culmont in France. Enthusiasm for these creatures really took off with Arthur Conan Doyle's *The Lost World* (1912) and the films that the novel then inspired, in which the mighty lizards circle over the great table mountains of southern Venezuela. The first film of the book, with stop-motion special effects by the man who later created King Kong, became the first in-flight movie when, in 1925, it was screened on an Imperial Airways flight from London to Paris in a converted Handley Page bomber. From then onwards pterosaurs have never been absent from screens and books for long. In 1978 the Belgian 'father of cryptozoology' Bernard Heuvelmans filled a whole

book, *Les derniers dragons d'Afrique*, with supposedly credible accounts of flying dragon-type creatures that sounded very much like pterosaurs. Prominent among them was the 'kongamato', which liked nothing better than swooping down to capsize a canoe full of terrified locals ... so long as there were no cameras about. Other sightings of living pterosaurs (which often followed press stories of discoveries of ancient remains) poured in from Madagascar, Namibia, New Zealand, Crete, Brazil, Argentina and Vietnam. Shortly after the excavation of Quetzalcoatlus fossils in Texas, for instance, several living ones were seen in the skies above the state.

More recently, attention has focused on something called the 'ropen', a long-necked, long-tailed beast which resembles the ancient *Rhamphorhynchus* and glows as it flies through the night skies of Papua New Guinea on the odd foray from caves where it dines on rotten human flesh. Actual sightings have been brief, indistinct and usually reported at third or fourth hand, and no one has actually photographed one, but institutions such as the Creation Evidence Museum in Glen Rose, Texas, remain stalwart in the faith.

After all, say some creationists, pterosaurs were a constant presence in the skies over Eden just a few thousand years ago, where they peacefully ate fruit and plants. With the Fall, however, pterosaurs turned to the Dark Side. 'Many of their descendants degenerated to a carnivorous diet and became feared by man, although non-wicked specimens preserved on the Ark helped to temper this degenerative tendency,' explains an organization called Objective Ministries. Some pterosaurs made a right nuisance of themselves, though, when Moses led his people out of Egypt. Normally the Jews would have been able to use ibises for protection because (as you may know) ibises and pterosaurs do not get along. But without their trusty ibises the Children of Israel were tormented by pterosaur attacks throughout their forty years in the wilderness. Luckily, things were brought under control after the Lord told Moses to create a pterosaur effigy on a pole to scare them off.

Scary winged creatures feature in the stories of other cultures too. Sometimes, as in the case of the

According to Objective Ministries, Velociraptors are also still alive, terrorizing the goat herders in Puerto Rico and guarding the remains of the Ark on Mount Ararat.

Ulama of Sri Lanka, they are some kind of 'devil bird'. But often they combine features of birds, bats and other beings. Chinese dragons, which are still seen today in changing cloud formations and as shadows on clouds stalking large jets, provide a conspicuous example. In historical accounts, notes Jorge Luis Borges, the Eastern Dragon of China has horns like a stag, a head like a camel, eyes like a devil, a belly like a clam, scales like a fish, talons like an eagle, footprints like a tiger and ears like an ox. Chinese dragons are found in all realms. There are celestial dragons, ones that rule over mountains and ones that dwell near tombs, and sea dragons in underwater palaces. Each stretches three or four miles in length. On changing position, they cause mountains to tumble.

Coming back to dreams of human flight, an unorthodox but appealing idea for some of those who would like it to be possible is the suggestion that humans are actually more closely related to flying animals than is usually thought. One version of this posits a 'stem-haematotherm' – a common ancestor to birds and mammals but not reptiles that presumably looked something like a cross between a primitive squirrel-like creature and an archaeopteryx (an early, feathered, gliding lizard bird). Richard Owen, the distinguished but deeply unpleasant nineteenth-century British naturalist who coined the word dinosaur, was an early champion of this hypothesis, and it persisted on the outer edges of serious discussion until the late twentieth century. Surely, its supporters argued, warm-bloodedness would not have evolved twice? Well, the answer turns out to be that surely it did.

But if not bird/human ancestors, then what about bat/human ones? In the 1980s an Australian neuroscientist called Jack Pettigrew saw similarities in the way that vision processing is organized in the brains of 'megabats' (such as our friend the Golden-capped fruit bat) and primates, but not in other mammals. Pettigrew became a champion of the 'flying primate theory' which holds that *before* our ancestors leapt from branch to branch, they flew. The idea has some appeal – 'that's not a bat, that's my brother,' as one science writer enthused – but it is rejected by most scientists.

Mark Elvin suggests that a real-world inspiration for the dragon may have been the reticulated python, which is partially aquatic and can reach ten metres in length. In the Middle Ages, Elvin writes, 'the Bái people and descendants of Chinese migrants in the Ěrhǎi region in the foothills of the eastern Himalayas conceived of themselves as living in a world where both nature and supernature were in many ways lethally dangerous ... It seems likely that these fears, even if at times expressed in a symbolic or exaggerated fashion, were grounded in a real, and difficult, and often bitter, struggle against various other forms of life.'

There is, however, at least one group of almost-flying beings that is more closely related to humans than bats are. These are the colugos of Southeast Asia, which are sometimes described, wrongly, as 'flying lemurs'. Colugos, our closest living non-primate relatives, are able to glide as much as 150 metres (more than 490 feet) between trees. They are the size of small cats – typically, they weigh 1–2 kilogrammes (2–4 lb) – and have slightly disturbing, googly eyes. The gliding membranes stretching between their arms, legs and tails give them the appearance, when in the air, of furry bath-mats. Their fingers are webbed too, like those of a bat, although much shorter. Thus they have some superficial resemblances to both pterosaurs and bats but are essentially different from both and, in millions of years of existence, they have not yet evolved true flight.

Of the primates alive today the most promising candidates for flight school are the sifakas, a genus of long-tailed lemur found in Madagascar. You may have seen them in nature films or the cartoon hit named after their island home, delicately prancing on two legs across the forest floor in a way that is both comic and delightful. Less well known is that sifakas have membranes on their arms covered in matted hair which forms a trailing edge resembling an aerofoil, and which may assist them in leaps. Sifakas can jump about ten metres (thirty-three feet) – a little further than the human long-jump world record – which is not bad given they are less than two foot high. But there is room for improvement, and at least one zoologist has suggested that the membranes and mats of hair on sifaka arms resemble an early stage in the evolution of bird wings. If this is right, there would be nothing, given enough time in the right conditions, to stop sifaka descendants developing their proto-'wings' some way further. The rapid destruction of their forest habitat by a growing number of hungry Malagasy people, however, means the prospects for sifakas' survival in the wild are slim.

Much of the imagined and real history of human attempts to fly, from Icarus onwards, is a story of nasty bumps and crashes. The first documented case

seems to be a base jump by the Andalusian polymath Abbas Ibn Firnas, who leapt from the top of the minaret of the great mosque of Cordoba in the year 852 dressed in a large, wing-like cloak. Ibn Firnas survived the fall of about twenty-five metres, with injuries that were not sufficient to put him off an even bolder attempt. For, if the scant records are to be believed, twenty-five years later at the age of sixty-five, he made what may have been the first successful attempt at controlled human 'flight' (actually, gliding). Launching himself from the Mount of the Bride near Cordoba in a hang-glider of his own design, he flew some distance and manoeuvred back to his take-off point, where he crashed. One witness said, 'We thought Ibn Firnas certainly mad ... and we feared for his life!' Another contemporary, the poet Mu'min ibn Said, accentuated the positive: 'He flew faster than the phoenix in his flight when he dressed his body in the feathers of a vulture.' (The poet did not add, 'but crashed into the ground like a bug into the face of a galloping horse'.) It seems that for all his close observation and study, Ibn Firnas failed to copy the way birds and other flying animals tend to slow down before they land. He survived the impact.

The conceptual breakthroughs underlying powered flight by heavier-than-air craft were made by George Cayley in 1799, but it wasn't until 1903 that the Wright brothers got such a contraption to lift off the ground and to stay there under some degree of control. The potential for such machines to outdo balloons and dirigibles in agility and speed, though not endurance, was apparent from the start. No one saw this more clearly than Alberto Santos-Dumont, the glamorous Brazilian balloonist who in 1901 had won the X Prize of the day by sailing around the Eiffel Tower in a small airship of his own design, and who wowed Parisian society by sailing over the boulevards before dropping in at a fashionable cafe. Santos-Dumont's first aeroplane, the *14-bis*, which looked like a motorized box kite, first flew suspended from one of his dirigibles before proving itself under its own power and setting the first aviation distance record in 1906. Before long Santos-Dumont had perfected the

Demoiselle (damselfly), a monoplane which outclassed anything built by the Wright brothers.

The difference in attitude between Santos-Dumont and the Wrights is like something out of a fable. Santos-Dumont thought aviation would bring a new era of peace and prosperity to all mankind, and should be for everyone. A proponent of what we now call open source, he made the designs of the *Demoiselle* freely available. The Wright brothers – highly secretive and protective of their patents – were eager to sell their machines to the US Government for use in war.

Santos-Dumont was the loser. The son of a wealthy coffee-planter, his childhood dreams of flight inspired by the spectacular afternoon cloudscapes on his father's huge estates, he had walked through life as money's guest. But after a nasty crash in 1910 he stopped flying and began a slow descent into incapacity and depression. The use of airplanes in World War One drove him deeper into darkness. At last, alone and childless, Santos-Dumont hanged himself – making practical use, with a noose, of the gravity he had so long defied.

History fulfilled Santos-Dumont's worst fears, not to mention the vision of H. G. Wells, who in his *The War in the Air* (1908) and *The World Set Free* (1914) predicted massive aerial bombardment (in the latter case with atomic bombs) as the shape of war to come, with peace only possible after stupendous loss of life, or the threat of it, has been made very clear. And, one could argue, this is not bad as a sketch of much of what happened subsequently, from the firestorms over Hamburg, Dresden and Tokyo via the destruction of Hiroshima and Nagasaki up to and including Mutually Assured Destruction in the Cold War and nuclear poker in Asia today.

At the same time, flight has, of course, brought benefits and joys beyond measure by transporting people great distances with a rapidity and ease that our ancestors could never have imagined. Most of us think this is a good thing, even if we've been stuck in some soulless terminal for hours. 'The central struggle of men has ever been to understand one another, to join together for the common weal,' wrote Antoine de Saint-Exupéry, the French aviator best known in

Gulliver's Travels (1726) contains what is probably the first description of aerial warfare in Western literature: the flying island kingdom of Laputa bombards rebellious cities with rocks. In *Dr Strangelove*, Stanley Kubrick's 1964 film of nuclear apocalypse, the primary target of the B52 flown by Major Kong is an ICBM complex at Laputa. The first film to depict aerial warfare was *The Airship Destroyer*, directed in 1909 by Walter R. Booth in England. To modern eyes, this film is at once comic – so crude are some of its special effects and melodramatic its acting – and chilling. It is online at europafilmtreasures.eu

THE BOOK OF BARELY IMAGINED BEINGS

English for *The Little Prince*; 'and it is this very thing that the [aeroplane] helps us to do! It begins by annihilating time and space [that separate us].' Writing soon after the destruction of Guernica in the Spanish Civil War and not long before the Nazi triumph in France, Saint-Exupéry was well aware that aircraft could be used to annihilate people but refused to be pessimistic.

In recent decades cheap flights have made beauty, joy, overcrowded beaches and drunken foreign weekends accessible to many of the top billion humans. But the potential for extreme violence never goes away: the vast, air-capable military machine that secures oilfields and sealanes for the easy flow of crude; the many thousands of hydrogen bombs that the United States and Russia *still* keep ready to launch at a few minutes' warning. And, of course, everyday emissions from flying make a significant and fast-growing contribution to the most rapid change in the composition of the atmosphere for several million years.

The reassuring day-to-day hum and pulse of our current world order depends on what has been described as a 'vast liquid clock'. Everyday, oil that has lain under the ground for millions of years is extracted, refined and pumped into waiting cars and aircraft. From the Forties Field in the North Sea, notes the arts group Platform London, the 'clock' takes ten days to turn crude into jet fuel powering a 747 across the Atlantic: 'ten days for the oil to move from 8,000 feet below the sea to 31,000 feet above it, for liquid rocks to melt into air, ten days for geology laid down 57 million years ago to be incinerated into gas'. We don't really know how long we've got on the clock, and whether we will come down with a gentle landing or a thump. Perhaps green technology – sustainably sourced biofuels, say, abundant and clean enough to power fast jets – really will save the day. I'll believe it when I see it.

In the 1930s Saint-Exupéry marvelled at the progress made by aircraft designers and craftsman, who followed the 'ultimate principle of simplicity' and refined the curve of a ship's keel or the fuselage of an airplane, 'until gradually it partakes of the elementary

purity of the curve of a human breast or shoulder'. Perfection, he wrote, 'is finally attained not when there is no longer anything to add, but when there is no longer anything to take away, when a body has been stripped down to its nakedness'.

Take this further than Saint-Exupéry had in mind and you may find yourself in the company of the modern heirs of Abbas Ibn Firnas: those who jump off high places and glide with the aid of wingsuits – costumes that resemble Superman capes but which are webbed between limbs and body.

If you jump off a cliff you will accelerate faster than a racing car and reach your terminal velocity of about 200 kph, or about 125 mph, in nine seconds. Before that, in the very first moments, you will – if you can overcome the terror – feel almost nothing: no sense of acceleration, for example, because your stomach and whole body is moving at the same speed. The pioneering base-jumper Stein Edvardsen says that the first time he tried, 'it felt like an eternity as Mother Earth was pulling me down'. But after about six seconds you start to feel air friction. To get an idea of what that feels like, 'put your hand out of the window of the car when you are driving at 150 kph [90 mph]'.

At a place like Trollveggen, the Troll Wall, in Norway you can fall straight down for more than thirty seconds, somersaulting and back-flipping, before deploying a parachute and floating gently to the ground. But if you want to 'fly', you spread your wings – that's to say, your wingsuit – at around the six-second mark. This can reduce your vertical speed to around 95 kph (60 mph), and even on occasions to as little as 40 kph (25 mph). Your horizontal speed will be greater: on the glide ratio of 2.5 to 1 typical of modern wingsuits you'll be covering 2.5 metres across the ground for every metre you fall. The aerial acrobatics that follow may be among the most extraordinary things ever done by humans.

At the time of writing, films of wingsuit 'flight' available online include *Grinding the Crack* by Jeb Corliss and *Sense of Flying* by Espen Fadnes.

Even the best jumpers have accidents. Karina Hollekim, for example, hit some rocks at over 100 kph when her parachute tangled in a jump in 2006. Her legs were fractured in twenty-five places, and she lost 3.5 litres (more than 7 pints) of blood, about three-

quarters of the blood in her body. She spent four months in hospital, had fifteen operations, narrowly avoided amputation of both legs, and spent nine months in rehabilitation. The pain, she told *The Economist*, was unbelievable. But she regrets none of it: 'It forces you to feel. Extreme fear, then relief, then happiness. In my everyday life I don't feel that much. But, in the air, it's like being in love.'

Saint-Exupéry describes how, after a forced landing in the Sahara Desert, he dozed off while lying on the sand:

> When I opened my eyes I saw nothing but the pool of the night sky, for I was lying on my back with my outstretched arms, face to face with that hatchery of stars. Only half awake, still unaware that those depths were sky . . . I was seized with vertigo and felt myself as if flung forth and plunging downward like a diver.

He did not fall, of course. Gravity, 'as sovereign as love', held him in place on the planet in the way one is 'glued to the side of a car on a curve'. But in a larger sense he continued to fall, as we all do: the Earth is travelling – falling under the constraint of gravity – at 30 km per second (108,000 kph, or 67,500 mph) with respect to the Sun. The Sun itself orbits around the centre of our galaxy at about 200 km per second. And the galaxy is moving at several hundred kilometres per second relative to the cosmic microwave background.

Brief forays a little way into the atmosphere above our Earth may, if we are fortunate, enhance our sense of connection to life as a whole without divorcing us from the intimate love for the particular that we can only know when we are on the ground. Saint-Exupéry expresses this as well as anyone in his fable of the Little Prince: the hero, having fallen to Earth, learns from a desert fox not to be dismayed that there are a vastly greater number of roses in the world than the one he thought was his own. And Saint-Exupéry's contemporary, the film-maker Jean Renoir, does it too in *La Grande Illusion*. The aviator Maréchal, played by

Jean Gabin, learns in the midst of a war in which millions are dying to look beyond hatred of an enemy whose language he cannot understand. In one of the simplest and grandest scenes in world cinema, he cuddles the daughter of a German woman with whom he has fallen in love and says, in the language of his enemies, '*Lotte hat blaue augen*' ('Lotte has blue eyes').

In a world that is not always playful – where the military is mastering the flight patterns of both the mosquito and the albatross for use by robotic killing machines – there are nevertheless some grounds for hoping that low-impact ways of flying may become increasingly feasible and popular. Among these, perhaps, could be methods which are linked intimately to the capacities of the human body, but which do not require extreme courage or recklessness.

The wing-suits in use today are still little more than flaps of cloth. Dynamic soaring at a human scale, never mind true flight, would require something vastly more sophisticated and, for now at least, almost beyond conception. Perhaps, some day, super-light wing-suits that are somehow manoeuvrable by human effort and capable of providing sufficient lift will allow us to come closer. But those suits will still be machines. In the narrow band between deep ocean and outer space, true flight with our own actual physical bodies, as distinct from sensitized virtual-reality systems, seems almost certain to remain a matter for dreams only. This is, literally, our ground truth.

A firmer understanding of our limits is no bad thing. Once we have it, we can also better appreciate the beauty of flight in other animals, recalling that, improbable as it may seem, there once really were beasts such as Quetzalcoatlus that weighed as much as we do but were able to take to the air.

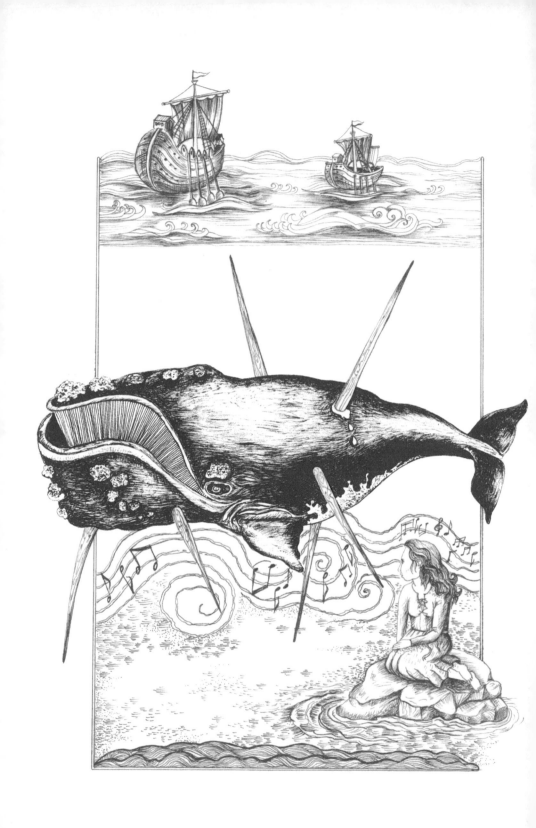

RIGHT WHALE

North Atlantic right whale
(Eubalaena glacialis), *North Pacific*
right whale (Eubalaena Japonica),
Southern right whale (Eubalaena
Australis) *and Bowhead, or Greenland*
right whale (Balaena mysticetus)

Phylum: Chordata
Class: Mammalia
Order: Cetacea
Family: *Balaenidae*
Conservation status: Threatened

In 2008, probably for the first time since the 1600s, not one North
Atlantic Right whale died at human hands.

New York Times, 16 March 2009

Some years ago I had the good fortune to sail in a small boat to Svalbard, the Arctic archipelago that includes the island of Spitzbergen. The beauty of the rocks, glaciers, birds and animals was beautiful beyond words, and made more poignant by the knowledge that what looked eternal to our eyes is being transformed by rapid global warming. But some of the things that struck me most were things we could not see. One evening a musician onboard used an underwater microphone to listen beneath the waves. He recorded a series of long whistles that started high and descended, very gradually – ever so slowly – right down the scale. The sound was something like a slide-whistle or theremin but richer and sweeter, suspended in a vast, echoing world on whose floor, far below the waves and ice, one could imagine, in the far distance, the rustle and click of crustaceans.

When the sea is in a gentle mood, the play of light on its ever-changing surface can be spellbinding. But sounds heard from beneath the sea are another thing. They make unseen space apparent, rather as raindrops on forest leaves or church bells echoing on a hillside describe landscape for a blind man. On our little boat those whistles shifted the focus of the mind's eye. No more were we merely bobbing and cutting through obdurate, shifting steel-grey water; we were in a spaceship drifting high above a hidden world.

The calls that we listened to that day – simple and unchanging in form – were made by a seal. At the time they seemed no less enchanting for that. All things make music with their lives, as John Muir said. Only later did it occur to me that what was really notable about that moment was not presence but *absence*. Until about three hundred years ago there would have been thousands of whales in these waters, and the call of a seal would have been a small part of the background to their songs and grunts rather than a lone call echoing through emptiness.

Remembering his first encounter with whale song via recordings made for the US Navy by Frank Watlington in the deep Atlantic in the 1960s, the biologist Roger Payne said it was 'as if I had walked into a dark cave to hear wave after wave of echoes cascading back and forth in the darkness beyond . . . That's what whales do, give the ocean its voice.' Fascinated, Payne and his colleague Scott McVay started to analyse the songs and discovered something that no one had expected. Far from being random, repetitive sounds like, say, the barking of dogs, the noises produced by Humpback whales were actually elements in rhythmical, precisely repeated sequences and in this sense qualified as true 'songs'.

With help from McVay and others, Payne produced an album from the tapes. Released in 1970, *Songs of the Humpback Whale* sold more than thirty million copies, becoming the biggest-selling nature recording of the twentieth century. For many in a generation that knew itself to be the first to see a photograph of the Earth taken from space, the songs of the Humpback were the soundtrack for the newly popular ideas of environmentalism and the sense that all life on Earth was precious and mutually dependent. The songs were even included on the discs of human greetings and music launched into interstellar space on the *Voyager* spacecraft in 1977. And the sense that whales are special has never entirely disappeared. 'Why do we feel differently about whales than about fish?' asks the marine scientist and writer Carl Safina. 'Is it because they have the largest brains in the known universe? No, it's because

their songs touch the song centers in our own brains. It's not intellect – it's soul.'

The reason there are next to no Right whales around Svalbard is in their name: they were the 'right whales' to hunt. These animals are slow, coastal swimmers and easy to kill. Unlike most other whale species, they float when dead so that they are easy to secure and bring to shore. Their bodies are extremely rich in fat, oil, meat and baleen – the long toothy plates in their mouths – all of them precious commodities. Humans hunted them to the brink of extinction.

Behind this utilitarian name are four species – the North Atlantic, the North Pacific and the Southern right whales, and the Greenland right whale, which is now more commonly known as the Bowhead. All four are classed in one biological family, the *Balaenidae*. The Atlantic, Pacific and Southern are more closely related to each other than they are to the Bowhead, and look very similar to each other even though they have probably not shared an ancestor for five or six million years. They are dark in colour, rotund, broad-backed and have no dorsal fin. Even the smallest adults, at about 11 metres, or 35 feet long, are longer than the old British double-decker Routemaster bus. Many grow to 17 metres, or 55 feet, and some are even bigger. A 17-metre Right whale can weigh 65 tonnes – nine times as much as the Routemaster.

To visualize the whale's mouth, which is up to a third of its entire length, place the back of your wrist against your nose with your knuckles against your forehead. Your fingers and thumb are making a pincer shape like the a much smaller version of its jawbones.

The mouth of the Right whale begins below the eye and sweeps forward and up so that the line of it, when closed, arches like the healed scar of a terrible slash-wound on the face a pirate. The upper jaw is rather like a curved cap on the huge cup of the lower mouth. Inside the upper jaw, several hundred baleen plates, mounted like the teeth of a comb but taller than a man, and bristly, form a sieve. To eat, the whale takes a wide-open gulp of water and closes its jaws to a slit so that as it pushes its tongue forwards and upwards, water is forced through the baleen while the copepods, krill and other animals it likes to eat remain in its mouth.

The faces of the Atlantic, Pacific and Southern right whales are also distinctive for the large white

swellings around their mouths and heads. These are callosities: roughened skin caused by infestations of whale 'lice' (which are actually parasitic crustaceans called cyamids less than an inch long that feed on flakes of skin). Perhaps at some time in the whale's evolutionary past its prospective lunch found a way of anchoring onto the outside of the vacuuming jaws of its would-be predator and staying there to feed.

In the absence of man and the occasional Killer whale hunting their calves, life is mellow for Right whales: a never-ending round of snacks, song, sleep and sex. As D. H. Lawrence wrote in his poem 'Whales', 'the sea contains the hottest blood of all'. The males compete not by fighting but by trying to out-produce each other in the sheer quantity of sperm that they pass to females in frequent and promiscuous couplings from their prodigious testicles (each one of a mature male's pair can weigh half a tonne, or about 550 lb – the largest of any animal). Females are typically bigger than males, and give birth every third year: they are pregnant for a year, nursing for a year and take another year to rest. Calves are about five metres long at birth and weigh about a tonne. They grow fast, doubling in length by the time they are weaned at a year old. Young whales may stay with their mothers for several years, and the bonds are very close.

Bowheads are usually larger than the other three Balaenidae, growing to as much as 21 metres, or 65 feet. They have the biggest mouths on the planet, bigger even than those of Blue whales, baleen plates 3–4.5 m (10–15 ft) high and a tongue 5 m (16 ft) long and 3 m wide. The copepods and other animals that they strain from the water with this huge apparatus are so small that hundreds of them would fit on a tea-spoon. A mature adult will typically eat hundreds of kilos of them every day. Bowheads' skulls are especially tough, enabling them to break through ice as much as 60 cm (2 ft) thick. A Bowhead's skin, says Barry Lopez in his classic work *Arctic Dreams*, is

> slightly furrowed to the touch, like coarse-laid paper, and is a velvet black color softened by gray.

Under the chin and on the belly the skin turns white. Its dark brown eyes, the size of an ox's, are nearly lost in the huge head. Its blowhole rises prominently, with the shape of a volcano, allowing the whale to surface in narrow cracks in the sea ice to breathe.

There are two principal populations of Bowheads: the eastern one, which comprises those in waters of the eastern Canadian Arctic, Greenland and a few other places such as Svalbard; and the western one in the Bering, Chukchi and Beaufort seas.

Bowhead blubber is the thickest of any whale. Although the name *Eubalaena glacialis*, which means 'true whale of the ice', is given to the North Atlantic right whale, it would more accurately describe the Bowhead, which lives at the very edges of the ice and often feed underneath it.

Bowheads are extremely gregarious. The males sing enthusiastically – one phrase up, one phrase down: *whoop eroop, whoop eroop*, as the philosopher and musician David Rothenberg describes it – and although their songs are not as intricate as those of Humpbacks they are varied enough to be called part of a culture. Songs are one of the means by which Bowheads stick together and encourage each other while navigating through ice and darkness. They also can live a long time. Until at least 2006 an individual called Nalutaliq, with a distinctive white head, had been sighted regularly off Baffin Island for more than a hundred years. In 1995 a crew of Iñupiat whalers from Wainwright, Alaska found two stone harpoon blades in the blubber of a Bowhead they were butchering. Stone points had not been used since commercial whalers brought metal tools to the Arctic and traded them to the natives over a hundred years earlier.

Native peoples in the far north still hunt a limited number of Bowheads, Grey whales and other cetaceans. They do this under internationally agreed terms and as part of their cultural heritage. The methods they use are sometimes traditional, or partly so, but some also use fast motors and – in Russia until recently, at least – explosive harpoons.

The earliest known images of whale hunting are in rock carvings made between 6,000 and 1,000 BC at Bangudae in what is now South Korea. They show people in small boats pursuing what appears to be a Right whale, using harpoons and air-filled bladders

tied to the whale with ropes. Resistance bladders tire the whale, and allow hunters to track its position, homing in for the kill when it is exhausted. The very same technique was still in use in the Pacific Northwest of America until the early twentieth century.

Archaeological evidence suggests that whalers were working in the Bering Straits and Chukchi Sea by about 2,000 BC, and that by around 800 AD the Thule culture in northern Alaska was hunting Bowheads in open water far from land. Their techniques rewarded the Thule with a plentiful supply of meat, blubber and even building materials – for they built the frames of their huts from the ribs and jawbones of whales – and they became the dominant culture in the North American Arctic, reaching as far east as Greenland in pursuit of the Bowhead. A warlike culture, they buried the bodies of many of their whalers and warriors between the mandibles and scapulae of whales.

In Europe, some of the earliest accounts of whaling are from 'dark age' Scandinavia and England. But killing for trade and profit rather than subsistence seems to have begun in earnest in the Bay of Biscay not long after the turn of the first millennium AD. If, in the eleventh or twelfth century, you wanted whale oil or meat, you traded with the Basques, who were by then expert hunters of the abundant North Atlantic right whales in their offshore waters. Suggestive of the influence of these early commercial whalers is the likelihood that our word 'harpoon' derives from a shard of their non-Indo-European language embedded in ours: apparently, the Basque word *arpoi* means 'to take quickly'.

Away from the hardscrabble reality of the hunt, medieval bestiaries describe whales as fantastical creatures. They are said to have sweet and enticing breath, an idea that may originate in observations that Sperm whales vomit up ambergris, a digestive secretion which, when dried, has a pleasant, earthy aroma and is a good fixative for perfume. In bestiaries, however, the sweet breath symbolizes the wiles of the devil, who will swallow up a sinner. Frequently, however, whales appear as great floating islands – accommodating a passing saint who decides that the high Atlantic is a

The weapons we now call harpoons (that is, barbed spears) long predate whaling. They were in use more than 40,000 years ago for hunting hippos in East Africa, and 20,000 years ago for hunting seals in Europe.

good place to hold mass, or being mistaken by sailors for a good place to light a campfire, startling the animal with pain so that it plunges for the bottom with the loss of all hands. This story inspired some entrancing images and was still popular in the late fifteenth century when William Caxton included it in his encyclopaedic *Myrrour of the World*, the first illustrated book to be printed in England.

In the real world, as numbers of North Atlantic right whales in nearby waters steadily declined, Basque whalers searched ever further afield. By 1530 they were hunting off Labrador and Newfoundland, and over the next eighty years killed tens of thousands in those waters (as well as some Bowheads). With most populations depleted and other Europeans increasingly competing for the catch, Basque whaling declined and finally petered out in the mid eighteenth century. English colonists started hunting the Right whales that were hugely abundant off Massachusetts within a few years of settlement in the early seventeenth century. Within little more than a hundred years they had taken almost all of a population of 5–10,000 and perhaps more, and Yankee whalers were starting to pursue other species further afield. William Scorseby Sr, a whaling captain at the turn of the nineteenth century who had more than 500 kills, said he had never seen a single Right whale on all his voyages. The odd individual was hunted and killed, however, as late as 1951. Today there are three or four hundred North Atlantic right whales alive wintering off Florida and Georgia and feeding in spring, summer and autumn from New York to Nova Scotia. The species is classed as critically endangered.

Whalers from the Netherlands, England and elsewhere, some of them initially trained by Basques, were already hunting Bowheads (as well as North Atlantic rights) in the waters around Svalbard and Greenland by the early seventeenth century. Later, the British expanded the hunt into the eastern Canadian Arctic. Before whaling began there were at least several tens of thousands and perhaps hundreds of thousands of Bowheads in these waters. The great majority were slaughtered, but enough survived to allow some recovery after they were finally protected

THE BOOK OF BARELY IMAGINED BEINGS

Juvenile Southern right whale.

in the twentieth century. Bowheads are now classified as of 'least concern' of extinction.

The hunt for Pacific and the Southern right whales started later than that of the North Atlantic right and Bowhead but it was no less vigorous. Japanese whalers were already hunting Pacific rights by the 1500s, but the industry only really kicked into top gear in the late 1700s with the arrival of the Europeans, Russians and European Americans. Within a hundred years all but a tiny fraction of a population that had been many tens of thousands strong was eliminated. In the 1840s alone up to 30,000 animals were taken. The future for those that are still alive – today a few hundred animals at most – is at least as precarious as it is for North Atlantic rights and perhaps more so.

Hunting of Southern right whales began in earnest at the end of the eighteenth century. Before then, there may have been 70,000 to 100,000 in four largely separate populations in the Southern Ocean, feeding off Antarctica in the Austral summer, and wintering and breeding mainly around Australia and New Zealand, South Africa and southern South America. By 1920 there were at most a few hundred individuals left in the world – perhaps as few as twenty-five breeding females – and whaling stopped. Having killed more than 99 per cent of the population, humans extended official protection to the survivors. This remnant was

remarkably resilient and fertile, and the population began to double every ten years or so. (By comparison the fastest that humans seem to be able to manage a doubling is about every three decades.) Noting, perhaps, this remarkable growth rate, the Soviets decided in the 1960s that it would be alright to take several thousand animals – something like half the population. Because hunting Southern rights was illegal they told international agencies they were taking only four. Fortunately, this only lasted a few years and after it stopped the population continued to recover. There are thought to be more than 10,000 Southern right whales alive today. Like Bowheads, but unlike North Atlantic and Pacific right whales, the future of the Southern right whale looks fairly secure, at least for the time being, and they are classified as of least concern of extinction.

The mass killing of the four Right whale species is, as already noted, just part of the larger story of whaling. More than 99 per cent of adult individuals from other species such as the Sperm whale and the Blue whale were also consumed in a bloody and entirely one-sided war for oil, flesh, ingredients for make-up, cat food, car brake-fluid and much else that only ended when tracking down the survivors became too time-consuming. About 150,000 whales had been slaughtered between 1770 and 1900, but three million or more were dispatched in the twentieth century. The writer Philip Hoare estimates that in 1958, the year he was born, more whales were caught by factory ships than during the entire 150 years of the epic Yankee era which we associate with *Moby-Dick*.

The North Atlantic right whale was protected in 1930 but the slaughter of Blue whales, Sperm whales and others continued until the 1960s. The International Whaling Commission finally established a global moratorium on commercial whaling in the 1980s. In 1994 the Southern Ocean was declared a whale sanctuary, and in 2003 the IWC declared whale conservation to be its primary goal.

Looking back, this wholesale slaughter by our ancestors and countrymen (if we are Europeans or Americans) seems unspeakably cruel, especially when we learn that the hunters knew how the animals suffered. The nineteenth-century explorer William Scoresby Jr describes a fight between whalers and a mother Sperm whale over her calf. The mother comes to the surface, Scoresby writes, darting back and forth, stopping short or suddenly changing directions. She tosses up water, churning up the seas, refusing to leave her offspring even though three ships and harpoons approach:

She loses all regard for her own personal safety, in the anxiety for the preservation of her young; dashing through the midst of her enemies. There is something extremely painful in the destruction of a whale, when thus evincing a degree of affectionate regard for its young, that would do honour to the superior intelligence of human beings. Yet the objects of the adventure, the value of the prize, and the joy of the seamen with the capture, cannot be sacrificed in reflecting on the refined feelings of compassion.

The value of the prize was some 30–35 barrels of fine-grade oil from a female Sperm whale (and up to 90 from a large bull, enough to fill a small swimming pool). The oil from a typical whale would light a signal lamp for almost a decade or keep a lighthouse beaming for up to a year. Blood for oil indeed. In another account, the mother is slaughtered and the entire sea around her body becomes white with her milk – something that makes even the crew that report it uneasy.

Even when a whale, exhausted after a long fight, was pierced through the heart or a main artery, sending a jet of blood through its spout – an event that the sailors would hail with a shout of 'fire in the chimney'– the drama was not over. Just before a Sperm whale's death, wrote the British surgeon Thomas Beale in 1839, 'the whole strength of its enormous frame is set in motion for a few seconds, when his convulsions throw him into a hundred different contortions of the most violent description, by which the sea is beaten into a foam, and boats are sometimes crushed into atoms, with their crews'.

A Bowhead, Barry Lopez observes, can be so sensitive to touch that, despite the thickness of its skin, one sleeping at the surface will start wildly at the footfall of a bird on its back. Whalers would surely have understood that the pain of a harpoon strike would be extreme. 'In 1856,' Lopez writes, 'a harpooner on the *Truelove* reported a whale that dived so furiously it took out 1,200 yards of line in three and a half minutes before crashing into the ocean floor, breaking

its spine and burying its head eight feet deep in the blue black mud.'

Today we are glad to see the back of such horrors, and many among us in Europe and North America feel justified in denouncing those in Japan, Norway and a few other countries who continue whaling on a relatively small scale, and who continually press for their industry to be allowed to grow. But whether or not we are right to condemn the actions of others and campaign for them to stop (and since the 1986 moratorium the total number of whales killed worldwide every year has risen from less than 200 to more than 1,000 a year), we should not neglect other, potentially greater risks to whales for which we continue to bear responsibility and which we can do something about.

Some generalized threats can prove relatively tractable when purpose and will are mobilized. Shipping lanes can be rerouted around seasonal feeding and breeding grounds so that the probability of collisions is reduced. This seems to have worked well in the case of the tiny remnant population of the North Atlantic right whale. Reducing engine and hull noise from shipping would also help. Sound travels further and faster underwater than it does in the air, and the roar of machines that now permeates the ocean undoubtedly affects whale communication and well-being. Before modern shipping made the oceans so noisy, whales would have been able to hear others more than 1,000km (600 miles) away. Because area scales as the square of distance, the space over which they can contact each other has shrunk tenthousand-fold.

The margin note reads:

> The impact of noise and other factors on Beaked whales may be particularly serious. But by the time we know more about these elusive, deep-diving species it may be too late.

Still other large-scale human impacts may actually present opportunities. Rapid warming in the twenty-first century may result in the disappearance of all summer sea ice in the Arctic as soon as the 2030s. If – a big if – drilling for oil and gas is not too disruptive and humans don't consume all the krill, copepods and fish, these newly open waters could be new feeding grounds for Bowheads and Grey whales even as other animals, such as polar bears, lose much of their habitat.

In the massacres that humans have inflicted on

them over the last few hundred years, Right whales and other whales have already been hit by about as great a cataclysm as is possible short of complete extinction. And yet they have come through. The changes to their environment that lie ahead may create conditions unknown to their ancestors for perhaps fifty million years. In the event that both the whales and humans with the time and inclination to have an interest survive, there is, perhaps, a prospect of richer forms of communication and appreciation between us. Noting the way in which Grey whales, which were once hunted remorselessly, now approach some humans in the Gulf of California, the marine biologist Toni Frohoff says:

> ... there's something very potent occurring here from a behavioral and a biological perspective. I'd put my career on the line and challenge anybody to say that these whales are not actively soliciting and engaging in a form of communication with humans, both through eye contact and tactile interaction and perhaps acoustically in ways that we have not yet determined. I find the reality of it far more enthralling than all our past whale mythology.

'We are not finished with the whale,' writes Philip Hoare. 'The remarkable thing is that the whale has not yet deserted us, either.' And with or without humans as witnesses, whales may be able to rebuild their world and spread music through waters that are now empty of their songs. Blue whales, notes David Rothenberg, have ten times as many neurons as we do devoted to picking up sounds below 100 Hz, way beneath the lowest notes on the piano. The largest animal that has ever lived on Earth makes a deep music with subtle variations that we are just starting to discover.

We may hope, but we also live in the shadow of history. An ancient tale of the Chukchi people of Siberia may be our story too. It is told that once, a young woman fell in love with a Bowhead whale and he, to please her, turned himself into a young man.

They married and the woman gave birth to human and whale children, who would play on the beach and in the lagoon. The woman would always tell her human children and grandchildren. 'The sea gives us food, but remember that your brothers the whales live there. Never hunt them but watch over them. Sing to them.' The village prospered for many years until one very hard winter came and the people began to starve. One of the grandsons of the women who had married the whale said to another, 'Why don't we kill and eat a whale? What kind of brothers are they? They live under the sea, and they don't know a word of human speech.' With that he paddled out to sea and easily speared the first whale that swam up to his boat. Returning to shore, he told his grandmother, 'I killed a whale! There is meat and blubber for us all to eat.' The woman who had married a whale already knew what had happened, and she cried, 'You killed your brother just because he doesn't look like you'. Then she closed her eyes and died. According to the Chukchi, it all went downhill from there. Now, even when a human kills another human, no one is really surprised.

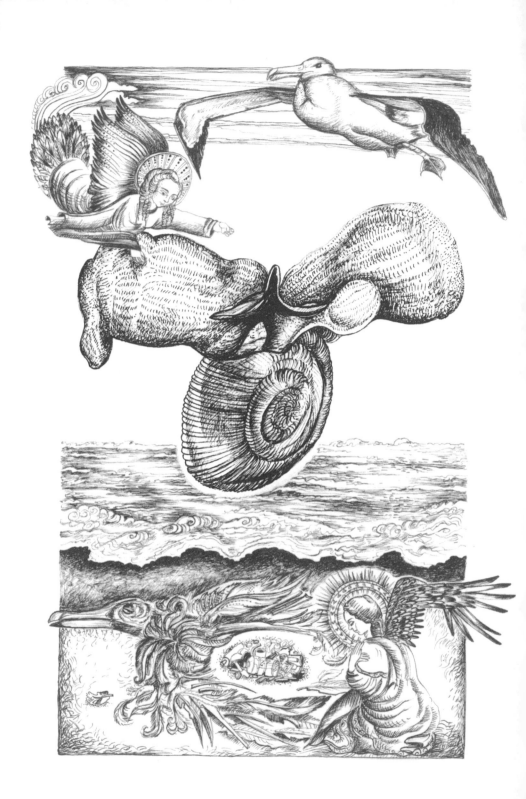

SEA BUTTERFLY

Phylum: Mollusca
Class: Gastropoda
Clade: Thecosomata
Conservation status: Many
species. Not listed

For innumerable Angels fly out at every touch.
Christopher Smart

ea butterflies are pteropods: sea snails that swim by flapping pad-like 'feet' which have grown into wings. They are about the size of lentils. A Right whale could swallow hundreds of thousands in a single mouthful. Some have shells on their backs: translucent cones, globules, whorls and other shapes. Others have no shells at all. All of them are delicate and beautiful to behold. A lucky human swimmer may on occasion see them in vast numbers, drifting through wave-warped sunlight like tiny angels.

Around the turn of the millennium, a biologist on a boat in the North Pacific saw a possible future of the oceans in the contents of a plastic jar. Victoria Fabry was doing experiments with *Cliopyramidata*, a Sea butterfly with a shell shaped like a pinched and pointy pyramid. She had filled several beakers with seawater and put a few of the animals into each one. Then she sealed the beakers tight and left them for varying amounts of time. When Fabry opened the jars that had been closed the longest she found something strange: 'the animals were still swimming like anything, but the tiny shells [on their backs] were visibly dissolving. I could see it with the naked eye.'

By sealing the jars Fabry had prevented the carbon dioxide exhaled by the Sea butterflies from escaping. As its concentration increased it had made the

There is a group of pteropods actually called Sea angels. They have also developed wing-like appendages but have no shells.

THE BOOK OF BARELY IMAGINED BEINGS

seawater in which they swam a little more acidic. There was nothing startling in that: carbon dioxide (CO_2) dissolved in water is a mild acid. What *did* surprise Fabry and her colleagues, however, was that such a seemingly small increase in acidity was enough to start dissolving the animals' shells. And the implications, they soon realized, were tremendous: the rapid increase in the concentrations of CO_2 in the atmosphere and oceans thanks to human activity risked doing to many organisms in the world ocean what the Sea butterflies were doing to themselves in the microcosm of the jars.

The oceans were supposed to be humanity's get-out-of-jail-free card when it came to global warming, or at least our stay of execution. They have absorbed more than half of the CO_2 we have dumped into the atmosphere since the industrial revolution began, as well as much of the additional heat that would otherwise be in the atmosphere. This, supposedly, has gifted us at least a few extra decades to deal with dangerous climate change. But the idea that all that extra CO_2 would not only alter the chemistry of all 1.3 billion cubic kilometres (312 million cubic miles) of the world ocean but also affect much of the life in it, and do it on a timescale of decades rather than (as had previously been assumed) centuries, came as a shock to many. Precisely that, however, was what Fabry's study, and a growing body of other studies in the first decade of the twenty-first century, indicated. Scientists knew that a change in ocean acidity of comparable magnitude around 55 million years ago had led to one of the most severe disruptions of ocean life in the last 500 million years: stony corals, which make their bones from calcium carbonate as pteropods make their shells, had been virtually eliminated for millions of years. This time, however, the change was happening at least ten times as fast.

Sea butterflies, which feed on the ocean's endless microscopic plankton, have been called the 'potato chip' of the seas because they are an abundant, irresistible and (unlike the potato chip) nutritious food source for many species of fish, including cod, salmon and mackerel. 'If we lose these organisms, the impact

on the food chain will be catastrophic,' says the marine biologist Gretchen Hofmann.

Plankton, the plural of plankter, is derived from the Greek word for wanderer. It's a rather vague term for any living thing that allows itself mostly to be carried in the current. (The rarely used mirror term for things that actively swim is nekton.) The number and diversity of marine plankton is almost beyond imagination, but one way to start bringing them into focus is according to where they derive the energy that enables them to live and grow. On this basis there are the phytoplankton – organisms that derive their energy from sunlight – and then there is almost everything else.

Phytoplankton (from the Greek *phyton*, plant) are 'primary producers' in the oceans – that is to say, they are 'eaters of sun' which use light to fix carbon in the same way that plants do on land. The great majority of other living things in the sea derive their energy from phytoplankton by eating them (as a cow eats grass), by eating something that has eaten them (as a lion eats a cow) or by eating the waste products or corpses of the creatures that have eaten them (as do rats and vultures). Phytoplankton also supply a large proportion of the atmospheric oxygen on which land-dwelling animals like us also depend, and play key roles in the cycling of carbon, silicon, nitrogen and other elements in the Earth system as a whole.

> Phytoplankton are photosynthesizers but they are not plants. They are members of the kingdom Chromista.

There are many thousands of species of phytoplankton, differing greatly in form and evolutionary inheritance. All of them live in the euphotic zone (from the Greek for 'well lit') – the top 200 metres of the ocean where sunlight strong enough to trigger photosynthesis can penetrate. Most are microscopic but even so their total biomass is greater than that of all marine animals (zooplankton, fish, whales and the rest) put together.

> Lower down, in the 95 per cent of the ocean where light does not penetrate, many living things feed on 'marine snow', the steady drizzle of particles of dead matter, whitish in colour, gradually sinking from the euphotic zone above. Other animals then feed on the 'snow' eaters.

The most common by far are cyanobacteria, which are also known as blue-green bacteria (and, misleadingly, as blue-green algae); we may call them, simply, the 'blue-greens'. These deceptively simple-looking entities, which often form chains like the beads of a necklace, are the oldest known photosynthesizing organisms on the planet and, arguably, the book to

which much of the rest life is a series of footnotes. The earliest varieties probably lived more than three billion years ago. Certainly, they had already evolved into many different species by well over two billion years ago. Blue-greens were the principal primary producers throughout the Proterozoic eon from 2.5 billion to 543 million years ago. And the various species alive today, many of which are little changed from those times, still account for as much as a quarter of all the photosynthesis on Earth. Free-living blue-greens thrive in damp, well-lit environments and are particularly widespread as marine plankton. They are packed with nutrition, and eaten by a vast array of organisms including health-conscious humans who consume forms such as Spirulina. The species *Prochlorococcus* is typical in that it is small enough for a million individuals to be found in a single drop of seawater. Across the world ocean as a whole *Prochlorococcus* and similar species exist in such large, Dr Seuss-like numbers – octillions – that the oxygen they release every day is enough for about one in five breaths that all animals, including humans, take. It may be the most abundant photosynthetic organism on the planet but it was only discovered in 1986.

Another major group of phytoplankton are single-celled algae called diatoms. Common in freshwater but massively abundant in the oceans, their contribution to marine primary production is probably second only to that of blue-green bacteria. Diatoms are characterized by a cell wall called a fistula made of silica, which usually has two overlapping sections. They are typically 'nano'-sized – from two to two hundred millionths of a metre across – although a few grow as big as 2 mm (a twelfth of an inch). But that tells you about as much as that great music is made out of notes, because the diversity of form among the roughly 100,000 living species of diatoms could fill months or years of study and appreciation, as the kinds of names they have inspired suggest:

the Swollen Epitheme, the Ant-like Bestback, The Necklaced Ladderwedge, the Fathead Congregant, the Tufty Table, the Spiral Curvydisc, the

An octillion is 10^{27} billion or a billion times a billion times a billion (1,000,000,000,000, 000,000,000,000,000). Perhaps that's more Carl Sagan than Theodor Seuss Geisel.

Marine diatoms from Madagascar.

Sharpsandal Floretflank, the Shortfooted
Foamflower, the Pot-bellied Gravyboat, the Noble
Featherjet, the Greater Coracle, Bidulph's Cutie,
the All-seeing Furrowdisc, the Crucial Pocket
Compass, the Star-bellied Footcord, the Globle-
stalked Lawless Dawn-nymph.

In *Cosmicomics*, Italo Calvino imagines the rescue from
the sea of a woman who remains encrusted in diatoms:

We rowed quickly, to pull her out and save her: her
body had remained magnetized, and we had to
work hard to scrape off all the things encrusted on
her. Tender corals were wound about her head,
and every time we ran a comb through her hair
there was a shower of crayfish and sardines; her
eyes were sealed shut by limpets clinging to the
lids with their suckers: squid's tentacles were
coiled around her arms and her neck; and her little
dress now seemed woven only of weeds and
sponges. We got the worst of it off her, but for
weeks afterwards she went on pulling out fins and
shells, and her skin, dotted with little diatoms,
remained affected for ever, looking – to someone
who didn't observe her carefully – as if it were
faintly dusted with freckles.

Genetic evidence suggests that diatoms evolved, or at least became prominent in the oceans, in the Mesozoic, the second phase of the Phanerozoic eon that began after Permian/Triassic catastrophe about 251.4 million years ago. The earliest diatom fossils, however, date from the Jurassic – well into the time that the dinosaurs reigned on land. As they increased in numbers, diatoms appear to have replaced other phytoplankton in the oceans. In addition to fixing carbon and releasing oxygen into the ocean and atmosphere, they play a major role in the cycling of silicon in the Earth system.

Another major phylum of phytoplankton, the dino-flagellates, includes organisms that undermine our common-sense notion of a world in which plant-like beings are separate and different from animal-like beings. Dinoflagellates are single-celled algae but they have a pair of whip-like tails for swimming about, and many species eat other plankton. Some have tiny eyes with actual lenses in them. (See *Erythropsidium* in Chapter 7.) Like diatoms, dinoflagellates are probably creatures of the second-half Phanerozoic: the earliest confirmed fossils date from after the Permian extinction. One genus, the zooxanthellae, live in symbiosis with tropical corals and other animals including clams, jelly-fish and nudibranchs, providing in some cases as much as 90 per cent of the nutrients the animal needs in return for a safe home. Without them, coral reefs – the largest structures made by living organisms – would not exist, at least in their present form, and other sea life would be much the poorer. Other varieties of dinoflagellates create the infamous and highly toxic 'red tides'. Still others, more benignly, bioluminesce: these are what you are seeing when a dolphin cuts through night-time waves and makes them glow.

Yet another phylum of phytoplankton, the Cocco-lithophores, get their name from the distinctive plates, called coccoliths, which they build around their bodies with calcium and carbon extracted from seawater. Light reflected off the myriad bodies of these single-celled algae turns tropical waters turquoise and northern waters – viewed from space – a swirling creamy white when they bloom in stupendous numbers in spring.

Foraminifera as depicted by Ernst Hackel. These 'tests', or shells, are no bigger than a grain of sand.

The deposition of coccolithophores in chalk formations is part of the 'biological pump' – a naturally evolved mechanism by which, over very long periods, dead plankton of many different kinds and the organisms that feed on them sink to the sea floor and are incorporated into rock and the precursors of what we know today as fossil fuels. About half of the oil and gas reserves being exploited today were laid down during the Jurassic and Cretaceous eras, when the seas were more densely populated by phytoplankton than at any other time in Earth history.

Chalk formations such as the white cliffs of Dover are largely composed of the bodies of countless billions of coccolithophores that bloomed, died and then sank to the seabed each season for millions of years. (The cliffs were later lifted above the sea by geological movements.)

The zooplankton and bacterioplankton that depend on the various photosynthesizers may have less total bulk than phytoplankton but they come in an even greater range of sizes. The menu in the plankton soup cafe offers not only small, medium and large (micro-, meso- and macro-) but also extremely and very small (pico- and nanno-) and supersize (mega-) plankton. The ubiquitous marine bacteria, for example, feeding on diseased and dead organisms and detritus, are picoplankton – typically between 0.2 and 2 millionths of a metre across. (Smaller even than this are marine viruses, 'femtoplankton' that feed on bacteria and other organisms. See Chapter 9.)

THE BOOK OF BARELY IMAGINED BEINGS

Larger than bacteria but still well under a millimetre across are single-celled planktonic organisms (that is, amoeboid protists), and prominent among these are radiolarians and foraminifera. Radiolarians are not as ancient as blue-green algae, but they are among the zooplankton with the longest traceable history. Fossils have been found dating to the beginning of our eon, the Phanerozoic, which began about 542 million years ago. Radiolarians make distinctive, intricate skeletons out of silicon in a great variety of beautiful forms. Some of these are described in Chapter 9. More than 90 per cent of the radiolarian species that have existed are now extinct, but living kinds are abundant in the oceans.

Foraminifera – forams for short – are related to radiolarians and probably just as ancient. Some live in the silty sea bottom but many are planktonic and, like radiolarians, munch on other plankton. Some forams allow single-celled algae to lodge on the surface of their bodies, rather as tropical coral do. A few eat the algae and use its chloroplasts – tiny green 'power houses' – to conduct photosynthesis directly themselves. Many make tiny shells, known as tests. At first glance these can look to the naked eye like burnished grains of sand, and only a close inspection reveals them to be beautiful whorls and spirals. In *On Growth and Form*, D'Arcy Wentworth Thompson recalled a memory from childhood:

> In days gone by I used to see the beach of a little Connemara bay bestrewn with millions upon millions of foraminiferal shells, simple *Lagenae*, less simple *Nodosariae*, more complex *Rotiliae*: all drifted by wave and gentle current from their sea-cradle to their sandy grave: all lying bleached and dead: one more delicate than another, but all (or vast multitudes of them) perfect and unbroken.

Remarkably, some forams appear to select the most brightly coloured sand grains to glue onto themselves. Lynn Margulis is a microbiological William Blake in her vision of these creatures. In distinguishing shape and colour, she suggests, forams make deliberate choices: 'awareness in some form has been naturally selected for at least 550 million years'.

Radiolarians and foraminifera are not animals but members of the kingdom Rhizaria. They are, however, heterotrophs: organisms that eat phytoplankton.

At around 2 mm (less than a twelfth of an inch) across, Sea butterflies are only about a tenth of the size of krill – the thumbnail-sized crustaceans which whales love to eat and which might spring to mind as your typical zooplankton. Even so, they are medium to large – meso to macro – on a plankton size scale. Sea butterflies, which evolved in the Palaeocene, the first epoch after the demise of the dinosaurs, are mostly passive feeders but at times they hunt, entangling smaller plankton in a net of mucous that can be up to 5 cm (2 inches) wide. If disturbed, they abandon the net and flap slowly away. At night they hunt at the surface and return to deeper water in the morning.

The largest planktonic organisms of all – jellyfish, comb jellies, salps and others which propel themselves weakly or only very occasionally through the water – can be a metre or more across. Some siphonophores (distant cousins of jellyfish) form colonies much bigger even than that; one called *Praya dubia* reaches more than forty metres in length. All of these creatures live by trapping smaller prey as they drift. Some very large actively swimming creatures also feed directly on plankton. These include Manta rays, which can grow up to 7.5 metres (25 feet) across, Whale sharks and, of course, Baleen whales.

Dramatic changes in the composition of oceanic plankton have taken place during all the great mass extinctions in the Earth's history. And it looks very much as if this is where we're heading now, with the rapid change in ocean acidity playing a central role. It is as if we were conducting a massive experiment without a control. But this makes our actions sound much more sensible than they are, because we are fiddling with several variables at the same time. Acidification is only one of several factors along with global warming, overfishing, toxic pollution and excessive nutrient loading from agricultural run-off and sewage, driving rapid change in the oceans and the rest of the biosphere. And, as a 2011 report by the International Programme on the State of the Ocean notes, the *combination* of these factors, acting synergistically, presents a greater threat to marine life than any of them on its own.

It's a reasonably safe bet however that, overall, bio-

Whale faeces is ideal plant food. It may be that the collapse in whale numbers in the twentieth century significantly reduced phytoplankton productivity.

THE BOOK OF BARELY IMAGINED BEINGS

diversity will be greatly reduced. A few species of algae are likely to choke formerly rich ecosystems such as coral reefs in slime – a realization of the worst nightmare of Coleridge's Ancient Mariner. Newly abundant species, such as jellyfish in the place of fish and toxic dinoflagellates in the place of formerly dominant plankton, may become the equivalent of rats, cockroaches and pathogens on land.

A particularly disturbing sign, already mentioned in Chapter 12, is evidence pointing to a marked and continuing reduction in the worldwide primary productivity of phytoplankton. A net decline of about 1 per cent a year doesn't sound like much, but if this decline is real and has, as studies suggest, already been under way for fifty years, then the drop has already been 40 per cent.

Meanwhile, humans are replacing much of the plankton with plastic. An area of the North Pacific twice the size of Texas is now entirely covered in pieces of floating plastic, and this is just one of several such patches in the world ocean. The beaches on the windward side of even the remotest islands worldwide are now permeated with plastic debris. One results has been an icon for life and death in the Anthropocene: the bloated, plastic-filled stomachs of dead albatrosses. But much of the plastic dumped by humans has disintegrated into particles too small to see, and these tiny fragments float in the sea where they are often ingested by various organisms, possibly with toxic effects. At the time of writing, US corporations were throwing significant resources into blocking measures that would reduce the amount of plastic entering the world's oceans.

Only in recent decades have we begun to appreciate the history, diversity and intricacy of life in the oceans and the tiny and small organisms up to and beyond the Sea butterfly. I will risk pressing what is now (alas) a tiresome cliché into service for a laboured pun: in this cause, like any that is worth fighting for, let us remember the better angels of our nature. If we fail, the oceans may recover their beauty, diversity and productivity thousands to millions of years hence, but humans are unlikely to be around to see their regeneration.

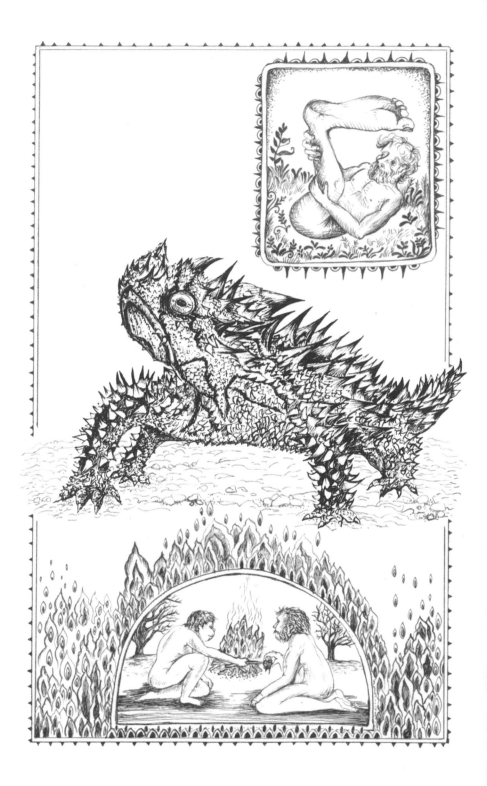

THORNY DEVIL

Moloch horridus

Class: Reptile
Order: Squamata
Family: Agamidae
Conservation status: Not listed

There's no point in walking back. The only life I saw for the last
million miles were the hypnotized bunnies and most of them are now
wedged in the tyres.
 Priscilla, Queen of the Desert

When I was eight I pinned a big map of Australia on the wall of my room. I decided that when I grew up I would live on a ranch half the size of England way out in the bush. Several decades have gone by since then and I still have not even visited the island continent. For all that I have actually seen with my own eyes Australia could be an elaborate fiction put together on a film set from pieces of Essex, southern California and New Guinea. But then there are the animals – creatures more fantastic than any found in bestiary or fairy tales. Nobody could have dreamt up the platypus or the kangaroo, still less the frill-necked lizard or the leafy sea dragon.

Adding to the fascination is the fact that such diverse and odd forms evolved in and around one of the harshest and most remote places on Earth where even non-indigenous species such as rabbits sometimes find it hard to get by. The Thorny Devil is a good example. This spiky lizard is one of the most remarkable Australian natives, although not in the way that its imported Latin name, *Moloch horridus*, suggests. (Moloch was a Canaanite god who in John Milton's account was smeared with the blood of human sacrifice.) A typical full-grown Devil will fit on the palm on your hand and its densely packed spikes are no bigger than the thorns of a rose, albeit a particularly

ferocious one. *Picayune pricklius* would be more like it. Not so much John Milton meets Ed Wood as Mark Twain meets Monty Python.

No, the Thorny Devil will not hurt a fly. Living as it does in the rough grass, bush and sandy desert that swathes much of Australia, it makes do with what there is, which happens to be ants. And this lizard is most partial to ants. It munches them as steadily as a moviegoer munches popcorn. (It would be nice to wander off here and celebrate the wonders of ants, a family of insects that have adapted to the most diverse and harsh environments on Earth. I'll resist the temptation but not before mentioning one of my favourite ant-facts: some species are so small, and others so big, that the small ones could walk around inside the heads of the big ones.)

Ants may be delicious but you need something to wash them down with and the Thorny Devil has a neat trick for trapping water. Its body has 'hygroscopic' (moisture-attracting) grooves between the thorns on its skin, and such dew (and rare rain) as falls onto the animal or onto the grass through which it walks is taken by capillary action into these grooves. The Devil then works its jaw steadily to move water along the grooves which lead eventually to its mouth. Thorny Devils thus concentrate and drink dew. Analogous systems have evolved in other arid places. There is a kind of rhubarb that thrives, where little else does, in the Negev Desert, al Naqab, by similar means, and a Namib Desert beetle which captures tiny droplets in the rear legs that it waves in the air. Real-world adaptations are more ingenious than imaginary ones such as those sported by the Monopods, legendary dwarfish men whose likeness may be found on medieval world maps and who supposedly shaded themselves from the heat of the sun with a giant single foot.

The Thorny Devil itself is a tempting meal to those few larger animals eking out a living in this hot land, such as the occasional snake, goanna, buzzard or human. In its defence, the Devil has its thorns of course, and it may also tuck its head between its legs to present a potential predator with a false second head that usually rides on the back of its neck

(making it, perhaps, lizard-kin to Denis Dimbleby Bagley in the 1989 film *How to Get Ahead in Advertising*). This false head can be bitten off without substantial harm to its bearer, and may eventually grow back. The Thorny Devil can also inflate its chest with air, like a Pufferfish of the desert: a harder prospect to swallow. But its best hope is to remain unseen in the first place and to this end the Devil, which is camouflaged in shades of brown and yellow, walks slowly and stops often, like a chameleon or a participant in a neverending game of grandmother's footsteps.

There was a time when the Thorny Devil lived in a busier land. Until just a few tens of thousands of years ago Australia teemed with large creatures even stranger than the ones that so struck eighteenth-century Europeans. Isolated from other continents for millions of years, animal diversity here had taken its own course. Marsupials evolved to fill niches that elsewhere were taken by large placental mammals. One species of wombat grew as large as a hippopotamus. There was a tapir-like animal the size of a horse, and a kangaroo that grew to be three metres, or ten foot, tall. Some of the monotremes (egg-laying mammals) also ballooned: there was a platypus as big as a Labrador and an echidna as big as a sheep. And there were lizards of tremendous size and strength: *Megalania* was at least 3.5 m (12 ft) long and possibly as much as twice that. A 5 m (16 ft) land crocodile called *Quinkana* evolved long legs on which it could trot briskly after its prey, and hundreds of teeth that combined the properties of steak knives and meat hooks to tear them apart. A python 10 m (33 ft) long – perhaps the longest snake ever to have lived – preyed on all manner of animals but not, presumably, on a two-horned tortoise as big as a car. Giant flightless birds also stalked the land – real-world equivalents of creatures morphed by radiation to huge dimensions in B movies from the 1950s. At three metres tall and about half a tonne (1,100 lb), Stirton's Thunder Bird was probably the largest bird ever to have lived. *Bullockornis* was a mere 2.5 m (8 ft) and 250 kg (550 lb), but it was a rapacious carnivore and has been nicknamed the Demon Duck of Doom.

THE BOOK OF BARELY IMAGINED BEINGS

Most of these beasts, along with others including another fifty or so species of giant marsupials, thrived until, between about 50,000 and 20,000 years ago, about 95 per cent of them went extinct. Exactly why this happened is debated. There may have been several factors at work, including natural climatic changes leading to drier conditions. But it is hard to avoid the conclusion that humans, spreading across Australia at just about that time, played a decisive role, and that they did so by causing great fires. The tough little Thorny Devil was among the 5 per cent that survived.

We are all familiar with fire's potential to destroy but we are also accustomed to seeing it as an elemental and creative force. The Sun, which seems like fire, has long been treated in myths and religions as a cause or origin of life. In an Australian aboriginal story, for example, the Sun goddess Yhi first awakens plants and creatures into a silent world. And, of course, such stories have some relation to reality: all living things depend on a constant flow of energy from outside, and on Earth that flow derives overwhelmingly from the Sun (with a much smaller part from volcanic activity). Since ancient times, too, people have seen a kinship between Earthly fire and life. Thomas Browne, writing at the dawn of the scientific age in the 1650s, linked all three: 'life is a pure flame, and we live by an invisible sun within us'. Research over the following century showed that fire and life really were equivalent at the level of what could now be described as a chemical reaction. By the 1780s Antoine Lavoisier could write that fire is 'a faithful picture of the operations of nature, at least for animals that breathe: one may therefore say with the ancients, that the torch of life is lighted at the moment the infant breathes for the first time, and is extinguished only on his death'. The contemporary science writer Oliver Morton summarizes some of the advances in understanding made in the twentieth century: 'life is a flame with a memory'.

One of the surprising truths about actual rather than metaphorical fire on Earth is that it is a child of life, not the other way around. As was noted in Chapter 5, as far as we can tell, wildfires did not occur until about nine-tenths of the way into life's existence

Lavoisier, arguably the first scientist to identify oxygen, was pointing to the equivalence between what we now call respiration – the process by which animals (and plants) take in oxygen and combine it with 'fuel' (food) to produce energy inside their cells – and combustion, in which a fuel (typically, a carbon compound) is rapidly combined with oxygen. In a living cell, molecules called ATP transport the captured energy around the cell in chemical form to where it is used ('burned'). New ATP is continuously being made in the cell. At any moment a human body contains about ten grams of ATP but we make and 'burn' our own body weight of it every day.

on Earth to date when, some 420 million years ago during the Silurian, suitable terrestrial plant material was present under atmosphere concentrations of oxygen rich enough to create the right conditions for combustion. If, as has often been said, fire is like an animal, that is because, like animals, it feeds off life (specifically, plant material). Over the hundreds of millions of years since it first appeared, wildfire has become integrated into successive and different ecosystems. Huge fires raged in the great lycopod and tree fern forests that covered much of the land during the Carboniferous (359 to 299 million years ago), but these did not prevent the deposition over millions of years of vast amounts of unburned plant material, much of which turned into coal. In later ages, shrubs and trees and, in the last eight million years or so, grasses evolved to benefit from the release of nutrients occasioned by frequent but for the most part low-intensity fires. In *Fire: A Brief History*, the biologist Stephen Pyne refers to this grand sweep of pre-human history as 'first fire'.

We may never discover exactly when man began to manipulate fire. One hypothesis says that our ancestors began to use it to cook food and protect themselves from night predators as long as 1.8 million years ago. Uncontested evidence, however, is no more than a few hundred thousand years old. But whenever it began, the human use of fire began our transformation into the dominant animal. And if man is 'the cooking ape' then it is more than food we cook. At some point, perhaps very early in the partnership with fire, our ancestors learned to start, and stop, bush fires in order to drive game and to produce succulent new growth. In doing so, they began to alter the ecology of entire landscapes. 'In effect', writes Pyne, 'humans began to cook the earth. They reworked landscapes in their ecological forges.' Later, perhaps, they harnessed fire to make new kinds of tools. From the fire-hardened spear-point to metalwork, from the combustion engine to the microchip: a hop, a skip and a jump. Taken together, these new uses of fire began to transform life on Earth as profoundly as did its original emergence. This is 'second fire'.

Richard Wrangham (2009) suggests that *Homo erectus* was cooking food by 1.8 million years ago. Cooking made more energy and nutrients available and also killed parasites and pathogenic bacteria, enabling a sustained growth in brain size, and also making it possible to absorb the calories that would support a hunter-gatherer lifestyle. The use of small controlled fires at night would also have kept predators away. There is, however, as yet no direct archaeological evidence of the use of fire at such an early date.

The use of fire to make tools long predates metalwork. By around 80,000 years ago Neanderthals were making a glue with which to attach stone points to spear hafts by heating birch pitch under anaerobic conditions.

THE BOOK OF BARELY IMAGINED BEINGS

The majority of the ancestors of the humans that we now think of as indigenous to other continents probably began to migrate out of Africa around 60,000 years ago. They were armed with 'second fire' and it is reasonable to suppose that successive generations burned large swathes of vegetation as they opened up new territories. By 40,000 years ago – some 800–1,000 generations later – people were living deep in the Australian interior. It may be that these early Australians burned the bush as enthusiastically and thoroughly as any landscape that humans had previously colonized or were to colonize later, but that, on this formerly isolated and exceptionally dry continent, the fires became more intense and widespread than almost anywhere else. As a result, most large herbivores rapidly lost their food supply and were driven to extinction along with the animals that preyed on them. Another possibility is that early Australians focused on hunting the big animals first and, with fewer herbivores to graze it, vegetation accumulated and became vulnerable to larger and more intense fires than those to which it was adapted. Whatever the precise causes were, the consequence was a sharp drop in the ecological productivity of the ecosystem: it probably diminished between ten and a hundredfold as many of its most efficient recyclers of nutrients were exterminated. Evidently, this was not sufficient to exterminate the Thorny Devil.

After the disappearance of most of the continent's large animals, aboriginal Australians developed a practice known today as 'fire-stick farming'. This involved burning relatively small areas of bush in low-intensity fires in such a way that kangaroos and other game were driven towards the hunters while, in the aftermath, nutrients released from the burned plant material fertilized the regrowth of edible plant species and attracted more game. Certainly, fire-stick farming was widespread on the continent at the time of European contact. 'The natives were about, burning, burning, ever burning; one would think they were of the fabled salamander race, and lived on fire instead of water,' wrote the nineteenth-century explorer Ernest Giles. Aboriginal Australians also set larger

fires as a weapon against their enemies, as Native North Americans were also observed to do.

The climate in the parts of Australia where the Thorny Devil lives, characterized by great heat and drought and occasional heavy rains, is among of the most extreme on Earth. If humanity continues to burn fossil fuels as we do at present, the atmosphere is likely to heat by 4°C or more by 2070. As a result the climate in some regions of the world may be as hot and arid as those in Australia today. Others are likely to become wetter than they are now, as well as hotter. By the twenty-second and twenty-third century human life as we know it could become impossible in many parts of the tropics that are at present densely populated. Australia itself will face near stupendous challenges. Perhaps the Thorny Devil – unbelievably tough and adaptable, superbly engineered by nature to manage its most precious resource, water, effectively – can teach us a lesson or two.

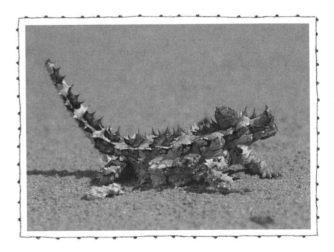

A Thorny Devil.

There's an old joke in which two Australians are marooned at sea in a small boat under a hot sun with nothing to drink. One of them finds a magic lamp in a locker and rubs it. A genie appears and says he will grant one wish. Without stopping to think the first

Australian says, 'turn the sea into beer'. Hey presto, the seawater turns into sparkling, cold beer. The genie vanishes. The two Australians look around, dumbfounded. Eventually, the second one speaks. 'Well done, mate,' he says; 'now we'll have to piss in the boat.' Humanity's job is to learn to see beyond a quick fix – to manage resources and environment so that we don't sink under the weight of the mess we create. We need to not piss in the boat.

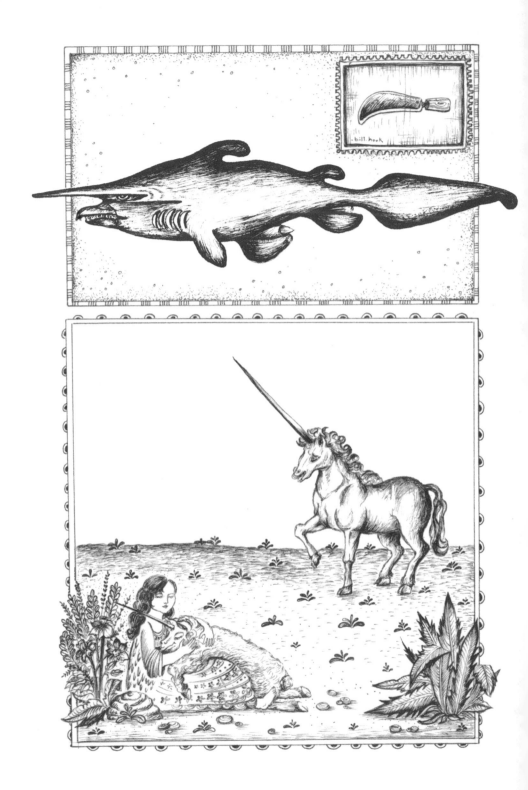

IN SEARCH OF
A UNICORN:
GOBLIN SHARK

Mitsukurina owstoni

Phylum: Chordata
Class: Chondrichthyes
Subclass: Elasmobranchii
Conservation status: Not listed

It may be that universal history is the history of the different intonations given to a handful of metaphors.
Jorge Luis Borges

I n our day the unicorn is a matter of pink plastic and children's cartoons, New Age foolishness and a synecdoche for the impossible and the delusory. In a medieval bestiary, however, it is something weirder – or rather several things. The unicorn, we read, is a fierce enemy of the elephant, which it attacks and pierces in the belly with its horn. But it is also an elusive quarry which men can only capture or kill with the help of a virgin who breastfeeds it until it falls asleep in her lap. And then there's Jesus, 'the spiritual unicorn', whose single horn signifies that Father and Son are one. And, oh, a unicorn's horn can be used to detect poison, and when ground to powder is both antidote and aphrodisiac.

For a sceptical modern reader, these ancient and medieval stories seem like leaves in one of those flip books which combine parts and qualities of different real or imaginary animals with a bewildering, dreamlike jumble as the result. But as with a dream or a hallucination, analysis can make some sense of them. Medieval authors (or at least their sources) do, for example, distinguish the fierce monoceros (which sounds very much like a rhino, albeit with the feet of an elephant) from the unicorn proper (which has a body like a goat, or a gazelle, or possibly a horse ...). And, taking it from there, commentators from the

THE BOOK OF BARELY IMAGINED BEINGS

early modern period onwards have deconstructed this confabulous beast or beasts, tracing the probable origins of its parts and offering explanations as to their significance.

But however systematic and complete the analysis, one is left with a sense of something unexplained. *Why* should people invest so much energy in a mythical animal? What is this superfluity of meanings *about*? An incomplete but enduring answer to the first of those two questions is simple, if crude: something that looked like a hard-on would give a man a hard-on. Unicorn's horn, made into a powder, was the Viagra of its day – only, being fantastically rare, it was of course fantastically expensive. The horn (actually a narwhal tusk) that Pope Clement VII gave to the heir to the French throne as a wedding present in 1533 cost nearly six times as much as Michelangelo was paid to paint the ceiling of the Sistine Chapel. A century later such gifts would look pretty dubious, and Thomas Browne made short work of it in his *Pseudodoxia Epidemica*, the *Bad Science* of 1646. It being the seventeenth century, Browne relied on rhetoric rather than the double-blind control trial (this was, after all, an age in which it was widely believed that ground elk hoof cured epilepsy), and one of his key rhetorical flourishes was inversion. Unicorns were not rare, they were everywhere:

> In the number of the Quadrupedes, we will concede no less than five: that is, the Indian Oxe, the Indian Asse, the Rhinoceros, the Oryx, and that which is more eminently termed Monoceros, or Unicornis: Some in the list of fishes ... and some unicorns we will allow even among insects.

Browne made mistakes, but his list was not bad for the time, and in the light of more than 350 years further field work it's clear he was understating the case. We live among an embarrassment of unicorns.

At ground level, rhinoceros beetles play variations on a single horn as dazzling as those of John Coltrane, but when it comes to animals more than a few inches long the ocean is the place. An update to Browne's list

See *The Natural History of Unicorns* by Chris Lavers. Alas, this excellent book offers no support for the idea favoured by wild-eyed cryptozoologists that the unicorn originates in folk memories of the *Elasmotherium*, a 3-metres-high rhinoceros with a huge horn that lived on the Asian steppe until 50,000 years ago and perhaps more recently.

Several land animals that became extinct long before the *Elasmotherium* did were also 'unicorns'. Among dinosaurs there was *Centrosaurus*, which had a horn up to a metre long, and *Einiosaurus*, whose single horn was curved over in the shape of a bottle-opener. The *Arsinoitherium*, a mammal that looked very much like a rhino, had two giant horns side by side where we would expect to see one.

of fishes could include the Swordfish and at least three kinds of Sawfish, the Unicorn Grenadier and seventeen species of Unicorn fish including the Horseface, the Sleek, the Humpback and the Elegant, not to mention more than a hundred species of Filefish which have a slender, retractable spine on the crowns of their heads, or the Smallspine spookfish, which looks like a cross between a unicorn and an elephant.

Selecting a single actual unicorn for a modern bestiary when there are so many to choose from is hard. Many people may go for the narwhal, which looks almost as unreal as the mythical unicorn, and whose single tusk really does have remarkable properties. A narwhal's tusk, which is actually a massively extended top-left incisor tooth twisted into a helix is not, or not merely, as zoologists once supposed, a secondary sexual characteristic which males use to joust and compete, and it is not, or not merely, an adaptation to help the animal swim faster. It is a hydrodynamic sensor capable of detecting changes in salinity, temperature, pressure and particle gradient in ways unmatched by anything else known in nature. The likely fate of the narwhal, moreover, makes it a good candidate: rapid climate change and other perturbations in the Arctic may soon send it to the same place as mythical beasts that never were.

My suggestion – and I know it's a stretch – is the Goblin shark: a primeval-looking beast which lives where the sun doesn't shine, hundreds of metres down in the cold black ocean. Its 'horn' is a blade-like snout jutting over extendable jaws lined with thin, fang-like teeth. The name of the shark comes from its supposed resemblance to a mythical Japanese goblin,

Fig. 26. *Mitsukurina owstoni.*

Drawing of the Goblin shark, *Mitsukurina owstoni*, 1921.

THE BOOK OF BARELY IMAGINED BEINGS

for it was in Japanese waters that it was first discovered. In profile, the Goblin shark's dorsal fins are rounded and its tail resembles an old-style garden billhook. The entire animal grows to over 3 metres long, making it one of the largest vertebrates living in the waters beneath the light-filled euphotic zone. Uniquely among sharks, it is pinkish in colour, like a dyspeptic northern European, owing to a semi-transparent skin through which the blood vessels are visible. This is one ugly shark, and at first glance you have to wonder if even its mother could love it. (Scientists think it gives birth to live young.) But look closer and it has a quality that a friend of mine once attributed to himself in a lonely-hearts ad: radiant inner beauty.

Like many a mythical beast, the Goblin shark is very rarely seen alive or dead. Fewer than fifty individuals have been formally identified since it was first scientifically described in 1897. And yet it manages somehow to be ubiquitous. Goblin sharks have been caught by accident off the coasts of Japan, Portugal, Australia, New Zealand, Mexico and elsewhere. Moreover, its 'horn' is as extraordinary as that of the narwhal, though very different in appearance and function: it is an electrosensitive beak that allows the animal to detect small variations in electrical charge in the water caused by its prey (typically, squid, crab and various deep-sea fish). Once the prey is detected, the shark's jaws shoot forwards in the manner of extendable tongs and trap it with a combination of clamp and pharyngeal suction. Like the Wuggly Ump, its other habits are obscure. We can say little more except that while this shark and its horn/snout may be strange and a little disturbing to our eyes, it is a bravura work of evolution. And here lies the secret of this creature's inner beauty. The Goblin shark, superbly suited to its for ever black world, is testament to the adaptability of the Elasmobranchii – a hugely diverse group of animals that includes sharks, rays and skates – and the endurance of the forms natural selection sometimes achieves.

The Goblin shark has hardly evolved in around 40 million years. Other species very similar to the kinds

At least two other, very different animals have converged on a similar device for the murky waters in which they hunt: the platypus and the giant freshwater paddlefish. Both are threatened with extinction.

of sharks we are familiar with in shallower waters first swam in the ocean more than 100 million years ago, long before T. Rex 'ruled' the Earth. But the earliest members of the shark order – a group distinguished from bony fishes by having a skeleton made of cartilage, several sets of replaceable teeth, no swim bladder and other features such as live birth in at least one lineage – are much more ancient. Several among the earliest species were decidedly odd. *Stethacanthus*, which lived around 360 million years ago, was superficially similar to a modern reef shark but it had a sizeable anvil-shaped lump covered in denticles (tooth-like scales) sticking out of its back. What purpose this served is unsure. Others were frankly terrifying. The magatoothed shark *Megalodon*, which lived from about 28 to 1.5 million years ago, grew to more than 16 metres, or 52 foot in length – a good 3 metres longer than the modern Whale shark (which is a gentle filter-feeder). *Megalodon* may have weighed over 50 tonnes and perhaps much more and, with jaws two metres across lined with very sharp teeth the size of a man's hand, probably preyed on whales.

Today well over 400 species of shark rival both fish and whales in their diversity, ways of life and range of habitats. But the rich variety of actual sharks contrasts strikingly with the limited ideas most humans still have about them. For all the efforts made by zoologists and conservationists in recent years, celebrity killers such as the Great white and the Tiger shark still dominate popular imagination in Western countries. Few scientific studies grab more attention than one that compares the seal-hunting strategies of a Great white to the carefully planned actions of a human serial killer. But most of us continue to know very little, and care less about, say, the Greenland shark (a slow-moving colossus that lurks beneath Arctic ice), carpet sharks such as the Wobbegongs (a large family notable for their shaggy 'beards' and gorgeously mottled bodies), the Crocodile shark (which uses its exceptionally large eyes to hunt at night) and many others including the nine different species of hammerheads, whose mesmerizingly strange heads evolved to give

THE BOOK OF BARELY IMAGINED BEINGS

the best possible binocular vision – a fact only confirmed in 2010. On the deep ocean floor live eel-like frilled sharks, with the same oversize mouth and needle-sharp teeth possessed by deep-water predatory fish. On continental shelves lurk Angel sharks – sluggish forms with square, flat bodies superficially resembling rays and torpedo fish – and Saw sharks whose grotesque snouts are fringed by outward-projecting teeth, making them hard to distinguish from 'true' swordfish.

For all the widespread indifference to many of these wonders, there are signs that attitudes are changing. Increasingly, you will find that people in Western countries are aware that, for one thing, sharks only threaten us when we behave foolishly. A statistic to remember is that, worldwide, less than a dozen people are killed by sharks in a typical year. Far more are killed by falling coconuts. Humans, by contrast, kill many tens of millions of sharks every year: a catastrophic rate of loss that has brought many species to the verge of extinction in just a few years.

The good news, potentially, is that the trajectory towards the elimination of sharks is not unstoppable. The huge growth in demand for shark meat, mainly the fins, driving the mass slaughter is a recent phenomenon. Of course it originates in an an old and completely erroneous belief common in East Asia that, like the horn of the unicorn, shark fin is an aphrodisiac. But present demand has only taken off thanks to the pumped-up advertising to consumers in newly prosperous countries such as China, and it is perfectly feasible to use similar techniques to inform people that they are being conned and that eating shark fins is not cool. There will be many defeats along the way, but already there are places where reef sharks can be worth far more alive than dead. In one recent study in Palau, each individual in a shark sanctuary was estimated to bring almost $2 million to the economy over its lifetime through dive fees and general tourism revenues. This is almost 200 times as much as it would fetch as meat.

Humans, says Robert Sapolsky, are 'obligate metaphorists': we cannot help but place symbolic

meanings on things. We do, however, have some choice in the metaphors we live (and die) by. And the more we learn about the biology of sharks and the character of the ecosystems of which they are part, the more we may be inclined to see them in a positive light. Our metaphors and meanings can, over time, align better with the realities of the natural world.

On the tropical coral reefs that are least damaged by human activity such as Kingman and Palmyra in the Line Islands far to the south of Hawaii, top predators like reef sharks and giant groupers are present in enormous numbers. The contrast to terrestrial ecosystems, where big fierce animals are rare, is striking. The presence of so many sharks shows just how productive a relatively healthy reef can be: small fish and other prey animals reproduce with such rapidity and abundance in their coral home that they can withstand heavy predation without damage to their viability as species. But the sharks are not free riders. These big predators are an important piece from the 'ecological machine' of the reef in which microbes, corals, plants, small fish and other organisms compete and cooperate. On reefs where sharks have been intensively hunted and are now absent, the underlying ecosystem tends to fray and fall apart.

The role of the Goblin shark in the mid-to-deep-water ecosystem worldwide is less clear. But let us allow that this animal (and others that are as yet poorly understood or even unknown) are important parts of their worlds. Their full significance, ecologically and for the human imagination, may not yet be well defined but, like that of the mythical unicorn in old stories, it may be subtle, surprising and – strangely – beautiful.

VENUS'S GIRDLE

Cestum veneris

Phylum: Ctenophora
Conservation status: Not listed

To the natural philosopher there is no natural object unimportant or trifling ... a soap bubble ... an apple ... a pebble ... He walks in the midst of wonders.

John Herschel

T he story of Aphrodite (in Latin, Venus) – a story of abundant, disruptive sexuality coursing through life from the seas to the heavens – is recalled in the name given by a lovelorn sailor or a playful biologist to one of the strangest and most beautiful of real creatures: the Venus's Girdle, a translucent ribbon of being that shimmers through the water and pulses in many colours when struck by sunlight.

The Venus's Girdle is a comb jelly, or ctenophore (pronounced 'ten-oh-four'). Jelly-like but not jellyfish, comb jellies are little changed since the Cambrian more than 540 million years ago. Their lineage is uncertain, and they may actually be more closely related to us than are jellyfish and other cnidaria. Comb jellies are named for neat lines of hair-like cilia that beat in Mexican waves down the sides of their bodies and propel them forward, reflecting and refracting light through all colours of the spectrum as they do so. No other multicellular creature moves in this way, a motion akin to more ancient microbial life. But here they are: see-through spaceships of the planktonosphere, shimmering orgasmic rainbow cascades. If squeezed they yield but then return to their original shape like gumbles, the fictional creatures in the neglected Australian children's classic, *Bottersnikes and Gumbles*.

Many species of comb jellies are roundish blobs with multicoloured seams running down their sides. These

Most but not all ctenophores also generate their own bioluminescent glow, but this light (which is usually blue or green) is only visible in darkness.

THE BOOK OF BARELY IMAGINED BEINGS

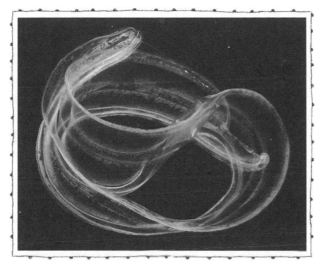

Venus's Girdle.

are the Cydippids, and the best known is the Sea goose-
berry, which looks to have been the inspiration for the
woodsprites in James Cameron's film *Avatar*. (The real-
world creature, at 20 mm or 1/8th inch across, is
smaller than the one in the film fantasy.) But not all
comb jellies take this form. Others, called Lobates, have
a pair of cup-like lobes, while Beroids are sacks with
large mouths. Still others, called Platyctenida, are flat,
and slide over the bottom like sea slugs. The Venus's
Girdle is also flat, like a large ribbon, but it swims free in
the water column by undulating its whole body as well
as by moving its cilia. It can grow up to a metre long,
making it the largest known comb jelly.

Comb jellies lack the most impressive 'technology'
of jellyfish – the nematocyst stinging apparatus which
is one of the most deadly weapons and fastest cellular
processes in nature. Instead, they capture their prey,
which typically consists of plankton up to the size of
krill, with little tendrils covered in sticky cells called
colloblasts. And yet comb jellies are far from primitive.
Some species can detect very subtle pressure differences
in the water caused by the movements of their prey
and, having done so, sneak up on their target (which
may be equally sensitive to water movements) by

channeling water around themselves by delicate movements so as to become hydrodynamically 'silent' in the manner of a stealth submarine. Many of them (although not the Venus's Girdle) possess an organ called a statolith – the equivalent of the otolith in the human inner ear, which allows us to balance.

Comb jellies are voracious and, unchecked, can reproduce very fast and take over a whole ecosystem. In the early 1980s the Warty comb jelly or Sea walnut was introduced (probably from the ballast water of ships from North America) to the Black Sea, a habitat in which it had no natural predators. By the summer of 1989 it was proliferating in such numbers and consuming so much plankton in the Black Sea that the fisheries dependent on the plankton crashed. By the 1990s the Warty comb jelly had passed through a canal into the Caspian Sea with equally dire results. Then, in the late 1990s a second alien species of comb jelly was introduced into the Black Sea and the Caspian. This preyed on the first and went through a population boom of its own. By the early years of the twenty-first century the densities of both species had come into balance with each other, but the populations of other animals had not recovered.

This devastation resulted from human carelessness, which brought alien species to a vulnerable environment. In their natural context, however – that is, the ecosystems in which they evolved – comb jellies are kept in check by predators and are harmless to the wider system. They are, I think, particularly beautiful parts of a dynamic whole. Further, while one may appreciate them simply for what they are, I also want to make a case for these scintillating bodies of rainbow-light as an emblem of the orgasmic beauty in nature as a whole.

Orgasm is celebrated without inhibition in many great works of art (and many that are not so great . . . or are not art). John Dowland's song *Come Again*, for example, has as much wit and light touch today as when it was written 400 years ago. Chopin's Prelude in C Major, no. 1, opus 10, pulls out all the stops to produce one of the greatest musical cascades ever achieved with two hands. Ecstatic unity is the power driving Walt Whitman's 'I Sing the Body Electric' ('If any thing is sacred, the human body is sacred'). It

would be a good thing if a similar sense of celebration were more frequently present in approaches to the biological sciences as well as in the arts.

As far as we can tell, most species enjoy sex. You can hear it, via technological means, in a school of cod, grunting at around 105 decibels as they spawn deep in the Atlantic, and you can, of course, feel it directly in birds singing their hearts out in spring. (The zoologist Norman J. Berrill put it well: 'To be a bird is to be more intensely alive than any other living creature, man included. Birds have hotter blood, brighter colours, stronger emotions . . . they live in a world that is always the present, mostly full of joy.') Even supposedly simple, brainless creatures such as box jellyfish engage in highly complex and elaborate 'dance' when coupling. And yet many scientists who want to be seen as serious tend to distance themselves as far as possible from any mention of animal pleasure. In Olivia Judson's amusing and informative book *Dr Tatiana's Sex Advice to All Creation*, for example, there are only two references to orgasm even though she describes the sexual behaviour of hundreds of animals. Similarly, as Jonathan Balcombe notes, a major volume about partnership in birds, which are often life-long, contains no references to affection but thirty to aggression.

In the opening of *On the Nature of the Universe*, the Roman poet of materialism Lucretius calls upon Venus, the goddess of love, abundance and regeneration, to help him tell the story of life. Even Mars, the god of war, says Lucretius, can be calmed by her beauty, and their daughter, Concordia, is the love that unites all people. Is durable peace an illusion? Perhaps Lucretius is like the mountebank in the old tale, merely 'conjuring / with rainbow names and handfuls of sea-spray'. But even if this is the case, the dance of matter and the living forms it creates such the Venus's Girdle are sublime. Death, writes Lucretius, breaks down existing configurations of atoms, allowing for new conjunctions,

> making all things
> To change their shapes and colour and receive
> feeling
> And in an instant yield it up again.

WATERBEAR

Eutardigrada sp.

Phylum: Tardigrades
Conservation status: Not listed

Let Chuza rejoice with the Sea-Bear, who is full of sagacity and prank.
Christopher Smart

Space is the place.
Sun Ra

Outer space is not a comfy place for a human to be. Direct exposure will of course kill you in minutes, although not in the way many people think: your eyeballs do not pop out, and you have a good chance of making a full recovery if your exposure does not exceed 30–90 seconds. But even when protected by a spacesuit or the walls of a spacecraft, the body is subject to stresses such as exposure to high levels of radiation that take a toll. This, and the sheer time required to travel the huge distances of space at the speeds likely to be achievable for manned craft, mean that for the foreseeable future humans are unlikely to go much further than Mars or, at a stretch, the moons of Jupiter. Travel outside the solar system is likely to be done only by proxy in unmanned, robotic craft.

If and when humans do establish a greater and more durable presence in space we may have the Waterbear, also called the Tardigrade, to thank. In an experiment in 2007, helpfully labelled 'Tardigrades in Space', numbers of this tiny animal spent ten days in orbit without any protection and lived. They withstood the almost complete vacuum and temperatures ranging from of $-272.8\,^{\circ}$C (which is very close to absolute zero) up to $+151\,^{\circ}$C. They survived a dose of cosmic rays one thousand times as high as would kill a human and shrugged it off. When exposed to direct

Under this scenario pioneers on journeys into deep space would be non-biological or 'post-biological' entities: robotic craft with the ability not only to gather energy, but also to repair and even make new copies of themselves. Travelling at 1 per cent of the speed of light, self-replicating craft, or von Neumann machines, would be able to fan out and penetrate our entire galaxy in around twenty million years. They could also be programmed to synthesize biological life from common elements upon arrival in a suitable environment, assuming this knowledge were available to their creator.

THE BOOK OF BARELY IMAGINED BEINGS

solar radiation in addition to the cosmic rays, a large proportion of the test subjects bit the dust (in as far as there is any in the near vacuum of space) but, still, many survived. No other multicellular animal looks to be remotely capable of this. Perhaps, in the long term, the characteristics that enabled them to endure will be of use to humans . . . or our successors.

A typical Waterbear is about the size of the full stop at the end of this sentence. Under a microscope it looks something like a roly-poly teddy bear – if a teddy bear were to have claws, red eyes and two extra pairs of legs. The phylum has been around, little changed, since at least the Cretaceous and perhaps the Cambrian, and is more closely related to velvet worms and arthropods than anything else. (In appearance, Waterbears are more like Velvet worms; in ubiquity, more like arthropods.) There are about 750 different species of Waterbear on Earth today, living in almost every conceivable habitat from ice shelves to hot springs, from the tropics to the polar regions, and from more than 6,000 metres up in the Himalaya

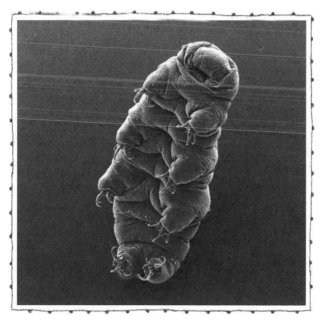

Hypsibius dujardini, a kind of Waterbear.

range to marine sediments in the abyssal zone more than 4,000 metres below sea level. In the laboratory they can withstand pressure six times as great as that felt at the bottom of the deepest ocean. This animal is what they call a polyextremophile, happy in many different extreme environments.

But even though it is a home planet extremist, the Waterbear is also, like Goldilocks, partial to in-between places that are neither too hot nor too cold, too hard nor too soft, such as marshes, dunes, beaches and freshwater and shallow water sediments. There are about seventy species in the tepid British Isles, where their habitat ranges from rare pockets of protected fenland to moss in the gutters of bog-standard houses in the cities. This fondness for moss has earned it another name: the moss pig.

A key to the Waterbear's success is its ability to wait out the most unfavourable times in a dormant or cryptobiotic state called a tun, in which it sheds almost all the water in its body and hardens its vital membranes with a non-reducing sugar called trehalose. On Earth it can stay this way for 120 years. When the good times do return, the Waterbear emerges from its nap – a micro, aqueous phoenix – rather as one of those Japanese paper flowers unfolds from a wad when put into a cup of water, and carries on doing whatever it was doing beforehand, which was most probably searching for algae and tiny invertebrates to eat or other Waterbears with which to mate. A well-developed ganglion, a ventral nerve cord, two simple eyes and long sensory hairs over its body, mean this animal is far from insensitive. A fortnight after Waterbears have done the wild thing, the young hatch from fertilized eggs with a full complement of body parts and exactly the same number of cells as they will have as adults, like the homunculi of medieval and Renaissance lore. All they have to do is swell up.

The success of Tardigrades in space earned the Waterbear a ticket on the Living Interplanetary Flight Experiment, or LIFE, a mission launched in November 2011 to see how Waterbears and other organisms would fare over three years of sustained exposure to

THE BOOK OF BARELY IMAGINED BEINGS

space on a journey to and from Mars's moon Phobos. To join the crew of LIFE you had to be as hard as one of the drinkers in the bar scene in *Star Wars*, and a lot smaller, and no member of the animal kingdom apart from the Waterbears made the grade. So there they boldly went, alongside representatives from the kingdoms archaea, bacteria, plantae and fungi, in an experiment to test, among other things, whether the 'seeds' of life could be transported from one planet to another and survive. Unfortunately, the Russian spacecraft carrying LIFE got stuck in Earth orbit and then burned up on re-entry, so the experiment was lost.

For now, then, the idea of surviving any distance in space remains both speculative and untested. What of life already there? Humans have a well-established and possibly irresistible tendency to fill empty places with phantasms. And ever since space flight started to look possible, we have peopled outer space with these forms just as we once saw fairies and all manner of other beings in the woods. The science indicates, however, that if there is any life elsewhere in the solar system, it will almost certainly take much less florid forms than those our imaginations can summon and be more akin to some of the obscure and sometimes surprising micro-organisms living in the harshest environments on Earth. The researcher Dirk Schulze-Makuch suggests that if there is any life in the oceans on Jupiter's moon Europa the top predator would be a fearsome creature with mass of 1 gram. If the surface lakes of Titan, one of Saturn's moons, are home to hydrocarbon-guzzling microbes they could, conceivably, be the size of boulders – more impressive in size, but still simple life.

How will we regard such discoveries, should they actually happen? It is easy to be dismissive. These would not, after all, be life forms we could talk to. But there is, I think, another way to approach the matter. Properly understood, even relatively simple life forms are marvels of complexity. If you're in any doubt, take a little time to look at the animations of molecular biology within a cell that can be found on the Internet.

And what of intelligent life beyond the solar

system? There are between one and four hundred billion stars in our galaxy and given what we know of star and planet formation, it is almost certain that planets capable of supporting life orbit a significant proportion of those stars. Further, given the age and size of our galaxy (at least 13.2 billion years, with the hundreds of billions of stars distributed in a disc 100,000 light years across), there has been plenty of time and space for intelligent life and civilizations more advanced than ours to have evolved millions of years before we did. And from this it would seem to follow that we should be able to see evidence of them, either because they would have transmitted electromagnetic signals (which would span the galaxy in a few tens of thousands of years) or because they would be capable of deploying robotic craft able to go everywhere in the galaxy within twenty million years. Humans have already been sending signals into deep space deliberately for decades, and robots capable of interstellar travel may be only a few decades or hundreds of years away. Some argue that a civilization at least as technologically advanced as ours should, therefore, be evident across the entire galaxy. And this is before we even take into account the hundred billion or so other galaxies in the visible universe. To date, however, we have seen no signal or evidence of the existence of another intelligent civilization anywhere.

For an online tour of the whole shebang in six minutes, see *The Known Universe* by the American Museum of Natural History.

The contradiction between the idea that intelligent life elsewhere in the universe is extremely probable and the lack of evidence for it (which is known as the Fermi paradox after the physicist Enrico Fermi, who first articulated it in 1950, as the 'Where the hell are they?' problem) can be explained in several ways. Maybe other intelligent life is wise, content to live within limits and leave us alone. Maybe it is watching us silently and waiting until we are wise enough to be let into the club. (And maybe it will destroy us without hesitation if it sees reason to do so.) These, and other explanations, cannot be ruled out at this stage, but a better one may be that something makes the evolution of intelligence and its endurance once it has evolved much rarer than has been supposed.

The apparent absence of any intelligent life apart from us in the galaxy and to some beyond suggests that there is a 'great filter' or 'improbability barrier' that blocks the evolution of all but the very simplest organisms almost everywhere. Earth, on this reasoning, is a rare exception. We have already passed through one or more of these barriers (which may include the evolution of eukaryotic cells and of multi-cellular life in the first place *and* of having a planet free of shocks that destroy all life for enough time afterwards for intelligent life to evolve). But – more disturbingly – we have not yet run into the biggest barrier of all, which, the philosopher Nick Bostrom suggests, could be an almost invariable tendency of advanced civilizations to destroy themselves.

A great filter may be the best explanation of our apparent solitude but, as has often been said, when drawing conclusions about the probability of 'intelligent' life, we should not forget that when it comes to hard data we have a sample size of one. All we can say for sure is that *we* exist and that we are intelligent beings for at least some of the time – or at least that we have good grounds for believing ourselves so to be; the possibility that we are simulations inside some great machine cannot be ruled out completely

In a half-joke, the cosmologist Stephen Hawking calls humans a 'chemical scum', so tiny and insignificant are we in the vastness of space. The physicist Paul Davies disagrees: 'It's very easy to denigrate human beings because we've made a mess of the planet and we do silly things, but ... we have the spark of rationality and the ability to decode nature that makes us very special.' Similarly, the physicist David Deutsch says, 'We are a chemical scum that is different' – notably our ability, through science, to understand and explain the cosmos as it really is.

For as long as we have been human we have looked in wonder at the stars. But for almost all that time we have had no idea what they really were. Only in the early twentieth century, following the discovery of radioactivity, did scientists begin to understand what actually makes them shine, and to develop a robust explanation of star formation, duration and dissolution.

When a galaxy forms, energy streams from a supermassive black hole at its centre, releasing the energy of a trillion suns: that is a quasar.

Today we even understand quasars, the most distant and powerful phenomena in the known universe. But, according to Deutsch, even more remarkable than the quasar itself is:

> the capacity of one physical system, the [human] brain, to contain an accurate working model of the other, the quasar. And not just a superficial image of it – though it contains that as well – but an explanatory model, embodying the same mathematical relationships and the same causal structure. That is knowledge! And if that wasn't amazing enough the faithfulness with which the one structure resembles the other is increasing with time. That is the growth of knowledge.

In contrast to the vast majority of places in the universe, which are dark and cold, we live in a place that is saturated with information and energy. This has made possible creatures such as ourselves with the capacity to already 'be' everywhere in the universe through the use of reason and imagination in a way that nothing else we know of can be. Our ability to understand the cosmos – which is likely only to increase for as long as intelligent life continues – even has the potential to influence events at the cosmic scale.

Such grand claims and cosmic dreams may seem to be remote from our ordinary concerns in a crowded, hungry and rapidly changing world. But, Deutsch insists, they are of paramount importance. We may, for example, be able to intervene in the processes of a main sequence star such as the Sun in order to prolong conditions suitable for life in the solar system. This depends 'on what people do: what decisions they make, what problems they solve, and on how they behave towards their children'.

Philosophers from Plato to Spinoza and Hegel have argued that those who act freely in accordance with what is revealed by reason will be loving towards others. History is a sometimes harsher master than philosophy. Science and reason have often been harnessed by political and religious systems to hugely destructive

ends. The discovery of radioactivity led to the creation of nuclear weapons as well as insight into the nature of a star.

The tiny Waterbear can endure almost unbelievably harsh conditions and return to life as if nothing had happened. Further study of its remarkable abilities may lead to specific lessons in how to enhance human physical resilience in the face of challenges coming our way. We do not know whether collapse and catastrophe or something generally much more positive will result from our activities in the twenty-first century. But perhaps we can take this little bear as a talisman: a real-world, microscopic version of the ancient Egyptian scarab, representing endurance, regeneration and hope.

'Rationality will not save us ... The indefinite combination of human fallibility and nuclear weapons will lead to the destruction of nations.'
(Robert McNamara, US Secretary of Defense, 1961–8)

XENOGLAUX, THE LONG-WHISKERED OWLET

Xenoglaux loweryi

Phylum: Chordata
Class: Aves
Order: Strigiformes
Conservation status: Not listed

There is no rest except on these branching moments.
Rumi

T he *Xenoglaux*, or long-whiskered owlet, is
not especially beautiful or wise. It does not
catch prey in spectacular manner, and its
cry – a single, deep, husky almost disyllabic
woh, once every three seconds or so – is not particularly
melodious. Its plumage – dull brown, and whiskery
around the beak – is nothing special. Almost all the
features that make it remarkable – excellent vision,
feathers engineered for silent flight, and zygodactylous
feet (pairs of front- and back-facing claws that act like
strong claspers; I wish I had them myself) – are ones it
shares with virtually all other owls. It is exceptionally
small for an owl – including tail feathers, shorter than
your hand – but it is not the smallest; that fame
belongs to the Elf Owl of North America.

Still, the *Xenoglaux* is not without charm. With
large, orange-brown eyes and yellow-white eyebrows,
this tiny being is more reminiscent of a cross between
a tarsier and a wren than an owl. Its diminutive size is
an excellent adaptation to its unusual habitat, the
cloud forests high in the mountains of Peru. Here, the
slopes are drenched in fog almost continuously, and
the vegetation varies from tall trees at the lower end
of its range (which is about 1,800 metres) to 'elfin', or

miniature ones at the upper end (which is about 2,300
metres). The wet conditions favour thick ground
cover, while the trees are clothed with epiphytes: a

THE BOOK OF BARELY IMAGINED BEINGS

garden gone wild in every dimension. The owl likes to stay well hidden in the understory and midstory, waiting patiently before it hops or swoops through a narrow gap to surprise insects, rodents and other small prey.

Xenoglaux is also remarkable for its elusiveness and rarity. It was discovered in 1976 and only photographed for the first time in 2010. There were probably never very many of them but today there may be fewer than 250 individuals alive and the species is endangered because its remaining areas of suitable habitat are being cleared for timber, agriculture and to secure ownership of the land. This makes it a 'typical' endangered bird: from *Xenoglaux* to the Cerulean warbler, habitat loss or degradation is the main threat for around three-quarters of endangered birds.

Tropical cloud forests and the lowland rainforests downstream of them contain a greater variety of life forms than anywhere else on Earth. A typical square kilometre of montane or lowland primary rainforest in Peru (or Congo, or Borneo) can contain more different species of tree than all the land in the northern hemisphere outside the tropics, an area four million times larger. The ratio is similar for animal life. So tropical deforestation is a matter of huge concern if one believes that the sheer diversity of living things and the rarity of many of them, is of value. But there are more utilitarian reasons to care. Cloud forests extract more water from the air than falls as rain, with the result that in addition to supporting extraordinary flora and fauna themselves they also provide signif icantly more water to ecosystems and people downstream than would otherwise be the case. The additional moisture, known as occult precipitation, is intercepted by vegetation that is adapted to extract it from the air. Lowland rainforests, in turn, also influence temperature and water availability in surrounding regions. And they are, of course, huge reservoirs of carbon, and clearing and draining them is one of the largest additional sources of greenhouse gas caused by human activity after the burning of fossil fuels. Deforestation in the Amazon basin alone may account for 2 or even 5 per cent of total global emissions.

Stopping global deforestation could cut carbon emissions by as much as three billion tonnes a year – the equivalent of more than one-third of fossil fuel emissions.

In 2008 the Peruvian Government announced that it would reduce logging of virgin forest nationwide to zero by 2020 while also ensuring that the needs of the Peruvian people for economic development are met. This is a very ambitious goal given the limited resources available for conservation and the forces militating against it. But, if achieved, it would be a significant contribution to the protection of plant and animal diversity for the whole world. Peru's sixty million forested hectares – the fourth largest area of tropical rainforest after Brazil, the Democratic Republic of Congo and Indonesia – contain more than 10 per cent of all bird species on Earth, and comparable proportions of other terrestrial animal and plant life.

Even if the forces opposed to forest conservation in Peru and other tropical countries are overcome there are the impacts of climate change to contend with. Just what these will be is extremely uncertain. At the time of writing the good news is that even if, as now seems likely, the global average temperature rises by more than 4°C this century, there may still be a chance of navigating away from a 'tipping point' where most or all of the Amazon rainforest dies back and is replaced by open woodland, scrub, savannah and even desert. This rainforest – an important and continuous part of Earth system functioning since the Cretaceous – is probably not yet history. But we are gambling for high stakes.

The idea of the tipping point, popularized in 2000 in a bestseller by Malcolm Gladwell, who applied it to everything from fashions in running shoes to the rate of teen suicides, was adopted by some climate scientists and ecologists in the first decade of the new century. The Earth systems scientist Tim Lenton and others identified six major ecosystems that, if pushed beyond a certain point, could unravel, resulting in climatic regimes unknown in the Holocene (the relatively stable period that favoured the rise of agriculture and industrial civilization). In addition to Amazon dieback, these included: the death of vast northern forests, resulting in large releases of carbon dioxide to drive further warming; the melting of polar sea ice and of

much of the Greenland and Antarctic ice sheets, lead-
ing to sea-level rise and further warming as more heat
from the sun is absorbed rather than reflected back
into space; severe disruption to the Indian and West
African monsoon; disruption to the formation of
Atlantic deep water near the Arctic Ocean (which is a
component of the thermohaline circulation); and the
loss of permafrost leading to potential Arctic methane
release and the 'clathrate gun' effect (in which large
quantities are released suddenly from permafrost and
the seabed), driving further warming.

How well this analysis holds up remains to be seen.
As has been stated, it's possible that rapid dieback of
forest in the Amazon basin may actually be one of the
less likely scenarios. But even without dramatic and
visible step changes such as this, we appear to be well
in to a sixth extinction: a 'perfect storm' that destroys
life's diversity thousands of times faster than new
species can evolve.

The 'storm' extin-
guishes many species
but even those it
doesn't wipe out are
greatly depleted.
There are a third
fewer wild animals
than there were 40
years ago.

Do individual species matter? Even for those who
take particular delight in rare and elusive creatures the
answer is not always clear. In *The Ghost with Trembling
Wings: Science, Wishful Thinking and the Search for Lost
Species*, Scott Weidensaul wonders why he is so obsessed
by a bird called the Cone-billed Tanager, which at the
time had not been seen in over sixty years (and which
was finally seen again two years after he wrote):

What makes the Cone-billed Tanager special is its
mystery; should it ever reappear, it would become
just another rare bird in a world already saddled
with too many threatened organisms. It may be
that we need icons of faith and aspiration, objects
of great quixotic quests, more than we need reality.

Or this may be the worst kind of rationalistic
bull. If we'd found the Tanager, no doubt I'd be
writing an equally eloquent denouement on the
joys of dreams realized, instead of dreams
deferred.

In an essay on the absurd, the philosopher Thomas
Nagel concludes that we shouldn't worry too much if
under the eye of eternity nothing matters because in

that case *that* doesn't matter either, and we can approach our lives with irony instead of heroism or despair. That looks about right, so long as we do not take irony to mean that nothing matters *to us*. There comes a point, however unpredictable and unreasonable, when we cannot help but value, take a stand and love (or to fail, finally, to do so). We can recognize that what we value, stand by or love will inevitably be lost – that, as a Buddhist saying has it, a fragile cup that we see before us may look whole and perfect but in the larger scheme of things it is already broken. But that does not mean that our situation is without joy and even a little comedy.

In the Peruvian cloud forest, conservationists are working to protect the *Xenoglaux* and other unique species by securing 180,000 hectares in the Alto Mayo region against any threat of clearance, and establishing a new reserve in the Cordillera de Colán. Such reserves may or may not be sufficient to protect wildlife. As the climate changes, additional pressures are likely to come from changes in vegetation and from animals that currently thrive at lower elevations but are now looking for somewhere cooler. This will mean, at the least, a new mix of animals and plants in the reserves. Whether or not *Xenoglaux* will survive is not clear.

I was deep in the rainforest in Sarawak, one of the Malaysian states on the island of Borneo, when I saw 'my' owl. Following a nightmare of a conference under air conditioning and no natural light in the big city, I was on a press junket promoting a plan to extend and enhance protection to significant areas of Borneo's remaining forests. We had spent the morning scrambling over steep ridges and looking, unsuccessfully, for the nests which orang-utans build in the trees every night. But now I was sitting beside a fast-moving stream and had become entranced by watching a sheet of water flowing over the flat surface of a rock in sunlight. Suddenly, and for no reason I was aware of, I looked up. High above on a branch was a fine, fierce-looking owl, much larger than *Xenoglaux*, staring at me. I could not identify the species – I am no birder – and there was no one

Climate change has been identified as the main culprit for the extinction or threatened extinction of several mountain species around the world. The Golden toad unique to the cloud forests of Costa Rica was the first. Among those likely to follow are the lemur-like Ringtail Possum of the highlands of Northern Queensland in Australia; the Pika, a thick-furred, rabbit-like animal of the American Rockies; and Sharpe's Longclaw and the Aberdare Cisticola, two passerine birds of the Kenyan Highlands.

nearby who could do so either, but that didn't matter. For me, this was *it*: I felt that I was encountering the very spirit of the forest, the herald of something tremendous. With hindsight I can reflect rationally upon the encounter: that powerful body and those brilliant, fierce eyes were merely adaptations for hunting. No special intelligence lurked behind them. Indeed, owls are far from being the brightest of birds. But in the moment of meeting in the real world and in the memory I have of it, such thoughts were secondary to the overwhelming magnificence of the animal – an emblem of the vibrancy and power that life itself can achieve in a forest.

Owls have fascinated humans for as long as there is any record. The meanings attributed to them, however, have varied greatly at different times and in different places. Often, in Europe, China and elsewhere, they have been regarded as harbingers of evil. One of the most striking European works of art in the shadow of this tradition may be Francisco Goya's etching in his *Caprichos* series, 'The Dream of Reason Produces Monsters', in which a sleeping human figure (perhaps the artist himself) is mobbed by owls and bats with terrible eyes. At other times, owls were regarded as beneficent. In Shang-dynasty China, elaborate bronze wine vessels shaped like owls accompanied fortunate souls into the afterlife. In ancient Greece owls were associated with Athena (in Latin, Minerva), the goddess of wisdom. ('Only when the dusk starts to fall does the owl of Minerva spread its wings and fly,' wrote Hegel, suggesting that wisdom comes late in the day if it comes at all.) And some cultures seem to have seen both good and bad in owls at the same time. The Mochica culture of northern Peru attributed healing powers and wisdom to owls that they represented in gorgeous gold and ceramic objects, but also associated them with a warrior involved in ritual decapitation of the dead.

Perhaps the chief image for our time should be the most ancient: a horned owl depicted in the Chauvet Cave in France. Unlike many of the other animals shown in the cave such as reindeer, cave lions, panthers, wooly rhinos and wild horses, the horned owl is

'In the horned owl ... the power of vision is so much increased that even in the faintest glimmer of night ... it can see more distinctly than we in the radiance of noon.' (Leonardo da Vinci)

'The dream of reason produces monsters' from the *Caprichos* by
Francisco de Goya (1799).

neither regionally or globally extinct. Like those
others, we can only guess its meaning for those who
painted it, but we do know that the continued
survival of the species is in our hands.

The Sleat Peninsula, sometimes called the garden
of the Isle of Skye, is mostly bog and moor. For much
of the Quaternary era – that is, the last 2.6 million
years – this land was covered by hundreds of metres
of ice and virtually devoid of life. But for the last
11,000 years or so it has largely been ice-free, and for
many thousands of years substantial parts of it were
densely wooded in hazel, birch, ash, oak and other
species. Then, from about 5,000 years ago, the combi-
nation of a change in climate to cooler and wetter
conditions and the relentless and increasing demand
for wood by human colonists reduced the woodlands
over time to a few small pockets in relatively inaccessi-
ble places, until almost none remained. One of those

THE BOOK OF BARELY IMAGINED BEINGS

that did, however, is a small woodland on the north shore of a loch hidden and inaccessible from any road. With a thick stand of big trunks next to the quiet water, and diverse, healthy trees climbing the hillside behind, this place is, by design or inattention, a sacred grove. Standing here on a still day, you only hear birdsong and the crash of a waterfall spilling through a little gorge above the opposite shore of the loch. Barn owls, Tawny owls, Long-eared owls and Short-eared owls, all of which are resident on Skye – and even, perhaps, the occasional Snowy owl visiting the island – hunt here.

'A most paradoxical mixture of sound and silence pervades the shady parts of the wood.' (Charles Darwin)

The British Isles are likely to see less dramatic changes in climate than many other parts of the world in the twenty-first century. They could, potentially, be an 'ark' for some wild species from mainland Europe whose habitats will become less favourable to their survival. Land is precious, of course, so there will be huge challenges to making this actually happen. Still, like the few scraps of cloud forest in Peru that may be kept for *Xenoglaux*, fragments of these islands could become havens for numerous threatened species, including lynx and eagle. One could make a wager: that humans can protect and restore the beautiful and the mysterious, and create new possibilities for future flourishing.

XENOPHYOPHORE

Syringammina fragilissima

Kingdom: Rhizaria
Phylum: Foraminifera
Class: Xenophyophorea
Conservation status: Not listed

Nature's silence is its one remark.
Annie Dillard

Picture a world teeming with amoebae as
large as human heads and steadily accreting
mineral crusts but as friable as sponge cakes.
You might think that such organisms, if they
existed at all, would be found elsewhere in the universe –
the sea of Saturn's moon Titan, say, or somewhere in
a Douglas Adams novel – but surely not on Earth. But
if you did you'd be wrong. *Fragilissima* is one of more
than forty species of Xenophyophore – pronounced
'zen-oh-fy-oh-four' – that densely populate large parts
of the abyssal plain that covers more than half of the
planet's surface, deep beneath the ocean.

Xenophyophores, which are members of the
phylum foraminifera, vary in appearance. Some are
flattened discs, some are angular and some are frilly
or spherical. *Fragilissima* looks like a muddy sponge
full of holes, a heap of tangled spaghetti or a rotten
lettuce. Xenophyophores also vary in size. At 20 cm (8
inches) across, *Fragilissima* is the largest. Most others
are no bigger than golf balls but even at this size they
are huge in comparison to most forams and to single-
celled organisms more generally, which are seldom
more than a fraction of a millimetre across.

In addition to being odd, *Fragilissima* and its Xeno-
phyophore cousins are poorly understood. Specimens are
always damaged during collection so even though it was
discovered 130 years ago (in 1882, during an expedition off
the northwest coast of Scotland led by the oceanographer

John Murray, who had distinguished himself on the *Challenger* expedition two years before), even today little is known about how it lives. We do not know precisely how *Fragilissima* feeds – whether it is a 'suspension feeder', pumping water through its body and sifting out tiny particles of food, or whether it relies entirely on extending pseudopods to capture food from the seabed. Nor do we know whether it reproduces sexually or asexually, or switches between the two as other forams do.

Much of what we *do* know about Xenophyophores is given in their name, which is Greek for 'bearer of foreign bodies'. Xenophyophores build their tests (the outer crusts) from the dead parts of other things, be they diatom skeletons, sponge spicules or broken shells, along with grains of sediment and fecal matter, which they compound into a thin layer of rocky cement. Inside, they are lumps of soft cytoplasm with many nuclei distributed throughout their whole mass, like porridge dotted with raisins. As they slide ever so slowly over the cold mud they deposit slimy mucus as snails do. Where they are present in large numbers (as many as 2,000 individuals per hundred square metres) the entire seabed may be covered with this slime. In sum, *Fragilissima* is an amazingly big single-celled animal with no brain that attaches poo and the parts of dead things to itself and leaves a trail of goo behind.

The place where they live is as alien to us as the creature itself. Under the sea there are mountain chains longer than the Andes and peaks rivalling those of the Himalayas in height, but away from these features and the continental shelves, about three quarters of the seabed is (with the exception of the scattered dots of seamounts) largely flat. These abyssal plains, mostly lying four to six thousand metres (2½ to 3¾ miles) below the sea surface, are covered with the accumulated skeletons of small plankton and animals that lived and died in the waters above. It is totally dark in these bottom waters except for the presence of some bioluminescent animals, and very cold: the water temperature ranges between –1 and +4°C. Water pressure is hundreds of times greater than air pressure in the atmosphere, and currents are slight. Intuition would tell you this should

At abyssal depths only two water masses – Antarctic Bottom Water originating in the austral winter in the Weddell Sea region, and North Atlantic Deep Water originating in the Greenland/Norwegian seas – extend over all the world oceans. As a result, physical conditions are virtually uniform across the abyssal plains right around the world.

be a place of death, and for more than seventy-five years after the pioneering deep-sea trawls undertaken by the *Challenger* expedition of 1872–6, scientists found few organisms. From the second half of the twentieth century onwards, however, more refined collection methods and exploration with remotely operated vehicles and the occasional manned submersibles meant that the number of discoveries increased dramatically.

We now know that the feculent silt of the deep seabed, or benthos, is actually one of the most biodiverse places on Earth. The abyssal plains may not have trees, grasses or shrubs but, like a savannah, they have herds of grazing animals. Sea urchins and sea cucumbers in profusion filter the mud and detritus. In addition, there are sea spiders with legs as long as your forearm and amphipods (woodlouse-like beings) the size of King Charles spaniels. In the mud itself tiny worms, clams, brittle stars, crustaceans and other organisms eke a living. Delicate glass sponges and crinoids protrude above them into the still waters. Small fish rest their tripod-like fins on the bottom. It's like something from a Dali painting.

All of these, and more, depend ultimately on the bacteria living in silt. And Xenophyophores seem to play an important role at this interface between surface and subsurface life. Places where they are present in large numbers – and there can be more 2,000 individuals per 100 square metres – have three to four times as many crustaceans, echinoderms and molluscs as places where they are not. In turning over the silt Xenophyophores are, perhaps, 'constant gardeners'. (They are also shelters or platforms for various other organisms including isopods, polychaete worms, nematodes, copepods and a kind of brittle star.)

Xenophyophore cousins to *Fragilissima* may be lurking behind another puzzle – strange, symmetrical patterns found in sea-floor rock in some places in the Atlantic. These patterns consist of sets of small holes arranged hexagonally like a honeycomb in cross section. Beneath the rock surface, the holes are connected by networks of straight tunnels, reinforcing the similarity to a honeycomb. There can be up to two or three hundred holes in a single pattern, and an entire

In 2010 animals of the phylum Locifera were found living deep in sediment without oxygen, something that had hitherto been considered completely impossible for multicellular creatures. Bacterial life may extend more than 1,600 metres below the sea floor.

THE BOOK OF BARELY IMAGINED BEINGS

set is no bigger than the palm of your hand. Photographed in contrasting shades of grey the patterns look as startlingly different from the seabed as the prints of Buzz Aldrin's boots do from the Moon's surface.

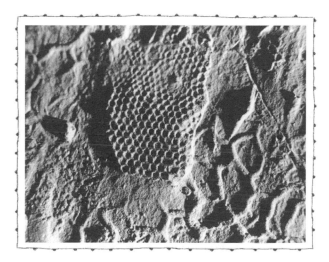

Traces of *Paleodictyon nodosum.*

This footprint on the Moon, made and photographed on 20 July 1969, will last for millions of years.

The oceanographer Peter Rona first noticed the hexagons in photographs taken in the 1970s by a remotely operated vehicle, and thought it was a practical joke. The pattern was real, however. Still, for many years he and other scientists were flummoxed. Finally, after examining sets of patterns discovered on a series of dives in submersibles between 1985 and 2003, Rona and his colleagues believed they might have an answer: the patterns could be evidence of the continued existence of *Paleodictyon nodosum*, an enigmatic organism previously known only from the fossil record and thought to have become extinct about fifty million years ago. Rona and his colleagues hypothesized that the pattern was a tunnel system built by still living *Paleodictyon* as part of a feeding strategy. But an equally plausible answer was that it was a tiny cave system carved in the rock by a Xenophyophore.

Another recent discovery suggests that organisms similar to Xenophyophores have been around for a very long time indeed. Palaeontologists had long wondered about fossilized tracks about 1.8 billion years old that seemed to have been left by something with bilateral symmetry (a left and a right). This was a puzzle because the timing was all wrong: bilaterians as we know them did not evolve until well over a billion years later – first with some of the Ediacarian animals, which lived from around 630 to 542 million years ago, and then with the creatures of the Cambrian explosion, which started around 542 million years ago. Then some biologists stumbled across fresh tracks on the sea floor of the Arabian Sea and near the Bahamas, which looked almost exactly like the fossilized ones. These tracks turned out to have been left by a bubble-like, grape-sized amoeba called *Gromia sphaerica*. Like the Xenophyores, this is a giant protist. 'We were looking for pretty animals [with] eyes, [bright] colours, or glow in the dark,' said lead researcher Mikhail Matz; 'instead, [we found] an organism that was blind, brainless, and completely covered in mud.'

Fragilissima accreting itself with stone, *Paleodictyon* living inside stone and *Gromia* (or something very like it) leaving its trace in ancient stone. These organisms

thrive in places we had previously thought to be among the least favourable to life, and they do so in intimate relationship with the most obdurate of materials: rock and debris that will become rock. They are life as we do not know it; ways of being that predate most of what we are accustomed to thinking of as life.

On land, too, we tend to think of rock as utterly dead. So, at least, it seemed to Primo Levi when, in the early years of World War Two, his training as a chemist granted him temporary refuge in an improbable venture to extract nickel from rock in Northern Italy:

> At moments of weariness I perceived the rock that encircled me [in] the Alpine foothills in all its sidereal, hostile, extraneous hardness: in comparison, the trees of the valley ... were like us, also people who do not speak but feel the heat and the frost, enjoy and suffer, are born and die ... obscurely follow the sun in its travels. Not the rock: it does not house any energy, it is extinguished since primordial times, pure hostile passivity.

Given the context – that he is looking back years later across an intervening time of unspeakable horror that followed – Levi's feeling about the rock is understandable. In reality, however, it was humans – the Fascists and those who acquiesced passively in their crimes – that were the agents of unbeing, not the rock. In a greater perspective that, in other circumstances, Levi himself would have appreciated, rock is not the opposite of life but its essential partner.

A full appreciation of this seemingly paradoxical truth has been a long time coming. It was prefigured metaphorically in the magical thinking that tens of thousands of years ago led people to interpret images painted on cave walls and rock faces as portals to other realms of existence. But it only started to come into focus when, a few hundred years ago, natural philosophers began to try to explain the nature and origin of fossils. An early attempt at systemic categorization of fossils and other stones has categories including:

'The walls, ceilings and floors of caves were [for palaeolithic artists] a membrane between subterranean activity areas and a chthonic spirit world behind the rock – the placing of animal images directly on the mediatory surface would have implied a relationship between the maker of an image and the spirit realm.' (David Lewis-Williams, 2010)

those which take their name from something in the sky; those which bear a resemblance to certain artificial things; those which resemble trees or portions of trees; those which resemble men or four-footed animals; those which derive their names from birds; and those which resemble things which live in the sea.

These descriptions and distinctions, which were suggested by the Swiss naturalist Conrad Gessner in 1565, look misguided, crude and quaint today but even so we can recognize in his work an attempt at a rational and explanatory order within the limits of available knowledge.

Over the next 300 years geologists and others built on such work, revising it in the light of new evidence to construct a framework still, broadly, in use today to describe the geological periods since animals and plants as we know them came into being (see Chapters 2 and 14). There continued to be many gaps and blind spots. Well into the twentieth century (and still, perhaps, in the minds of many eight-year-olds) fossils were largely a matter of the remains (ideally, the bones) of once-living creatures (preferably dinosaurs) in inanimate rock. And as late as the 1950s it was widely thought that life itself was less than a billion years old. But now, we believe, we have something approaching the whole picture, at least in broad outline. We know that life on Earth dates back well over three billion years, and that from the beginning rocks and life have been part of each other's making. Indeed, more than half of the 4,400 different kinds of mineral on Earth owe their existence to life.

The partnership between rocks and life works at many levels and time frames. Over the very long term – millions to hundreds of millions of years – the weathering of silicate rocks by plants, for example, has a significant effect on the temperature of the atmosphere, the ocean and the land, and may extend the duration of the biosphere by around a billion years. An intuition of Isaac Newton in 1675 is, broadly, accurate: 'nature is a perpetual circulatory worker, generating fluids out of solids, and solids out of fluids,

The Earth's crust is composed of two main kinds of mineral: carbonates and silicates. Over the very long term, weathering of silicates locks up large amounts of carbon in the rock and so makes the planet cooler than it would otherwise be. Plant life increases weathering rates greatly with the consequence that in the long term the amount of carbon in the atmosphere is reduced, other things being equal. Without plants the average temperature on Earth would be between 1° and 45°C warmer, because there would be much more CO_2 in the atmosphere.

fixed things out of volatile, & volatile out of fixed, subtle out of gross, & gross out of subtle.'

One may contrast Primo Levi's attitude to rock with that of Imre Friedmann who, like Levi, narrowly escaped annihilation in World War Two. Afterwards, he became a microbial ecologist, specializing in endoliths – bacteria, protists, lichens and other organisms that live inside rock. Many of those he studied live hidden within stones in very dry, high or cold places, and Friedmann felt a particular compassion for these. They were, he said, 'always hungry, always too cold, in this grey zone ... In human terms you could compare them to the most miserably living generations of pariahs in India'.

Not all endoliths live in conditions as harsh as those that fascinated Friedmann. Among them are the stromatolites formed by cyanobacteria and other organisms – great, pillow-shaped stone pillows that were abundant in the Precambrian times (from which time their fossils survive as what the Chinese call 'flower rocks' after their beautiful patterns) and still thriving in a few isolated places today. Then there are the mysterious organisms that create 'desert varnish', a black or orange glaze on certain rocks into which Native Americans once etched petroglyphs.

A legend of the Seneca people of North America has all stories originating from a marvellous stone. In some rocky landscapes I sometimes feel as if the stones are so alive and so vibrant that it is as if they are speaking, and it is we who cannot understand or who are too distracted to hear. All time since the creation of these rocks is *there* in their irrefutable presence, if only we can pay attention properly. Our own passing experiences – and even our most cherished hopes and dreams and memories – are momentary and insubstantial by comparison. Stone is not silent but moving to a different rhythm to ours.

A school of philosophy imagined by Jorge Luis Borges denies the existence of time and holds that the present is indefinite, that the future has no reality other than as a present hope, the past none other than present memory. The physicist Julian Barbour has gone so far as to suggest that, contrary to Newton's insistence and

common sense, time does not flow like a stream. Whether or not these intuitions reflect reality, we do sense, when holding onto a pebble, a stone or rock (or striking it with our foot, as Samuel Johnson might have recommended), that *something* is real.

It has been fashionable in recent years to marvel at the mystery of consciousness, but perhaps consciousness is the least mysterious thing in the world, and it is matter itself that is truly astonishing. An atom of hydrogen, the most common in the universe, consists of a single electron orbiting a positively charged particle called a proton. The radius of the proton is one ten thousandth of the radius of the orbit described by the electron. The electron is less than one thousandth the size of the proton. Thus, hydrogen is more than 99.9999999999999 per cent empty space. The proportion is similar for other elements. There is both less and more in a pebble than we can ever be aware of. And to take this on board is to only begin to be aware of what Richard Feynman rightly called 'the inconceivable nature of nature'.

'All our science, measured against reality, is primitive and childlike,' said Albert Einstein; 'and yet it is the most precious thing we have.' And we have, at least, expanded our vision of what it is to be alive, not least on the ocean floor where Xenophyophores roam, and in the rocks themselves.

YETI CRAB

Kiwa hirsuta

Phylum: Arthropoda
Subphylum: Crustacea
Class: Malacostraca
Conservation status: Least Concern

I should have been a pair of ragged claws
Scuttling across the floors of silent seas.

T.S. Eliot, *The Love Song of J. Alfred Prufrock*

Those who named the Yeti crab must have enjoyed coming up with a way to describe its odd conjunction of features. The outsized front 'arms' (strictly, pereiopods) *do* look a little like those of the Gigantopithecus, a huge and now extinct ape which some cryptozoologists claim as the still-living original for the Tibetan wild man of the snow. And the body *is* unmistakably that of a crustacean. As for the animal's scientific name, which combines the Maori oceanic creator god with the Latin for 'hairy', this too is resonant and precise. Still, those who coined these names missed a trick because this crab has about it something of Janus, the god of thresholds who gazes into both past and future.

The Yeti crab was discovered in 2005 in a place just about as far from human habitation on Earth as it is possible to get: the sides of a 'black smoker' some 2,200 metres (almost a mile and a half) beneath the sea surface on the Pacific–Antarctic ridge about 1,500 km (900 miles) south of Easter Island. Black smokers are chimney-like 'hydrothermal vents' in the ocean floor through which water and minerals that have been superheated inside the Earth are forced up at over 300–400°C (570–750°F) into surrounding ocean water that is typically about 2°C (35°F). The 'smoke', which is actually a super-hot fluid, is black because it contains mineral particles which absorb most of the

THE BOOK OF BARELY IMAGINED BEINGS

light beamed from any submersible that has plumbed these lightless waters. Amongst these particles are sulphides, and if you could smell it this place it would have a sulphurous smell, like a medieval hell.

Vents of this kind were first discovered on the Eastern Pacific Rise in 1977 – eight years after humans first set foot on the Moon (and the same year in which Elvis Presley died, The Clash released their first album and 'How Deep is Your Love' made the charts). Their discovery amazed oceanographers and biologists. Not only was there abundant and diverse life where none had been expected but it took forms of which no one had dreamed. This life drew its energy not from the Sun but from the heat within the Earth, using it to drive chemosynthesis, a process whereby microbes convert carbon and nutrients into organic matter by oxidizing hydrogen or hydrogen sulphide. These microbes in turn supported a range of organisms all the way up to Giant tube worms, which grow up to 2.4 metres (7ft 10 in) tall and are topped by blood-red fronds. They have no mouth, no stomach and no digestive system but live in symbiosis with bacteria inside their bodies that make up half their mass. Smaller in size than the Giant tube worm but more extreme in its hot-tub habits of living is the Pompei worm, named for the Roman city engulfed in a volcanic inferno. This animal anchors itself close to the hot vents where the temperature may be as high as 80°C (176°F) while its feather-like head sticks out of a tube into water a little further away that has already cooled to around 22°C (72°F). A fleece-like covering of bacteria on its back, with which it lives in symbiosis, probably insulates the Pompeii worm from the most extreme temperatures.

In the decades since the first discovery of black smokers, many more have been found at about fifty locations along the 64,000 km (40,000 mile) mid-ocean ridges that run around the seabed of the world ocean like the seams on a tennis ball. But only a fraction of the ridge and other possible locations have been explored. Future investigations could reveal even more and on them creatures at least as strange as the Giant tube worm and the Yeti crab. It has only

Another seminal event in 1977 was the classification, by Carl Woese, of archaea as a separate domain of life from bacteria.

recently been discovered, for example, that bacteria floating in the water at some distance from hydrothermal vents are able to perform the equivalent of photosynthesis by harvesting the very dim light from the infrared glow of the vents.

The Yeti crab is a creature of the threshold in several senses. First, by dint of its very presence on the black smoker, it inhabits the interface between the two worlds of scalding magma and cold water. Exactly what function its long hairy limbs serve was not, at first, completely understood and it was thought that they might enable the animal to straddle a boundary between the very cold surrounding water and the extremely high temperatures and noxious gases of the vent. The hairs – which are actually bristles, or setae, like those found on moths or bumblebees – would provide insulation (as do those of a Pompeii worm) when the crab reaches through scalding water in pursuit of prey. Another idea was that filamentous bacteria covering the hairs would either neutralize gases emitted from the vent or serve the crab directly as a food source. And this last idea received support when a second species of Yeti crab was discovered on cold seeps on the deep-sea floor near Costa Rica: *Kiwa puravida* harbours colonies of bacteria on the bristles of its claws which it scrapes off with its comb-like mouth. A loose analogy would be you or I sprouting cress seeds in the hair on top of our heads. Somewhat less hairy than *K. hirsuta*, it derives the second part of its name from a Costa Rican phrase for the good life, for *K. puravida* seems to spend much of its time in what its discoverers described as an extraordinary and comical dance as it waves its claws through the water, presumably in order to expose the bacteria to as much of the nourishing gases escaping from the seep as possible.

Like shrimps, lobsters and other crabs – animals with which many of us are broadly familiar, at least on a plate – the Yeti crab is a decapod: that is, a ten-limbed crustacean, and as such a member of the class known as Malacostraca. The five thousand or so species in this class, which has been around since the Cambrian, have played an almost endless set of variations upon the crustacean body form, diversifying into sixteen different

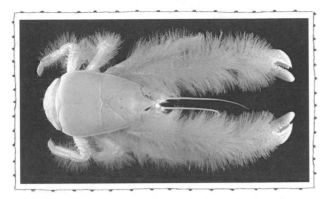

Kiwa hirsuta, the Yeti crab.

orders of being that include everything from the deli-
cate Harlequin shrimp, the Google eye fairy crab and
the Violet-spotted reef lobster to the terrifying Giant
isopod of the deep sea and its diminutive terrestrial
cousin the Woodlouse (not to mention *Gonodactylus*,
the genital-fingered stomatopod, described in Chapter
7). The Japanese spider crab, a Malacostracan, is the
largest crustacean in the sea, growing to 3.8 metres (12
ft 6 in) across. And the Coconut crab is the biggest
arthropod on land. Nearly a metre across, it climbs
trees and crushes coconuts with its massive claws.
Even diminutive krill are Malacostracans.

In Western culture there is a lingering sense that
crustaceans are ugly and alien. This may be down to
the fact that, as arthropods, they are, loosely speaking,
very large bugs and therefore versions of organisms
which, in many cultures, are associated with dirt and
disease. For Jean-Paul Sartre they evoked a disturbing
mixture of disgust and kinship. The narrator in
Sartre's novel *Nausea* starts to feel revulsion towards all
of existence but particularly towards himself and
other humans, whom he begins to see as crabs: slimy
and hard on the outside and soft and formless on the
inside. (Sartre, who set great store by puns, noted that
the French for lobster, *homard*, from the Latin *homarus*,
is a homonym of *homme-ard* – the word for 'man' with
a pejorative suffix, meaning something like 'nasty little
man', or 'shit'.) Sartre's attitude may have been

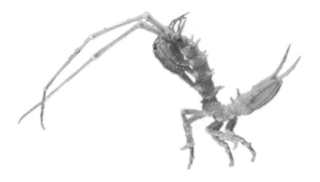

Other creatures, even stranger than the Yeti crab, lurk at depth. This is
a Deepsea arcturid Isopod from a coral seamount in the Indian Ocean.

unusual, even extreme, but it is on a continuum with
something that is still present in Western culture.

Marine photography in recent decades has shown
something that Sartre and other crustacea-phobes
never knew: that crustaceans can be creatures of
beauty. Porcelain crabs dress in polka dots of purple
on white, white on red and a dozen other combina-
tions. Hermit crabs sometimes sport anemones on
their shells as if wearing wild medieval hats. It's also
the case that we now understand that many species of
crustacean have if not feelings exactly then at least an
exquisite tactile sense, facilitated by hundreds of
thousands of tiny hairs that protrude through their
carapace. In his meditation on the lobster the novelist
David Foster Wallace quotes from a standard guide to
the fishery: 'although encased in what seems a solid,
impenetrable armor, the lobster can receive stimuli
and impressions from without as readily as if it pos-
sessed a soft and delicate skin'.

And yet they remain so alien to us. Watching the
twitching arthropod mouthparts of a crab pushing
food particles into itself I cannot shake a gut feeling,
however irrational it may be, that I am looking at an
obscenely voracious machine. This, then, is a second
way in which a Yeti crab, along with its many

Malacostracan cousins, is a creature of the threshold. It bridges over a distinction we are used to make between living and non-living things. I think there is a parallel here with robots and our attitudes towards them.

For most of the ninety years since they were imagined by Karel Čapek in 1921, robots in the real world have either been crude or only able for narrow and specialized tasks. Over the last decade or so, however, we have entered what appears to be the start of a mechanical Cambrian explosion, in which mechanical entities with capacities hitherto possessed only by humans and other animals – agility, awareness, and adaptability – proliferate. There is, for example, a 'snake-bot' that can worm its way into your heart to perform a medical procedure. There is a robot that can adjust delicate mechanical parts on the International Space Station better than any astronaut can. There are robots that can climb trees like caterpillars, robots that perform traditional Japanese dance forms, bipedal robots fast enough to run us down and others that, one day, will outclass us at football. Although robots are still strikingly limited in many ways, some of them already surpass us in a range of physical and information processing tasks. From squishybot (soft and bendy forms that resemble the arms of cephalopods) to micro-insectoid drones networked to intelligent systems, robots are starting to evolve forms and uses that we can as yet barely picture.

Does this mean we are crossing a threshold into new ways of perceiving and being in the world? Sherry Turkle, a sociologist of science and technology, is concerned that the ability of robots to provide nurturance (that is, care for human needs) will prove to be the killer app. We are, she points out, vulnerable to new attachments, and risk emotional seduction by machines that either care for us or, in the case of robot pets and companions, ask for our care. These machines will pretend to converse, but will not really understand what we say. Engrossed by sociable robots, we experience what we imagine to be a new sense of intimacy, and yet because this contact is not with other humans, Turkle fears, we will

be diminished. (An extreme, sexualized vision of human dependency on machines appears in Fritz Lang's 1927 film *Metropolis*, in which a machine-human shaped like a beautiful women turns men into slavering beasts.)

For Peter Singer (not the Australian philosopher but the American writer on military affairs), the killer app for robots is, well, the killer app. Increasingly, he says, wars will be fought by robots, and these machines are creating new dimensions and dynamics for human wars and politics that we are only now just beginning to fathom. The technologist Rodney Brooks, by contrast, says there is nothing, really, to worry about. Sentient robots with high capabilities will be no problem; we just have to get used to the idea that it's one less way in which we are special.

A third way in which the Yeti crab is a creature of the threshold relates to the first one mentioned in this chapter: its presence at the interface between two different worlds. For although black smokers are a feature of the modern ocean, where the chemistry is quite different from what it was billions of years ago, and no single smoker is particularly old (like Japanese wooden temples, they are constantly being renewed), they may stand as a token for something much older: the kind of place where life may have emerged from non-life.

The creation myths that people invent are dazzling in their variety. Many of them are complex and violent, but some are relatively simple and gentle. In a story told by the Ainu people of Japan, the creator sends down a wagtail which flutters over the ocean, splashing little areas of waters aside with its wings, stamping on the mud below with its feet and beating the mud with its tail until it becomes firm. In this way the islands where the Ainu live were made. Chinese tradition, by contrast, holds that mountains, rivers, trees and grass are parts of the body of the first being, Pangu, after he falls exhausted from the task of separating Heaven and Earth. According to the Mandé people of Mali, the creator tries to make life from the seed of a particularly tough and thorny acacia but fails, and has to start again using four

THE BOOK OF BARELY IMAGINED BEINGS

pairs of grass seeds with contrasting properties in each pair: a West African yin and yang. And in a version of a story told by peoples of the Pacific Northwest of America, the trickster Raven mates with a giant clam shell. Nine months later Raven hears voices coming from inside and opens the shell to find little men. Later, he finds female companions for the men inside a chiton and is greatly pleased at how the two interact.

Scientific hypotheses regarding the origin of life are not as numerous and diverse as creation stories but they are, arguably, more intriguing because they are based on observations of processes in the actual world and are, in theory, testable (even if such tests are beyond present abilities). One of the first – Aristotle's idea that life (or at any rate the 'primitive' forms such as worms and maggots) generated spontaneously from mud and ordure – was put into doubt as early as 1688 when the Italian physician Francesco Redi showed that no maggots appeared in dead meat when flies were prevented from landing on it, and all but dismissed for good when, in 1861, Louis Pasteur showed that bacteria and fungi never grow in a sterile, nutrient rich medium sealed from the outside world. But Charles Darwin's idea, outlined in 1871, that life might have begun at a 'warm little pond with all sorts of ammonia and phosphoric salts, light, heat, electricity, etc. present' proved to be more productive. This was an intellectual ancestor of the 'primordial soup' hypothesized in the 1920s by Alexander Oparin and J.B.S. Haldane – a world in which relatively simple organic molecules known as monomers (that is, amino acids, which are the building blocks of proteins), lipids, sugars and bases (the building blocks of RNA and DNA) were spontaneously generated by the reaction of even more simple chemicals on the early Earth in the presence of lightning. An experiment undertaken in 1952 by Stanley Miller and Harold Urey, in which they produced many amino acids by 'zapping' a mix of chemicals believed to be present in the early atmosphere with electricity, appeared to support this idea. And yet, as was recognized, the mere creation of monomers from which life is made was

not in itself enough. You can keep on zapping the soup but beyond a certain point all you get is a sticky mess. Chicken soup does not give rise to a chicken, however long you cook it.

The apparent intractability of this problem led some scientists to suggest that life on Earth may have been 'seeded' by microbial forms arriving on meteorites from outer space. 'Panspermia' is not, as it may sound, the name of a distant planet in the 1974 soft-porn shlockfest *Flesh Gordon* but a perfectly serious scientific idea. The trouble with panspermia, however, is that rather than explaining how life originated it just pushes the riddle elsewhere. All we can say with reasonable certainty is that many of the building blocks of life were already present in space, and that a large proportion of some elements and compounds essential to life probably arrived on the young Earth from space. Carbon, for example, the backbone of every organic chemical, is actually quite rare on Earth – it is the fifteenth most common element, and 0.046 per cent of Earth's crust – and may largely originate from a rain of extraterrestrial particles. Much of our water, without which life as we know it is impossible, might first have arrived in meteorites and other matter that smashed into the Earth up to and including what is known as the late heavy bombardment 3.9 billion years ago. Some meteorites have been found to carry dozens of amino acids including at least six proteins employed by life. They also contain sugars and fats that are common in living cells.

Study of outer space, then, turns up ingredients for a soup but still (or as yet) no chicken. But there is another way of approaching the riddle of life and its origins that casts more light. That is to consider what life *does* rather than what it *is*. For, much as life depends on ingredients, it is also a process. And fundamental to that, as Erwin Schrödinger saw in the 1940s, is life's capacity to concentrate a 'stream or order' upon itself – to harness an external flow of energy and so resist the universal tendency for things to tend towards randomness and chaos. This insight leads to the idea that life is likely to originate where

THE BOOK OF BARELY IMAGINED BEINGS

there is, among other things, a steady flow of energy – a gradient – that can be captured by a complex but non-yet-living system, rather as a waterwheel captures energy from a stream.

The largest and most obvious flow of energy on Earth comes, of course, from the Sun – a fact that makes our star a god and the father (or mother) of life in many cultures. But the discovery in the 1970s of black smokers hidden in darkness far from the Sun and yet covered in strange and primitive life forms led scientists to ask whether it was in these conditions – a steady flow of heat, reliable chemical gradients – that life could have first arisen. The idea looked promising. Growing up (more or less) in the last decades of the twentieth century I recall it being widely discussed. After the initial excitement, however, experimental work cast doubt on this explanation. The nucleic acids thought likely to have been involved in the formation and replication of early cells would have been destroyed in the harsh conditions at black smokers.

Then, in 2000, a quite different type of deep-sea hydrothermal vent was discovered with no black smoke. Releasing large amounts of methane and hydrogen which react with seawater and rock, the vents create towering white pinnacles. The first site to be studied, rising from the sea floor in the mid Atlantic, was named, rather predictably, the Lost City, although its formations resemble the crazed landscapes of Dr Seuss or the tsingy (eroded limestone needles in Madagascar) more than the church spires to which they are often compared. Although they are not rich in life these structures create what some scientists believe to be ideal conditions for proto-life. They are full of tiny chambers that concentrate life-friendly compounds bubbling up from the vent inside ideal reaction vessels. In addition, differences between the chemicals that seep out of the vents and those in surrounding waters create an electrical potential that could have provided energy to drive the chemical reactions taking place inside. Some scientists have expressed a high degree of confidence that such were the right conditions for the emergence of life. 'The last common ancestor of all life was not a free-living

As Oliver Morton put it in 2007, 'Life doesn't just form out of things; it forms out of processes.' Scientists trying to create chemical systems capable of autonomous evolution in laboratories today suggest that such systems must have three basic characteristics. First, there must be a 'library' of related molecules whose structures represent encoded information that can be transferred between generations. Second, these molecules must support a metabolism, a set of chemical reactions that produces useful energy. Third, the molecules must be able to form enclosed spaces where this metabolism can proceed undisturbed.

cell at all, but a porous rock riddled with bubbly iron-sulphur membranes that catalysed primordial biochemical reactions,' suggests the microbiologist Nick Lane. Powered by hydrogen and proton gradients, he argues, this natural flow reactor filled up with organic chemicals, giving rise to proto-life that eventually broke out as the first living cells – not once but twice, giving rise to the bacteria and the archaea.

Not everyone accepts this 'alkaline vent' hypothesis. Quite a few researchers continue to make the case for other explanations, arguing that life may have originated far closer to the interface between the planet's surface and incoming solar energy; shallow freshwater lagoons on tropical volcanic islands, for example, could provide conditions in which proto-living systems assembled inside the first 'carapaces' – primitive cell walls made from lipid membranes. Perhaps Darwin's vision of a warm pond as the location of life's origin will turn out to be close to the truth after all.

In my lifetime, creatures of the deep-sea vents such as the Yeti crab have gone from being completely unknown to being seen as denizens of the kind of place where life itself may have originated. From there they have become just another part of our expanding knowledge of the world of beings. In 2011 a third species of Yeti crab was discovered on the hydrothermal 'Dragon Vent' in the southwest Indian Ocean. The as yet unclassified species has shorter claws than its Eastern Pacific cousins, and bristles all over the underside of its body, but it is very likely related. What was an astonishing, one-off discovery in 2005 may prove to be just a pinpoint in a global distribution of animals of which we previously knew nothing.

In an old book, Yahweh asks Job: 'Hast thou entered into the springs of the sea? Or hast thou walked in the recesses of the deep? Have the gates of death been revealed unto thee?' Had Job been given a chance to answer, he would of course only have been able to say no. Some twenty-five centuries after his story was written we are approaching something like yes. We can travel to the bottom of the sea and are close to making testable hypotheses about the origins

of life, if not already there. And we know that –
baring intervention by an intelligent agent – life on
Earth will become insupportable in about 1.1 billion
years from now as a hotter Sun causes the oceans to
evaporate. Long before then, however, life may trans-
form in ways far beyond our current imagining. We
may look as primitive to the beings that come after us
as deep-sea crabs, scuttling in darkness, look to us
today.

ZEBRAFISH

Danio rerio

Phylum: Chordata
Class: Actinopterygii
Family: Cyprinidae
Conservation status: Least Concern

... rejoice with Boca, which is a fish that can speak.
Christopher Smart

V oltaire admired the English but he barbed his praise: 'Do not, while in their company,' he wrote, 'express surprise that they can have such pretty children.' And had Voltaire been a biologist in the twenty-first century he might have said something similar of zebrafish, a minnow from the Ganges. The adult is a pleasant enough little thing with bluish and white longitudinal stripes, but no stunner. It is easy to breed in captivity and it has been a standard inhabitant of aquaria for more than a century but, really, the zebrafish is a rather ordinary freshwater fish. Its babies, however, have a special kind of beauty.

The beauty lies in the process of change as the embryo develops. Watching speeded-up film of zebrafish embryonic development on a computer screen gives you the general idea, but to really appreciate the process I recommend you watch for yourself in real time, as I have been fortunate enough to do. A microscope creates a hyper-stereoscopic view: vertiginous height and extreme proximity at the same time, and you are *actually there*. The egg – which starts as a tiny, translucent bubble, a see-through moon – is subsumed as, curling around it, an infant fish takes shape. What starts as a dark streak on the edge of the egg pulses and morphs as backbone, heart and eyes form and becomes a recognizable, wriggling and entirely transparent embryo. The transformation takes about two days.

In an age when researchers often study subtle mechanisms within individual cells or work on computerized genomic sequencing and theoretical models, there is something appealing about watching the development of a zebrafish embryo with your own eyes. Watching individual cells developing, grouping and branching to form major organs and other structures, it feels as if one is in on the ground floor in biology and that one can, as the saying goes, observe a lot just by watching.

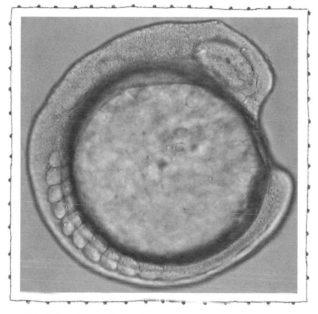

Zebrafish embryo, 14 hours old.

The sight that impressed a rookie like me is a routine one for thousands of researchers using zebrafish to investigate anything from abnormal brain development to regeneration of the heart. These scientists may be tinkering with the development of the embryos – making alterations to the genomes of some batches, say, so that a fluorescent protein makes parts of them glow like alien beings – but as far as I can tell most of them are still awed by the processes that they see repeated so often, and virtually all are

excited by what they may be able to learn from this and a few other animals, from axolotl to fruit fly, about the potential for small but concrete steps in the relief of human suffering and the prolongation of life. How strange – how marvellous – to find such beauty in the superficially ugly environment of the lab with its institutional lighting and smelly chemicals. When scientific progress goes (in Calvin and Hobbes's eternal phrase) 'boink', it stands on the blastula of zebrafish as well as the shoulders of giants.

'Work as if you live in the early days of a better nation,' advises the writer Alasdair Gray. I applaud the sentiment and, when considering what good science and careful thought, compassionately applied, are capable of, could almost become an optimist. But where may our increasing ability to manipulate life lead? Martin Brasier, a sober palaeontologist, goes so far to say that willy-nilly, we may be living in the early days of a transformation greater than anything since the Cambrian explosion, when multicellular life blossomed into a huge variety of new and amazing forms. The physicist Freeman Dyson has suggested that science is bringing us to the end of the 'Darwinian interlude', an entr'acte of a few hundred million years in which species had distinct identities. And this thought, assuming one accepts it or something like it to be true, is at least vertiginous, if not scary. Even those who see flaws in the larger claims (pointing to evidence that biology has always been a more open source than Dyson's rhetoric suggests) tend to agree that advances underway are likely to create radically new situations and choices.

Some developments that have been in the news, remarkable as they are, may deliver less than is claimed. So, for example, when in 2010 a team headed by Hamilton Smith and Craig Venter said they had created life from scratch, the claim was not entirely as it had seemed. What they actually did was make a copy of the genome of an already existing microbe, with excisions, and put it inside the cell walls of another one. Other developments have received less attention to date but may prove equally or more significant. So, for example, some researchers may be close to 'reprograming the code of life' to make living systems that

THE BOOK OF BARELY IMAGINED BEINGS

use amino acids unknown in life since the Archaean (or Life 1.0, as some call it). The idea, explains the researcher Jason Chin, is to go beyond the twenty amino acids used by all life so far, to develop 'the first real parallel and independent genetic code within the cells' – a new translation system for the biosynthesis of polymers unknown in living cells to date.

Innovations such as these, whether oversold or undersold, could be just the first baby steps in what may prove to be the age of synthetic biology – the development of entirely new organisms from 'an idea rather than an ancestor' (as an editorial in *Nature* put it). What is to come is likely to be decisively influenced by humans or their successors: intelligent, if not necessarily wise, designers.

To date, some harbingers of change seem trivial and amusing. In 2003, for example, a US company capitalized on research in Singapore and started to sell GloFish® – zebrafish engineered to fluoresce in Starfire Red®, Electric Green® and Sunburst Orange® – as pets. But other developments have (I think) a sinister edge even while they arrive with a large helping of farce. In the summer of 2008 a South Korean company cloned pup pies to commercial order for the first time in the world. Coming just three years after a leading Korean scientist had been exposed for faking evidence of the cloning of human embryos and stem cells, the announcement was met with suspicion. But the puppies were real enough – the word made flesh and the offspring (if that's the right word) of Booger, a pit bull. Booger's owner, an American named Joyce McKinney whose sensational earlier life is explored in Errol Morris's film *Tabloid*, named her new treasures Booger McKinney, Booger Lee, Booger Ra, Booger Hong and Booger Park after herself and the scientists who had ministered to their virgin birth.

But the methods used in South Korea in 2008 are already old news. Researchers are beginning to be able to produce animals with entirely new capabilities. There is, reportedly, a supermouse capable of feats of extreme athletic endurance – the mouse equivalent of a human sprinting up a high mountain without stopping once for breath. For reasons that

are not well understood, the supermouse also lives longer and has more sex than normal mice, and is very aggressive.

Some of the future designers of life and those who pay them may be wise and compassionate individuals. Many will be in the employ of the state, the military, corporations, criminals or some combination thereof. It's easy to picture a mix of outcomes, some of them very nasty indeed, as Margaret Atwood does in recent fictions, or as David Eagleman has God doing when he discovers that Mary Shelley has understood His trajectory exactly. Early attempts to weaponize biological systems such as those made in the clandestine Soviet programme of the 1970s and 1980s may be as nothing compared to projects already secretly underway or soon to begin.

And, of course, innovations in biology will only be one part of future scientific and technological development. Ray Kurzweil, an engineer and inventor of unquestionable brilliance, believes that by the 2040s artificial intelligence and nanotechnology will have advanced so far that, should he have managed to stay alive that long, it will be possible to transfer the contents of his brain into a new substrate: a supercomputer, a bespoke real or virtual body, or a swarm of nanobots. 'The non-biological proportion of our beings [such as computer-based intelligence] will be powerful enough to completely model and simulate the biological part,' he says; 'it will be a continuum, a continuity of pattern.'

Kurzweil sounds here like Maxim Gorky, writing nearly a hundred years ago of his hopes for Soviet science. 'Everything', wrote Gorky, 'will [be] transmuted into pure thought, which alone will exist, incarnating the entire mind of humanity.' Even if the technology underlying Kurzweil's vision proves to be viable, however, there is still an illusion or at least paradox at the centre of his dreams of eternal life. For, as the philosopher John Gray points out: 'in the immortalist scenario, humans engineer their own extinction.'

The singularity that Kurzweil and others envisage – a moment when various technologies fuse together, become independently hyper-intelligent and start to move so fast that 'humans 1.0' are left for dust – may

THE BOOK OF BARELY IMAGINED BEINGS

be an illusion. Very probably, Kurzweil is mistaken about some key technological possibilities in the next few decades. But there is surely, as the science writer Oliver Morton puts it, a big 'change' coming. Over the coming years deliverables from synthetic biology and other rapidly advancing technologies are likely to be revolutionary. Some of the innovations will be 'tools that enable humanity.' Researchers may engineer algae that can easily be turned into fuel and bacteria that clean up toxic wastes. They may drastically extend the human life span, develop animals and plants better able to adapt to climate change and recreate valued extinct species. As a bit of fun on the side, it may even be possible to reverse-engineer dinosaurs from the DNA of chickens.

At all events, wisely guided innovation is desperately needed, where the wisdom has a lot to do with recognizing limits. The development of a zebrafish, stupendously complex as it is, follows well-determined biological, chemical and physical laws that limit its growth and activity. Humans, as biological organisms, also live within well-defined limits. But our technology, economy and culture have taken us far beyond this into a different realm of being. Our rates and manner of consumption are pushing us way beyond the boundaries of what the planet can sustain.

The philosopher Nick Bostrom has identified four scenarios for the future of humanity: extinction, recurrent collapse, plateau and post-humanity. His outline of the implications of each is worth considering so long as we also ask what kind of future would we *like*? If, as the zoologist E. O. Wilson warns, the Anthropocene (the era in which humans have had a significant impact on the Earth's ecosystems and geology) is becoming the Eremozoic (an 'age of loneliness'when, as a result of human action, life on Earth is greatly impoverished), *how* may we start to imagine a more favourable direction? Can we, for example, imagine an Ecozoic, which the theologian and ecologist Thomas Berry defined as a period when humans will be present upon the Earth in a mutually enhancing manner? How about a Nöocene – an age in which humans become wiser with the help of technology but not subservient to it –

'The unstated but crucial foundation of Kurzweil's scenario requires that at some point in the 2020's, a miracle will occur ... Kurzweil [conflates] biological data collection with biological insight ... [and] ... betrays a basic misunderstanding of brain architecture.' (David J. Linden, 2011)

Much more efficient use of energy use is not so much a technical challenge – Cullen *et al* (2011), for example, outline a 73 per cent gain is possible with current technologies – as a political, economic and organizational one. Rather, as Umair Haque (2011) argues, there is a massive malfunctioning of the global economy, and at the root of the problem is 'dumb growth'. which, 'rather than reflecting enduring wealth creation, largely reflects the transfer of wealth: from the poor to the rich, the young to the old, tomorrow to today, and human beings to corporate persons.' See also Tim Jackson (2009).

James Cascio (2009)
suggests that by 2030
humans will have
developed 'a better
capacity to manage
both partial attention
and laser-like focus,
and be able to slip
between the two
with ease'. Similarly,
Garry Kasparov
(2011), argues that
machines are not
'taking over' but
merely becoming
better human tools.

achieving, rather, 'continuously augmented awareness'? Well maybe, but perhaps the sceptic is right who says that our trouble is not the overall absence of smartness but the intractable power of stupidity, and no machine, or mind, can be extended enough to cure that.

How should we imagine our future selves, and the humans and other persons who come after us? David Hume argued that while there are excellent grounds for pessimism about human folly and viciousness, a generous view of human nature is ultimately wiser. He warned, too, of the dangers of hasty and unconsidered comparisons of humans either to other animals or imaginary higher beings. Both these points still stand, but it is also true that, with some 250 years of further study of animal and human nature since Hume died, we can make a richer assessment of what we share with other animals and how we differ.

Consider an animal that is a 'sport of nature' – a freak that is in at least one essential respect like us: the Galapagos penguin. This improbable bird lives on the coasts of a hot desert archipelago slap bang on the Equator. A quirk of fate – the cool waters of Humboldt Current – bore its ancestors here from the cold South in pursuit of fish, and here the penguin thrived, at least until humans arrived in large numbers and brought the species to the verge of extinction. Watch these penguins in the water, as it is still possible to do, and it is abundantly clear that they rejoice in nothing so much as racing and diving through the shallow rocky waters. They swim for fun as well as to become better fishers. To recognize this is not to commit the folly of anthropomorphism, but to recognize reality.

Here, then, is what we share: play is fundamental to the well-being of both improbable penguin and human, and for both we can use the same equation: $play = joy + learning$. (In the case of humans, play is the first step to practical wisdom, which as Aristotle saw, is the ground of virtue.) Zebrafish embryos are, of course, too young to play, and are vastly less intelligent than penguins, never mind humans. But we can watch and study them in a spirit that is playful in the most profound sense: a joyful attention to and exploration of the things we share (at a genetic

and developmental level, they are like us in so many ways) and the ways in which we differ.

Many scientists researching the mysteries of the cell are eager to share their excitement. Paul Nurse, who won a Nobel Prize for his work in genetics and cell biology, enthuses about the capabilities and processes of a single cell: 'Within a single cell only micrometres across many thousands of chemical reactions are going on simultaneously. This is absolutely extraordinary and wonderful!' Günter Blobel, another Nobelist, says: 'The number of things we *don't* know [about the cell] is staggering.' The more we learn, the more it seems appropriate to say of a cell what Carl Sagan said of the cosmos – that it has 'a magnificence, and an intricate, elegant order far beyond anything our ancestors imagined'.

The processes that Nurse describes are hard to appreciate if you don't already know something about cell biology. This is beginning to change: new techniques such as the visualizations made possible by molecular animation are helping to make some of these wonders more readily apparent to non-specialists. For all that, animations are just 'maps': we cannot, at the time of writing, see the *real* thing because the inside workings of a cell are so small. By contrast, watching the intricate dance of many cells forming a zebrafish embryo is something we *can* experience directly.

See, for example, molecularmovies.com

'A good case can be made for our non-existence,' wrote Lewis Thomas in his 1974 essay, *The Lives of a Cell*; 'we are shared, rented, occupied.' Our selves do not have independent existence, but are part of contingent networks and wider patterns. But in so far as we do exist, the zebrafish – far below us as it may be on the cognitive ladder – is our poor earth-bound companion, and a companionable form. Watching the perfect, blind orchestration of its embryonic development, the inevitability and surety with which it unfolds, offers an opportunity to dwell on the wonder of what apparently is, as well as to be mindful of what may be. Like the zebrafish, we are somewhere in the middle: between the tiny cell (and its constituents) and the whole world, and between the beginning of life and whatever comes next.

Lewis Thomas suggested a similar role for humans in the Earth's ecology:

This might turn out to be a special phase in the morphogenesis of the earth when it is necessary to have something like us, for a time anyway, to fetch and carry energy, look for new symbiotic arrangements, store up information for some future season, do a certain amount of ornamenting, maybe even carry seeds for the solar system. That kind of thing. Handyman for the earth.

I would much prefer this useful role, if I had any say, to the essentially unearthly creatures we seem otherwise on the way to becoming. It would mean making some quite fundamental changes in our attitudes towards each other, if we were really to think of ourselves as indispensable elements of nature.

Similarly, Carl Woese recommends that as our ability to understand nature increases, our first priority should be not to engineer nature but to listen to its harmonies. We must, as Voltaire has Candide conclude, cultivate our garden. In close attention to the nature of being and of the beings around us, and the continuous revelation that follows, we may find a form of prayer for the less deceived.

A CONCLUSION,
IN WHICH NOTHING
IS CONCLUDED

This book is an attempt to better understand and imagine being and beings. If I have made any progress at all it will be thanks to what has been revealed by the vision and thought of others – especially what has been revealed by scientific method, which Richard Feynman defined as the best way we have learned about how to keep from fooling ourselves. But however powerful those insights and that method are, human understanding of the world that we are creating remains poor. In some respects, even the best maps and projections of our future are likely to prove little more accurate than a medieval *mappa mundi*.

The last chapter cited a well-known line from *Candide*: 'we must cultivate our garden'. But what sort of garden are we cultivating in the Anthropocene and what sort of creatures will flourish in it? How will things turn out? When will we know? A true gardener wants to be able to see into the future – a good 'eleven hundred years,' joked Karel Čapek, 'to test, learn to know, and appreciate fully what is his'.

A few things look reasonably sure. Humanity will continue to have an enormous impact on the Earth

Detail from the Mappa Mundi at Hereford cathedral, circa 1300.

system. The greenhouse gases we have added to the atmosphere will probably prevent any ice ages that would otherwise have happened for the next 48,000 years, and the way things are going it is likely we will prevent all of those that would have occurred in the next half million years. In the nearer term, over the next century or two, we are in for a bumpy ride unless we develop much better systems for managing resources and pollution and for anticipating and dealing with risk and conflict. Still, human creativity and innovation seem to be almost boundless.

When it comes to predicting how things will go with any precision, however, all these factors, and others, are like Rorschach's ink blots: we can read almost (but not quite) whatever we want into them. If the complexity of the Earth–human system means that much will remain necessarily unknowable, then we need, as two critics of transhumanism put it, to 'rehabilitate humility.' Only then can we listen to voices that are hard to hear as well as those we want to hear. As in the story of Oedipus, the tragedy occurs when we refuse to listen.

'When faced with a difficult question, we often answer an easier one instead.' (Daniel Kahneman, 2011)

THE BOOK OF BARELY IMAGINED BEINGS

More than four years have passed since I began writing this bestiary. The process has been a little like trying to design, build and tow a juggernaut – one of those temple cars intended to convey a Hindu god: a huge wooden tower on wheels bedecked with multiple roofs, decorations, images, flags, sticks of incense and what-not. Sometimes, the whole thing has threatened to topple over and crash to the ground. At others, I have put a good deal of time and effort into moving a tiny distance only to find I have been going in the wrong direction.

The more I have worked, the more I have come to realize that this project can never be finished. Too many new wonders are coming to light all the time. ('Living things embody intricate structures that render them far more mysterious than atoms or stars,' observes the astrophysicist Martin Rees.) Still, one thing seems clearer to me than ever: we are only fully human when we act as if the life beyond us matters.

By the time this book is actually published more than five years will have passed since the picnic that I described in the introduction. I have seen my daughter grow from a helpless baby to a bright, energetic and delightful little girl. A sign at the Occupy Wall Street demonstrations in 2011 read, 'The beginning is nigh.' I like that. My daughter's world, and yours, is only just beginning.

APPENDIX I: BIOLOGICAL CLASSIFICATION

Most of the beings in the titles to the chapters in this book are introduced with at least two names: the common name given to the species in English, and their scientific name in Latin. In addition, they are labelled by family, order and/or class, and phylum. All these labels are part of a system of classification which indicates how closely or distantly species are related to others. But what do all these labels mean and how do they fit together? What is a genus, what is a class and what is a phylum?

Modern biological classification began with Carl Linnaeus (1707–1778), who grouped species according to shared physical characteristics. These groupings have since been revised in the light of the Darwinian principle of common descent and, in recent decades, molecular phylogenetics, which uses DNA sequences as data. Revisions to the system continue.

Start with the biggest category of all. All the beings in this book are animals, or members of kingdom Animalia. A kingdom is a subdivision of everything that is classified as alive. Other kingdoms include plants, fungi, chromista and protista.

(Actually, kingdoms are themselves subdivisions of an even larger set of categories, called domains. All the kingdoms previously mentioned, for example, are members of the domain Eukaryota, which means all life forms whose cells have a true nucleus in which DNA is stored separately. Other domains are bacteria and archaea.)

Animals, a word which derives from the Latin for breath, are 'heterotrophic', which means they cannot fix carbon essential to life for themselves but have to depend on others that can, notably plants, which are 'autotrophic'. (An animal that eats only other animals is still dependent on plants; it just relies on the animal it eats having eaten plants, or having eaten others animals that have done so.)

Within kingdom Animalia, creatures are categorized by phylum, of which there are about thirty-six. (Incidentally, species from virtually all phyla (the plural of phylum) live in the sea, while only about sixteen live

in tropical rainforests, the most biodiverse terrestrial environments.) An animal is allocated to a particular phylum if it shares key features, notably a fundamental body plan, with other species in that phylum. So for example all chordates have a central nerve chord (notochord) along the back (dorsal side) of their body. (Most chordates are also vertebrates, which means they have a spine made of bone or, in the case of sharks and rays, cartilage.)

Within a phylum, animals are typically categorized in a subphylum according to features that they share only with other animals in that subphylum. Within the phylum chordates, subphyla include tunicata, or tunicates: sack-like filter feeders, and vertebrata, or vertebrates. Different subphyla may contain very different numbers of species. There are, for example about 3,000 tunicates but about 56,000 vertebrates.

Within a subphylum, animals are grouped according to class, of which the definition is not precise but on which taxonomists agree in most cases. In the case of the vertebrates, classes include: agnatha – jawless vertebrates such as hagfish; osteichthyes – bony fish; reptilia – air-breathing, ectothermic ('cold-blooded') animals that lay eggs with shells; aves, or birds – feathered, winged, bipedal, endothermic ('warm-blooded') egg-layers; and mammalia, which are hairy and give milk to their young. (Classes may also be grouped into a superclass. So, for example, amphibia, reptilia, aves and mammalia are all in the superclass tetrapoda, from the Greek for 'four-limbed'.)

Within a class, animals are grouped according to (yes) subclass. Among mammals there are two: prototheria – the egg-laying monotremes, platypus and echidna; and theria – everything else. In some phyla, subclasses are further divided by infraclass. In the case of mammals there are two: marsupial and placental mammals.

Within a given class, animals are grouped by order, which is distinguished from others by anatomical features shared only with members of that order. In the case of mammals, the order of primates are characterized by larger brains than other mammals and an increased reliance on stereoscopic vision at the expense of smell, while members of the rodent order are characterised by two continuously growing incisors in the upper and lower jaws which are only kept short by gnawing. An order may also be divided by suborder or infraorder. In the case of primates, suborders include the Strepsirrhini, 'wet-nosed' non-tarsier prosimians such as lemurs and lorises, and the Haplorhini, 'dry-nosed' tarsiers, monkeys and apes.

Within an order, animals are also grouped by family. Again, there is no precise rule as to what constitutes a family, but in the case of primates super-families and families include: the Cercopithecidae, or Old World monkeys, five families of New World monkeys and the Hominidae, or Great Apes.

Within a family, animals are grouped by subfamily and genus (plural: genera). In the case of Hominidae, there are three genera in the subfamily Homininae – Gorilla, Pan (Chimpanzees) and Homo, while Orang-utans are in a different subfamily, Ponginae. Animals within a given genus are classified as different species but they are so closely related that, in many cases, they are able to interbreed. Genus *Homo*, which first evolved around 2 million years ago, has included about a dozen species so far. Our own species, *Homo Sapiens*, mated with other species of *Homo* as it expanded out of its African homeland within the last 60,000 years. If you are European, Asian or New Guinean you have about 2.5 per cent Neanderthal DNA. If you are Melanesian, about 5 per cent of your DNA is from the Denisovans, humans that lived in Russia at the same time as Neanderthals lived in Europe.

So here, in outline, is the hierarchy of classification, using the example of humans:

Domain	Eukaryotes
Kingdom	Animals
Phylum	Chordates
Class	Mammals
Order	Primates
Family	Great apes
Genus	Homo
Species	Modern humans

The conservation status of a species is an internationally accepted measure of the risk that it is threatened with extinction and/or the likelihood it will be at greater risk in the near future if deliberate measures to conserve it are not undertaken. The full list of categories is as follows:

Extinct
 Extinct
 Extinct in the Wild

Threatened
 Critically Endangered
 Endangered
 Vulnerable

At Lower Risk
 Conservation Dependent
 Near Threatened
 Least Concern

Most of the animals in this book are not listed as being at risk of extinction. In many cases this is because it is currently thought that the risk is negligible. In a few cases, such as that of the Atlantic right whale, it is judged that there has recently been a reduction in the risk that they will become extinct. All these labels are, however, hostages to fortune. The Anthropocene is an epoch of rapid and unpredictable transformation.

APPENDIX II:
DEEP TIME

The Earth is about 4.54 billion years old. The geological timescale is a way of measuring time over this history based on stratigraphy – the study of how rocks are laid down over time. If eons are like months, then eras are like days, periods are like hours and epochs are like minutes (or in the case of the most recent, fractions of a second).

The time elapsed since an interval began is stated in the table below. Figures are rounded, in the case of some of the earlier periods to the nearest million years. In some instances, uncertainty remains as to when an period began and ended. For the Ordovician, estimates vary by 1.5 million years or more.

Different periods on the scale are defined by major geological or paleontological events such as mass extinctions, or a combination of both. An extinction event is a sharp decrease in the diversity and abundance of macroscopic life such as animals and plants. (Microbial life may be little affected.) The best known is the Cretaceous–Tertiary extinction about 65.6 million years ago, which wiped out the dinosaurs, pterosaurs and many marine animals, but there have been five in the Phanerozoic eon, including the Permian–Triassic extinction about 252.3 million years ago, which killed more than 95 per cent of marine animals and 70 per cent of vertebrates on land. Many biologists believe humans are now driving other species to extinction at hundreds of times the normal, or 'background', rate typical in the long periods between previous mass extinctions. The result may be a new event comparable in scale and severity – a 'sixth extinction'.

Eon	Era	Period	Epoch	began (million years ago)
Phanerozoic	Cenozoic		Anthropocene	0.0002
('visible life')	('recent life')		Holocene	0.01
	(Age of mammals)	Quaternary	Pleistocene	2.6
			Pliocene	5.3
			Miocene	23
			Oligocene	34
			Eocene	56
		Tertiary	Palaeocene	65.5
	Mesozoic	Cretaceous		144
	'middle life'			
	Age of reptiles	Jurassic		208
		Triassic		251
	Paleozoic	Permian		299
	'ancient life'			
		Carboniferous		359
		Devonian		416
		Silurian		444
		Ordovician		488
		Cambrian		542
Proterozoic				2500
('early life)'				
Archaean				3900
Hadean				4540

The table opposite gives little sense of the relative lengths of different eons, eras and periods. The graphic below does that better, as well as showing some key events in the history of life.

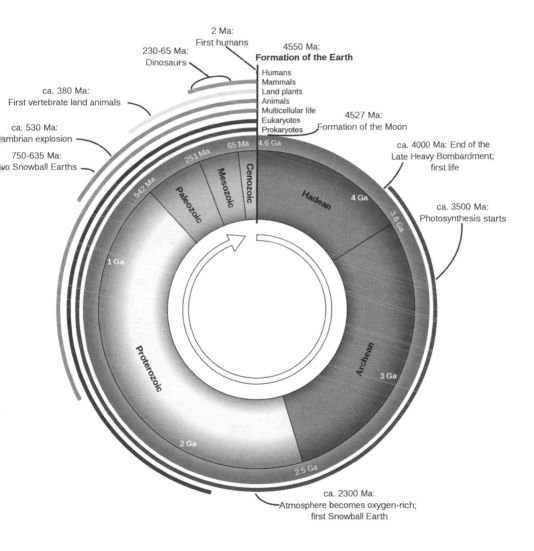

2 Ma:
First humans

230-65 Ma:
Dinosaurs

4550 Ma:
Formation of the Earth

Humans
Mammals
Land plants
Animals
Multicellular life
Eukaryotes
Prokaryotes

ca. 380 Ma:
First vertebrate land animals

ca. 530 Ma:
ambrian explosion

750-635 Ma:
vo Snowball Earths

4527 Ma:
Formation of the Moon

ca. 4000 Ma: End of the
Late Heavy Bombardment;
first life

ca. 3500 Ma:
Photosynthesis starts

542 Ma 251 Ma 65 Ma 4.6 Ga

Paleozoic Mesozoic Cenozoic Hadean 4 Ga 3.8 Ga

1 Ga

Proterozoic Archean 3 Ga

2 Ga

2.5 Ga

ca. 2300 Ma:
Atmosphere becomes oxygen-rich;
first Snowball Earth

BIBLIOGRAPHY

Here are some of the books, journal articles, news reports and other materials referred to in, or that inform the preceding chapters. For more go to www.barelyimaginedbeings.com

INTRODUCTION

Archer, David, 2008, *The Long Thaw: How Humans Are Changing the Next 100,000 Years of Earth's Climate*, Princeton University Press.

Barber, Richard, 1993, *Bestiary: Being an English Version of the Bodleian Library, Oxford M.S. Bodley 764*, Boydell Press.

Bierce, Ambrose, 1911, *The Devil's Dictionary*, Neale Publishing Co.

Borges, Jorge Luis, 1942, 'An Essay on the Analytical Language of John Wilkins', (originally published in Spanish) in *Selected Non-Fictions,* Penguin Books (1999).

Borges, Jorge Luis, 1967, *The Book of Imaginary Beings*, Vintage Classics.

Bryson, Bill, 2003, *A Short History of Nearly Everything*, Black Swan Books.

Calvino, Italo, 1980, *The Literature Machine*, Vintage Classics.

Crutzen, Paul J., 2000, 'The Anthropocene', *IGBP Newsletter 41*, May 2000.

Geuss, Raymond, 2008, *Philosophy and Real Politics*, Princeton University Press.

Harrison, Robert Pogue, 1993, *Forests: The Shadow of Civilization*, Chicago University Press.

Henderson, Caspar, 2003, 'Cape Farewell: An Arctic Diary', http://www.opendemocracy.net, accessed 1 January 2012.

Hofstadter, Douglas, 2007, *I Am a Strange Loop*, Basic Books.

McEwan, Ian, 2005, 'Save the boot room, save the Earth!', *The Guardian*, 19 March 2005.

McEwan, Ian, 2010, *Solar*, Jonathan Cape.

Montaigne, Michel de, 1567, 'An Apology for Raymond Sebond's Natural Theology, or The Book of Creatures', (first published in French) in *The Complete Essays*, Penguin (2003).

Rees, Martin, 2003, *Our Final Century: Will Civilisation Survive the 21st Century?*, William Heinemann.

Roberts, Callum, 2012, *Ocean of Life: The Fate of Man and the Sea*, Allen Lane.

Tattersall, Ian, 1998, *Becoming Human: Evolution and Human Uniqueness*, Houghton Mifflin Harcourt.

Thurman, Judith, 2008, 'First Impressions: What Does the World's Oldest Art Say about Us?' *The New Yorker*, 23 June 2008.

Voytek, Bradley, 2011, 'We are all inattentive superheroes', *Oscillatory Thoughts*, 5 September 2011, http://blog.ketyov.com, accessed 31 December 2011.

Anderson, Jason S. *et al.*, 2008, 'A stem batrachian from the early Permian of Texas and the origin of frogs and salamanders', *Nature*, 453, 515–18.

Aristotle, c 350 BC, *The History of Animals*, translated by D'Arcy Wentworth Thompson, http://classics.mit.edu/Aristotle/history_anim.html, accessed 30 November 2011.

Browne, Thomas, 1646, 1672, *Pseudodoxia Epidemica, or Enquiries into very many received tenets and commonly presumed truth*, online edition at http://penelope.uchicago.edu/pseudo-doxia/pseudodoxia.shtml, accessed 1 January 2012.

Browne, Thomas, 1658, *The Garden of Cyrus*, online edition at http://penelope.uchicago.edu/hgc.html, accessed 1 January 2012.

Bryant, S.V. *et al.*, 2002, 'Vertebrate limb regeneration and the origin of limb stem cells,' *Int. J. Dev. Biol.*, 46: 887–96.

Cabeza de Vaca, Álvar Núñez, 1542, *La Relación*, translated and edited by Cyclone Covey, (1986) as *Adventures in the Unknown Interior of America*, University of New Mexico Press.

Cellini, Benvenuto, c 1558, *The Autobiography*, Penguin (2010).

Clack, Jennifer, 2002, *Gaining Ground: The Origin and Early Evolution of Tetrapods*, Indiana University Press.

Cortázar, Julio, 1952, *Axolotl*, Buenos Aires Literaria.

Daeschler, Edward B. *et al.*, 2006, 'Devonian tetrapod-like fish and the evolution of the tetrapod body plan,' *Nature*, 440, 757–63.

Dawkins, Richard, 2004, *The Ancestor's Tale: A Pilgrimage to the Dawn of Life*, Houghton Mifflin.

Diamond, Jared, 1997, *Guns Germs and Steel: The Fate of Human Societies*, W.W. Norton.

Díaz del Castillo, Bernal, c 1568, *The Truthful History of the Conquest of New Spain*, translated by J.M. Cohen, Penguin, 1963.

Eiseley, Loren, 1957, *The Immense Journey*, Random House.

Franklin, Benjamin *et al.*, 1784, 'Rapport des commissaires chargés par le Roi de l'examen du magnetisme animal', Imprimé par ordre du Roi; Sur la Copie imprimeé au Louvre; Paris.

Gould, Stephen Jay, 2003, 'Freud's Evolutionary Fantasy' in *I Have Landed: Splashes and Reflections in Natural History*, Vintage.

IUCN/SSC Amphibian Specialist Group, http://www.amphibians.org, accessed 30 November 2011.

Jones, Frederic Wood, 1919, *Man's Place Among the Mammals*, Edward Arnold.

Kumar, A. *et al.*, 2007, 'Molecular Basis for Nerve Dependence on Limb Regeneration in an Adult Vertebrate', *Science*, 318, 5851: 772.

Lewin, Roger, 2004, *Human Evolution: An Illustrated Introduction*, 5th edn, Wiley-Blackwell.

Mullen, L.M. *et al.*, 1996, 'Nerve dependency of regeneration: the role of Distal-less and FGF signaling in amphibian limb regeneration', *Development*, November 1996, 12211: 3487–97.

Muneoka, Ken *et al.*, 2008, 'Regrowing Limbs: Can People Regenerate Body Parts?', *Scientific American*, 17 March 2008.

Naish, Darren, 2008, 'Aquatic proto-people and the hypothesis of initial bipedalism', *Tetrapod Zoology*, 17 March 2008, http://scienceblogs.com/tetrapodzoology, accessed 1 January 2012.

Patterson, N. *et al.*, 2006, 'Genetic evidence for complex speciation of humans and chimpanzees', *Nature*, 441, 1103–8.

Pliny the Elder, AD 77–79, *The Natural History*, translated into English by Philemon Holland, 1601, http://penelope.uchicago.edu/holland/index.html, accessed 30 November 2011.

Sebald, W. G., 1995, *The Rings of Saturn*, Harvill Press.

Shepard, Charles, 1982, 'Nature and Madness', in T. Roszak *et al.* (eds), *Ecopsychology*, 1995, Sierra Club Books.

Shubin, Neil H., 2008, *Your Inner Fish*, Pantheon.

Smart, Christopher, 'Jubilate Agno', 1759–63, *Selected Poems*, Carcanet 1972.

Steingass, Francis Joseph, 1992, *A Comprehensive Persian–English Dictionary: Script and Roman*, Asian Educational Services.

Stuart, Simon N. *et al.*, 2004, 'Status and Trends of Amphibian Declines and Extinctions Worldwide', *Science*, 306 (5702), 1783–6.

Zimmer, Carl, 1999, *At the Water's Edge: Fish with Fingers, Whales with Legs*, Simon & Schuster.

BARREL SPONGE

Attenborough, David and Matt Kaplan, 2010, *First Life*, Collins.

Brasier, Martin, 2009, *Darwin's Lost World*, Oxford University Press.

Bergquist, P.R., 2001, 'Porifera Sponges', *Encyclopedia of Life Sciences*, John Wiley.

Brümmer, F. *et al.*, 2008, 'Light inside sponges', *Journal of Experimental Marine Biology and Ecology*, 367(2): 61–4.

Fortey, Richard, 1997, *Life: The Unauthorised Biography*, Flamingo.

Hickman, C.P. Jr. *et al.*, *Integrated Principles of Zoology*, 11th edn, McGraw-Hill.

Hooke, Robert, 1665, *Micrographia*, National Library of Medicine, http://archive.nlm.nih.gov/proj/ttp/books.htm, accessed 12 January 2012.

Hutton, James, 1795, *Theory of the Earth*, Creech.

Ingraham, John L., 2010, *March of the Microbes*, Harvard University Press.

Knoll, Andrew H., 2003, *Life on a Young Planet: The First Three Billion Years of Evolution on Earth*, Princeton University Press.

Love, Gordon D. *et al.*, 2009, 'Fossil steroids record the appearance of Demospongiae during the Cryogenian period', *Nature*, 457, 718–21.

Margulis, Lynn and Dorion Sagan, 1987, *Microcosmos: Four Billion Years of Evolution from Our Microbial Ancestors*, HarperCollins.

McPhee, John, 1981, *Basin and Range*, Farrar, Straus and Giroux.

Mukherjee, Siddhartha, 2010, *The Emperor of All Malodies*, Fourth Eatate.

Scamardella, Joseph M., 1999, 'Not plants or animals: a brief history of Protista–Proctista–Protozoa', *Int. Microbiol*, December 1999, 2(4): 207–16.

Zelnio, Kevin, 2011, 'Evolution's Temperament, Movement 1: Adagio', *Scientific American*, 15 August 2011, http://blogs.scientificamerican.com/evo-eco-lab/, accessed 2 December 2011.

CROWN OF THORNS STARFISH

Alroy, J., 2010, 'The Shifting Balance of Diversity Among Major Marine Animal Groups', *Science*, 329, 5996, 1191–4.

Atran, Scott, 1990, *Cognitive Foundations of Natural History: Towards an Anthropology of Science*, Cambridge University Press.

Betts, Richard A. *et al.*, 2011, 'When could global warming reach 4°C?', *Philosophical Transactions of the Royal Society A*, 369, 1934, 67–84.

Bowden, David A. *et al.*, 2011, 'A lost world? Archaic crinoid-dominated assemblages on an Antarctic seamount,' *Deep Sea Research*, Part II: *Oceanography*, vol. 58, issues 1–2.

Burroughs, William, 1959, *Naked Lunch*, Olympia Press/Grove Press.

Census of Antarctic Marine Life, 2010, 'Diversity and Change in the Southern Ocean Ecosystems'.

Cote, Isabelle M. and John D. Reynolds (eds), 2006, *Coral Reef Conservation*, Cambridge University Press.

Davidson, Osha Gray, 1998, *The Enchanted Braid*, Wiley.

Darwin, Charles, 1842, *On the Structure and Distribution of Coral Reefs*.

Drew, J. A., 2005, 'Use of Traditional Ecological Knowledge in Marine Conservation', *Conservation Biology*, 19: 1286–93.

Donner, S.D., 2009, 'Coping with Commitment: Projected Thermal Stress on Coral Reefs under Different Future Scenarios', *PLoS ONE*, 46: e5712.

Diaz-Pulido, G. *et al.*, 2009, 'Doom and Boom on a Resilient Reef: Climate Change, Algal Overgrowth and Coral Recovery', *PLoS ONE*, 44: e5239.

Eiseley, Loren, 1978, *The Star Thrower*, Wildwood House.

Gawande, Atul, 2010, 'Letting Go: What should medicine do when it can't save your life?', *The New Yorker*, 2 August 2010.

Gooding, Rebecca *et al.*, 2009, 'Elevated water temperature and carbon dioxide concentration increase the growth of a keystone echinoderm', *Proceedings of the National Academies of Sciences*, 106, 23: 9316–21.

Goreau, Thomas, 2010, 'Coral Reef and Fisheries Habitat Restoration in the Coral Triangle', Proceedings of the the Coral Reef Management Symposium on the Coral Triangle Area, accessed 1 December 2011.

Gould, Stephen Jay, 1983, 'Worm for a Century and All Seasons', first published in *Hen's Teeth and Horse's Toes: Further Reflections on Natural History*, Random House.

Hoegh-Guldberg, O. *et al.*, 2007, 'Coral Reefs Under Rapid Climate Change and Ocean Acidification', *Science,* 318, 5857, 1737–42.

Isaacson, Andy, 2011, 'A New Species Bonanza in the Philippines', http://www.smithsonianmag.com, 9 August, 2011, accessed 1 December 2011.

Jones, Steve, 2007, *Coral*, Little, Brown.

Marshall, Charles R., 2010, 'Marine Biodiversity Dynamics over Deep Time', *Science,* 329, 5996, 1156–7.

Pandolfi, J.M. *et al.*, 2003, 'Global Trajectories of the Long-Term Decline of Coral Reef Ecosystems', *Science,* 301, 5635, 955–8.

Rumphius, Georgius Everhardus, 1705, *The Ambonese Curiosity Cabinet*, Yale University Press (1999).

Sapp, Jann, 1999, *What is Natural? Coral Reefs in Crisis*, Oxford University Press.

Veron, J.E.N., 2008, *A Reef in Time: The Great Barrier Reef from Beginning to End*, Belknap Harvard.

Vogler, Catherine *et al.*, 2008, 'A threat to coral reefs multiplied? Four species of crown-of-thorns starfish,' *Biol., Lett.* 23 December 2008, vol. 4, no. 6, 696–9.

Wallace, Alfred Russel, 1869, *The Malay Archipelago: The Land of the Orang-utan and the Bird of Paradise*, Macmillan & Co.

Worsley, Peter, 1997, *Knowledges: What Different People Make of the World*, Profile.

DOLPHIN

Bell, Julian, 2010, *Mirror of the World: A New History of Art*, Thames and Hudson.

Darwin, Charles, 1870, *Descent of Man: Selection in Relation to Sex*, Penguin Classics (2004).

Dudzinski, Kathleen M. and Toni Frohoff, 2010, *Dolphin Mysteries*, Yale University Press.

Everett, Daniel, 2007, *Don't Sleep, There Are Snakes*, Profile

Favareau, Donald, 2006, *Introduction to Biosemiotics*, Springer, Berlin. Marcello Barbieri (ed.)

Hume, David, 1739–40, *A Treatise of Human Nature*, http://www.earlymoderntexts.com/f_hume.html, accessed 12 January 2012.

Hurford, James R., 2007, *The Origins of Meaning: Language in the Light of Evolution*, Oxford University Press

Joelving, Frederik, 2009, 'Whistles with Dolphins', *Scientific American*, 26 January 2009.

Lilly, John, C., http://www.johnclilly.com, accessed 1 December 2011.

Linden, Eugene, 2002, *The Octopus and the Orangutan*, Dutton.

MacIntyre, Alasdair, 2001, *Dependent Rational Animals*, Open Court Publishing Co.

Marino, Lori *et al.*, 2007, 'Cetaceans Have Complex Brains for Complex Cognition', *PLoS Biol.*, 55: e139.

Psihoyos, Louie (director), 2009, *The Cove*, Lionsgate Roadside Attractions, http://save-japandolphins.com, accessed 1 December 2011.

Rachels, James, 1990, *Created From Animals: The Moral Implications of Darwinism*, Oxford University Press

Reiss, Diana and Lori Marino, 2001, 'Mirror self-recognition in the bottlenose dolphin: A case of cognitive convergence', *PNAS*, vol. 98, no. 10, 5937–42.

Rendell, Luke and Hal Whitehead, 2001, 'Culture in whales and dolphins', *Behavioural and Brain Sciences*, 24: 309–24.

Pryor, K. *et al.*, 1990, 'A dolphin-human fishing cooperative in Brazil', *Marine Mammal Science*, 6: 77–82.

Turvey, Sam, 2008, *Witness to Extinction: How We Failed to Save the Yangtze River Dolphin*, Oxford University Press.

White, Thomas I., 2007, *In Defense of Dolphins: The New Moral Frontier*, Blackwell Publishing.

EEL

Asma, Stephen T., 2009, *On Monsters: An Unnatural History of our Worst Fears*, Oxford University Press.

Carel, Havi, 2007, 'A phenomenology of tragedy: illness and body betrayal in The Fly,' *SCAN Journal of Media Arts Culture*, Media Department, Macquarie University.

Coleridge, Samuel Taylor, 1798, 'The Rime of the Ancient Mariner', in *Selected Poetry*, Oxford World's Classics (2009).

Freud, Sigmund, 1919, 'The Uncanny', first published in *Imago*, reprinted in *Sammlung, Fünfte Folge*, translation at: http://web.mit.edu/allanmc/www/freud1.pdf, accessed 12 January 2012.

Jefferies, Richard, 1883, *The Story of My Heart*, Project Gutenberg online text.

Jefferies, Richard, 1885, *After London*, Project Gutenberg online text.

Jensch, Ernst, 1906, 'On the Psychology of the Uncanny' ('Zur Psychologie des Unheimlichen'), *Psychiatrisch-Neurologische Wochenschrift* 8.22 and 8.23, translation at: http://art3idea.psu.edu/locus/Jentsch_uncanny.pdf, accessed 12 January 2012.

Kearns, Ian, 2011, 'Beyond the UK: Trends in Other Nuclear Armed States', British American Security Information Council, 30 October 2011.

Lawrence, D. H., 1923, *Studies in Classic American Literature*, Penguin Classics 1990.

Melville, Herman, 1851, *Moby-Dick*, Oxford World's Classics (1988).

Miller, Michael J., 2009, 'Ecology of Anguilliform Leptocephali: Remarkable Transparent Fish Larvae of the Ocean Surface Layer', *Aqua-BioSci. Monogr*, vol. 2, no. 4, 1–94.

Norton-Tayor, Richard, 2011, 'Nuclear powers plan weapons spending spree, report finds', *The Guardian*, 30 October 2011.

Prager, Ellen, 2011, *Sex, Drugs and Sea Slime*, Chicago University Press.

Quammen, David, 2003, *Monster of God: The Man-Eating Predator in the Jungles of History and the Mind*, W.W. Norton.

Rhodes, Richard, 2007, *Arsenals of Folly: The Making of the Nuclear Arms Race*, Knopf.

Schell, Jonathan, 1982, *The Fate of the Earth*, Knopf.

Schweid, Richard, 2009, *Eel*, Reaktion.

Snyder, Timothy, 2009, 'Holocaust: The Ignored Reality', *New York Review of Books*, 16 July 2009.

Tributsch, H., 1984, *How Life Learned to Live*, MIT Press.

Woese, Carl, 2004, 'A New Biology for a New Century', *Microbiology and Molecular Biology Reviews*, June 2004, vol. 68, no. 2, 173–86.

FLATWORM

Atran, Scott, 2002, *In Gods We Trust*, Oxford University Press.

Bakewell, Sarah, 2010, *How To Live, or A Life of Montaigne*, Chatto & Windus.

Becker, Ernest, 1973, *The Denial of Death*, Simon & Schuster.

Bloom, Paul, 2009, *Pleasure*, W.W. Norton.

Čapek, Karel, 1929, *The Gardener's Year*, Modern Library (2002).

Carel, Havi, 2007, 'My 10-year death sentence', *The Independent*, 19 March 2007.

Carson, Rachel, 1951, *The Sea Around Us*, Oxford University Press, 2003

Chen, Jun-Yuan *et al.*, 2004, 'Response to Comment on Small Bilaterian Fossils from 40 to 55 Million Years Before the Cambrian', *Science*, 306, 5700, 1291.

Critchley, Simon, 2008, *The Book of Dead Philosophers*, Granta.

Darwin, Charles, 1881, *The Formation of Vegetable Mould through the Action of Worms, with Observations on their Habits*, complete works online at http://darwin-online.org.uk.

Fortey, Richard, 2011, *Survivors: The Animals and Plants that Time has Left Behind*, Harper Press.

Fox, Douglas and Michael Le Page, 2009, 'Dawn of the animals: Solving Darwin's dilemma', *New Scientist*, 14 July 2009.

Hamilton, W.D., 1996, 'Between Shoreham and Downe: Seeking the Key to Natural Beauty', and 'My Intended Burial and Why', reprinted in *Narrow Roads of Gene Land*, vol. 3: *Last Words*, Oxford University Press

Harrison, Robert Pogue, 2008, *Gardens: An Essay on the Human Condition*, University of Chicago Press.

Harris, Eileen, 2007, 'The discreet charm of nematode worms', *New Scientist*, 25 December 2007.

Irvine, William B., 2009, *A Guide to the Good Life: The Ancient Art of Stoic Joy*, Oxford University Press.

Jones, Steve, 2000, *Darwin's Ghost: The Origin of Species Updated*, Random House.

Lane, Nick, 2009, *Life Ascending*, Profile.

Maxman, Amy, 2011, 'Evolution: A can of worms', *Nature* 470, 161–2.

Perin, Rodrigo *et al.*, 2011, 'A synaptic organizing principle for cortical neuronal groups', *PNAS*, vol. 108, 5419–24.

Raffles, Hugh, 2010, *Insectopedia*, Vintage.

Russell, Bertrand, 1903, 'The Free Man's Worship', vol. 12, *The Collected Papers of Bertrand Russell*, Routledge.

Sapolsky, Robert, 2009, 'Toxo – A Conversation with Robert Sapolsky', http://edge.org, accessed 1 January 2012.

Schneider, Eric D. and Dorion Sagan, 2005, *Into the Cool: Energy Flow, Thermodynamics and Life*, University of Chicago Press.

Schrödinger, Erwin, 1944, *What is Life?*, Cambridge University Press.

Vedral, Vlatko, 2010, *Decoding Reality: The World as Quantum Information*, Oxford University Press.

Volk, Tyler, 2002, *What is Death?*, John Wiley.

Wagner, Daniel E. *et al.*, 2011, 'Clonogenic Neoblasts Are Pluripotent Adult Stem Cells That Underlie Planarian Regeneration', *Science*, 332, 6031, 811–16.

Zimmer, Carl, 2000, *Parasite Rex*, Simon & Schuster.

Zimmer, Carl, 2008, 'The Most Popular Lifestyle on Earth', *Conservation Magazine*, October–December 2008, vol. 9, no.4.

GONODACTYLUS

Albert, D. J., 2011, 'What's on the mind of a jellyfish?', *Neuroscience and Behavioural Reviews*, January 2011, 353:474–82.

Bickman, Joanna, 2008, 'The Whites of their Eyes: Evolution of the Distinctive Sclera in Humans', *Lambda Alpha Journal*, vol. 38.

Cronin, Thomas W. and Megan L. Porter, 2008, 'Exceptional Variation on a Common Theme: The Evolution of Crustacean Compound Eyes', *Evolution: Education and Outreach*, vol. 1, no. 4, 463–75.

Darwin, Charles, 1859, *The Origin of Species*, complete works online at http://darwin-online.org.uk.

Dillard, Annie, 1975, *Pilgrim at Tinker Creek*, Harper's Magazine Press.

Frith, Chris D., 2007, *Making Up the Mind: How the Brain Creates Our Mental World*, Blackwell

Gaidos, Susan, 2009, 'From green leaves to bird brains, biological systems may exploit quantum phenomena', *Science News*, May 9th, 2009

Gislén, Anna *et al.*, 2003, 'Superior Underwater Vision in a Human Population of Sea Gypsies', *Current Biology*, Vol 13, 833–836,

Hartline, H. Keffer, 1967, Nobel Prize Lecture, http://www.nobelprize.org.

Ings, Simon, 2007, *The Eye: A Natural History*, Bloomsbury.

Kozmik, Z. *et al.*, 2003, 'Role of Pax genes in eye evolution: a cnidarian PaxB gene uniting Pax2 and Pax6 functions.', *Developmental Cell*, November 2003, 55:773–85.

Land, Michael F. and Dan-Eric Nilsson, 2002, *Animal Eyes*, Oxford University Press.

Leslie, Mitch, 2009, On the 'Origin of Photosynthesis', *Science*, 323, 5919, 1286–7 DOI.

Lévi-Strauss, Claude, 1978, *Myth and Meaning*, Routledge (2009).

Melcher, David and Carol L. Colby, 2008, 'Trans-saccadic perception', *Trends in Cognitive Sciences*, vol. 12, issue 12, December 2008.

Myers, P. Z., 2006, 'The eye as a contingent, diverse, complex product of evolutionary processes', http://scienceblogs.com/pharyngula, 15 November 2006.

Nabokov, Vladimir, 1957, *Pnin*, Penguin Classics (2000).

Nilsson, Dan-E. and Susanne Pelger, 1994, 'A Pessimistic Estimate of the Time Required for an Eye to Evolve', *Proc. R. Soc. Lond. B*, vol. 256, no. 1345, 53–8.

Patek, S.N. *et al.*, 2004, 'Mantis shrimp strike at high speeds with a saddle-shaped spring', *Nature*, 428, 819–20.

Patek, S. N., and R. L. Caldwell, 2005, 'Extreme impact and cavitation forces of a biological hammer: strike forces of the peacock mantis shrimp, Odontodactylus scyllarus', *Journal of Experimental Biology*, 208(19), 3655–64.

Roberts, N.W. *et al.*, 2009, 'A biological quarter-wave retarder with excellent achromaticity in the visible wavelength region', *Nature Photonics*, 3, 641–4.

Sacks, Oliver, 1995, *An Anthropologist on Mars: Seven Paradoxical Tales*, Knopf.

Sacks, Oliver, 2008, 'Patterns', *The New York Times*, 13 February, 2008.

Schopenhauer, Arthur, 1851, 'On the Suffering of the World,' *Parerga and Paralipomena*, Clarendon Press (2000).

Schwab, I. R., 2004, 'You are what you eat', *British Journal of Ophthalmology*, 889: 1113.

Tomasello, Michael *et al.*, 2007, 'Reliance on head versus eyes in the gaze following of great apes and human infants: the cooperative eye hypothesis', *Journal of Human Evolution*, 523: 314–20.

von Feuerbach, Anselm, 1832, *Kaspar Hauser, ein Beispiel eines Verbrechens am Seelenleben*.

Zack, T. I. *et al.*, 2009, 'Elastic energy storage in the mantis shrimp's fast predatory strike', *Journal of Experimental Biology*, 212: 4002–9.

Zimmer, Carl, 2008, 'The Evolution of Extraordinary Eyes: The Cases of Flatfishes and Stalk-eyed Flies', *Evolution Education and Outreach*, 1: 487.

Yong, Ed, 2009, 'Mantis shrimp eyes outclass DVD players, inspire new technology', *Not Exactly Rocket Science*, http://blogs.discovermagazine.com/notrocketscience/.

HUMAN

Ball, Philip, 2010a, *The Music Instinct*, Oxford University Press.

Ball, Philip, 2010b, 'The Hunt for Harmonious Minds', *New Scientist*, 10 May 2010.

Blumenfeld, Larry (producer), 1995, *Echoes of the Forest: Music of the Central African Pygmies*, Ellipsis arts. A compilation of recordings by Colin Turnbull and Louis Sarno.

Brody, Hugh, 2000, *Maps and Dreams*, Faber.

Browne, Thomas, 1658, *Hydriotaphia*, online at: http://penelope.uchicago.edu/hgc.html.

Chen, Ingfei, 2006, 'Born to Run', *Discover.com*, 28 May, 2006.

Christian, Brian, 2010, *The Most Human Human*, Viking Penguin.

Critchley, Simon, 2009, 'Why Heidegger Matters', *The Guardian*, 8 June 2009.

Cross, I. and I. Morley, 2008, 'The evolution of music: theories, definitions and the nature of the evidence', in Stephen Malloch and Colwyn Trevarthen (eds), *Communicative Musicality*, pp. 61–82, Oxford University Press.

Diamond, Jared, 1991, *The Rise and the Fall of the Third Chimpanzee*, Hutchinson Radius.

The Economist, 2008, 'Why Music?', 18 December 2008.

Ehrenreich, Barbara, 2007, *Dancing in the Streets: A History of Collective Joy*, Granta.

Filkins, Dexter, 2008, *The Forever War*, Knopf.

Heinrich, Bernd, 2002, *Why We Run: A Natural History*, HarperPerennial.

Humphrey, Nicholas *et al.*, 2005, 'Human Hand-Walkers: Five Siblings Who Never Stood Up', CPNSS Discussion Paper Series 77/05, London School of Economics.

Humphrey, Nicholas, 2007, 'Society of Selves', *Phil. Trans. R. Soc. B*, 362, 745–54.

Humphrey, Nicholas, 2011, *Soul Dust: the Magic of Consciousness*, Quercus. Also, reviews by Galen Strawson in *The Observer*, 9 January 2011 and Mary Midgely in *The Guardian*, 5 February 2011.

Kingdon, Jonathan, 1993, *Self-Made Man: Human Evolution From Eden to Extinction*, Simon & Schuster.

Kingdon, Jonathan, 2003, *Lowly Origin: Where, When, and Why our Ancestors First Stood Up*, Princeton University Press.

Lewis, Jerome, 2012, 'A Cross-Cultural Perspective on the Significance of Music and Dance on Culture and Society, with Insight from BaYaka Pygmies', in Michael Arbib (ed.), *Language, Music and the Brain: A Mysterious Relationship*, MIT Press.

Liebenberg, L.W., 1990, *The Art of Tracking: The Origin of Science*, David Philip, Publishers.

Liebenberg, L.W., 2006, 'Persistence hunting by modern hunter-gatherers', *Current Anthropology*, 47, 1017–25.

McDermott, Josh, 2008, 'The Evolution of Music', *Nature*, 453, 287–8.

Mithen, Steven, 2005, *The Singing Neanderthals*, Phoenix.

Morley, Iain, 2003, 'The Evolutionary Origins and Archaeology of Music', Darwin College Research Report, Cambridge, www.dar.cam.ac.uk/dcrr/dcrr002.pdf, accessed 2 December 2011.

Patel, Aniruddh, 2008, *Music, Language and the Brain*, Oxford University Press.

Pinker, Stephen, 1997, *How the Mind Works*, new edn, Penguin (2003).

Provine, Robert R., 2000, 'The Laughing Species', *Natural History*, December 2000.

Richmond, Brian G. and William L. Jungers, 2008, 'Orrorin tugenensis Femoral Morphology and the Evolution of Hominin Bipedalism', *Science*, 319, 5870, 1662–5.

Sacks, Oliver, 2007, *Musicophilia*, Knopf.

Sahlins, Marshall, 1968, 'Notes on the Original Affluent Society', in R.B. Lee and I. DeVore (eds), *Man the Hunter*, Aldine Publishing Company.

Sebald, W.G., 2001, *Austerlitz*, Random House.

Thomas, Keith, 1983, *Man and the Natural World: Changing Attitudes in England 1500–1800*, Penguin.

Wrangham, Richard, 2009, *Catching Fire: How Cooking Made Us Human*, Profile.

Young, Emily, 2007, *Time in the Stone*, Tacit Hill Editions.

IRIDOGORGIA

Ball, Philip 2009, *Nature's Patterns: A Tapestry in Three Parts*, Oxford University Press.

Bloch, William Goldbloom, 2008, *The Unimaginable Mathematics of Borges' Library of Babel*, Oxford University Press.

Cairns, Stephen D. *et al*, 2008, 'From offshore to onshore: multiple origins of shallow-water corals from deep-sea ancestors', *PLoS ONE*, 3(6): 1–6.

Cairns, Stephen D. *et al.*, 2009, *Cold-Water Corals: The Biology and Geology of Deep-Sea Coral Habitats*, Cambridge University Press.

Carey, Nessa, 2011, *The Epigenetics Revolution: How Modern Biology is Rewriting Our Understanding of Genetics, Disease and Inheritance*, Icon Books

Census of Marine Life, 2010, http://www.coml.org.

Crick, Francis, 1994, *The Astonishing Hypothesis: The Scientific Search for the Soul*, Scribner.

Dawkins, Richard, 1976, *The Selfish Gene*, Oxford University Press.

Gould, Stephen Jay, 1992, Introduction to *On Growth and Form* by D'Arcy Wentworth Thompson. Cambridge.

Garrett, Laurie, 2011, 'The Bioterrorist Next Door', *Foreign Policy*, 15 December 2011.

Gibson, Daniel G. *et al.*, 'Creation of a Bacterial Cell Controlled by a Chemically Synthesized Genome', Science, 329, 5987, 52–6.

Haeckel, Ernst, 1904, *Art Forms of Nature*, Dover Publications (2004).

Hume, David, 1757, 'Of the Standard of Taste', http://www.davidhume.org.

Humphrey, Nicholas, 2010, 'The Nature of Beauty', *Prospect*, September 2010.

Joyce, James, 1914–15, *Portrait of the Artist as a Young Man*, Oxford World's Classics (2010).

Kaku, Michio, 2005, 'Unifying the universe', *New Scientist*, 15 April 2005.

Kelly, Kevin, 2009, 'Ordained Becoming', The Technium, http://www.kk.org/thetechnium.

Kemp, Martin, 2006, 'Natural intuitions of science and art', *New Scientist*, 9 September 2006.

Kling, Stanley A. and Demetrio Boltovskoy, 2002, 'What are Radiolarians?', http://radiolaria.org.

Koslow, Tony, 2007, *The Silent Deep: The Discovery, Ecology and Conservation of the Deep Sea*, University of Chicago Press.

Krystal, Arthur, 2010, 'What We Talk About When We Talk About Beauty', *Harper's Magazine*, September 2010.

Lane, Nick, 2009, *Life Ascending*, Profile.

Noble, Denis, 2006, *The Music of Life: Biology Beyond the Genome*, Oxford University Press.

Nobrega, M.A. *et al.*, 2004, 'Megabase deletions of gene deserts result in viable mice', *Nature*, 431, 7011, 988–93.

Nouvian, Claire, 2007, *The Deep: The Extraordinary Creatures of the Abyss*, University of Chicago Press.

Pennisi, Elizabeth, 2011, 'Going Viral: Exploring the Role of Viruses in Our Bodies', *Science,* 331, 6024, 1513.

Rees, Martin, 1999, *Just Six Numbers*, Phoenix.

Ryan, Frank P., 2009, *Virolution*, Collins.

Scarry, Elaine, 1999, *On Beauty and Being Just*, Princeton University Press.

Showalter, Mark R., 2005, 'Saturn's Strangest Ring Becomes Curiouser and Curiouser', *Science*, 310, 5752, 1287–8.

Szostak, Jack, 2010, 'Recreate life to understand how life began', *New Scientist*, 9 August 2010.

Thompson, D'Arcy Wentworth, 1917, *On Growth and Form*, Cambridge University Press.

Wald, George, 1970, 'The Origin of Death', http://www.elijahwald.com/origin.html, accessed 2 December 2011.

Zimmer, Carl, 2011, *A Planet of Viruses*, University of Chicago Press.

Zimmer, Carl, 2011, 'The Human Lake', http://blogs.discovermagazine.com/loom, 31 March, 2011, accessed 12 January 2012.

JAPANESE MACAQUE

Ardrey, Robert, 1969, preface to Eugene Marais, *The Soul of the Ape* (1919), Penguin (1973).

Balcombe, Jonathan, 2010, *Second Nature*, Palgrave Macmillan.

Baumard, Nicolas, 2011, 'Adam Smith on mirror neurons and empathy', 23 June 2011, http://www.cognitionandculture.net, accessed 2 December 2012.

Berger, John 1990, 'Ape Theatre', first published in *Keeping a Rendezvous* (1992), republished in *Why Look at Animals?*, Penguin 2009.

Bulgakov, Mikhail, 1938, *The Master and Margarita*, English translation, Harvill Press (1967).

Cheney, Dorothy L. and Robert M. Seyfarth, 2007, *Baboon Metaphysics: The Evolution of a Social Mind*, University of Chicago Press.

Corbey, Raymond, 2005, *The Metaphysics of Apes: Negotiating the Animal-Human Boundary*, Cambridge University Press.

Curtis, Adam, 2007, 'The Trap: What Happened to Our Dream of Freedom', BBC2 television, 11 March 2007.

de Waal, Frans, 1982, *Chimpanzee Politics*, Harper & Row.

de Waal, Frans, 2005, *Our Inner Ape: The Best and Worst of Human Nature*, Granta.

de Waal, Frans *et al.*, 2006, *Primates and Philosophers: How Morality Evolved,* Princeton University Press.

de Waal, Frans, 2009, *The Age of Empathy: Nature's Lessons for a Kinder Society*, Souvenir Press.

Dunbar, Robin, 2010, *How Many Friends Does One Person Need? Dunbar's Number And Other Evolutionary Quirks*, Faber and Faber.

Freud, Sigmund, 1913, 'Totem and Taboo', a translation of 'Totem und Tabu: Einige Übereinstimmungen im Seelenleben der Wilden und der Neurotiker', *Imago* (1912–13), http://en.wikisource.org/wiki/Totem_and_Taboo.

Freud, Sigmund, 1930, *Civilisation and its Discontents*, a translation of *Das Unbehagen in der Kultur*, http://www.archive.org/details/CivilizationAndItsDiscontents.

Glover, Jonathan, 1999, *Humanity: A Moral History of the Twentieth Century*, Yale University Press.

Harlow, H. F. *et al.*, 'Total Social Isolation in Monkeys', *PNAS*, 54 (1): 90.

Harlow, Harry F. and Stephen J. Suomi, 1970, 'Induced Psychopathology in Monkeys', *Engineering and Science*, 33(6), 8–14.

Hinton, David, 2008, *Classical Chinese Poetry: An Anthology*, Farrar, Straus and Giroux.

Huxley, Thomas Henry, 1863, *Man's Place in Nature*, Williams & Norgate.

Kropotkin, Peter, 1902, *Mutual Aid: A Factor in Evolution*, Dover Edition (2006).

Lenton, Tim and Andrew Watson, 2011, *Revolutions That Made the Earth*, Oxford University Press.

Machiavelli, Niccolò, 1513, *The Prince*, Penguin (2003).

Machiavelli, Niccolò, c 1517, *Discourses on Livy*, Prentice Hall (2000).

Maestripieri, Dario, 2007, *Machiavellian Intelligence: How Rhesus Macaques and Humans Have Conquered the World*, University of Chicago Press.

McCarthy, Cormac, 1985, *Blood Meridian, or the Evening Redness in the West*, Random House.

Milgram, Stanley, 1974, *Obedience to Authority; An Experimental View,* Harper & Row.

Morris, Errol, 2003, *The Fog of War: Eleven Lessons from the Life of Robert S. McNamara* (film), Sony Picture Classics.

Nowak, Peter and Roger Highfield, 2011, *Supercooperators*, Canongate.

Orwell, George, 1948, *1984*, Penguin (2011).

Parfit, Derek, 1984, *Reasons and Persons*, Oxford University Press.

Parfit, Derek, 2011, *On What Matters*, Oxford University Press.

Pinker, Steven, 2002, *The Blank Slate: The Modern Denial of Human Nature*, Penguin.

Pinker, Steven, 2011, *The Better Angels of Our Nature: The Decline of Violence in History and Its Causes*, Viking.

Reed, Carol, Graham Greene and Orson Wells, 1949, *The Third Man*, British Lion Films.

Sahlins, Marshall, 2008, *The Western Illusion of Human Nature*, Prickly Paradigm Press.

Singer, Peter, 1975, *Animal Liberation*, Harper Perennial 2009.

Snyder, Timothy, 2012, 'War No More: Why the World Has Become More Peaceful', *Foreign Affairs*, January/February 2012, http://www.foreignaffairs.com/, accessed 28 December 2011.

Smith, Adam, 1759, *The Theory of Moral Sentiments*, http://www.econlib.org/library/Smith/smMS.html.

Sorenson, John, 2009, *Ape*, Reaktion.

Wynne, Clive D.L., 2005, 'Kissing Cousins', *The New York Times*, 12 December 2005.

KÌRÌPᴴÁ-KÒ AND TᴴÌK̇'ÌLÍ-KO: THE HONEY BADGER AND THE HONEYGUIDE

Abram, David, 2007, *The Spell of the Sensuous: Perception and Language in a More-than-Human World*, New York: Vintage.

Corbin, Jane, 2007, 'Basra: The Legacy', *Panorama*, BBC, 17 December 2007.

Favareau, D., 2010, 'Essential Readings in Biosemiotics, *Biosemiotics 3*, Springer Science+Business Media.

Finkel, David, 2009, 'The Hadza', *National Geographic*, December 2009.

Fitch, W. Tecumseh, 2010, *The Evolution of Language*, Cambridge University Press.

Flannery, Tim, 2002, *The Future Eaters: An Ecological History of the Australasian Lands and People*, Grove Press.

Gibson, Graeme, 2005, *The Bedside Book of Birds*, Bloomsbury.

Hrdy, Sarah Blaffer, 2009, *Mothers and Others: The Evolutionary Origins of Mutual Understanding*, Cambridge University.

Ikhwan al-Safa, c.1110, *The Animals' Lawsuit Against Humanity*, Fons Vitae.

Isack, H.A. *et al.*, 1989, 'Honeyguides and Honey Gatherers: Interspecific Communication in a Symbiotic Relationship', *Science*, 243 (4896): 1343–6.

Judson, Olivia, 2010, 'Divide and Diminish', *The New York Times*, 16 March 2010.

Kingdon, Jonathan, 1988, *East African Mammals: An Atlas of Evolution in Africa*, vol 3, part 1, University of Chicago Press.

Marlowe, Frank, 2002, 'Why the Hadza are Still Hunter-Gatherers', in Sue Kent (ed.) *Ethnicity, Hunter-Gatherers, and the 'Other': Association or Assimilation in Africa*, Smithsonian Institution Press, pp. 247–75.

Thoreau, Henry David, 2009, *The Journal 1837–1861*, New York Review Books.

Tomasello, Michael, 2008, *Origins of Human Communication*, MIT Press.

Woodburn, James, 1970, *The Material Culture of the Nomadic Hadza*, British Museum Press.

Workman, James, 2009, *Heart of Dryness: How the Last Bushmen Can Help Us Endure the Coming Age of Permanent Drought*, Walker & Co.

Yong, Ed, 2009, 'Revisiting FOXP2 and the origins of language', *Not Exactly Rocket Science*, 11 November 2009, http://blogs.discovermagazine.com/notrocketscience, accessed 12 January 2012.

LEATHERBACK

Adler, Robert, 2011, 'The Many Faces of the Multiverse', *New Scientist*, 26 November 2011.

Appenzeller, Tim, 2009, 'Ancient Mariner', *National Geographic*, May 2009.

Bjorndal, Karen A. and Alan B. Bolten, 2003, 'From Ghosts to Key Species: Restoring Sea Turtle Populations to Fulfill their Ecological Roles', *Marine Turtle Newsletter*, 100:16–21.

Boyce, Daniel G. *et al.*, 2010, 'Global phytoplankton decline over the past century', *Nature*, 466, 591–6.

Camus, Albert, 1942, *The Myth of Sisyphus*, Penguin (2005).

Draaisma, Douwe, 2004, *Why Life Speeds Up as You Get Older*, Cambridge University Press.

Dutton, Peter, 2006, 'Building Our Knowledge of Leatherback Stock Structure' in *The State of the World's Sea Turtles*, vol. 1, *http://seaturtles.org*, accessed 21 January 2012.

Frith, Chris, 2007, *Making up the Mind: How the Brain Creates our Mental World*, Blackwell.

Gefter, Amanda, 2009, 'Multiplying Universes: How Many is the Multiverse?', *New Scientist*, 29 October 2009.

Herzog, Werner, 1999, 'The Minnesota declaration: truth and fact in documentary cinema', http://www.wernerherzog.com/52.html, accessed 12 January 2012.

Papworth, S. K. *et al.*, 2008, 'Evidence for shifting baseline syndrome in conservation', *Conservation Letters*, 22: 93–100.

Pauly, Daniel, 1995, 'Anecdotes and the shifting baseline syndrome of fisheries', *Trends in Ecology and Evolution*, 1010: 430.

Roberts, Callum, 2007, *The Unnatural History of the Sea*, Island Press.

Safina, Carl, 2006, *Voyage of the Turtle: In Pursuit of the Earth's Last Dinosaur*, Henry Holt.

Spotila, James R. *et al.*, 2000, 'Pacific leatherback turtles face extinction', *Nature*, 405, 529–30. Walcott, Derek, 2010, *White Egrets*, Faber and Faber.

Wallace, David Rains, 2007, *Neptune's Ark: from Ichthyosaurs to Orcas*, University of California Press.

Young, Peter, 2003, *Tortoise*, Reaktion.

MYSTACEUS

BBC News online, 1999, 'Message from Allah found "in tomato"', 9 September 1999.

Borges, Jorge Luis, 1944, 'Funes, His Memory', in *Fictions*, Penguin (2000).

Casselman, Anne, 2011, 'Jumping Spiders in Love', Lastwordonnothing.com, 25 July 2011.

Cech, T.R., 2011, 'The RNA World in Context. Department of Chemistry and Biochemistry', *Cold Spring Harbor Perspectives in Biology*, February 16 2011.

Chown, Marcus, 2007, *The Never-Ending Days of Being Dead*, Faber and Faber.

Collingwood, R. G., 1924, *Speculum Mentis, or The Map of Knowledge*, Oxford University Press.

Foster, Jonathan K., 2008, *Memory: A Very Short Introduction*, Oxford University Press.

Hume, David, 1739, *A Treatise on Human Nature*, http://www.davidhume.org.

James, William, 1890, *The Principles of Psychology*, Dover Publications.

Judson, Olivia 2009, 'Memories in Nature', *The New York Times*, 29 December 2009.

Kafka, Franz, 1917–1923, 'A Little Fable', published in *Beim Bau der Chinesischen Mauer*, 1931.

Lem, Stanisław, 1961 (English translation 1971), *Solaris*, chapter 8: 'Monsters', Faber and Faber (2003).

Nietzsche, Friedrich, 1886, *Beyond Good and Evil: Prelude to a Philosophy of the Future*, Penguin (2003).

Wood, Harriet Harvey, A. S. Byatt *et al.*, *Memory: An Anthology*, Chatto & Windus.

NAUTILUS

Barthes, Roland, 1980 (1982), *Camera Lucida*, Jonathan Cape.

Benjamin, Walter, 1999, 'Little History of Photography,' in *Selected Writings*, edited by Michael W. Jennings, 2:507–30, Harvard Belknap.

Calvino, Italo, 1965, *Cosmicomics*, Penguin (2010).

Dutlinger, Carolin, 2008, 'Imaginary Encounters: Walter Benjamin and the Aura of Photography', *Poetics Today*, 29:1 (Spring 2008).

Eyden, Phil, 2003, 'Nautiloids: The First Cephalopods', *The Octopus News Magazine*, available online at http://www.tonmo.com, accessed 21 January 2012.

Eyden, Phil, 2003, 'Ammonites: A General Overview', *The Octopus News Magazine*

Eyden, Phil, 2004, 'Nipponites – The Ultimate Weird Ammonite?', *The Octopus News Magazine*.

Glacken, Clarence J., 1976, *Traces on the Rhodian Shore*, University of California Press.

Henderson, Caspar, 2009, 'Hypnogogia', *Archipelago 5*, Clutag Press, and at http://barri-erisland.blogspot.com.

Paterson, Don, 2010, *Rain*, Faber and Faber.

Rudwick, M. J. S., 1985, *The Meaning of Fossils: Episodes in the History of Paleontology*, University of Chicago Press.

Rudwick, M. J. S., 2005, *Bursting the Limits of Time: The Reconstruction of Geohistory in the Age of Revolution*, University of Chicago Press.

Sontag, Susan, 1977, *On Photography*, Farrar, Straus and Giroux.

Stevenson, Sara, 2002, *Facing the Light: The Photography of Hill and Adamson*, National Galleries of Scotland.

Stewart, Matthew, 2003, *Monturiol's Dream: The Extraordinary Story of the Submarine Inventor Who Wanted to Save the World*, Profile.

Ward, Peter, 1988, *In Search of Nautilus*, Simon & Schuster.

OCTOPUS

Aldrovandi, Ulisse 1606, *De reliquis animalibus exanguibus libri quatuor*, http://amshistorica. cib.unibo.it/18.

Caillois, Roger, 1973, *La Pieuvre – essai sur la logique de l'imaginaire*, La Table Ronde.

Chatham, Chris, 2007, 'Platform-Independent Intelligence: Octopus Consciousness', http://scienceblogs.com/developingintelligence, 5 April, 2007, accessed 12 January 2012.

Gesner, Conrad, 1551–8, *Historiae Animalium*.

Grasso, Frank and Wells, Martin, 2010, 'Tactile Sensing in the Octopus', http://www.scholarpedia.org.

Judd, Alan, 2000, 'Swallowing Ships', *New Scientist*, 29 November 2000.

Kaplan, Eugene H., 2006, *Sensuous Seas*, Princeton University Press.

Kuba, M. J. *et al.*, 2006, 'Why do Octopuses Play?', *Journal of Comparative Psychology*, vol. 120(3), 184–90.

Lanier, Jaron, 2010, *You Are Not a Gadget*, Knopf.

Mather, Jennifer A., 2008, 'Cephalopod consciousness: Behavioural evidence', *Consciousness and Cognition*, vol. 17, issue 1.

Montaigne, Michel de, 1567, 'Apology for Raymond Sebond', op. cit.

Myers, P.Z., 2006, *Octopus Brains*, Pharyngula, 30 June 2006, http://scienceblogs.com/pharyngula, accessed 21 January 2012.

Norman, Mark, 2000, *Cephalopods: A World Guide*, ConchBooks.

Pliny Philemon Holland, translator: 1601 http://penelope.uchicago.edu/holland/pliny9.html

Rossby H. T. and P. Miller, 2004, 'Ocean Eddies in the 1539 Carta Marina', *Oceanography*, vol. 16, 77.

Vecchione, M. *et al.*, 2001, 'Worldwide Observations of Remarkable Deep-Sea Squids', *Science*, 294, 5551, 2505.

PUFFERFISH

Delpeuch, Francis *et al.*, 2009, *Globesity: A Planet Out of Control?*, Earthscan.

Jackson, Jeremy, 2010, 'The Future of Oceans Past', *Phil. Trans. R. Soc. B*, vol. 365, no. 1558, 3765–78.

James, Oliver, 2007, *Affluenza*, Vermillion.

Marshall, Michael, 2010, 'The most kick-ass fish in the sea', Zoologger, *New Scientist*, 5 May 2010.

Phillips, Adam, 2011, *On Balance*, Penguin.

Pollan, Michael, 2006, *The Omnivore's Dilemma*, Penguin.

Thoreau, Henry David, 1854, *Walden: or, Life in the Woods*, Oxford World's Classics (2008).

QUETZALCOATLUS

Amenábar, Alejandro, 2004, *Mar Adentro* (film), released as *The Sea Inside* (UK) or *Out to Sea* (US), Fine Line Features.

Anon, 2007, 'Falling off High Places: Human Lemmings', *The Economist*, 19 December 2007.

Dawkins, Richard, 1996, *Climbing Mount Improbable*, W. W. Norton.

de Becker, R., 1968, *Dreams, or Machinations of the Night*, Allen & Unwin.

de Saint-Exupéry, Antoine, 1939, *Wind, Sand and Stars*, Penguin (2011).

de Saint-Exupéry, Antoine, 1943, *The Little Prince*, Egmont (1991).

Elvin, Mark, 2007, 'The spectrum from myth to reality: the folk psychology of dangerous animals and natural disasters in western Yúnnán province, China, in mediaeval times', personal communication.

Empson, Jacob, 2002, *Sleep and Dreaming*, Palgrave Macmillan.

Naish, David, 2006–2011, http://scienceblogs.com/tetrapodzoology.

Pettigrew, J.D., 1986, 'Flying primates? Megabats have the advanced pathway from eye to midbrain', *Science*, 231, 1304–6.

Platform London, 2007, 'Burning Capital, a documentary on BP's fourth quarter and full year results', http://www.platformlondon.org.

Shuker, Karl P.N., 1997, *From Flying Toads to Snakes with Wings: In Search of Mysterious Beasts*, Bounty Books.

Unwin, David, 2006, *The Pterosaurs*, Pi Press.

RIGHT WHALE

Beale, Thomas, 1839, *The Natural History of the Sperm Whale*, Holland Press.

Caxton, William, 1481, *Myrrour of the Worlde*

Crane, J. and R. Scott, 2002, 'Eubalaena glacialis', Animal Diversity Web, accessed 17 March 2011.

Dean, Cornelia, 2009, 'Fall and Rise of the Right Whale', *The New York Times*, 17 March 2009.

Hoare, Philip, 2008, *Leviathan, or The Whale*, Fourth Estate.

Hoare, Philip, 2010, 'Whales: we owe them an apology', *Slate*, 5 March 2010.

Lee, S.-M. and D. Robineau, 2004, 'The cetaceans of the Neolithic rock carvings of Bangu-dae, South Korea and the beginning of whaling in the North-West Pacific', *L'anthropologie*, 108.

Lopez, Barry, 1986, *Arctic Dreams: Imagination and Desire in a Northern Landscape*, Bantam Books.

Payne, Roger S. and Scott McVay, 1971, 'Songs of Humpback Whales', *Science,* 173, 3997, 585–97.

Prochnik, George, 2010, *In Pursuit of Silence: Listening for Meaning in a World of Noise*, Doubleday.

Reilly, S. B. *et al.*, 2008, Eubalaena glacialis, in IUCN Red List of Threatened Species, version 2010.4, www.iucnredlist.org.

Roman, Joe, 2006, *Whale*, Reaktion.

Rothenberg, David, 2008, *Thousand Mile Song: Whale Music in a Sea of Sound*, Basic Books.

Siebert, Charles, 2009, 'Watching Whales Watching Us', *The New York Times*, 12 July 2009.

SEA BUTTERFLY

Barnett and Holloway, 2007, 'Small Worlds: The Art of the Invisible' at the Oxford Museum of the History of Science in 2007–8. http://www.mhs.ox.ac.uk/smallworlds/exhibition.

Boyce *et al.*, 2010, 'Global phytoplankton', op. cit.

Caldeira, K. and M. E. Wickett, 2005, 'Ocean model predictions of chemistry changes from carbon dioxide emissions to the atmosphere and ocean', *J. Geophys. Res.*, 110, C09S04.

Collini, Elisabetta *et al.*, 2010, 'Coherently wired light-harvesting in photosynthetic marine algae at ambient temperature', *Nature*, 463, 644–7.

Fabry, Victoria J. *et al.*, 2008, 'Impacts of ocean acidification on marine fauna and ecosystem processes', *ICES J. Mar. Sci.*, 65 (3): 414–32.

Hayes, Nick, 2011, *The Rime of the Modern Mariner*, Jonathan Cape.

Huxley, Thomas, 1868, 'On a Piece of Chalk', *Collected Essays*, Macmillan & Co. (1894).

IPSO, 2011, International Earth system expert workshop on ocean stresses and impacts, http://www.stateoftheocean.org/, accessed 2 December 2011.

Lynas, Mark, 2011, chapter on ocean acidification in *The God Species*, Fourth Estate.

Margulis, Lynn, 2009, essay contribution to 'Does Evolution Explain Human Nature?', Templeton Foundation.

Orr, James C. *et al.*, 2005, 'Introduction to special section: The Ocean in a High-CO_2 World', *J. Geophys. Res.*, 110, C09S01.

Orr, James C. *et al.*, 2005, 'Anthropogenic ocean acidification over the twenty-first century and its impact on calcifying organisms', *Nature*, 437, 681–6.

Southwood, T.R.E., 2003, *The Story of Life*, Oxford University Press.

Tréguer, Paul *et al.*, 1995, 'The Silica Balance in the World Ocean: A Re-estimate', *Science*, 268, 5209, 375–9.

UK Ocean Acidification Research Programme, 2010, 'Briefing note on Matt Ridley's article, "Who's Afraid of Acid in the Ocean? Not Me"' http://www.oceanacidification. org.uk.

THORNY DEVIL

Bowman, M. J. S. *et al.*, 2010, 'Fire in the Earth System', *Science*, 324 5926, 481–4.

Flannery, Tim, 1994, *The Future Eaters*, Grove Press (2002).

Flannery, Tim, 2011, *Here on Earth: A New Beginning*, Allen Lane.

Johnson, Christopher N., 2008, 'The Remaking of Australia's Ecology', *Science*, 309, 5732, 255–6.

Jones, Rhys Maengwyn, 1969, 'Fire-stick farming', *Australian Natural History*, 16:224–8.

Miller, Gifford H. *et al.*, 2005, 'Ecosystem Collapse in Pleistocene Australia and a Human Role in Megafaunal Extinction', *Science,* 309, 5732, 287–90.

Moffett, Mark M., 2010, *Adventures Among Ants: A Global Safari with a Cast of Trillions*, University of California Press.

Morton, Oliver, 2007, *Eating the Sun*, Fourth Estate.

Pianka, Eric R., 'Australia's Thorny Devil', http://uts.cc.utexas.edu/~varanus/moloch.html.

Pyne, Stephen J., 1998, 'Forged in fire: History, land, and anthropogenic fire' in W. Balée (ed.), *Advances in Historical Ecology*, Columbia University Press, pp. 64–103.

Pyne, Stephen J., 2001, *Fire: A Brief History*, British Museum Press.

Reed, A.W., 1999, *Aboriginal Myths, Legends and Fables*, Reed Natural History, Australia.

Wilson, E. O. and Bert Hölldobler, 1994, *Journey to the Ants*, Harvard University Press.

UNICORN – GOBLIN SHARK

Borges, Jorge Luis, 1962, 'The Fearful Sphere of Pascal' in *Labyrinths*, New Directions Publishing Corporation and Penguin Classics (2000).

Crawford, Dean, 2008, *Shark*, Reaktion Books.

Knowlton, N. and Jackson, J. B. C., 2008, 'Shifting Baselines, Local Impacts, and Global Change on Coral Reefs', *PLoS Biology*, 62: e54.

Laidre, Kristin L. *et al.*, 2008, 'Quantifying the Sensitivity of Arctic Marine Mammals to Climate-Induced Habitat Change', *Ecological Applications*, 18: S97–S125.

Lavers, Chris, 2009, *The Natural History of Unicorns*, Granta.

Martin, R. Aidan, 2001, 'Biology of Sharks and Rays', www.elasmo-research.org.

Meeuwissen, Tony, 1997, *Remarkable Animals: 1000 Amazing Amalgamations*, Frances Lincoln.

Nweeia, Martin, 2005, 'Marine Biology Mystery Solved: Function of Unicorn Whale's 8-foot Tooth Discovered', Harvard Medical School press release, 13 December 2005.

Sapolsky, Robert, 2010, 'This Is Your Brain on Metaphors', *The New York Times*, 14 November 2010.

Saez Castan, Javier and Miguel Murugarren, 2003, *Animalario Universal del Profesor Revillod* Fondo de Cultura Económica, Mexico.

Wilson, E. O., 1996, *In Search of Nature*, Island Press.

VENUS'S GIRDLE

Amos, William H., 2004, 'Venus's Girdle', http://www.microscopy-uk.org.uk, accessed 2 December 2011.

Balcombe, Jonathan, 2006, *Pleasurable Kingdom*, Macmillan.

Boero, Peter *et al.*, 2007, 'Cnidarian milestones in metazoan evolution', *Int. Comp. Bio.*, 47:5.

Etnoyer, Peter, 2008, 'The Nematocyst: apex of organelle specialization', *Deep Sea News*, 1 May 2008, http://scienceblogs.com/deepseanews/, accessed 2 December 2011.

Colin, Sean P. *et al.*, 2010, 'Stealth predation and the predatory success of the invasive ctenophore Mnemiopsis leidyi', *PNAS*, 20 September 2010.

Judson, Olivia, 2002, *Dr Tatiana's Sex Guide to All Creation*, Vintage.

Kideys, Ahmet E., 2002, 'Fall and Rise of the Black Sea Ecosystem', *Science*, 297, 5586, 1482–4.

Knoll, Andrew H. and Sean B. Carroll, 1999, 'Early Animal Evolution: Emerging Views from Comparative Biology and Geology', *Science*, 284, 5423, 2129–37.

Lucretius, 1997, *On the Nature of Things,* translation by Ronald Melville, Oxford Word's Classics.

Nüchter, T. *et al.*, 2006, 'Nanosecond- scale kinetics of nematocyst discharge', *Current Biology* 16, R316-R318, 9 May 2006.

Whitfield, J., 2004, 'Everything You Always Wanted to Know about Sexes', *PLoS Biology*, 26: e183.

WATERBEAR

The American Museum of Natural History, 'The Known Universe', http://www.amnh.org/news/2009/12/the-known-universe/, accessed 23 December 2011.

Bostrom, Nick, 2007, 'The Future of Humanity', published in *New Waves in Philosophy of Technology,* Palgrave Macmillan, 2009.

Bostrom, Nick, 2008, 'Where are they? Why I hope the search for extraterrestrial intelligence finds nothing', *MIT Technology Review*, May/June 2008.

Davies, Paul, 2010, speaking to Philip Dodd on *Nightwaves*, BBC Radio 3, March 2010.

Deutsch, David, 1997, *The Fabric of Reality*, Penguin.

Deutsch, David, 2005, 'Our Place in the Cosmos', http://www.ted.com.

Deutsch, David, 2009, 'A New Way to Explain Explanation', http://www.ted.com.

Deutsch, David, 2011, *The Beginning of Infinity*, Allen Lane.

Howard, Andrew W. *et al.*, 2010, 'The Occurrence and Mass Distribution of Close-in Super-Earths, Neptunes, and Jupiters, *Science*, 330, 6004, 653–5.

Jönsson, K. Ingemar *et al.*, 2008, 'Tardigrades survive exposure to space in low Earth orbit', *Current Biology*, vol. 18, issue 17, pp. R729-R731.

Mach, Martin, 2000, 'The incredible water bear', http://www.microscopy-uk.org.uk, accessed 2 December 2011.

Mantel, Hilary, 2008, 'That Wilting Flower', *London Review of Books*, 24 January 2008.

Roach, Mary, 2010, *Packing For Mars*, W.W. Norton.

XENOGLAUX

Anderson, K. and Bows, A., 2011, 'Beyond "dangerous" climate change: emission scenarios for a new world,' *Philosophical Transactions of the Royal Society A*, 369: 20–44.

Barnosky, Anthony D. *et al.*, 2011, 'Has the Earth's sixth mass extinction already arrived?', *Nature*, 471, 51–7.

BirdLife International, 2011, species factsheet: *Xenoglaux loweryi*.

Darwin, Charles, 1839, *The Voyage of the Beagle*, http://darwin-online.org.uk.

Deakin, Roger, 2007, 'The Sacred Groves of Devon', in *Wildwood: A Journey Through Trees*, Hamish Hamilton.

Gladwell, Malcolm, 2000, *The Tipping Point: How Little Things Can Make a Big Difference*, Little Brown.

Global Biodiversity Outlook, 2010, UNEP, www.unep.org/pdf/GBO3-en.pdf.

Hamilton, Garry, 2011, 'Welcome Weeds: How Alien Invasion Could Save the Earth', *New Scientist*, 12 January 2011.

Kolbert, Elizabeth, 2009, 'The Sixth Extinction?' *The New Yorker*, 25 May 2009, http://www.newyorker.com/talk/comment/2011/12/05/111205taco_talk_kolbert, accessed 30 November 2011.

Lenton, Tim *et al.* 2007, 'Tipping Elements in the Earth's Climate System', *PNAS*, 12 February, 2008, vol. 105, no. 6, 1786–93.

Malhi, Yadvinder *et al.*, 2008, 'Climate Change, Deforestation, and the Fate of the Amazon', *Science*, 319, 5860, 169–72.

Malhi, Yadvinder *et al.*, 2009, 'Exploring the likelihood and mechanism of a climate-change-induced dieback of the Amazon rainforest', *PNAS*, 13 February 2009.

Marris, Emma, 2011, 'Can vulnerable species outrun climate change?', http://e360.yale.edu/ 3 November 2011, accessed 2 December 2011.

Morris, Desmond, 2009, *Owl,* Reaktion Books.

Nagel, Thomas, 1979, 'The Absurd', in *Mortal Questions*, Cambridge University Press.

Nepstad, Daniel *et al.*, 2009, 'The End of Deforestation in the Brazilian Amazon', *Science*, 326, 5958, 1350–51.

Pan, Yude *et al.*, 2011, 'A Large and Persistent Carbon Sink in the World's Forests', *Science*, 333, 6045, 988–93.

Pimm, S. *et al.*, 2006, 'Human impacts on the rates of recent, present and future bird extinctions', *PNAS*, vol. 103, no. 29, 10941–6.

Rumi, Jalal ad-Din (1207–1273), 'Spring is Christ', from *The Essential Rumi: Selected Poems*, Penguin (2004).

Thomas, Chris, 2011, 'Britain should welcome climate refugee species', *Trends in Ecology and Evolution*, vol. 26, p. 216.

Thompson, Ken, 2010, *Do We Need Pandas? The Uncomfortable Truth about Biodiversity*, Green Books.

Tolefson, Jeff, 2010, 'Amazon drought raises research doubts', *Nature*, 466, http://www.nature.com/news, 20 July 2010, accessed 21 January 2012.

Volk, Tyler, 1998, *Gaia's Body: Toward a Physiology of Earth*, MIT Press (2003).

Weidensaul, Scott, 2002, *The Ghost with Trembling Wings: Science, Wishful Thinking, and the Search for Lost Species*, Farrar, Straus and Giroux.

van der Werf, G.R. *et al.*, 2009, 'CO_2 emissions from forest loss,' *Nature Geoscience*, 2, 737–8.

WWF Global, Heart of Borneo Initiative, http://wwf.panda.org/.

Zelazowski, Przemyslaw *et al.*, 2011, 'Changes in the potential distribution of humid tropical forests on a warmer planet', *Phil. Trans. R. Soc. A*, 369.

XENOPHYOPHORE

Barbour, Julian, 2000, *The End of Time*, Phoenix.

Borges, Jorge Luis, 1940 (translated 1961), 'Tlön, Uqbar, Orbis Tertius', in *Labyrinths*, op. cit.

Close, Frank, 2007, *The Void*, Oxford University Press.

Broad, William J., 2009, 'Diving Deep for a Living Fossil', *The New York Times*, 25 August 2009.

Danovaro, Roberto *et al.*, 2010, 'The first metazoa living in permanently anoxic conditions', *BMC Biology*, 8: 30.

Dillard, Annie, 1982, *Teaching a Stone to Talk*, HarperPerennial (1988).

Hazen, Robert M., 2010, 'Evolution of Minerals', *Scientific American*, March 2010.

Hazen, Robert M. and J.M. Ferry, 2010, 'Mineral evolution: Minerology in the fourth dimension', *Elements*, 6, 1: 9–12.

Levi, Primo, 1975, *The Periodic Table*, Schocken Books.

Lewis-Williams, David, 2010, *Conceiving God: The Cognitive Origin and Evolution of Religion*, Thames & Hudson.

2008, The 27 Best Deep-Sea Species: No. 22 'Xenophyophores', 28 October 2008, http://deepseanews.com.

Matz, M. *et al.*, 2008, 'Giant Deep-Sea Protist Produces Bilaterian-like Traces', *Current Biology*, 18: 1–6.

Newton, Issac, Letter to Oldenburg (7 December 1675) in H. W. Turnbull (ed.), *The Correspondence of Isaac Newton, 1661–1675* (1959), vol. 1, 366.

Rona, P. *et al.*, 2003, 'Paleodictyon, a Living Fossil on the Deepsea Floor', American Geophysical Union, Fall Meeting 2003.

Schwartzman, D. W. and T. Volk, 1991, 'Biotic Enhancement of Weathering and Surface Temperatures on Earth since the Origin of Life', *Global and Planetary Change*, vol. 4, 357–71.

Seneca legend, http://www.firstpeople.us, accessed 2 December 2011.

Sherratt, Thomas N. and David M. Wilkinson, 2009, 'How Will the Biosphere End' in *Big Questions in Ecology and Evolution*, Oxford University Press.

Swinbanks, D.D. and Y. Shirayama, 1986, 'High levels of natural radionuclides in a deep-sea infaunal xenophyophore', *Nature*, 320, 354–8.

Young, Craig M., 2007, 'The Deep Seafloor: A Desert Devoid of Life?', essay in Claire Nouvian, *The Deep*, op. cit.

YETI CRAB

Beatty, Thomas J. *et al.*, 2005, 'An obligately photosynthetic bacterial anaerobe from a deep-sea hydrothermal vent', *Proceedings of the National Academy of Sciences*, vol. 102, issue 26.

Brownlee, Donald E., 2010, 'Planetary habitability on astronomical timescales', in Carolus J. Schrijver, *et al.*, *Heliophysics: Evolving Solar Activity and the Climates of Space and Earth*, Cambridge University Press.

Duprat, J. *et al.*, 2010, 'Extreme Deuterium Excesses in Ultracarbonaceous Micrometeorites from Central Antarctic Snow', *Science*, 328, 5979, 742–5.

Earle, Sylvia and Glover, Linda, 2009, *Oceans: An Illustrated Atlas*, National Geographic Society.

Lane, Nick, 2009b, 'Was our oldest ancestor a proton-powered rock?', *New Scientist*, 19 October 2000.

Macpherson, E. *et al.*, 2005, 'A new squat lobster family of Galatheoidea Crustacea, Decapoda, Anomura from the hydrothermal vents of the Pacific-Antarctic Ridge', *Zoosytema*, 27 (4).

Morelle, Rebecca, 2011, 'Deep-sea creatures at volcanic vent', BBC News, 28 December 2011.

Royle, Peter, 2008, 'Crabs', *Philosophy Now*, May/June 2008.

Sartre, Jean-Paul, 1938, *La Nausée*, New Directions (2007).

Singer, P. W., 2009, *Wired for War*, Penguin Books.

Thurber, A.R. *et al.*, 2011, 'Dancing for Food in the Deep Sea: Bacterial Farming by a New Species of Yeti Crab', *PLoS ONE*, 6(11): e26243.

Wallace, David Foster, 2005, *Consider the Lobster and Other Essays*, Little, Brown.

ZEBRAFISH

Adler, Ray, 2010, 'Ray Kurzweil: Building bridges to immortality', *New Scientist*, 27 December 2010.

Atwood, Margaret, 2003, *Oryx and Crake*, Bloomsbury.

Atwood, Margaret, 2009, *The Year of the Flood*, Bloomsbury.

Berry, Thomas, 2009, *The Sacred Universe: Earth, Spirituality, and Religion in the 21st Century*, Columbia University Press.

Berry, Wendell *et al.*, 2007, 'Our Biotech Future: An Exchange', *New York Review of Books*, 27 September 2007.

Bostrom, Nick, 2007, 'The Future of Humanity', op. cit.

Bosveld, Jane, 2009, 'Evolution by Intelligent Design: Bioengineers will likely control the future of humans as a species', *Discover.com*, March 2009, http://discover-magazine.com, accessed 21 January 2012.

Brazier, Martin, 2009, 'The Deep History of Life on Earth', Remarks at the Geological Society, 25 June 2009.

Cascio, James, 2009, 'Get Smarter', *The Atlantic*, July/August 2009.

Chalmers, David J., 2010, 'The Singularity: A Philosophical Analysis', *Journal of Consciousness Studies* 17:7–65.

Chin, Jason, 2009, 'Reprogramming the code of life', the Francis Crick Prize lecture, The Royal Society, 26 November 2009.

Cullen, Jonathan M. et al., 2011, 'Reducing Energy Demand: What Are the Practical Limits?' *Environ. Sci. Technol.*, 45 (4), 1711–18.

Dyson, Freeman, 2007, 'Our Biotech Future', *New York Review of Books*, 19 July 2007.

Eagleman, David, 2009, *Sum*, Canongate.

Endersby, Jim, 2007, *A Guinea Pig's History of Biology*, William Heinemann.

Gopnik, Adam, 2011, 'The Information: How the Internet gets inside us', *The New Yorker*, 14 February 2011.

Gray, John, 2002, *Straw Dogs*, Granta.

Gray, John, 2011, *The Immortalization Commission: Science and the Strange Quest to Cheat Death*, Allen Lane.

Haque, Umair, 2011, 'Egypt's Revolution: Coming to an Economy Near You', *Harvard Business Review*, 1 February 2011.

Haque, Umair, 2011, 'The Eudaimonic Transformation', http://www.umairhaque.com/, accessed 2 December 2011.

Hoffman, David E., 2010, *The Dead Hand: The Untold Story of the Cold War Arms Race and its Dangerous Legacy*, Anchor.

Hume, David, 1741, 'On Dignity and Meanness of Human Nature', http://www.david-hume.org.

Jackson, Tim, 2009, 'Prosperity Without Growth', a report for the UK Sustainable Development Commission, http://www.sd-commission.org.uk, accessed 12 January 2012.

Kasparov, Garry, 2011, 'The Chess Master and the Computer', *New York Review of Books*, February 2011, being a review of Diego Rasskin-Gutman, *Chess Metaphors: Artificial Intelligence and the Human Mind* (2011), MIT Press.

Kikuchi, Kazu et al., 2010, 'Primary contribution to zebrafish heart regeneration by gata4+ cardiomyocytes', *Nature*, 464, 601–5.

Linden, David J., 2011, 'The Singularity is Far: A Neuroscientist's View', http://boing-boing.net, 14 July 2011, accessed 30 November 2011.

Lynas, Mark, 2011, *The God Species: How the Planet Can Survive the Age of Humans*, Fourth Estate.

Morris, Errol, 2010, *Tabloid*, Air Loom Enterprises.

Morton, Oliver, 2007, op. cit.

Nature editorial, 2008, 'Beyond the origin', 20 November 2008, *Nature*, 456, 281.

Nurse, Sir Paul, 2010, 'The Great Ideas of Biology', http://royalsociety.org/royalsociety.tv.

Poss, Kenneth D. et al., 2002, 'Heart Regeneration in Zebrafish', *Science*, 298, 5601, 2188–90.

Rockström, Johan et al., 2009, 'A safe operating space for humanity', *Nature*, 461, 472–5.

Russell, Claire, 2003, 'The roles of Hedgehogs and Fibroblast Growth Factors in Eye Development and Retinal Cell Rescue', *Vision Research*, 43, 899–912.

Sagan, Carl, 1996, *Billions and Billions*, Ballantine Publishing Group.

Thomas, Lewis, 1974, 'Natural Man', an essay republished in *The Lives of a Cell*, Bantam Books.

Voltaire, 1759, *Candide*, Penguin Classics (2006).

Zimmer, Carl, 2008, *Microcosmos: E Coli and the New Science of Life*, Pantheon.

Žižek, Slavoj, 2010, 'Interlude 4: Apocalypse at the Gates' in *Living in End Times*, Verso.

CONCLUSION

Allenby, Brady and Daniel Sarowitz, 2011, *The Techno-Human Condition*, MIT Press.

Black, Richard, 2012, 'Carbon emissions will defer Ice Age', BBC News, 9 January 2012.

Heidegger, Martin, 1949, 'The Question Concerning Technology', in David Farrell Krell (ed.), *Basic Writings*, Routledge 2011.

Kahneman, Daniel, 2011, *Thinking, Fast and Slow*, Farrar, Straus and Giroux.

Marris, Emma, 2011, *Rambunctious Garden: Saving Nature in a Post-Wild World*, Bloomsbury.

Rees, Martin, 2011, 'Higgs Boson Might Yield Origins of Universe But Questions Remain', http://www.Thedailybeast.com, 19 December 2011.

Stager, Curt, 2011, *Deep Future: The Next 100,000 Years*, Thomas Dunne Books.

THANKS

Thanks to my agent James Macdonald Lockhart, without whom this book would never have got off the ground, and whose sustained care and attention made all the difference. Thanks to Robert Macfarlane. Thanks to Sara Holloway and her colleagues at Granta who saw potential and supported it. Sara was the best editor I could hope for. Thanks, also, to her assistants – first Amber Dowell and later Anne Meadows, who helped in many ways. Thanks to Benjamin Buchan for copy-editing, and Slav Todorov for proof-reading. Thanks to David Atkinson for the index. Thanks to Christine Lo, Michael Salu, Sarah Wasley and all those involved in design, production and promotion at Granta. Paola Desiderio assisted with picture research. Thanks to Golbanou Moghaddas for her striking and captivating illustrations.

The Ashden Trust and Pedro Moura Costa generously funded an earlier project on the fate of the world's coral reefs that has yet to see the light. The work they supported informs this book, and I remain very much in their debt. Thanks to those involved in the Society of Authors Roger Deakin Award and the Royal Society of Literature Jerwood Award for Non-Fiction, both of which selected *The Book of Barely Imagined Beings* as work in progress.

Thanks to Peter Barnes and all those who made possible my stay at the Mesa Refuge in Point Reyes, California. Thanks to Anna and Chris for having me at Tom's Bothy in Achmore, to Brian and Lucy Poett for Tokavaig and to Rebecca Carter for making arrangements in Walsingham. In these beautiful places I was able to think and write.

Thanks to staff at the Bodleian for unfailing help and courtesy, to Bruce Barker-Benfield for showing me the original Ashmole and Bodley bestiaries, to Julia Walworth and her colleagues at Merton College Library for a view of their bestiaries, and to M. Katharine Simms at Trinity College Dublin for insight into the Old Irish Pangur Bán. I am also most grateful to Dr Claire Russell at the Royal Veterinary College in London, who kindly allowed me to spend time in her lab watching zebrafish embryos.

Paula Casal, Melanie Challenger and Benjamin Morris read drafts of some chapters, and made helpful comments. Other friends, acquaintances and colleagues offered invaluable ideas, practical support or encouragement along the way. Even if they weren't aware of it or it didn't seem like much to them at the time, it mattered. Among them were Neil Astley, Nicola Baird, Anthony Barnett, Meg Berlin, Geoffrey Best, David Bodanis, Harvey Brown, Bernd Brunner, David Buckland, Philippa Bushell, Robert Butler, Alex Butterworth, Susan Canney, Navjyoat Chhina, Sue Comber, James Crabtree, Max Eastley, Steven Goldman, Chris Goodall, Tom Goreau, Clive Hambler, David Hayes, Stefan Hain, Judith Herrin, Paul Hilder, Roland Hodson, Matthew Hoffman, Paul Kingsnorth, John Kitching, Lee Klinger, Alan Knight, Charlie Kronick, Sarah Laird, Antonia Layard, Annie Levy, Jenny Lunnon, Mark Lynas, Ruth Nussbaum, James Marriott, George Marshall, Greg Muttitt, Andrew McNellis, George Monbiot, Pedro Moura Costa, Peter Oldham, Mario Petrucci, Laura Rival, Callum Roberts, Bradon Smith, Joe Smith, Oliver Tickell, Patrick

Walsh, Marina Warner, Hugh Warwick and Kenny Young. Thanks, too, to my colleagues at UKERC in 2011.

This book is for my beloved wife, Cristina: *Defender la alegría como una bandera*. It is also for our families, including Angel Miguel Mateos Batalla and John Huchra who are much missed; I hope they would have enjoyed it. Above all this book is for Lara: 'O brave new world that has such creatures in it!'

PICTURE CREDITS

The author and the publisher have made every effort to trace copyright holders. Please contact the publisher if you are aware of any omissions.

TEXT CREDITS

The author and the publisher have made every effort to trace copyright holders. Please contact the publisher if you are aware of any omissions.

Lines from *The Denial of Death* copyright © The Estate of Ernest Becker, 1973.

Lines from *Why Look at Animals?* copyright © John Berger, 1991. Reprinted by kind permission of the author.

Lines from *The Benevolent Emporium of Celestial Knowledge* copyright © The Estate of Jorge Luis Borges, 1942. Reprinted with the permission of Penguin.

Lines from *The Book of Imaginary Beings* copyright © The Estate of Jorge Luis Borges, 1967. Random House.

Lines from *Funes the Memorious* copyright © The Estate of Jorge Luis Borges, 1944. Reprinted with the permission of Pollinger Ltd.

Line from *The Fearful Sphere of Pascal* copyright © The Estate of Jorge Luis Borges. Penguin

Lines from *Cosmicomics* copyright © The Estate of Italo Calvino, 1965. Reprinted with permission of Penguin, Harcourt and The Wylie Agency.

Lines from *The Sea Around Us* © The Estate of Rachel Carson, 1951.

Lines from *Caspar Hauser* copyright © David Constantine, Bloodaxe, 1994.

Lines from *The Enchanted Braid* copyright © Osha Gray Davidson, 1998. Reprinted with the kind permission of the author.

Lines from *Wind, Sand and Stars* copyright © The Estate of Antoine de Saint-Exupéry, 1939. Reprinted with the kind permission of Succession Antoine de Saint-Exupéry-d'Agay.

Lines from *The Fabric of Reality* copyright © David Deutsch, 1997. Reprinted with the kind permission of the author. Penguin.

Line from *Teaching a Stone to Talk* copyright © Annie Dillard, 1982. Reprinted by the permission of Russell & Volkening as agents for the author's estate.

Lines from *Why Life Speeds Up As You Get Older* copyright © Douwe Draaisma, 2004. Reprinted with the kind permission of the author.

Lines from *Sum* copyright © David Eagleman, 2009. Reprinted with the kind permission of the author.

Lines from *Burnt Norton* and *The Love Song of J. Alfred Prufrock* copyright © The Estate of T. S. Eliot, 1915, 1941. Reprinted with permission of Faber and Faber.

Lines from *The Immense Journey* copyright © 1957 The Estate of Loren Eiseley, Random House.

Words of Toni Frohoff reprinted with her kind permission.

Lines from *The Eye* copyright © Simon Ings, 2007. Reprinted by permission of the author and Bloomsbury.

Words of Jerome Lewis reproduced with his kind permission.

Lines from *Machiavellian Intelligence* copyright © Dario Maestripieri, 2007. Reprinted by kind permission of the author.

Lines from *1984* copyright © The Estate of George Orwell, 1948. Reprinted by permission of Penguin and A. M. Heath.

INDEX

Axolotl

Barrel Sponge

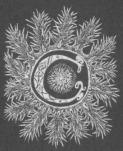

Crown of Thorns
Starfish

Dolphin

Eel

Flatworm

Gonodactylus

Human

Iridogorgia

Japanese Macaque

Kìrìpʰá-kò,
the Honey Badger

Leatherback

Mystaceus